Mysteries of Fifty Centuries

Masterpieces of Fifty Centuries

The Metropolitan Museum of Art

Introduction by Kenneth Clark

New York (City). Metropolitan Museum of Art.

E. P. Dutton & Co., Inc. New York
in association with The Metropolitan Museum of Art

Published simultaneously in Canada by
Clarke, Irwin & Company Limited, Toronto and Vancouver

Library of Congress Catalog Card Number: 76-122794

SBN 0-525-15423-X (Cloth edition) SBN 0-525-03950-3 (Paper edition)

Grateful acknowledgment is made for permission to quote the following copyright material:
"The Great Figure." From William Carlos Williams, *Collected Earlier Poems.*
Copyright 1938 by William Carlos Williams. Reprinted by permission of
New Directions Publishing Corporation.

Photograph Credits
Color photographs by William Pons, The Metropolitan Museum of Art,
except: Kodansha, 42, 43, 176; Malcolm Varon, 9, 75, 89, 90, 115, 117,
121, 136, 142, 151, 209, 234, 277, 279, 301, 314, 326, 336, 337, 338, 391.
 Black and white photographs by William Pons, The Metropolitan Museum
of Art, except: Christie, Manson and Woods, 360; Robert Lehman Collection,
148, 169, 178, 180, 182, 184, 189, 190, 195, 198, 199, 205, 225, 226, 231, 242,
282, 295, 309, 357; Sotheby and Co., 188; Taylor and Dull, 116, 139,
350, 352; Charles Uht, 39, 40, 41, 70, 110, 262, 263, 264, 265, 267, 268, 269, 270,
353, 354, 355.

Photocomposition by Westcott & Thomson, Inc., Philadelphia, Pennsylvania
Black and white lithography and paper edition binding,
The Murray Printing Company, Forge Village, Massachusetts
Color lithography, Amilcare Pizzi, S.P.A., Milan, Italy, from separations
produced by Nievergelt Offset-Reproduktionen AG, Zurich, Switzerland,
produced in association with Chanticleer Press, Inc., New York
Cloth edition binding, American Book-Stratford Press, Inc., New York
Designed by Ellen Hsiao

The exhibition *Masterpieces of Fifty Centuries*
is made possible through the generosity of these
sponsoring organizations:

American Electric Power Corp.
Bankers Trust Co.
The Chase Manhattan Bank Foundation
Chemical Bank
Columbia Broadcasting System
Corning Glass Works
Eastern Airlines
Fifth Avenue Association
First National City Bank
IBM Corporation
International Telephone and Telegraph Corporation
Irving Trust Co.
McGraw-Hill, Inc.
Morgan Guaranty Trust Co.
New York Life Insurance Co.
The New York Times
Reader's Digest
Standard Oil Company (New Jersey)

Acknowledgments

A special exhibition that calls on the artistic resources of all seventeen curatorial departments of the Museum is an especially complex and demanding task. Many people with heavy responsibilities elsewhere gave unstintingly of their time and effort. Without the cooperation of the entire staff, this undertaking would not have been possible.

A number of people deserve special recognition. Theodore Rousseau, Vice-Director and Curator in Chief, by his knowledge and long experience, gave shape and focus to the project from the beginning. It was his sensitivity that created the possibility of a major exhibition that presented a comprehensive and unified view of the Museum's first 100 years, and the promise of its second century. To Michael Botwinick, Associate Curator of Medieval Art and The Cloisters, and Colin Streeter, Executive Assistant to the Curator in Chief, go the fullest credit for the realization of the exhibition. Together they took on, and executed to perfection, the enormous task of planning, organizing, and coordinating every aspect of the show. Kay Bearman, Administrative Assistant, Department of Twentieth Century Art, smoothly handled the day-to-day problems and details, and created an efficient department for the show where none had existed. Margaretta Salinger, Curator, Department of European Paintings, deserves special recognition for her excellent work in the endless task of supervising the catalogue entries. Allen Rosenbaum created an opportunity for major educational experimentation in this exhibition and fulfilled that opportunity admirably. Judith Straeten was responsible for all photographic materials and photographic research. Susan MacMillan did research projects for many aspects of the show with originality and ingenuity. Ferle Bramson handled the work of a dozen with patience and humor. Patrick Cooney and Ronald Deane who came to the staff as summer interns made major contributions to all aspects of the show. Rosemary Levai and Julia Polk coaxed the exhibition through its early stages. Stuart Silver, Manager, and Peter Zellner, Associate Manager, of Exhibition Design and their staff have created a stunning setting for this show which proves again the importance and excellence of their contribution to the Museum. George Trescher, Secretary, 100th Anniversary Committee, and his Centennial Staff provided all of the support and help anyone could ask for in this final Centennial project.

There are many others who deserve recognition, too many to list. But for all of the curators who gave their fullest cooperation, for all of those who helped by providing catalogue material, for all of the departmental

technicians, riggers, carpenters, electricians, guards, and others for their dedication and professionalism, and for all of the staff in various departments who gave so generously of their time and effort go thanks and the hope that the image of the Museum that they have helped present is justification for their effort.

Grateful acknowledgment is given to the following members of the Museum staff who contributed catalogue material:

Jacob Bean, Virgil Bird, Dietrich von Bothmer, Michael Botwinick, William Burgess, Adolph S. Cavallo, Hermine Chivian, Fong Chow, Vaughn E. Crawford, Carl C. Dauterman, Jessie McNab Dennis, Jim Draper, Elizabeth Easby, Everett P. Fahy, William H. Forsyth, Margaret Frazer, Jiri Frel, Henry Geldzahler, Linda Gillies, Ellen Gleason (The Museum of Primitive Art), Carmen Gómez-Moreno, Yvonne Hackenbroch, Prudence Oliver Harper, Jane Hayward, Jeffrey Hoffeld, Penelope Hunter, Timothy Husband, Colta Feller Ives, Marilyn Jenkins, Marilynn Johnson, Julie Jones (The Museum of Primitive Art), Clare Le Corbeiller, Leslie Lee, Marie Grant Lukens, Oscar White Muscarella, Douglas Newton (The Museum of Primitive Art), Helmut Nickel, Andrew Oliver, Jr., James Parker, John Goldsmith Phillips, Olga Raggio, Edwin M. Ripin, Margaretta M. Salinger, Jean K. Schmitt, John F. Scott, Nora Scott, Natalie Spassky, Harvey Stahl, Edith Standen, Colin Streeter, Suzanne Valenstein, Clare Vincent, John Walsh, Jr., Emanuel Winternitz, James Wood.

Contents

Foreword

Art is and always has been an integral part of man's life. Today it takes a bigger place than ever before. Never have there been so many artists, so many art schools, so many museums, such an active market, and such broad public interest.

This is due to a new situation peculiar to our times. Not only has our knowledge of art increased immeasurably through photographic reproductions that put the whole range of art within the grasp of anyone, but the tremendous number of images that are now constantly before our eyes has given us an appetite for the visual which never existed before. Pictures have replaced the written word as the principal means of conveying ideas. They are everywhere. Everything one buys is decorated with them. They invade the printed page. Everyone has a camera, and the most common forms of relaxation are the movies and television—images that entertain and inform. The great majority of these are advertisements—propaganda, intended to make us act without further thought: buy something, go somewhere, eat, drink, smoke, think in a certain way. Given no time for reflection, we are expected to react almost automatically. For the image to achieve this, the spectator must play a passive role.

Now, the museum is a treasury of images. But these images are fundamentally different from the stupefying kind we are constantly assailed by. The work of art is an image to which we respond rather than submit, and this response is an antidote to unquestioning acceptance. The museum offers something that is fast becoming lost in modern life: a place where one can exercise one's power of choice and appreciation entirely at one's own will. A place where enjoyment can be an inspiration to learning.

Masterpieces of Fifty Centuries is an attempt to provide this experience through the Metropolitan's own collections. It is composed of a choice of the finest objects in each one of the Museum's seventeen departments. They are arranged chronologically from the earliest beginnings 5,000 years ago to the present, so that at each period it is possible to see what was being done in the different parts of the civilized world.

An exhibition of this scope is not easy to visit. Although it cannot claim to be absolutely complete, its range and its variety may well be overwhelming. It is not meant to enshrine "art" in an impressive temple. It is not meant to awe. It is intended to give each visitor a very personal and rewarding experience, one that will call on his whole being, his senses, his mind, and his spirit. To achieve this he must be willing to

give the object his fullest attention and allow himself to become completely absorbed by it.

Each object in the exhibition has been selected for its exceptional quality. This is what appeals first to the senses which react instinctively to beauty of form, color, execution. Sometimes beauty is sought by the artist in his subject matter, and sometimes he seeks it, in part or in whole, in the physical means he uses to create the work of art, the metal, the stone, the paint itself.

Every work of art is a mirror, reflecting the time and the place in which it was made, and the feelings of the human being who created it. The artist, like all men, is either drawn to the material, to actions and appearances, or to the spiritual, to dreams and emotions. He expresses this in many different ways. To see and understand this in a work of art is one of the most satisfying aspects of its enjoyment.

The reader of this book and the exhibition visitor will become aware of certain basic concerns that exist throughout all art: the concept of man, the concept of God, the interpretation of nature, the interpretation of man's inner being, the representation of reality or its abandonment in favor of abstraction. He will see that the art of certain cultures bears a meaning for other foreign cultures, is imitated by them, and survives for many generations. Sometimes the style of a culture will disappear for centuries, only to be born again, reinterpreted in a new time and a new place. The conclusion is inescapable: the human race is one. All men share the same feelings. There is no "ancient" art, no "modern" art. There are simply human instincts and emotions constantly recurring and inspiring different peoples at different times.

Theodore Rousseau
Vice-Director and Curator in Chief,
The Metropolitan Museum of Art

Unity in Diversity

Kenneth Clark

The historian of art is bound by his profession to dwell on diversity. He is trained to distinguish between different schools and successive styles; and if he reads the writings of his predecessors, he must be surprised, and perhaps depressed, by the diversity of their judgments. The works of art they admire, and the reasons they give for admiring them, seem to differ in every decade. He may well feel that the appreciation of art is merely a matter of fashion, and, as with fashion in dress, one comes to accept anything: with the difference that there is no unvarying human body under the dress. Students of aesthetics, on the other hand, have tended to the opposite extreme. They have tried to find a single cause for the pleasure that we derive from works of art, and have usually been driven back to such vague terms as rhythm, harmony, or significant form, which do no more than push the need for definition one stage further into the penumbra. Neither approach is satisfactory. The historian loses his sense of values, the aesthetician loses touch with direct experience.

We need a philosophy of art based on experience, but only during the last fifty years has this become possible. Thanks to photography, easy travel, and the liberal policies of museums and galleries, we can now see and compare the best surviving works of every culture. Fashion will always play a part in our judgments, but it has become a much more superficial part. Fundamentally we are far more inclusive. We can never again be in the position of our ancestors, who believed that all medieval art was barbarous and all Chinese art frivolous. Even the generation before our own thought Byzantine mosaics "stiff," Bernini "vulgar," and Guido Reni "ridiculous." We can accept them all and respond to them with a delight that may vary in degree according to our mood or our personal preference, but is basically the same.

This inclusiveness is sometimes taken as a sign that we lack any real stylistic conviction. I think that this misinterprets an important development of our mental outlook. We have lost a great deal in the last fifty years, but one thing we have gained is a wider horizon. We have a better understanding of the past, a firmer conviction of the unity of mankind, and a realization that the appreciation of art cannot be limited to a small section of society. All these new inclusions are related to one another.

One result of our wider horizons is that the line between museums and picture galleries has tended to disappear. In the last century picture galleries still retained the character of salons or academies, with oil paintings in gold frames packed from floor to ceiling; and museums were thought of primarily as collections of historical specimens, amassed and

3

arranged in order to provide information about the past. Under these conditions it was almost impossible to form any conception of the totality of human achievement. The Metropolitan Museum of Art has been one of the first modern museums in which the visitor can pass easily from one epoch to another, from ancient Egypt to Degas, and gain thereby a more vivid feeling of the unifying factors in art. It is entirely appropriate that the culminating exhibition of its centennial year, as revealed in this book, should be conceived on these lines, with a bold inclusiveness and a regard for excellence never attempted before. This is not simply an exhibition of "masterpieces": it is an opportunity to study and compare the creative powers of man; and it is an opportunity to consider, from direct experience, what we mean when we use the debatable expression "a work of art."

The very earliest manmade objects to which one can apply the word "art" fall into three categories: there are sculptured figurines; there are cave paintings of animals; and there are pots or bones decorated with abstract designs. Ultimately they all have the same intention, but they try to achieve it by different means. They express man's consciousness of the fleeting and disorderly nature of existence. They want to make time stand still; they want to give disorder a shape; they want to make visible the feeling, born of the recurring seasons and the movements of the heavenly bodies, that there must be some pattern in the universe.

Of these three modes of art, the first produced the greatest works because men discovered that the desire for personal or godlike immortality could be achieved by what we call *form*. What meaning can we attach to that mysterious word which is used so blithely by critics and writers on aesthetics? A study of the present exhibition should help us to decide. An Egyptian portrait, a figure of Gudea, a statue of a Greek youth of the fifth century B.C., and (if they were present) a figure from Chartres Cathedral or Rheims, or a fresco by Giotto or Masaccio, would all be accepted without argument as showing a sense of form. The same would be true of Titian's *Man with a Glove* or Cézanne's *Madame Cézanne*.

All these are representations of human beings; and I think it probable that the sense of form is closely dependent on the intense awareness of the living creature, human or animal. At a very early stage in man's development he felt that the living body must be simplified in order to conform with certain fundamental shapes—the sphere, the egg, the pillar, the pyramid—which seemed to him guarantees of order and permanence. We must suppose that this feeling was instinctive. Certainly it antedates

the consciousness of Euclid's geometry and has been used subsequently by painters and sculptors who have no knowledge of measurable calculation. We can imagine that the early sculptor who formed the features of a head conforming to an ovoid, or the body conforming to a column, had a deep satisfaction. "Now it looks as if it would last."

Thus began that interplay between observation and the idea which underlies the greatest art. We may agree that in certain early works—the figure of Gudea or the Greek Kouros—the idea has too evidently the upper hand. A head like a melon escapes the triviality of imitation, but it does not interest us as much as a head by Titian. Form must never entirely lose its original association with the human body, for that alone gives it vitality. As a great modern artist (whose work is often far from naturalistic) has said, "Each particular carving I make takes on in my mind a human, or occasionally an animal character and personality, and this personality controls its design and formal qualities."

So when form moves us most, the idea has been warmed by a feeling of our normal human needs. And next to survival, the strongest of these needs is the sexual impulse. A narrowly sexual aesthetic is incomplete, but it seems probable that our feelings of intense satisfaction when we contemplate certain pieces of sculpture or even pottery, our pleasure in apprehensible bulk, in smoothness of transition, in ratios of size between spheres and cylinders, arise from a physical cause rather stronger than the intellectual consolations of geometry. Ruskin said that ultimately sculpture derived its power from "bosiness or pleasant roundness"—one may speculate how far he was aware of the implications of this phrase, which the conventions of his time did not allow him to explore.

If ideal form is vitalized by our interest in the body, it is also modified by our interest in the visible imprint of the mind. The feeling of inner life does not show itself in the art of the Indus and the Euphrates, but it appears early enough in the art of the Nile, and under Akhenaten an outburst of spiritual enlightenment allows a penetration into the human psyche as deep and as disturbing as anything in art. We feel that the envelope of flesh has never been thinner. How strange that the Greeks, who showed in their literature such a profound understanding of human emotions, should have allowed so little of it to appear in their sculpture. Then, as the Hellenistic authority of ideal form declined, in late Roman portraits the *vie intérieure* appears. Man was in search of a soul; and after the long eclipse of the Dark Ages, he had found one which shines

through the heads of the saints and the Virgins in Gothic art. They too are subordinate to an ideal form, but it has changed from the sphere and cylinder of antiquity to a new shape, which found its greatest expression in the pointed arches and vaults of Gothic architecture. In its simplest form it is the shield with its armorial bearings; and the exquisite faces of Gothic saints are controlled by the idea of a shield. But they also reveal in their movements a quality inherited from the minor arts of Greece, the quality we call grace. That word, which can be stretched from theology to athletics, always implies some inner certainty, and when externalized in the turn of a head or the gesture of a hand, communicates that certainty by a single flowing rhythm.

In the Renaissance the sphere and the cylinder returned. That the classical oval did not necessarily preclude inner life is proved by the marble busts of Florentine ladies, whose sensuality is enhanced by the geometrical form in which it is enclosed. The process culminates in the Mona Lisa, where a head as perfect as a new-laid egg reveals an inner life of baffling complexity.

Given the interest in ourselves which grew up in the fifteenth century, individual likeness was bound sooner or later to supersede the ideal. One may say that it began to do so with Jan van Eyck and the Flemish portrait painters. But even in the apparently impartial scrutiny of Van der Weyden or Memling, the underlying sense of form remains. Only, perhaps, in the work of Holbein (who used a mechanical aid) are we conscious that description has become more important than the idea, although it is description so skillful and economical that it still gives us an aesthetic shock.

The portrait is a thorn in the side of the student of aesthetics. Having established to his satisfaction that art does not consist in imitation, he must face the fact that three of the greatest artists who ever lived, Titian, Rembrandt, and Velázquez, gave the best of their talents to painting portraits, and that in the rank only just below them, artists like Frans Hals and Houdon did practically nothing else.

It looks as if the old Greek doctrine that art consists in imitation is not quite so foolish as it sounds, always allowing that imitation means transformation into a medium—paint, terracotta, stone, or bronze—which is in itself an act of self-revelation. It is even possible that by giving his whole conscious attention to likeness, the artist may liberate his unconscious to express itself in the manipulation of his medium. His

fingers are free to be wiser than his mind. The actual quality of the paint on the head of Rembrandt's *Woman with a Pink* gives us the same feeling of rapture as a lyrical passage in Shakespeare, which depends equally on its *matière,* the sensuous quality of words.

To return to my three sources of art: the prehistoric wall paintings of animals introduce another element, the communication of energy. They are concerned with movement and were the work of people who were themselves in movement. The original centers of civilization were, or wished to be, static. They were the cultures of the overflowing rivers, the Nile, the Euphrates, the Indus, the Hwang Ho. They were, literally, stick-in-the-mud cultures that aimed above all at avoiding change, and in Egypt achieved this aim for about three thousand years. These cultures produced what we call monumental art. But beyond their frontiers was the vast, seething cauldron of the wandering peoples, turbulent, aggressive, and liable at any moment to boil over across the Urals, across the Caucasus, across the Danube, or across the Great Wall of China. They brought with them the portable arts of the weavers and the smith in works of magical intensity and coiled-up energy. Like the prehistoric wall painters they thought of movement in terms of animals, only the animals had long ago changed from snapshots to hieroglyphs and movement was conveyed by flow of line. The wandering people were hostile to settled societies. Tartars, Mongols, Lombards, Visigoths, Norsemen, they came down like wolves on the passive sheep who for so long have symbolized the congregation of the just (although in fact we keep them in order that we may eat them). But they were not wholly destructive, because their powerful rhythms revitalized a worn-out naturalism. The most obvious example is the style that we call Romanesque, in which the exhausted remnants of antique art are revived by both northern and Islamic energy. A more mysterious interaction of nomadic and established styles had taken place two thousand years earlier in the ritual bronzes of Shang China, whose monumental forms are covered with symbols of movement—clouds, birds, and fabulous monsters of terrifying vitality.

With these awe-inspiring objects we reach the third of my original impulses, the need to decorate surfaces with patterns that should express some belief in the magical power of the elements. The decorated pots of Egypt or Mesopotamia convey a sense of order through geometry and repetition. The bronze vessels of early China combine symbolism, magic, and vitality in a way that makes them almost unique among the decorated

surfaces of the world's art, although certain Central American reliefs have a curiously similar effect. In the spectrum of art, this is the opposite end to Egyptian and early Greek.

As Hellenistic art declined, the art of decorated surfaces took its place. The Judaic prohibition of images was adopted (like so much else in Judaism) by Mahomet, but Islam only gave the force of arms to a *fait accompli.* Aniconic art had been in the ascendant for over a century. The Church of the Holy Wisdom in Constantinople originally contained no representation of living things, but abstract designs of consummate beauty. In Islamic art, the image was replaced by the word, and the Cufic script became one of the supreme motifs of decoration. For eight hundred years this style spread over an area far greater than that of the Roman Empire, and like the Hellenistic style before it, it changed remarkably little in time or place. It even gained a more exhilarating invention of abstract design and a more sensuous beauty. Among the less orthodox Persians it admitted illustrations of enchanting delicacy, which create a world as polite as fifteenth-century Burgundy, but remain in the area of surface decoration. In the Metropolitan's exhibition and in this book, for almost the first time the decorative arts will appear on a level with the arts of imitation and ideated movement.

To think of any human activity in terms of its origins is a useful beginning, but at a certain point this line of thought must be abandoned if it is not to become a limitation. In art we reach this point when the relationship of objects or figures to each other becomes more important than the form of the objects themselves. This was seldom true of ancient Egypt or Assyria, but when one comes to the three seated figures of the Parthenon gable, one is aware of a complex interplay of forms. The overworked phrase "it adds a new dimension" is literally true; only in Greek art the new dimension was curiously shallow. No one has ever explained satisfactorily why the Greeks did not compose in depth; perhaps it was because their temples had no significant interiors. At all events, it was after the long acceptance of the Gothic nave that fifteenth-century Florentines developed the system known as perspective, by which figures in space could be shown in measurable relationship to one another. From the point of view of realism, strict perspective is positively a nuisance, but it perfectly expressed the philosophy of the time. When the enclosed world of early humanism was shattered by Luther and Copernicus, a new feeling for spatial relationships emerged that grew into the unifying sweep of Baroque.

Parallel with this penetration into space there was developed a pictorial science by which figures could be so arranged as to give the scene a feeling of architectural unity and permanence, without any lessening of dramatic effect. The picture space became like a stage scene handled by a master director; and in fact many of the painters who practiced this art, from Masaccio to Poussin, built up their compositions with the help of miniature models in a toy theater. It is arguable that the great dramatic compositions of Italian paintings—Giotto's frescoes in the Arena Chapel, Masaccio's in the Carmine, Raphael's in the Stanze of the Vatican—are the summit of European art, the point at which formal and imaginative power have been directed by the highest intelligence. In these great works the art of picture making is entirely at one with a passionate involvement in the subject represented, so that a description of the subject matter becomes automatically an exposition of the design. Unfortunately it is impossible to include these masterpieces in the present exhibition, but their principles can still be seen in Poussin's *Rape of the Sabine Women* and David's *Death of Socrates,* which, although painted almost four hundred years later than Giotto's *Entombment,* is obviously part (and we may add almost the last part) of the same tradition. No wonder that a mastery of this kind of composition came to be considered the highest achievement of art, "the Grand Manner of historical paintings." And yet the century of Raphael also produced Hieronymous Bosch and Pieter Bruegel, for whom such massive pictorial constructions were entirely unnecessary. The fascination their paintings have for us shows that however highly we may rate the claims of form, rhythm, and design, there is no denying that our attachment to works of art is very largely due to their direct reference to life. From the eighth-century B.C. ivory of a Nubian slave to an ink drawing by Rembrandt, it is this quality of human pathos that we value, and it makes us often look with particular delight at details that play no part in the general design. Students of aesthetics who examine their own responses may be dismayed to find how often they are narrowed down to a single detail—the turn of a head, a vase of flowers, or the light falling on a piece of silk—elements that play no part in the systems of aesthetic philosophy.

From the sixteenth century onward relationships of form are supported by relationships of color. Of course there is enchanting color in the Sienese painting of the preceding century, but it is independent of the form. The use of color to enhance the impact of form was a Venetian discovery, and gives to the rare works of Titian that are well preserved

their extraordinary resonance. This form-color relationship was carried to its highest point by Cézanne. Few painters have had a nobler sense of form in the simple terms that I described earlier; but he determined to give form an even fuller development (*sa plénitude*) by rendering it with the maximum strength of color. The simpler his subjects, the more profound his effects, and no doubt the effect on our emotions of his pears and apples is due to very deep analogies in human experience.

There remains one branch of art that seems to be outside the original life-preserving functions of form, line, and composition, the art of landscape painting. It was the invention of the Chinese (for Hellenistic landscapes seem to have been no more than decorative fantasies) and represents a Wordsworthian desire to lose the self in contemplation of nature. In this respect the great Chinese landscapes reach a point that Western artists have never equaled, because they are not the result of an impression, but of prolonged meditation, in which each object is thought of both as a living thing and as a symbol. The richness and complexity of these works can hardly be equaled in Europe, but the nearest approach to them is in the landscapes of Poussin and Claude. In both of them a wealth of natural observation is used to create a single mood, or rather, to illustrate a single poetic thought, and in both the equivalent of Chinese symbolism is the memory of some antique myth. Poussin's thoughts dwell more earnestly on the meaning of each legend; Claude allows each legend to suggest the mood and then abandons himself to the rapture of light.

The landscape of poetry and legend was a relatively short episode. The landscape of optical experience lasted for over two hundred years, from Ruisdael to Monet, and was the form in which the best painters of the later nineteenth century found their means of expression. The Impressionists probably still give more pleasure to the average man than any other school of painting. They have opened our eyes to light and atmosphere, and in our urbanized society they evoke a lost paradise. Their success would have seemed inconceivable to connoisseurs of the seventeenth century, whose theory of art was based on the belief that the subject of a picture must have some historical or ethical significance. Yet these same connoisseurs loved the drawings of Claude, which show precisely the same kind of sensibility as the Impressionists.

It is in a painter's drawings that he reveals his personality, and the fact that for almost five hundred years drawings have been preserved and collected shows how great a part this kind of intuition and spontaneous

self-revelation play in our love of art. Ultimately the artist may be reaching toward a timeless ideal, but he remains a fellow being, and we suddenly find ourselves listening to him, as we would to some inspired companion. Even the Egyptian sculptors of time-defying monuments left drawings as free and personal as Picasso's.

Form unites, subject divides. To walk round this exhibition looking solely at the subjects would be an interesting exercise in social history, but would tell us very little about the essential nature of art. It is true that a bad Greek marble and a bad Impressionist landscape would seem to have nothing in common. But as soon as we are aware of a hand responsive to some moving sensuous experience and controlled by the discipline of an idea, we are back in the realm of aesthetic experience, and this can take place in any age, any style, or any medium. The brush strokes with which Cézanne conveys his feeling for the sky have the same vitality as the symbolic clouds on a fine Chinese bronze. The chief artists of our own time have moved much less far than was at first supposed outside the gravitational pull of a continuous artistic tradition. Douanier Rousseau's naïve remark to Picasso—that he was the greatest living painter in the Egyptian style—now seems to us an obvious truth. Matisse, who was a master of classic form, as his early drawings and sculpture prove, did his finest work after he had absorbed the arabesques and flat color of Islamic art, the most unclassical of all styles. Henry Moore, whose early work seemed like a deliberate rejection of the Renaissance tradition, has ended as the disciple of Giovanni Pisano and Michelangelo.

Unity in diversity: those were the words in which Winckelmann, the first critical art historian, summed up his aesthetic theory of antique sculpture, and the present exhibition will be an opportunity to see how far this dictum can be applied to the art of the whole world. The ways in which men have tried to give an ideal, time-defying shape to experience have varied; but the experiences, because they are related to basic instincts of human life—the instinct to survive, to worship, to play, to make love—are the same. And the bodily means—sharpness of eye, visual memory, movement of wrist and finger—are the same. So in the end, unity is stronger than diversity, and *Masterpieces of Fifty Centuries* should confirm our belief that art is the one thing, in this distracted world, that we all have in common.

London, May, 1970

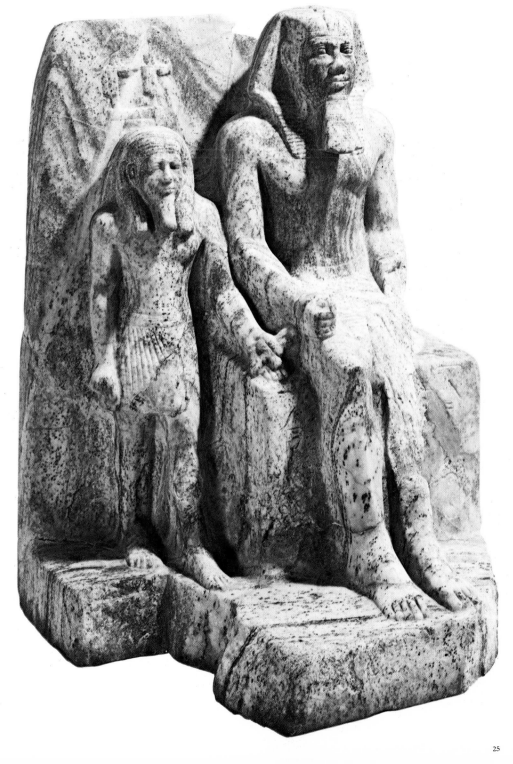

King Sahure and a Divinity
Egyptian, V Dynasty, *ca.* 2480 B.C.
Diorite
Cat. No. 9

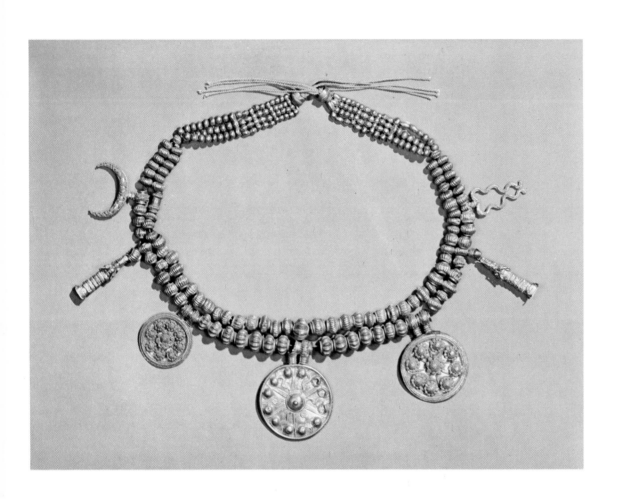

Necklace with Pendants
Ancient Near East,
Late Babylonian or Early Kassite,
ca. XVI century B.C.
Gold
Cat. No. 13

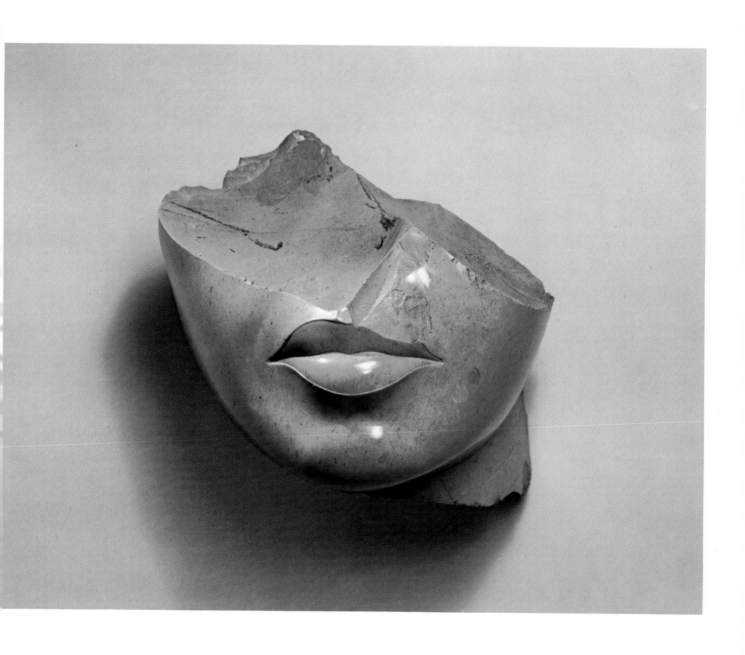

Fragment of Head of Teye
Egyptian, XVIII Dynasty, *ca.* 1380 B.C.
Yellow jasper
Cat. No. 25

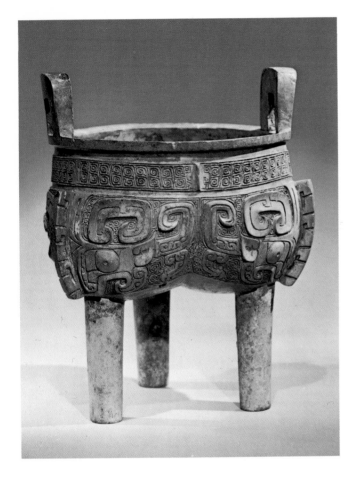

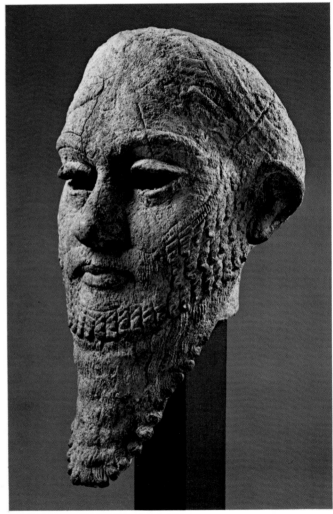

Ritual Vessel (Li Ting)
Chinese, Shang Dynasty,
ca. 1300–1000 B.C.
Bronze
Cat. No. 35

Head of a Ruler
Ancient Near East, Elamite,
1300 B.C. or earlier
Copper
Cat. No. 42

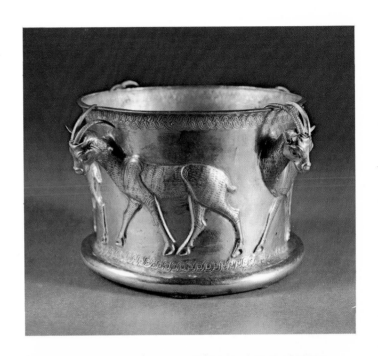

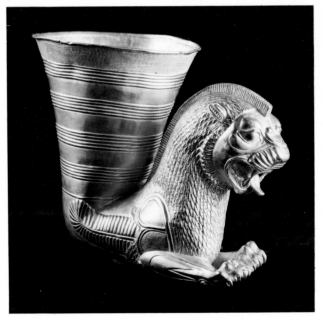

Cup with Four Gazelles
Ancient Near East, Iranian, *ca.* 1000 B.C.
Gold
Cat. No. 43

Rhyton Ending in the Forepart of a Lion
Ancient Near East, Achaemenian,
ca. VI–V century B.C.
Gold
Cat. No. 61

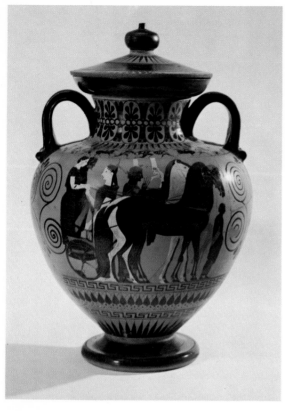

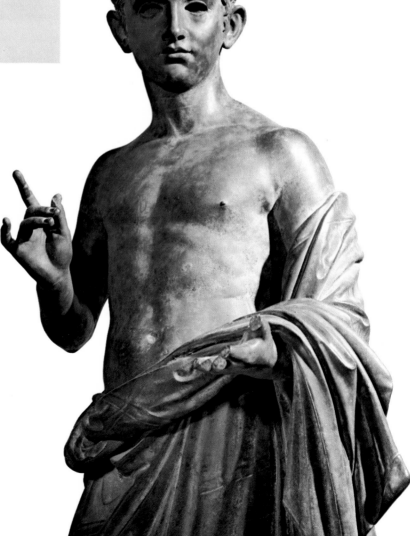

Neck Amphora with Lid
Greek, *ca.* 540 B.C.
Terracotta
Cat. No. 75

Statue of a Roman Prince (detail)
Roman, late I century B.C.
Bronze
Cat. No. 89

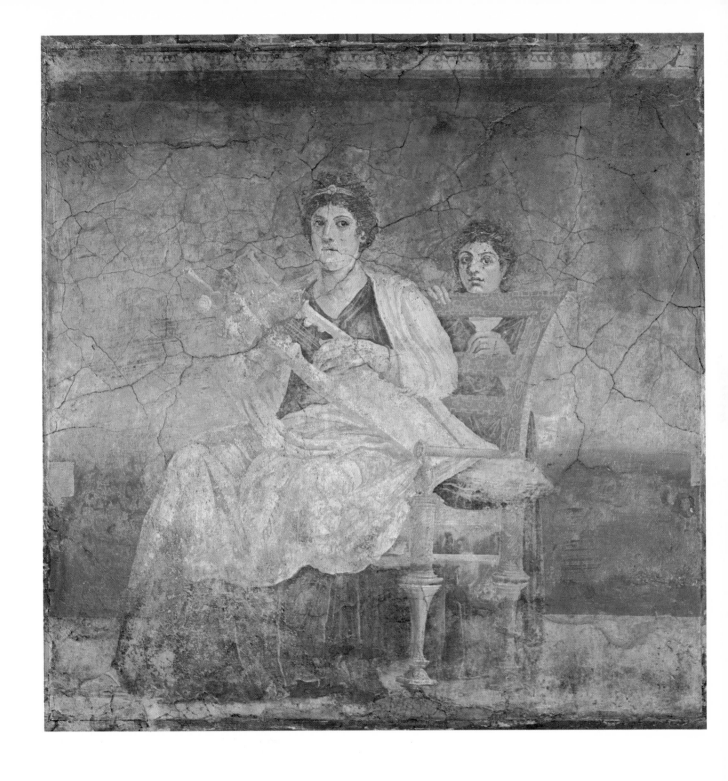

**Section of a Wall Painting
from a Villa at Boscoreale:
Lady Playing a Kithara**
Roman, I century B.C.
Cat. No. 90

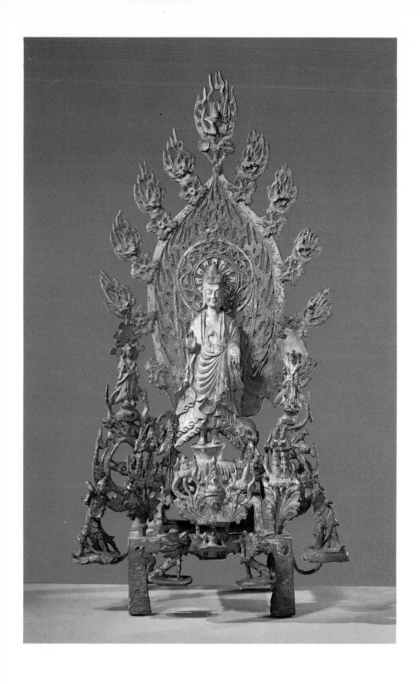

Altar Shrine with Maitreya
Chinese, Northern Wei Dynasty,
dated A.D. 524
Gilt bronze
Cat. No. 109

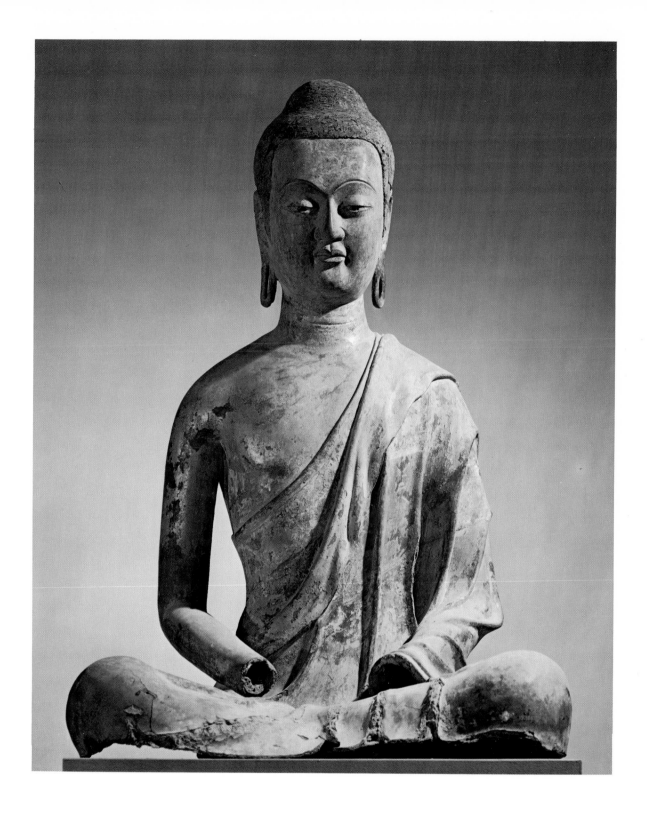

Seated Buddha
Chinese, probably late VI century
Dry lacquer
Cat. No. 117

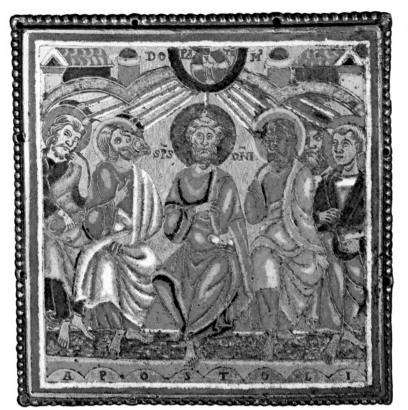

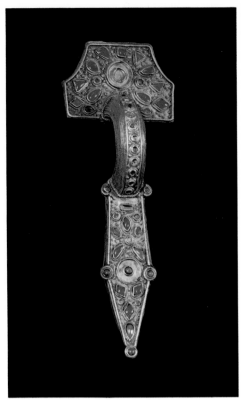

The Pentecost
Mosan, Meuse Valley,
third quarter of the XII century
Champlevé enamel on copper gilt
Cat. No. 121

Proto Gothic Fibula
Proto Gothic type, late IV or V century
Gold leaf over silver core, and jewels
Cat. No. 115

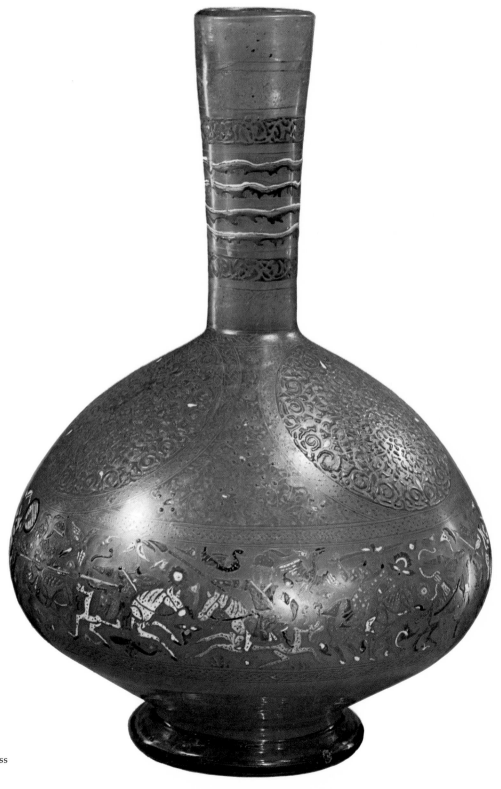

Bottle
Syria, Mamluk Period, *ca.* 1320
Polychrome enameled and gilded glass
Cat. No. 128

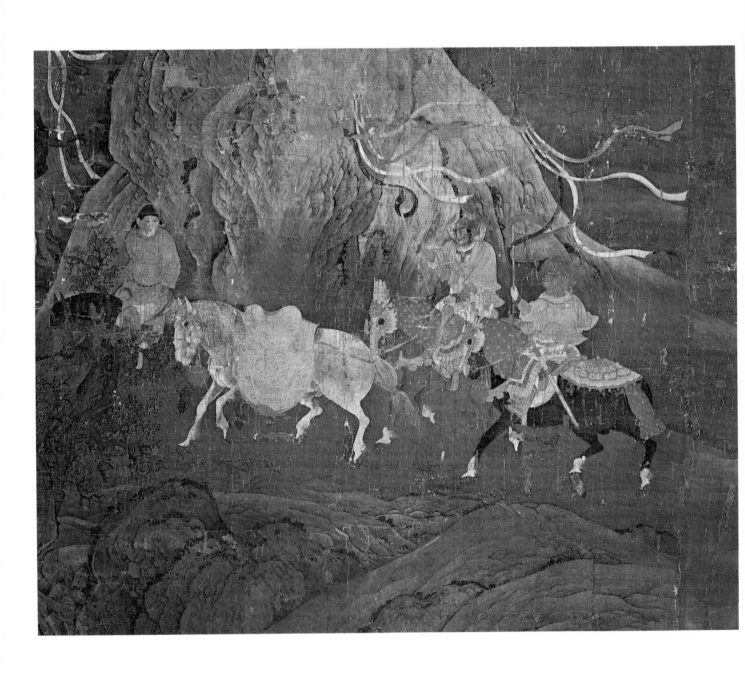

The Tribute Horse (detail)
Chinese, Sung Dynasty, X–XII century
Ink and colors on silk
Cat. No. 136

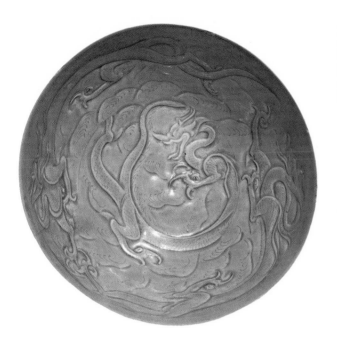

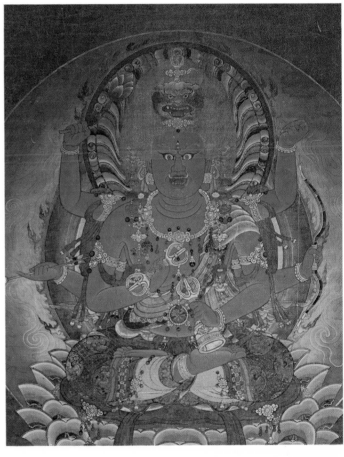

Bowl
Chinese, Yüeh ware, X century
Stoneware
Cat. No. 141

Aizen Myo-O (detail)
Japanese, Kamakura Period, 1185–1333
Colors, and cut and painted gold on silk
Cat. No. 142

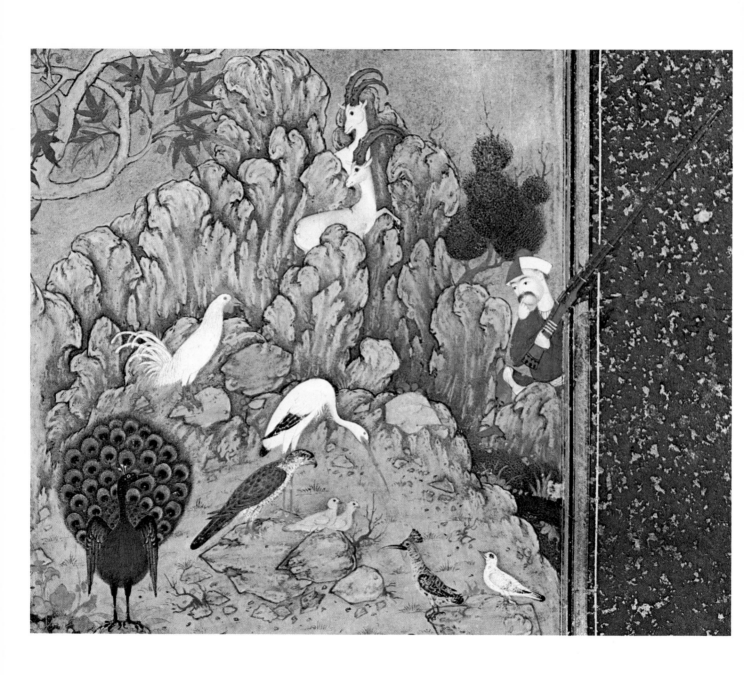

"Language of the Birds" (detail),
from the *Mantiq al Tayr*
School of Bihzad
Iran, Herat, 1483
Colors, silver, and gold on paper
Cat. No. 157

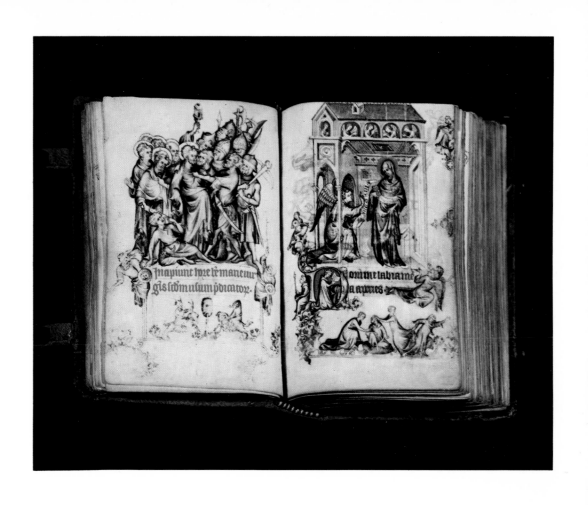

"**The Annunciation to the Shepherds,"**
from *Book of Hours of Jeanne d'Evreux*
Jean Pucelle
French, *ca.* 1325–1328
Parchment
Cat. No. 151

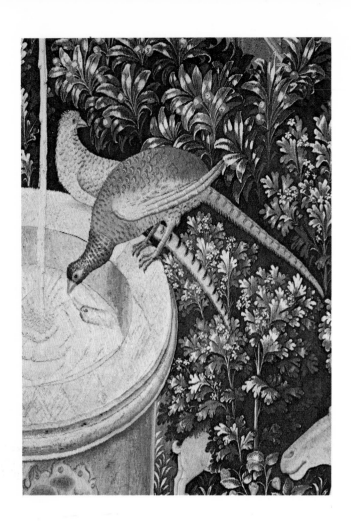

The Unicorn at the Fountain (detail)
Franco-Flemish, *ca.* 1500
Tapestry
Cat. No. 176

The Journey of the Magi (detail)
Sassetta
Tempera on wood
Cat. No. 181

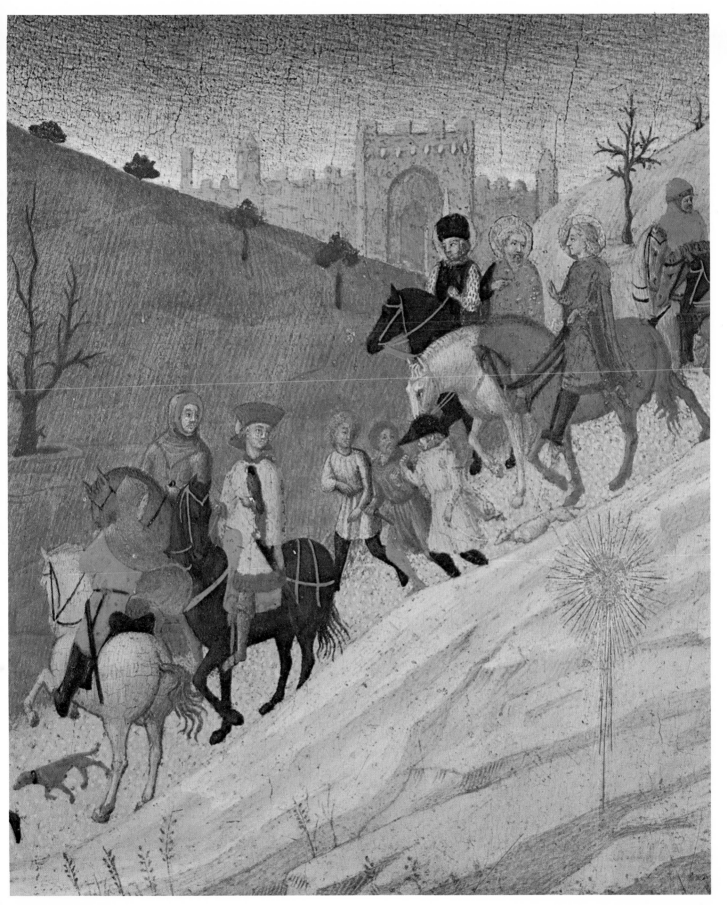

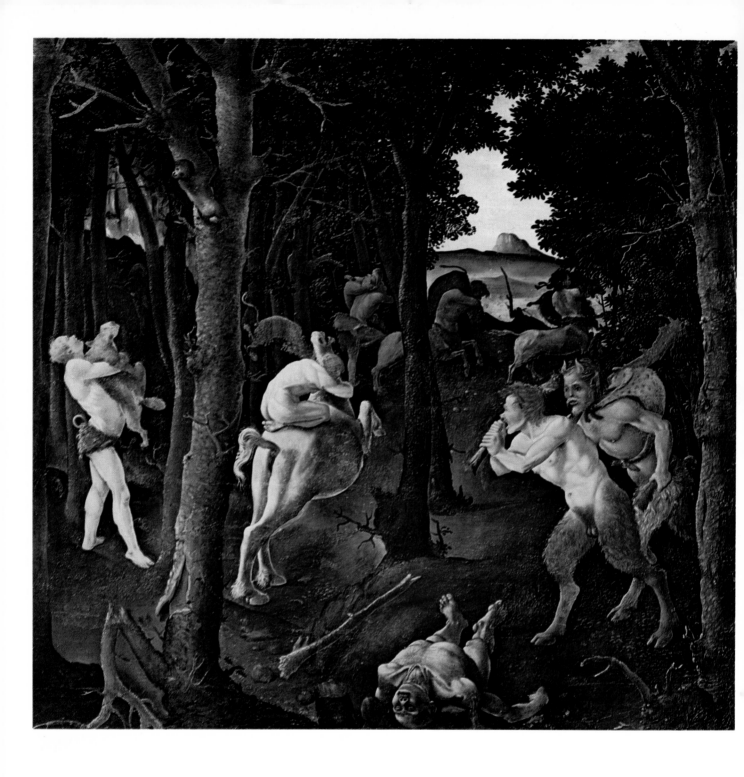

A Hunting Scene (detail)
Piero di Cosimo
Tempera and oil on wood
Cat. No. 187

Study from the Ducal Palace at Gubbio (detail)
Italian, *ca.* 1476–1480
Mosaic of walnut, beech, rosewood,
oak, and fruitwoods
Cat. No. 194

The Meditation on the Passion
Carpaccio
Tempera on wood
Cat. No. 197

The Last Judgment (detail)
Hubert van Eyck
Tempera and oil on canvas,
transferred from wood
Cat. No. 202

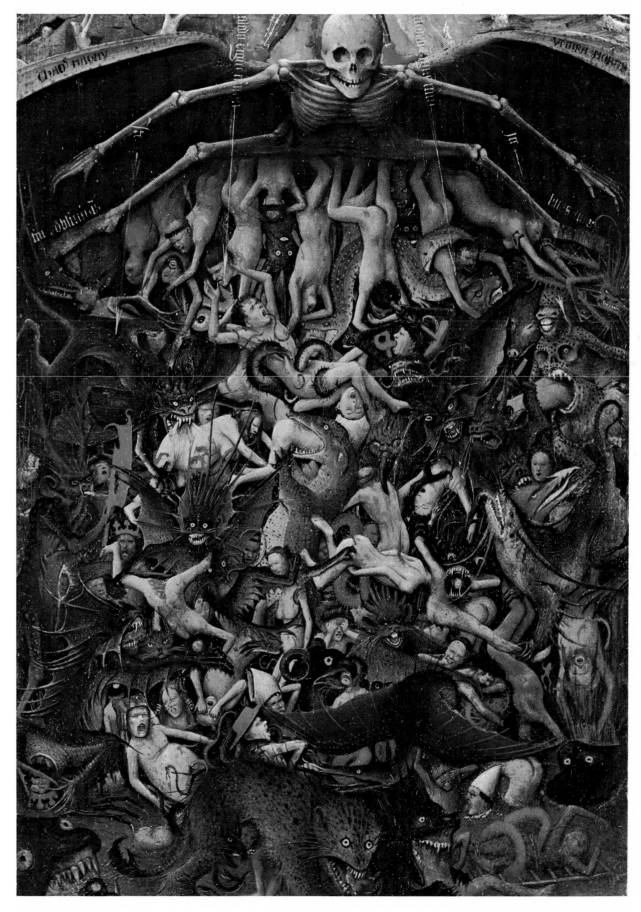

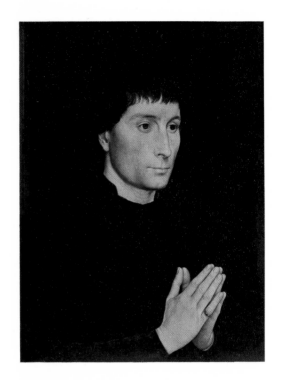 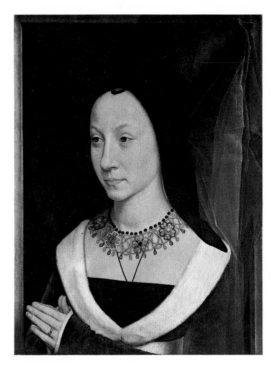

Tommaso Portinari
Memling
Tempera and oil on wood
Cat. No. 209

Maria Portinari
Memling
Tempera and oil on wood
Cat. No. 208

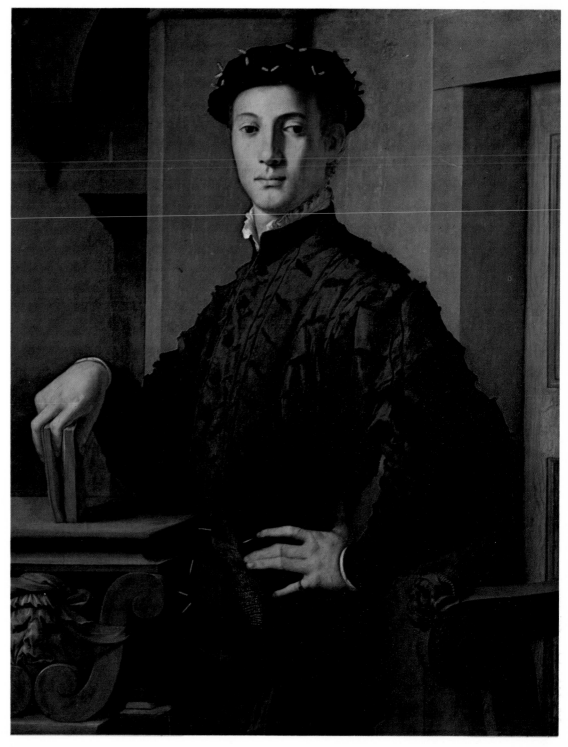

Portrait of a Young Man
Bronzino
Oil on wood
Cat. No. 214

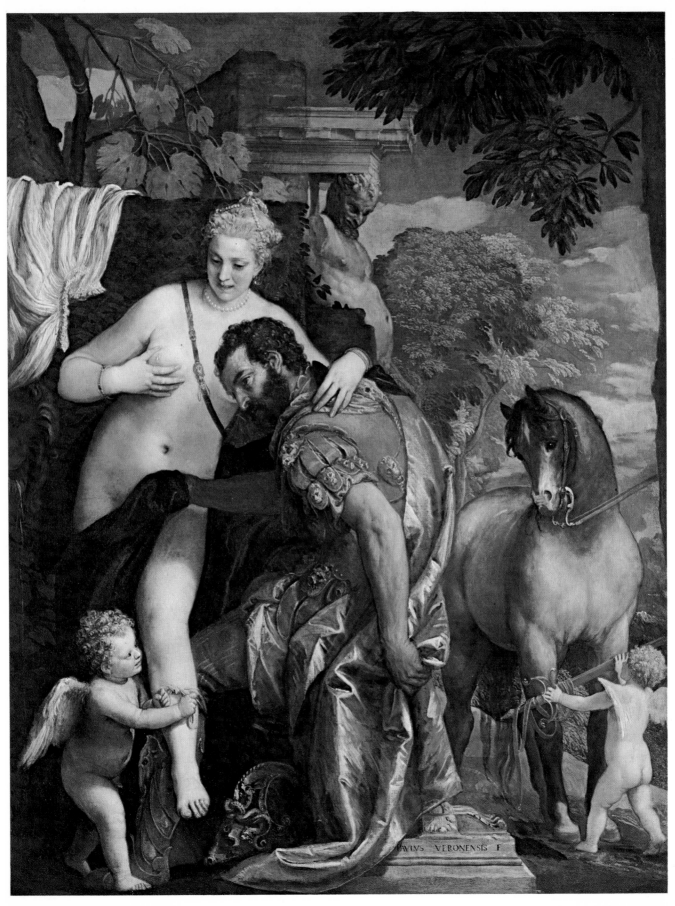

PAVLVS. VERONENSIS. F

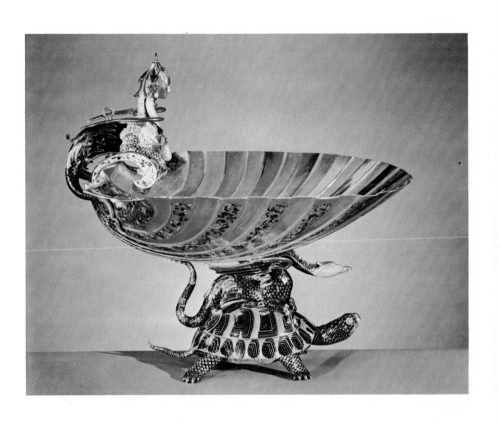

Mars and Venus United by Love
Veronese
Oil on canvas
Cat. No. 215

Rospigliosi Cup
Italian, last quarter of XVI century
Gold, enamel, and pearls
Cat. No. 230

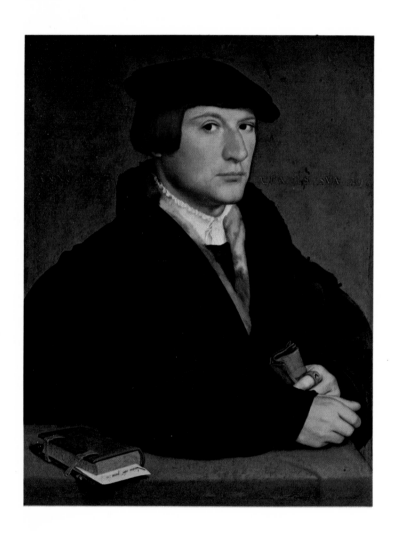

Portrait of a Member of the Wedigh Family
Hans Holbein the Younger
Tempera and oil on wood, 1532
Cat. No. 234

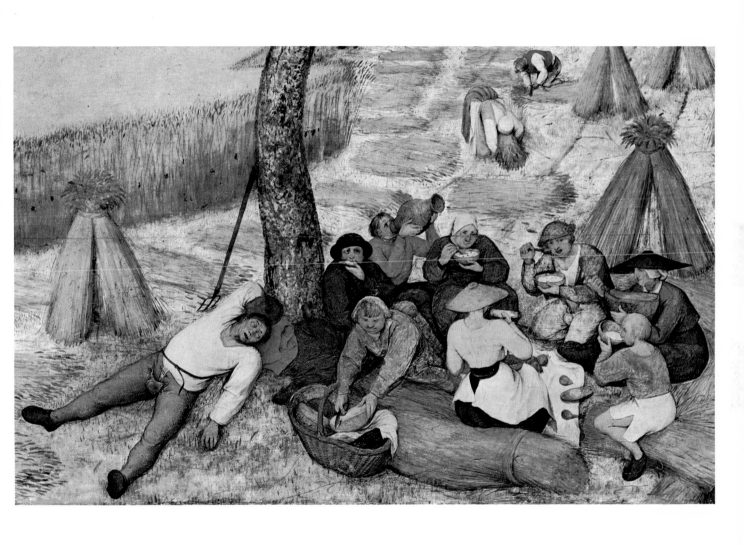

The Harvesters (detail)
Pieter Bruegel the Elder
Oil on wood, 1565
Cat. No. 236

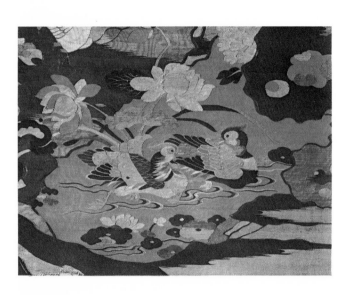

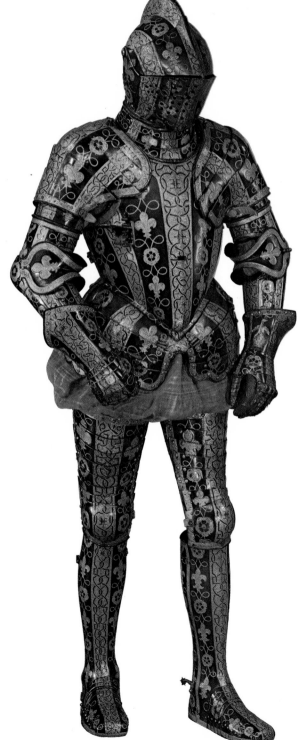

Fêng Huang in a Rock Garden (detail)
Chinese, early XVII century
Silk tapestry with details in gold-wrapped silk thread
Cat. No. 256

Suit of Armor Made for Sir George Clifford
English, *ca.* 1590
Steel: blued, etched, and gilded
Cat. No. 250

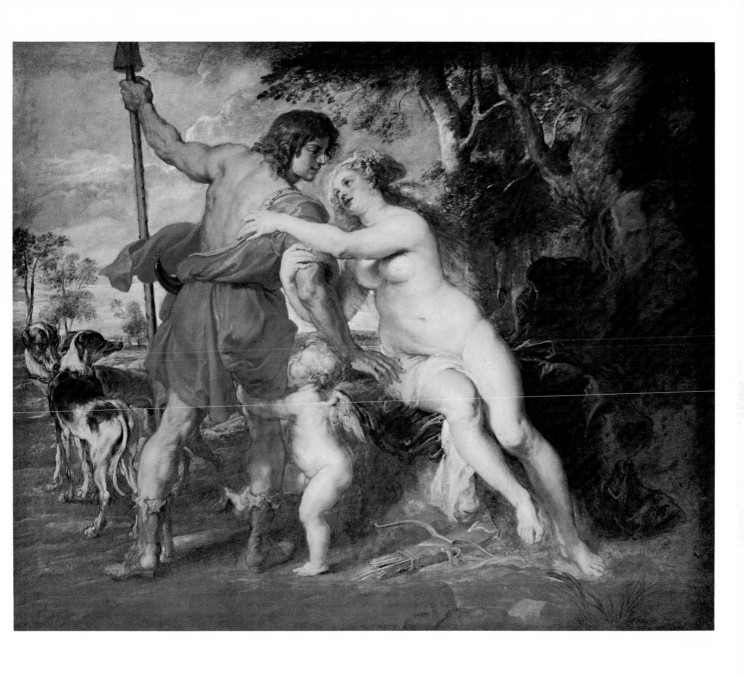

Venus and Adonis
Rubens
Oil on canvas
Cat. No. 276

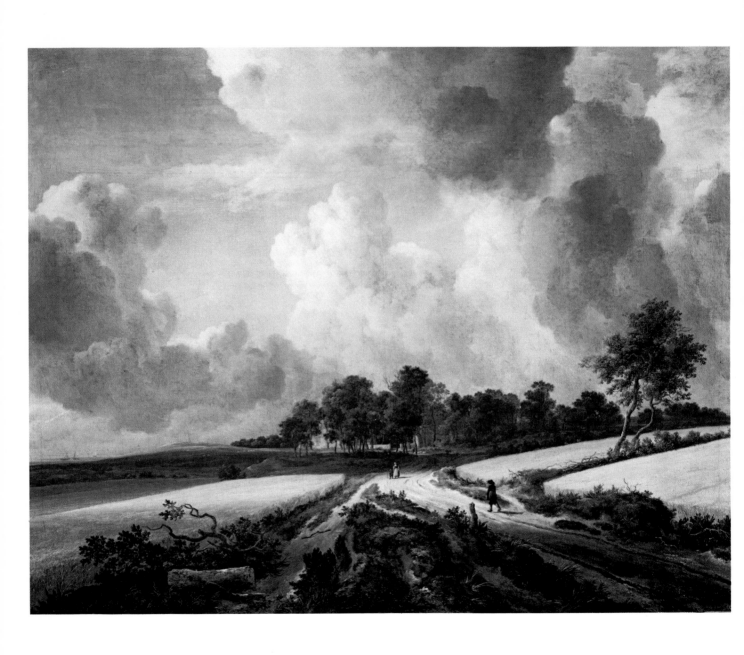

Wheatfields
Jacob van Ruisdael
Oil on canvas
Cat. No. 277

54

**Aristotle Contemplating
the Bust of Homer** (detail)
Rembrandt
Oil on canvas, 1653
Cat. No. 279

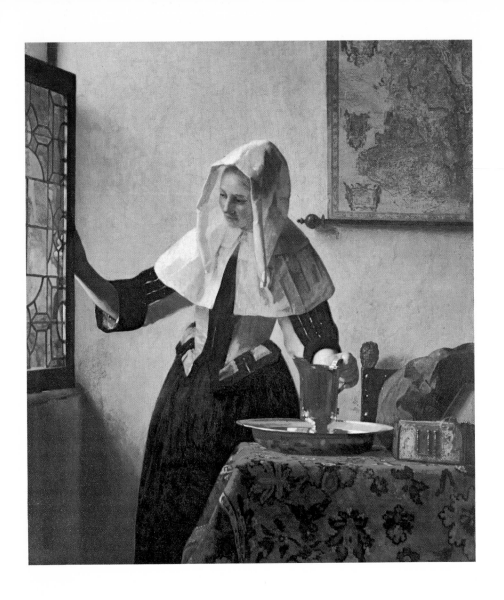

Young Woman with a Water Jug
Vermeer
Oil on canvas
Cat. No. 283

The Rape of the Sabine Women (detail)
Poussin
Oil on canvas
Cat. No. 293

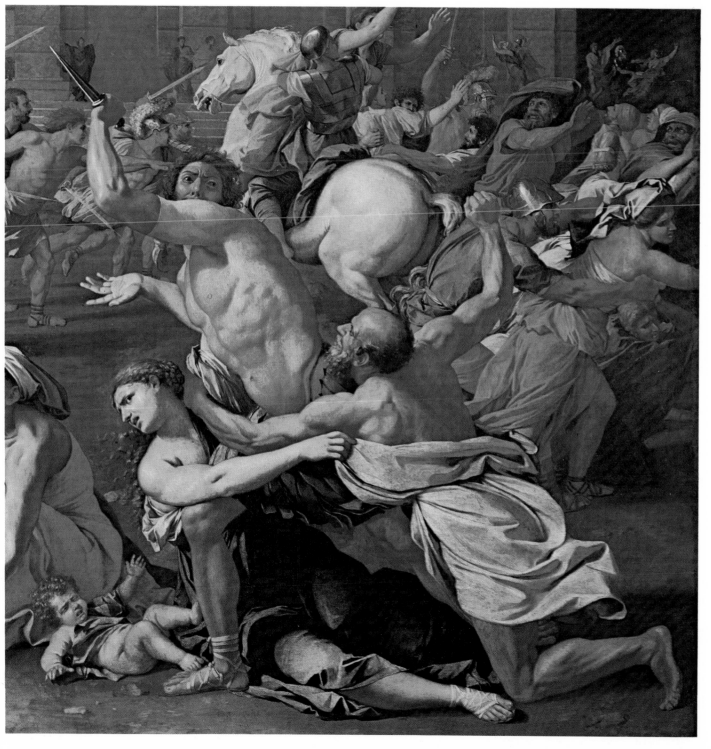

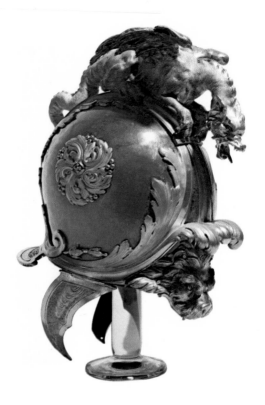

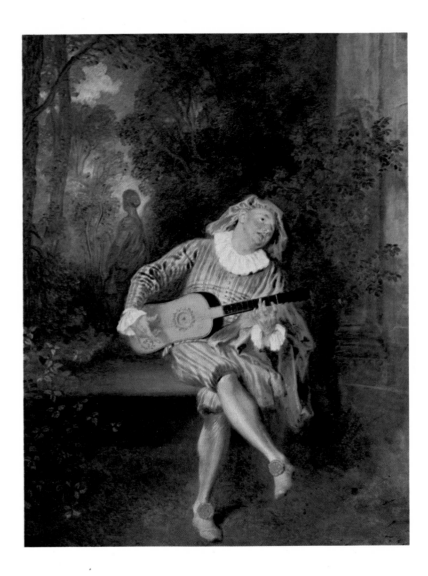

Parade Helmet Made for Louis XIV of France
French, second half of XVII century
Bronze, partly gilded and partly silvered
Cat. No. 301

Mezzetin
Watteau
Oil on canvas
Cat. No. 303

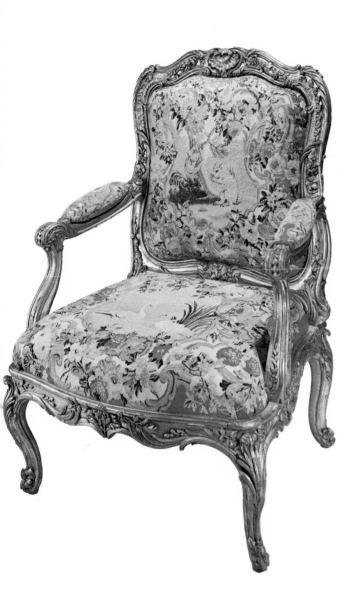

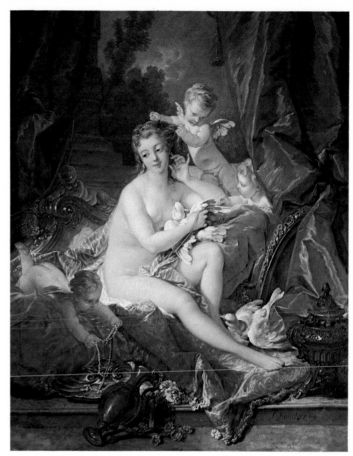

Armchair
Nicolas-Quinibert Foliot
French, 1753–1756
Gilded beechwood covered with wool tapestry
Cat. No. 314

The Toilet of Venus
Boucher
Oil on canvas, 1751
Cat. No. 304

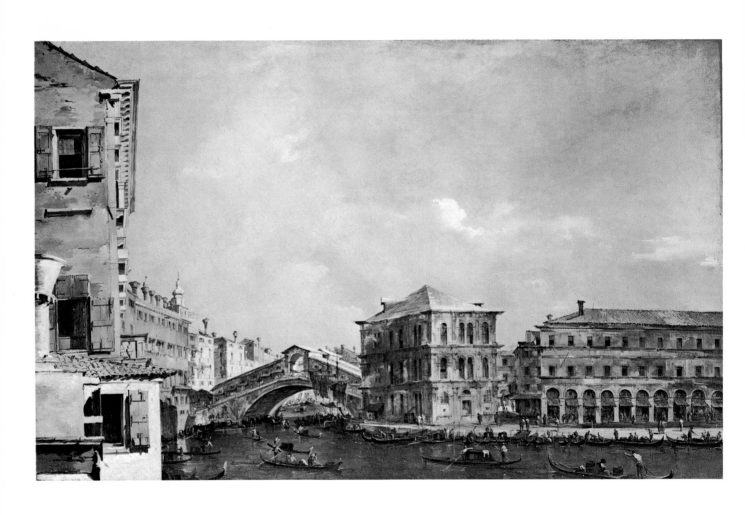

The Grand Canal Above the Rialto (detail)
Guardi
Oil on canvas
Cat. No. 326

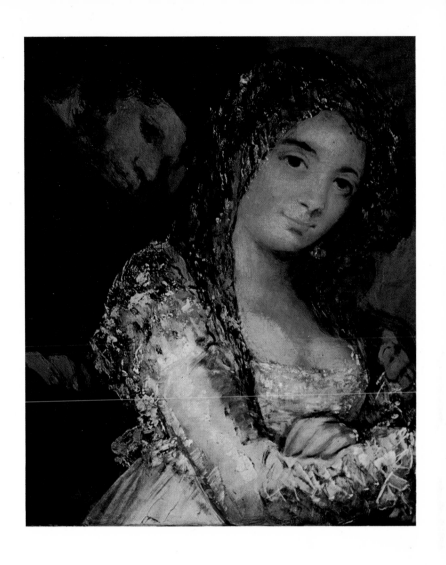

Majas on a Balcony (detail)
Goya
Oil on canvas
Cat. No. 327

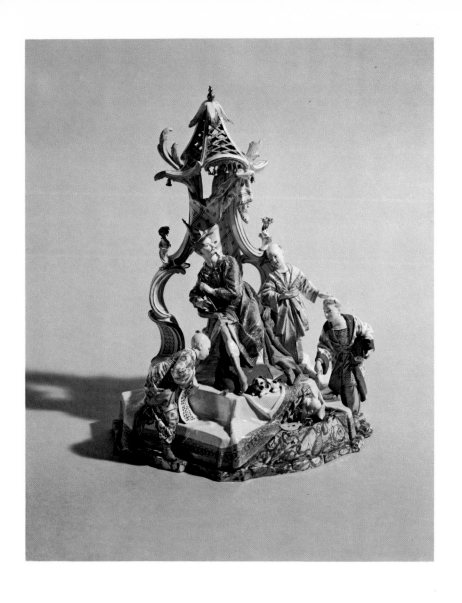

**An Artist and a Scholar
Being Presented to the Chinese Emperor**
German, Höchst, *ca.* 1765
Hard-paste porcelain
Cat. No. 336

**Colonel George K. H. Coussmaker,
Grenadier Guards**
Reynolds
Oil on canvas, 1782
Cat. No. 337

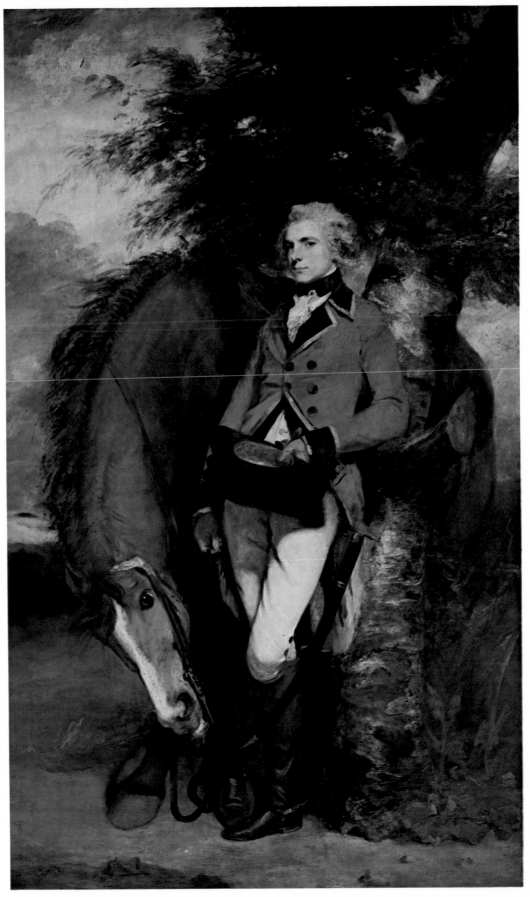

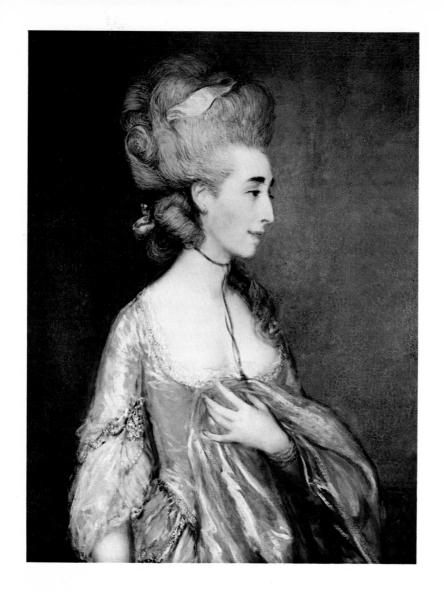

Mrs. Grace Dalrymple Elliott (detail)
Gainsborough
Oil on canvas
Cat. No. 338

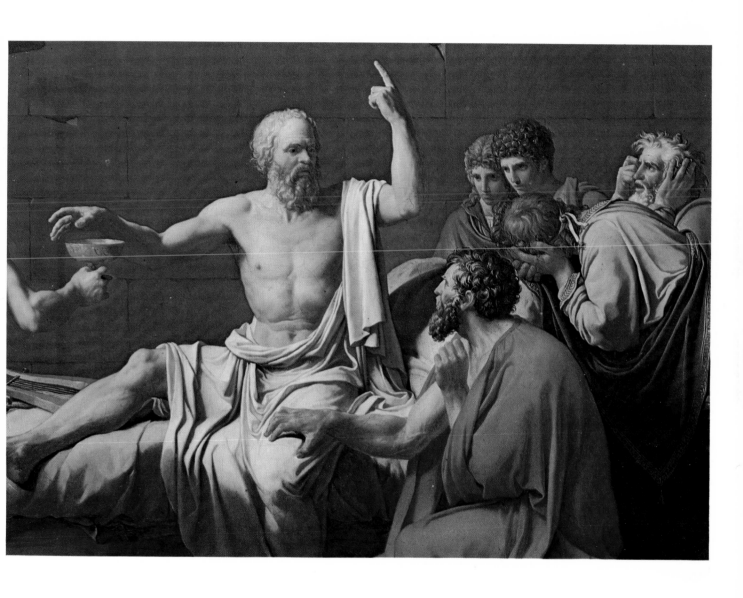

The Death of Socrates (detail)
Jacques Louis David
Oil on canvas, 1787
Cat. No. 356

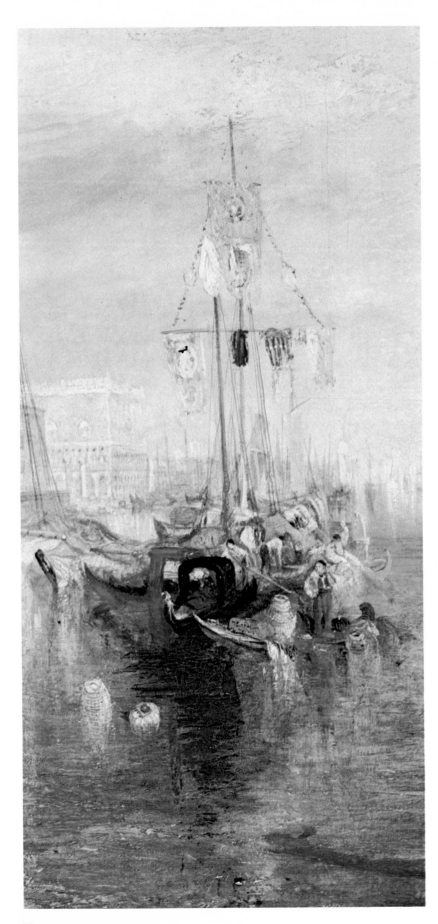

The Grand Canal, Venice (detail)
Turner
Oil on canvas
Cat. No. 361

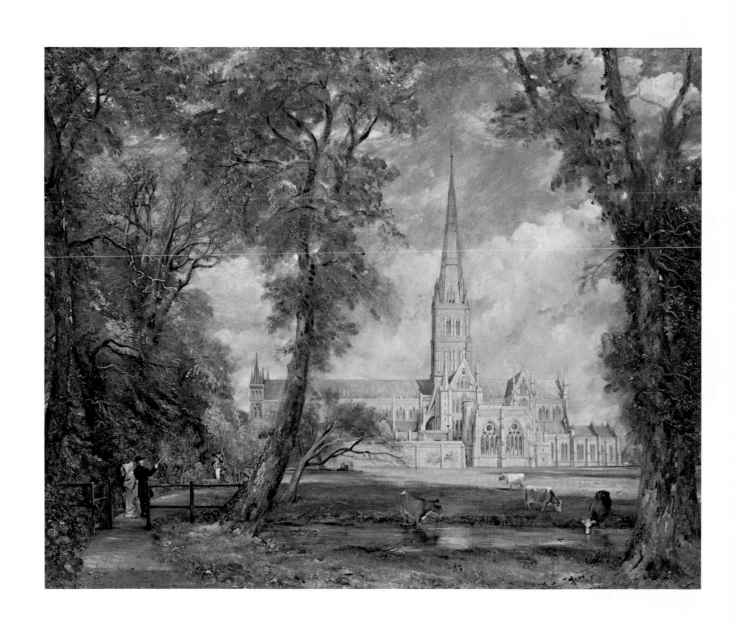

Salisbury Cathedral from the Bishop's Garden
Constable
Oil on canvas
Cat. No. 362

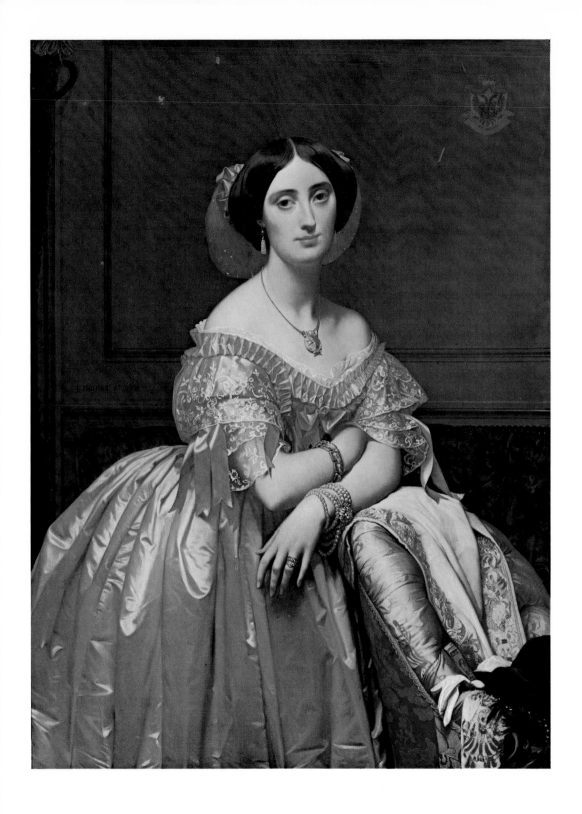

Princesse of Broglie
Ingres
Oil on canvas
Cat. No. 357

Woman with a Parrot
Manet
Oil on canvas
Cat. No. 373

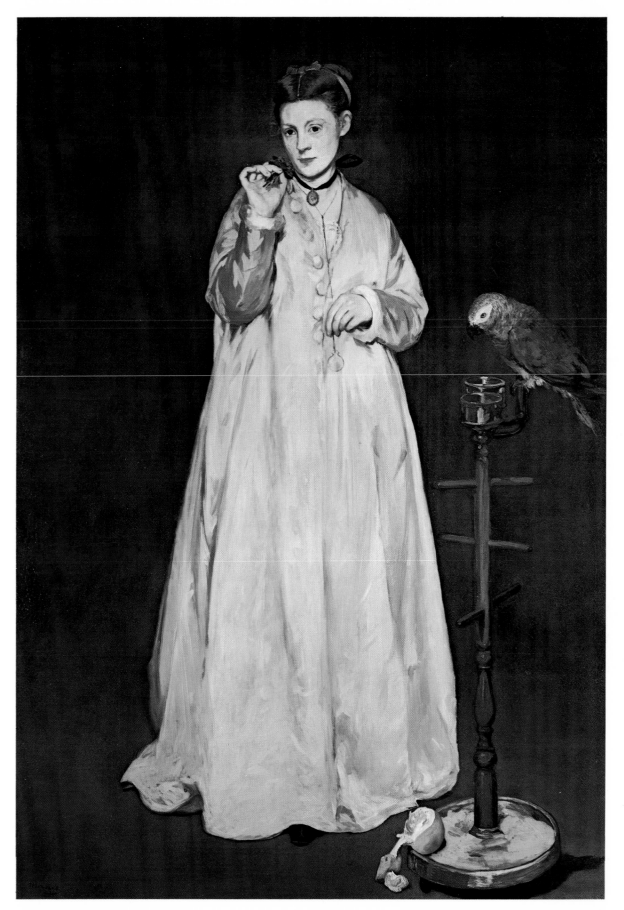

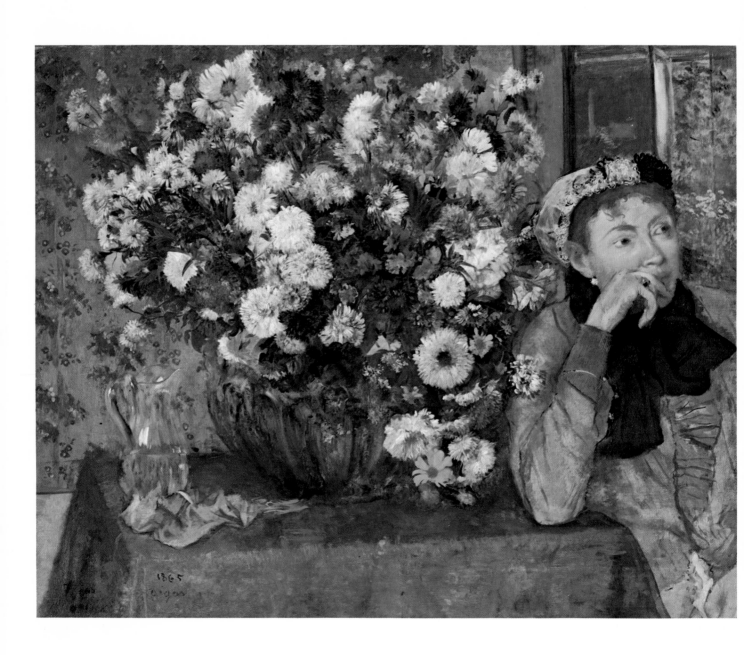

A Woman with Chrysanthemums
Degas
Oil on canvas, 1865
Cat. No. 375

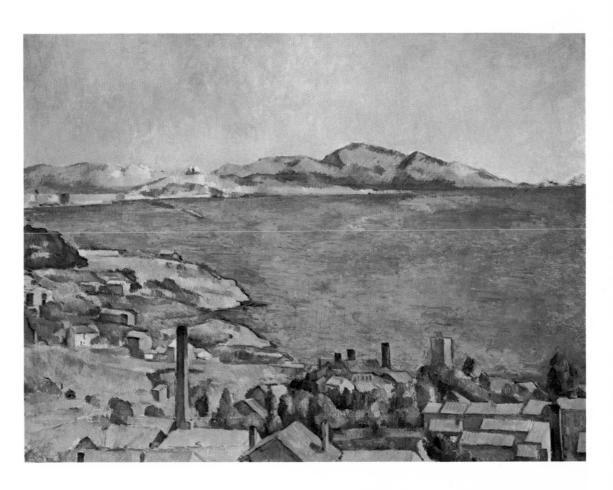

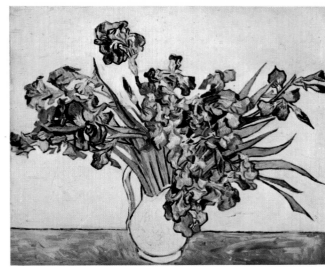

The Gulf of Marseilles
Seen from L'Estaque **Irises**
Cézanne Van Gogh
Oil on canvas Oil on canvas
Cat. No. 383 Cat. No. 386

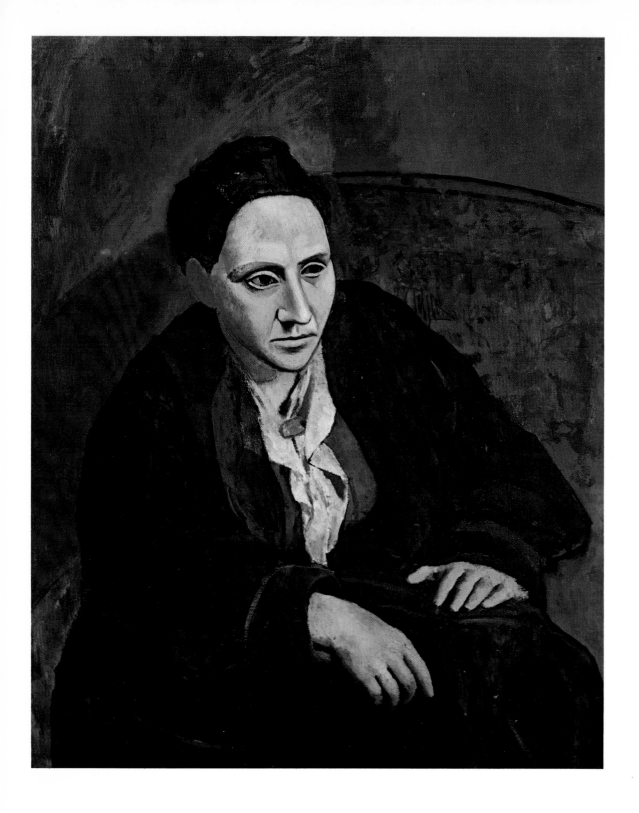

Gertrude Stein
Picasso
Oil on canvas, 1906
Cat. No. 391

Section I: ca. 3500–ca. 900 B.C.

3000	Copper in wide use in Egypt, bronze appears in Near East
2900–2700	Kingdoms of Lower and Upper Egypt united
2570–2500	Great Pyramids and Great Sphinx at Giza
ca. 2300	Hieroglyphic writing came into use in Egypt
ca. 2250	Gudea reigns; Classical Period of Sumerian sculpture and literature
2200	Transition in Indus Valley in Northwest India from nomadic culture to village culture
ca. 2000	Bronze Age in Europe
ca. 1792–1750	Hammurabi introduces first code of law in Babylon
ca. 1600	Transition in China from nomadic culture to village culture
1520–1480	Reign of Queen Hatshepsut in Egypt
ca. 1500	Stonehenge constructed in England
ca. 1400	Earthquakes destroy Knossus on Crete
1375–1358	Reign of Akhenaten in Egypt
1184	Sack of Troy by Greeks ends Trojan War
ca. 1100	The Dorian invasion of Greece
ca. 1000	David, King of Israel

West	Near East	Far East	America

3500

3000

44. Cycladic,
III millennium, B.C.

2. Iranian,
ca. 3500 B.C.

1. Chinese,
ca. 3000–1750 B.C.

2500

3. Iranian,
ca. 3000 B.C.

2000

5. Neo-Sumerian,
ca. 2150 B.C.

1500

36. Chinese,
late II millenium, B.C.

1000

46. Mycenaean,
1200–1125 B.C.

20. Egyptian,
ca. 1495 B.C.

950

40. Olmec,
ca. 1000 B.C.

900

Neolithic Far East: ca. 3000–1750 B.C.

Before the discovery of metalworking techniques, several late Neolithic cultures existed at various times throughout the basin of the Yellow River in China. The Yang-Shao culture is an early manifestation of an extensive culture which spread westward over several northern Chinese provinces in prehistoric times.

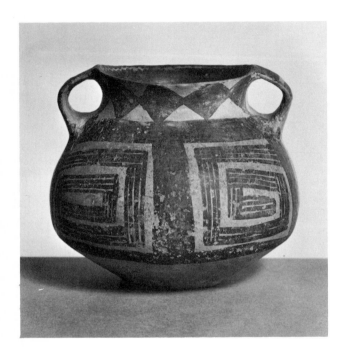

1. Urn: Yang-shao Redware
Chinese, Neolithic Period, *ca.* 3000–1750 B.C.
Buff pottery with painted designs
Height: 4 inches; Width: 4¹⁵⁄₁₆ inches

Several Late Neolithic cultures existed in overlapping sequence throughout the Yellow River area of China in prehistoric time (*ca.* 3000–1750 B.C.). Each of these cultures was named by modern archaeologists for the type site where the culture was first discovered and for the distinctive type of pottery found there. The earliest of these cultures, to which this urn belongs, is called the "Yang-shao painted pottery culture" or the "Yang-shao redware culture" after the type site at Yang-shao-ts'un in Honan Province where a distinctive reddish-buff pottery with bold painted designs was made for use in both storage and burials.

This small two-handled jar is typical of Yang-shao culture as it existed in Kansu Province. The buff pottery body was probably polished with a hard stone before it was fired and later painted in black with lozenges and bold angular spirals. The widemouthed shape and X design between two vertical lines under the handles appear in another pot which was excavated in Kansu Province. A reserved line of thin zigzags is inside the neck rim, and large droplets hang from the wide band below.

50.61.4 The Metropolitan Museum of Art, Harris Brisbane Dick Fund, 1949.

Early Near East:
Sumerian, ca. 3500–2370 B.C.
Akkadian, ca. 2370–2230 B.C.
Neo-Sumerian, ca. 2150–2000 B.C.

The earliest signs of settled life in the Near East appear in the upland sites of Anatolia, Iran, and Iraq. Southern Mesopotamia, however, became the focal point of ancient Near Eastern civilization, once irrigation was developed. Under the dominance of the Sumerians life was organized around the temple of a patron deity, with the city leader assuming the roles of both priest and king. Except for a brief revival of literature and sculpture in the Neo-Sumerian period, the Semitic-speaking Akkadians gained and maintained political dominance after 2370 B.C. Their military conquests produced larger governmental units and introduced an age of empire.

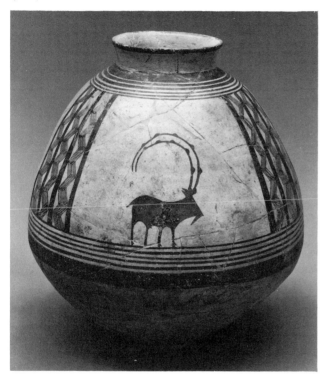 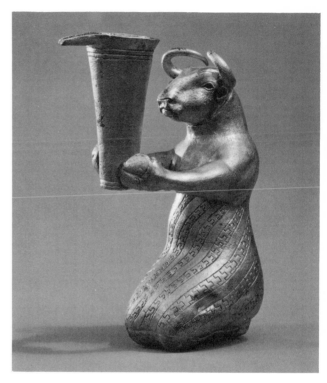

2. Jar

Ancient Near East, Iran, *ca.* 3500 B.C.
Terracotta
Height: 20⅞ inches; Diameter: 19⅛ inches

This pear-shaped vessel is a masterpiece of the art of early pottery, both in its graceful shape and controlled artistic decoration. Against a buff background, and appearing only on the upper two-thirds of the vessel, are three ibexes painted in dark brown paint. Each ibex is placed in the center of a large buff-colored panel and is shown in silhouette facing right with large stylized horns. The panels are bordered at the top and bottom by several thin bands and at the sides by zones of vertical, neatly drawn zigzags framed within thick vertical bands.

Ghirshman, R., *Fouilles de Sialk.* Paris, 1938, Pl. LXXIV, s. 1748 and s. 1691.

59.52 The Metropolitan Museum of Art, Joseph Pulitzer Bequest, 1959.

3. Bull in Human Posture Holding Vase

Ancient Near East, Proto-Elamite, *ca.* 3000 B.C.
Silver
Height: 6⅜ inches; Width: 2½ inches;
Diameter: 4¼ inches
Western Iran

This small bull dressed in human clothing and assuming a human posture, with a spouted vase held between the hooves of his forelegs as if they were human hands, is a work of exceptional quality. The figure was constructed from a number of pieces. The insertion of the head at the beginning of the neck is obvious. The horns and ears were made separately. The forelegs were added to the torso, and the bottom of the figure appears to be a separate piece as well. The off-shoulder dress is decorated with geometric design.

Hansen, D. P., "A Proto-Elamite Silver Figurine in the Metropolitan Museum of Art." *The Metropolitan Museum Journal,* Vol. III, 1970.

66.173 The Metropolitan Museum of Art, Joseph Pulitzer Bequest, 1966.

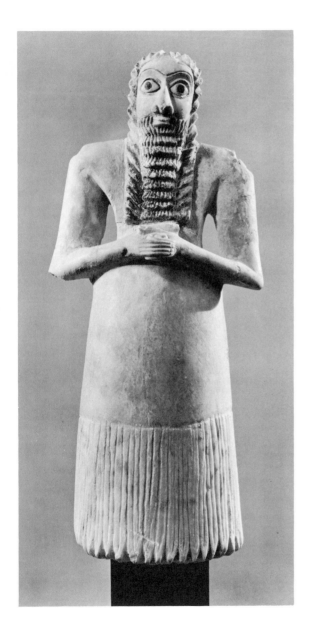

4. Standing Male Figure

Ancient Near East, Sumerian, *ca.* 2600 B.C.
White gypsum
Height: 11⁷⁄₁₆ inches
Tell Asmar, Iraq

The upright male figure, with missing feet and base, represents the abstract geometric style of the first half of the Early Dynastic Period of Sumerian sculpture. The large head has a dominant triangular nose and prominent eyeballs made of shell set in bitumen; the one pupil that is preserved is cut from black limestone. Traces of the bitumen that once heavily colored the long hair, moustache, and beard are still to be seen, recalling the fact that the Sumerians referred to themselves as the "black-headed people." While the torso is square in section, the lower part of the figure is a truncated cone. In characteristic Sumerian style, the bare-chested male figure is clad in a long skirt. For all its abstraction, or perhaps even because of it, the statuette seems to exude life and power.

Frankfort, H., *The Art and Architecture of the Ancient Orient.* Baltimore, 1955, pp. 23–31.

40.156 The Metropolitan Museum of Art, Fletcher Fund, 1940.

5. Statue of Seated Gudea

Ancient Near East, Neo-Sumerian, *ca.* 2150 B.C.
Diorite
Height: 17⁵⁄₁₆ inches
Mesopotamia

Gudea was a governor of Lagash in the late third millennium B.C. This statue is one of a pair which represented him in the temple of his god Ningizzida in Girsu (Telloh) in what is now southern Iraq. The other piece is in the Louvre. This figure is the only complete statue of Gudea in this country, and even it was decapitated in antiquity as were most such likenesses of him. The join between the head and the body, however, leaves no doubt that they belong together.

Our Gudea sits on a low chair in a formal attitude of conscious piety, conveyed by the sculptor's careful attention to detail, the schematic turban, the proper angle of the head, the steady forward gaze of the eyes, the unnaturally clasped hands with their very long fingers, and the neatly draped garment. Like most Gudea statues, it has an identifying inscription: "It is of Gudea, the man who built the temple: may it make his life long." Since Gudea ordered twin statues, he may have hoped that a pair would make his life doubly long.

Parrot, A., *Sumer.* New York, 1961, pp. 204–19.

59.2 The Metropolitan Museum of Art, Harris Brisbane Dick Fund, 1959.

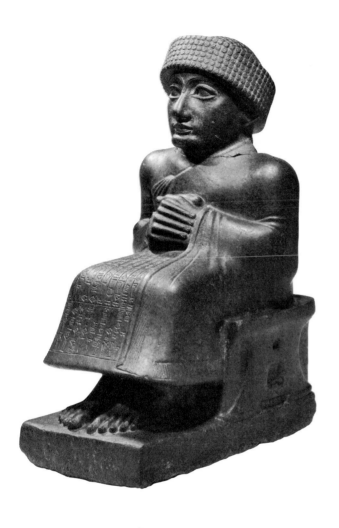

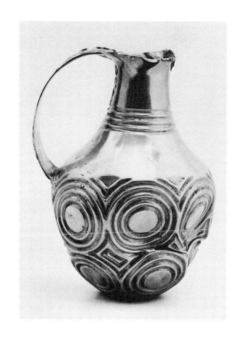

6. Jug with Geometric Design

Ancient Near East, Pre-Hittite, *ca.* 2100 B.C.
Gold
Height: 7 inches; Diameter (below handle): 4¾ inches

In shape this jug is quite similar to a number of others fashioned in gold, silver, copper, and terracotta, and the metal ones have geometric decorations in repoussé, much like the designs on this one. The swastika that is on the bottom appears on at least one other jug.

This jug is said to have come from a site near Amasya, south of Samsun on the Black Sea. Although it bears witness to the skill of its creator, the absence of its spout, which has been cut off, prevents its rivaling the beauty of finer, complete examples of the same type that come from Alaca Huyuk and are now to be found in the Hittite Museum in Ankara.

Akurgal, E., *The Art of the Hittites*. New York, 1962, p. 18, Pls. 14–16.

57.67 The Metropolitan Museum of Art, Harris Brisbane Dick Fund, 1957.

Egypt: Pre- and Proto-Dynastic, ca. 4000–ca. 2680 B.C.

In this period, independent kingdoms and tribal confederacies in the Delta and in the narrow fertile strip along the Nile were first united under one king, who combined the crowns of Lower Egypt (the Delta and Memphis) and Upper Egypt (between Assiut and Aswan).

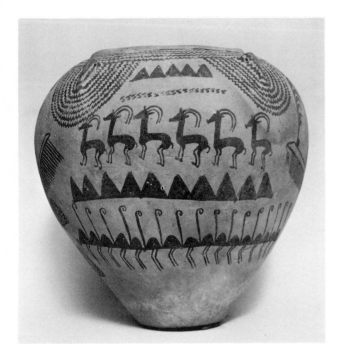

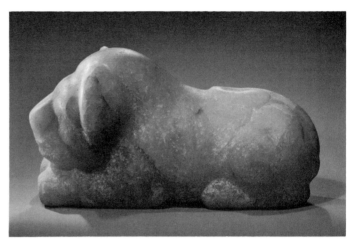

8. Lion

Egyptian, Archaic Period, *ca.* 3100 B.C.
Quartz
Height: 4¾ inches; Length: 9¹⁵⁄₁₆ inches
Gebelein

This appealing figure belongs to the very beginning of Egypt's historic period. It represents a lion—or possibly, because of the size of the head and the fact that the mane is not indicated, a lion cub—with its chin resting on its front paws, ready to pounce. Although a simplified treatment is characteristic of the time, here it was demanded by the extreme hardness of the material, quartz, and because metal tools capable of working it were not yet available. The form was first pounded out with hammers of even harder stone, then polished down with abrasives.

Only one other figure of a lion of similar size is known, a slightly later example in the East Berlin Museum which has a schematized mane and a raised head. Small figures of lions of this second type are quite usual for the period, however; they were pieces for one of the ancient board games with a symbolic meaning which were provided for the use of the deceased in the next world. Our figure, which is too important to have belonged to a private individual and too large for actual use, must have been made for one of the first of the Egyptian kings, and was probably a royal gift to a temple.

Cooney, J. D., "Egyptian Art in the Collection of Albert Gallatin." *Journal of Near Eastern Studies,* Vol. XII (January, 1953), pp. 2–3.

66.99.2 The Metropolitan Museum of Art, Gallatin Collection, Fletcher Fund and Gift of Dr. and Mrs. Edmundo Lassalle through The Guide Foundation, 1966.

7. Pottery Vessel: Decorated Ware

Egyptian, Late Predynastic-Early Dynastic, 3200 B.C.–3000 B.C.
Pinkish-buff pottery with red line decoration
Height: 11¹³⁄₁₆ inches; Diameter: 11¹³⁄₁₆ inches

This type of pottery was produced in the transitional period when the land of Egypt was being united into a single kingdom.

The scenes on this vessel are the most elaborate of any that have survived. The decoration is organized into four panels, each with a self-contained scene, in which the most important actors in the ceremonies are rendered in larger scale than the others. Each scene depicts a single moment of frozen action, a fundamental characteristic of ancient Egyptian art, but at this period explanatory hieroglyphs had not yet become an integral part of the scenes and their meanings remain obscure.

The motifs which create the environmental settings, the wavy water lines, mountains, bushes, ibexes, long-legged birds, and large, many-oared galleys with cabins and ensigns were dominant on this type of pottery during the several hundred years it was being manufactured.

Kantor, H., "The Final Phase of Predynastic Culture." *Journal of Near Eastern Studies,* Vol. III (April, 1944), p. 115.

20.2.10 The Metropolitan Museum of Art, Rogers Fund, 1920.

Egypt: Old Kingdom, ca. 2680–2258 B.C.

During the IV Dynasty (ca. 2613–2494 B.C.), the great age of the Pyramid Builders, the classic conventions for monumental sculpture were formulated and the first free-standing stone buildings were erected. An afterlife, at first reserved for the divine pharaoh, gradually was extended to the nobility and then to the common people. A rapid succession of brief dynasties followed the collapse of central authority about 2180 B.C.

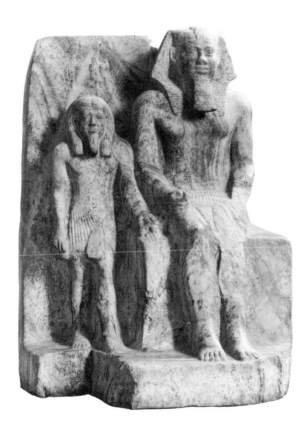

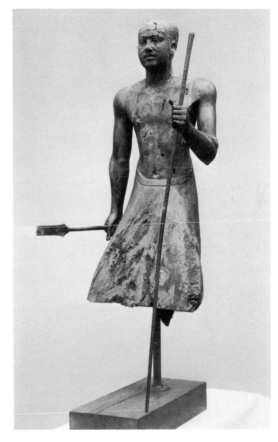

9. King Sahure and a Divinity

Egyptian, V Dynasty, *ca.* 2480 B.C.
Diorite
Height: 24¾ inches

Sahure and his two brothers overthrew the Fourth Dynasty, and themselves established the Fifth. Sahure was second to reign. An ancient folktale describing the brothers as children of the god Re probably reflects a story circulated at the time to support their claim to the throne.

This statue is the only known representation of Sahure. Wearing the royal *nemes* headdress and beard, he is enthroned beside a figure personifying Coptos the Fifth Nome (province) of Upper Egypt. The figure offers him the symbol of life with one hand and holds that of universal power in the other.

Smith, W. S., *A History of Egyptian Sculpture and Painting in the Old Kingdom.* London, 1946, pp. 46 ff.

18.2.4 The Metropolitan Museum of Art, Rogers Fund, 1917.

10. Statue of Mitry

Egyptian, V Dynasty, *ca.* 2480 B.C.
Wood
Height (without base): 39¾ inches
Sakkareh

Mitry was buried near Nykure at Sakkareh. As a provincial governor and privy councillor, he was able to afford no fewer than eleven statues of himself and his wife. Five are in the Metropolitan Museum. Each statue is of imported coniferous wood, made in several pieces to save material. After the sculptor had finished his work, the figures were covered with a fine layer of plaster painted in the colors that traditionally represented flesh and details of costume. This layer of painted plaster also served to conceal the dowels that held the different parts of the statue together and the wooden plugs used to patch the knotholes in the wood.

Here Mitry, with his hair cut short and wearing a long kilt, may be dressed in the costume of one of his many other offices, that of a priest of Maaet, goddess of truth.

Smith, W. S., *A History of Egyptian Sculpture and Painting in the Old Kingdom.* London, 1946.

26.2.4 The Metropolitan Museum of Art, Rogers Fund, 1926.

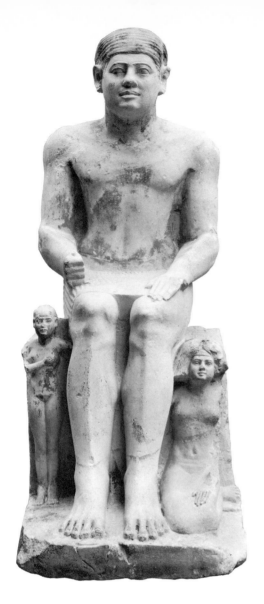

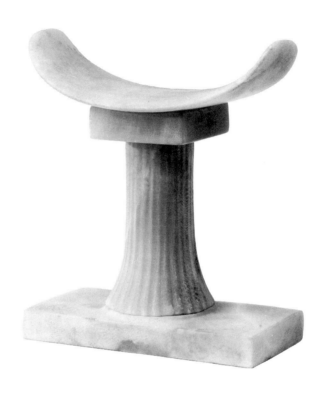

11. Granary Official Nykure and His Family
Egyptian, V Dynasty, *ca.* 2350 B.C.
Limestone, painted
Height: 22½ inches; Width: 9 inches;
Diameter: 12¾ inches
Sakkareh

Nykure's wife kneels beside him on one side, their little
daughter on the other, each clutching one of his legs
affectionately. They are represented in a much smaller
scale than the head of the family, according to convention.
The statues come from a Fifth Dynasty tomb near the Step
Pyramid of Sakkareh excavated in 1925–1926 (the same year
that the nearby tomb of Mitry was discovered). It was
during the Fifth Dynasty that small limestone statues of
private citizens were made for the first time, apparently
because the army of sculptors necessary for the great works
of the Fourth Dynasty pharaohs was released from royal
service and available for private commissions.

Scott, N. E., "Two Statue Groups of the V Dynasty."
The Metropolitan Museum of Art Bulletin, n.s., Vol. XI, No. 4
(December, 1952), pp. 116–22.

52.19 The Metropolitan Museum of Art, Rogers Fund, 1952.

12. Headrest
Egyptian, VI Dynasty, *ca.* 2330 B.C.
Alabaster
Height: 7⅝ inches
Sakkareh

The Egyptians often slept on the ground and a headrest was
necessary for their comfort. It was usually of wood and usually
consisted of three parts, a curved pillow, a shaft, and a base. The
pillow supported the neck rather than the head, and was of the same
height as the shoulder of a man sleeping on his side, as was the
Egyptian custom.

This headrest was found in the burial shaft of the tomb of a powerful
official, Khentykuy, who as vizier, or chief secular administrator, held
a position of extreme importance under two kings of the Sixth
Dynasty, Tety and Pepy I. The tomb itself had been plundered, and
the headrest was the only object left to give any idea of the beautiful
and luxurious furnishings provided for Khentykuy's life in the
hereafter.

James, T. G. H., *The Mastaba of Khentika Called Ikhekhi.* London, 1953.

26.2.11 The Metropolitan Museum of Art, Rogers Fund, 1926.

Mesopotamia:
Babylonian, ca. 2000–1600 B.C.
Kassite, ca. 1600–1150 B.C.

Early in the second millennium B.C., Babylon became the first capital of an empire. The First Dynasty of Babylon is perhaps best remembered for the Law Code of Hammurabi. Soon after the sacking of Babylon by the Hittites about 1600 B.C., the Kassites took control. They adopted the language and culture of the more mature Babylonians over whom they ruled for the next four hundred years.

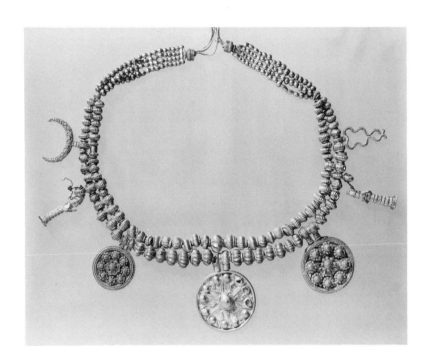

13. Necklace with Pendants
Ancient Near East, Late Babylonian or Early Kassite, *ca.* XVI century B.C.
Gold
Length: 15¾ inches
Mesopotamia

This elaborate gold necklace, allegedly from the region of Babylon, is difficult to date. The extensive use of granulation sometimes in the shape of triangles on the pendants of the necklace and the form of the beads are characteristic of objects of the Kassite Period (*ca.* thirteenth century B.C.) from Aqar Quf in Mesopotamia. The necklace has however been variously dated from the early to mid second millennium B.C.

The pendants include the lightning fork of the god Adad, the crescent of Sin, three circular medallions, perhaps signifying the god Shamash and the goddess Ishtar, and two figures of the goddess Lama, who acted as a mediator between man and the gods. These goddesses, although minute in size, are carefully delineated. Their flounced robes, horned crowns of divinity, and heavy necklaces with counterweight behind are all depicted in fine detail.

Meissner, B., "Altbabylonische Plastik." *Der Alte Oriente,* Nv. XV, 1 and 2, 1915, p. 64.

47.1a–n The Metropolitan Museum of Art, Fletcher Fund, 1947.

Egypt: Middle Kingdom, XI and XII Dynasties, ca. 2134–1786 B.C.

Military successes and expansion of commerce accompanied renewed order and security under a government in which the nobles exercised considerable influence. The Middle Kingdom was brought to an end by the infiltration of peoples from the northeast, the Hyksos, part of a widespread migration of peoples all over the ancient Near East and the Aegean.

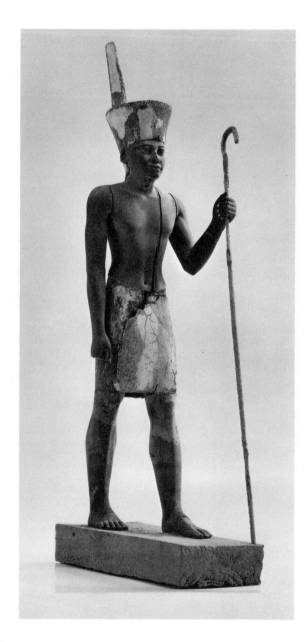

14. King Sesostris I
Egyptian, XII Dynasty, 1972–1928 B.C.
Wood and plaster, painted
Height: 23 inches
Lisht

This figure, wearing the Red Crown of Lower Egypt, and a mate wearing the White Crown of Upper Egypt were found in a secret chamber in the wall around the tomb of Sesostris' chancellor, Prince Imhotep.

Our figure is made of sixteen pieces of finely grained cedar skillfully joined together, the joins once hidden by the pinkish paint applied to the flesh and by the painted plaster kilt. The king strides forward holding his *hekat*-scepter, a sign of royal power derived from the crook of prehistoric shepherd kings.

The royal portraits of the Twelfth Dynasty combine the dignity and restraint associated with the office of pharaoh with an uncompromising realism rarely applied in the ancient world when the subject was a king. Here Sesostris seems to be a rather young man with a cheerful expression and unlined face, unaffected by the troubles reflected in the portraits of some of his successors.

Hayes, W. C., "Royal Portraits of the Twelfth Dynasty." *The Metropolitan Museum of Art Bulletin,* n.s., Vol. V (December, 1946), pp. 119–24.

14.3.17 Excavations of The Metropolitan Museum of Art, Edward S. Harkness and Rogers Fund, 1914.

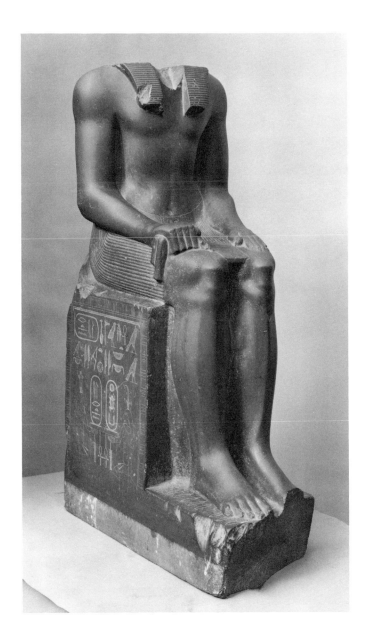

15. Seated Statue of Sesostris I
Egyptian, XII Dynasty, 1972–1928 B.C.
Black basalt
Height: 40½ inches
The Fayyum

Sesostris' father, Amunemhet I, founded the Twelfth Dynasty, and by his ability and energy inaugurated an era of national prosperity maintained by his equally vigorous and intelligent son, who accomplished an expansion of his country that had never before been imagined. This statue comes from a temple in the Fayyum that was greatly enriched by the kings of the Twelfth Dynasty —that of the crocodile god Sobk. The king sits on a throne whose sides and back are inscribed with his name and titles, and with symbols that represent the uniting of the "Two Lands," the Nile Valley and the Delta. He wears a finely pleated kilt and holds a folded handkerchief. His feet rest on the "Nine Bows," the emblems of the traditional enemies of Egypt.

The missing head, wearing the *nemes* wig cover, may have been carved separately and attached by a tenon, or it may have been broken off and rejoined in antiquity.

Hayes, W. C., *The Scepter of Egypt.* New York, 1953, Pt. I, p. 180 f.

25.6 The Metropolitan Museum of Art, Gift of Jules S. Bache, 1925.

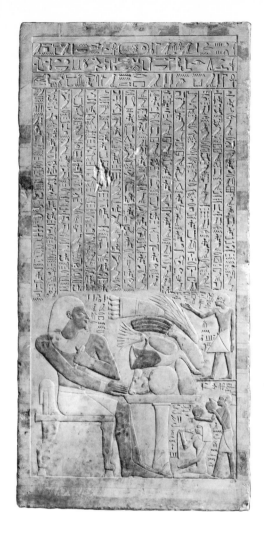

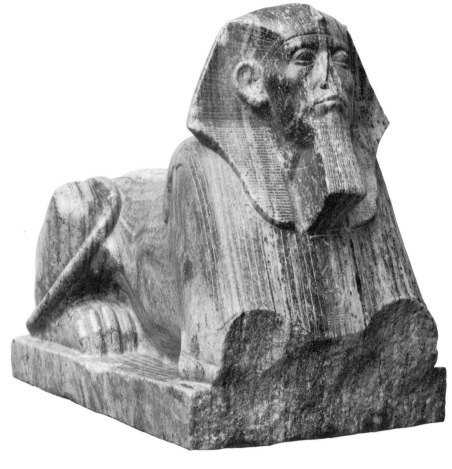

16. Stela of Montuwosre
Egyptian, XII Dynasty, 1955 B.C.
Limestone, painted
Height: 41 inches
Abydos

This stela is remarkable for the excellence of its style, its
state of preservation, and for the interest of its long
autobiographical text. It was a present from Sesostris I to a
favorite official, his steward Montuwosre, and was set up at
Abydos (the ancient holy place where the Egyptians
believed the god Osiris was buried) at the king's order in
his seventeenth year.

The words of the text are spoken by Montuwosre himself,
who sits behind a table of offerings presented by his son,
Inyotef, below whom (but actually nearer the spectator)
are "his beloved daughter Dedyet" and his father, another
Inyotef. Montuwosre describes his various duties, his
unfailing generosity to the unfortunate, and his wealth,
ending with a request for offerings from "all persons who
approach this stela."

Hayes, W. C., *The Scepter of Egypt.* New York, 1953, Pt. I,
p. 298 f.

12.184 The Metropolitan Museum of Art, Gift of Edward
S. Harkness, 1912.

17. Sphinx of Sesostris III
Egyptian, XII Dynasty, 1878–1843 B.C.
Diorite
Length: 28¾ inches; Width: 11½ inches; Height: 16¾ inches

The lion has always been regarded as the king of beasts; the Egyptians
considered their king a lion among men. In this magnificent sphinx, we
see Sesostris III, one of Egypt's greatest soldiers and administrators, with
the body of a lion and his own unmistakable, proud but careworn face.
We do not need the two names from his titulary carved on the breast
to identify him, "Divine-of-Forms" and "Shining-are-the-*kas*-of Re."

The first astronomically fixed date in history occurs in the seventh year
of Sesostris' reign.

Hayes, W. C., "Royal Portraits of the Twelfth Dynasty." *The Metropolitan
Museum of Art Bulletin,* n.s., Vol. V (December, 1946), pp. 119–24.

17.9.2 The Metropolitan Museum of Art, Gift of Edward S. Harkness,
1917.

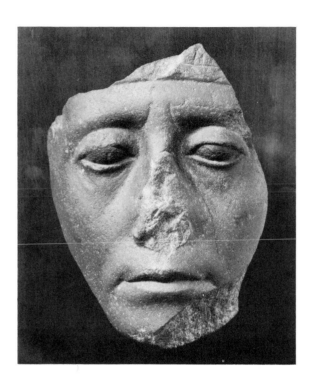

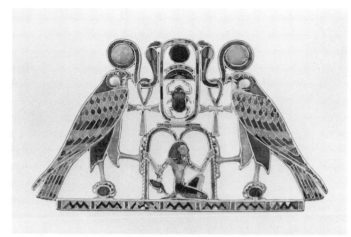

18. Carnarvon Head of Sesostris III
Egyptian, XII Dynasty, *ca.* 1850 B.C.
Red quartzite
Height: 6½ inches

This face, though sadly broken, is the most famous of all the extant portraits of Sesostris III. The heavy-lidded eyes, furrowed brow, and lined cheeks are those of his sphinx, but the expression of the mouth seems melancholy rather than disdainful. The head, for all its fleshlike quality, is carved in one of the hardest stones used by the Egyptians.

Hayes, W. C., "Royal Portraits of the Twelfth Dynasty." *The Metropolitan Museum of Art Bulletin*, n.s., Vol. V (December, 1946), pp. 119–24.

26.7.1394 The Metropolitan Museum of Art, Carnarvon Collection, Gift of Edward S. Harkness, 1926.

19. Lahun Pectoral
Egyptian, XII Dynasty, *ca.* 1880 B.C.
Gold with turquoise, lapis lazuli, carnelian, garnet;
necklace: gold, green feldspar, lapis lazuli, carnelian
Length: 3¹⁄₁₆ inches; Height: 1¾ inches
Length of necklace: 32½ inches
Lahun

This pectoral is considered the finest single piece of Egyptian jewelry extant. It belonged to Princess Sit-Hathor-Yunet, the sister of Sesostris III, and was given her by their father, Sesostris II. Elegant in design and of superb workmanship, it bears the cartouche of Sesostris, supported by two falcons representing the sun god and by hieroglyphs reading "Hundreds of Thousands of Years" and "Life." The base is of gold, to which are soldered fine gold wires to outline the details of the design. Each little cloison is filled with a minute piece of turquoise, lapis lazuli, or carnelian, cut to the exact size; the eyes of the falcons are of garnet. In all, there are 372 pieces of hard, semiprecious stone, each cut and polished individually. Details of the design are modeled and engraved on the golden back, which in its own way is as extraordinary as the brightly colored front.

Brunton, G., *Lahun I, The Treasure.* London, Vol. XXVII, 1920–1923, p. 33. Winlock, H. E., *The Treasure of el Lahun.* New York, The Metropolitan Museum of Art, 1934.

16.1.3 The Metropolitan Museum of Art, Rogers Fund and Contribution of Henry Walters, 1916.

Egypt:
New Kingdom, XVIII Dynasty, 1580–1350 B.C., and
XIX Dynasty, 1350–1200 B.C.

*Under the XVIII Dynasty the Egyptian Empire reached its greatest expansion; far-ranging
commerce and the flow of tribute contributed to this richest phase of Egyptian culture. During
the short-lined "Amarneh Revolution," the pharaoh Amenhotep IV replaced the traditional
gods with a monotheistic religion centered on worship of the sun-disk.*

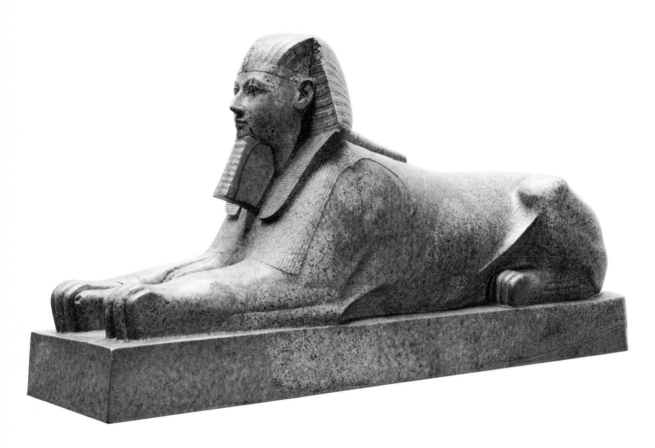

20. Hatshepsut as a Sphinx
Egyptian, XVIII Dynasty, *ca.* 1495 B.C.
Red granite
Length: 11 feet, 3 inches; Height: 5 feet, 4½ inches
From the Temple of Hatshepsut, Deir el Bahri, Thebes

Hatshepsut was the daughter of Thotmose I and the widow of Thotmose II, who died in 1504 B.C.
A year later, stating she was in reality the daughter of the queen (who had been heiress to the throne)
and the god Amun himself, she declared herself King of Egypt. She reigned for twenty-four years,
supplanting her husband's son by a minor wife, the future Thotmose III.

Four statues of Hatshepsut are shown in this exhibition. They were among the two hundred that
embellished her temple at Deir el Bahri, opposite the modern Luxor. All were dragged out of the
temple, broken up, and dumped into nearby quarries at her death at the order of her unforgiving
stepson. There the fragments were found by the Museum's Egyptian expedition. The present portraits
show Hatshepsut as a sphinx, as a king, and as a king who was also a woman.

This sphinx was one of six arranged in pairs along the central terrace of the temple. Monumental and
simplified in detail, the head is an idealized portrait of the queen, while the lion's body expresses the
power and majesty of a pharaoh.

The inscription on the lion's chest gives the queen's throne name, Maaetkare. It was once painted blue,
but otherwise color was used only to emphasize the eyes and the striping of the headdress.

Winlock, H. E., *Excavations at Deir el Bahri, 1911–1931.* New York, 1942.

31.3.166 Excavations of The Metropolitan Museum of Art, Rogers Fund, 1926–1928.

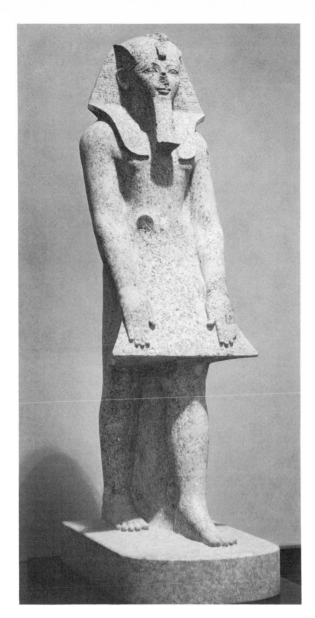

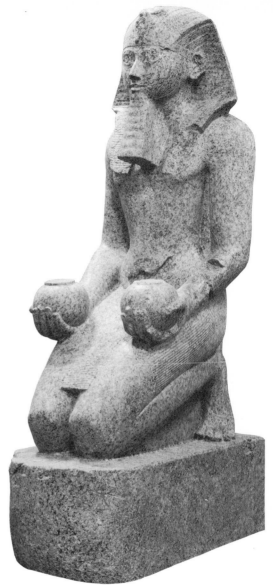

21. Standing Figure of Hatshepsut
Egyptian, XVIII Dynasty, *ca.* 1495 B.C.
Red granite
Height (without restored base): 95 inches
From the Temple of Hatshepsut, Deir el Bahri, Thebes

The great standing statue was one of a pair that stood on
the uppermost terrace of the temple; they flanked the
gateway leading to the terrace's court, their hands lowered
in an attitude of adoration. Hatshepsut again wears the
nemes, and a pleated triangular apron has been added to the
kilt. A royal decoration, the beadwork sporran hanging
from the kilt, is bordered by cobras. Both statues were
badly broken, but this one is almost complete except for
the base, which has been restored.

Winlock, H. E., *Excavations at Deir el Bahri, 1911–1931.*
New York, 1942.

28.3.18 Excavations of The Metropolitan Museum of Art,
Rogers Fund, 1926–1928.

22. Kneeling Figure of Hatshepsut
Egyptian, XVIII Dynasty, *ca.* 1495 B.C.
Red granite
Height: about 8 feet, 7 inches
From the Temple of Hatshepsut, Deir el Bahri, Thebes

This figure is one of eight colossal kneeling statues that
lined the way across the uppermost terrace. Massive
examples of architectural sculpture, simplified and stylized,
they kneel, presenting jars of offerings to the god. An
inscription on the base of our figure declares the contents
of the jar: "truth."

Winlock, H. E., *Excavations at Dir el Bahri, 1911–1931.* New
York, 1942.

29.3.1 Excavations of The Metropolitan Museum of Art,
Rogers Fund, 1926–1928.

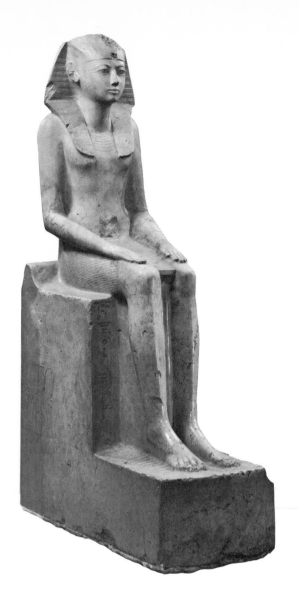

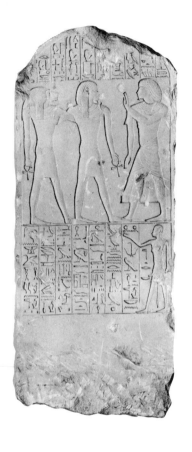

23. Seated Figure of Hatshepsut
Egyptian, XVIII Dynasty, *ca.* 1495 B.C.
White limestone
Height: 6 feet, 4 inches
From the Temple of Hatshepsut, Deir el Bahri, Thebes

This white limestone statue is the finest of all the sculptures from Deir el Bahri. For this reason, and because its size and material are unique, it is thought to have come from the queen's own chapel. Hatshepsut is shown seated on her throne in much the same way that Sesostris I was shown wearing the *nemes* and pleated kilt, her feet on the "Nine Bows," the throne again inscribed with symbols of the unification of Egypt. But her hands are empty and lie flat on the kilt; and the bull's tail—a symbol of royalty attached to the back of the belt—is shown dangling between her legs. Although dressed as a king, the figure is so slender and graceful and so essentially feminine in feeling, that there is no doubt as to Hatshepsut's sex.

This statue, like the granite ones, was left unpainted, with color used only to pick out details of face, costume, and throne.

Winlock, H. E., Excavations at Deir el Bahri, 1911–1931. New York, 1942.

29.3.2 Excavations of The Metropolitan Museum of Art, Rogers Fund, 1926–1928.

24. Stela of Senu
Egyptian, XVIII Dynasty, *ca.* 1400 B.C.
Limestone
29¼ × 12½ inches
Tuneh

This is one of several stelae, of which The Metropolitan Museum has two, from the tomb of the Scribe of the Recruits, Senu. It comes from Tuneh in Middle Egypt, a provincial site, and gives evidence of the uniform excellence of the work being done all through Egypt during the reign of Amenophis III.

This stela shows Senu worshiping two gods of the dead, the human-headed Imsety, and Hapy, who is ape-headed. Below, a priest called Pawahy asks various gods to provide sustenance for Senu's soul. Senu's costume is that of a rich official of the later Eighteenth Dynasty, the two divinities are garbed in the archaic dress in which gods are always shown, and Pawahy wears the leopard skin of his calling. Both stelae are remarkable for the gemlike quality of their carving.

Hayes, W. C., The Scepter of Egypt. Pt. II: The Hyksos Period and the New Kingdom (1675–1080 B.C.). Cambridge, Mass., 1959, pp. 272–74.

12.182.39 The Metropolitan Museum of Art, Rogers Fund, 1912.

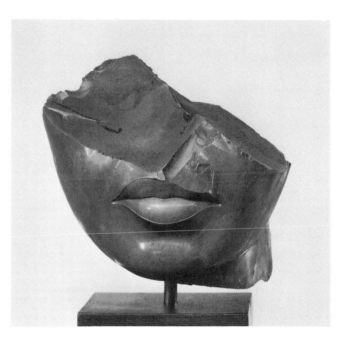 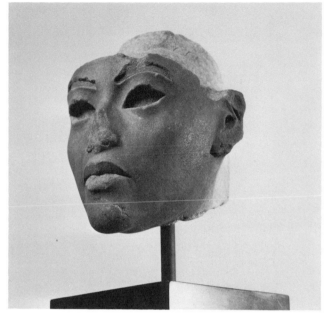

25. Fragment of Head of Teye
Egyptian, XVIII Dynasty, *ca.* 1380 B.C.
Yellow jasper
Length: 5⅜₆ inches

The yellow jasper head probably represents Queen Teye and presumably belonged to a statue of which the flesh parts were of jasper and the costume of hard white limestone, with details in gold and polychrome. Only this fragment has survived.

Jasper is one of the hardest stones. When the head was first received, there was no implement in the Museum capable of making the drill hole necessary to mount it. Yet the Egyptian sculptor with the primitive tools at his disposal was able to produce this marvelous portrait.

The fragment, sadly broken though it is, reveals the extraordinary subtlety of the great master sculptors of the end of the Eighteenth Dynasty. No existing statues of the period rival its perfection.

Hayes, W. C., *The Scepter of Egypt.* Pt. II: *The Hyksos Period and the New Kingdom (1675–1080 B.C.).* Cambridge, Mass., 1959, pp. 259–60.

26. Akhenaten
Egyptian, XVIII Dynasty, *ca.* 1365 B.C.
Dark red quartzite
Height: 4⅜ inches
Amarneh

This head can be placed among the rather later portraits of Akhenaten, although the face still shows the ruler as a young man. It formed part of one of the composite figures characteristic of Amarneh, in which several materials were combined; the tenon over the forehead was inserted into a *nemes* headdress of another color. Although not "the first individual in history" as once claimed, Akhenaten certainly had a most original mind: this small head with its petulant lips and fanatical eyes gives us a glimpse of his character.

It is believed that this head came from the studio of the master sculptor, Thotmose, at Amarneh, where the famous portraits of the royal family now in Berlin were found.

Hayes, W. C., *The Scepter of Egypt.* Pt. II: *The Hyksos Period and the New Kingdom (1675–1080 B.C.).* Cambridge, Mass., 1959, p. 288.

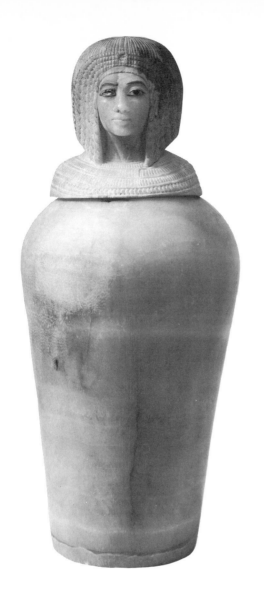

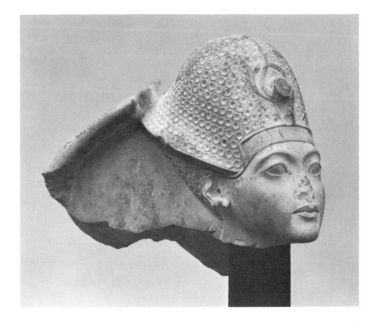

27. Princess Meryetaten

Egyptian, XVIII Dynasty, *ca.* 1365 B.C.
Alabaster; eyes inlaid with glass
Height: head, 7 inches; jar, 14½ inches
Valley of Kings, Thebes

Akhenaten was succeeded by a younger half brother, Smenkhkare, who was married to his eldest daughter, Meryetaten. Smenkhkare lived for only a few more months, and his funerary equipment was not ready when he died, so a set of canopic jars that had already been prepared for his wife was appropriated for his own use. They were of alabaster, inscribed in front with her name, and their stoppers were portraits of the princess in the delicate, refined style of Akhenaten's later years. The inscriptions were erased, and royal cobras (now missing) were attached over the foreheads. The closely related husband and wife probably resembled each other; and, since both men and women wore the valanced wig of the portrait, the jars were now ready to receive the organs of the young king.

Aldred, C., *Akhenaten, Pharaoh of Egypt.* London, 1968.

07.226.1; 30.8.54 The Metropolitan Museum of Art, Gift of Theodore M. Davis, 1907; Bequest of Theodore M. Davis, 1915.

28. Tutankhamun Crowned by Amun

Egyptian, XVIII Dynasty, *ca.* 1360 B.C.
Indurated limestone
Height: 6 inches

Smenkhkare was succeeded by Tutankhamun, possibly another half brother of Akhenaten. When he was a child of nine or ten, Tutankhamun was already married to the third of the Akhenaten daughters—a marriage that strengthened his claim to the throne. Tutankhamun's brief life ended before he was twenty. His modern fame rests chiefly on the magnificent treasure with which he was buried, discovered in 1922 by Lord Carnarvon and Howard Carter; but he had lived long enough to return to Thebes and restore the property of the god Amun.

This portrait is from a group commemorating his coronation, the "laying on of the hands" by Amun himself. All that remains is the head of Tutankhamun and the much larger hand of the god, gently placed on the "Blue Crown." Tutankhamun is shown with the typical Amarneh features: almond eyes, pointed chin, full lips turning down at the corners, but the rounded cheeks are still those of a child. The statue is of the hard, marble-like material known as indurated limestone much favored by the sculptors of Amarneh.

Lansing, A., "A Head of Tut'Ankhamun." *Journal of Egyptian Archaeology,* Vol. XXXVII, 1951, p. 3–4.

50.6 The Metropolitan Museum of Art, Rogers Fund, 1950.

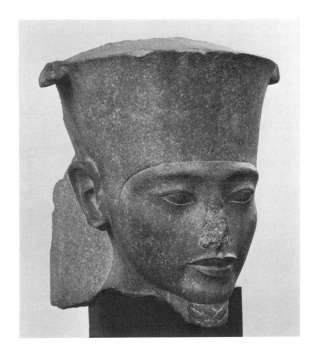

30. Gazelle

Egyptian, XVIII Dynasty, *ca.* 1355 B.C.
Ivory and wood
Height: 4½ inches; Length: 3⅞ inches

The little gazelle stands on a desert crag covered with flowering shrubs. Its ears have been broken off and the horns, which were probably of precious metal, are missing. The base is wood painted dark brown and the plants are inlaid in a thick blue pigment. This small *objet d'art* seems to have served no useful purpose, but was meant simply to give pleasure.

Hayes, W. C., *The Scepter of Egypt.* Pt. II: *The Hyksos Period and the New Kingdom (1675–1080 B.C.).* Cambridge, Mass., 1959, pp. 313–14.

26.7.1292 The Metropolitan Museum of Art, Carnarvon Collection, Gift of Edward S. Harkness, 1926.

31. Horse

Egyptian, XVIII Dynasty, *ca.* 1355 B.C.
Ivory
Length: 5⅞ inches

The horse was the handle of a whip, or perhaps of a horsehair fly whisk. Stained a reddish brown, its mane and the stripe of hair running down its back are black. The eyes were garnet (one is now missing).

The horse and the gazelle (see No. 30) are the finest Egyptian ivories known.

Hayes, W. C., *The Scepter of Egypt.* Pt. II: *The Hyksos Period and the New Kingdom (1675–1080 B.C.).* Cambridge, Mass., 1959, pp. 313–14.

26.7.1293 The Metropolitan Museum of Art, Carnarvon Collection, Gift of Edward S. Harkness, 1926.

29. The Great God Amun

Egyptian, XVIII Dynasty, *ca.* 1355 B.C.
Porphyritic diorite
Height: 16 inches

This head, like the small white head showing Tutankhamun's coronation, illustrates that pharaoh's devotion to Amun. It recalls a group in the Louvre in which an over-life-size seated figure of the god extends his hands to touch the shoulders of a small standing figure of the pharaoh.

In ours, as in the Louvre's sculpture, the god is shown, according to custom, with the features of the reigning king —Tutankhamun. The face is a little older and thinner than it is in the limestone portrait.

There is no doubt about the identity of the god, who has a braided beard and his characteristic cap, from which, however, the plumes have been lost.

Hayes, W. C., *The Scepter of Egypt.* Pt. II: *The Hyksos Period and the New Kingdom (1675–1080 B.C.).* Cambridge, Mass., 1959, p. 300.

07.288.34 The Metropolitan Museum of Art, Rogers Fund, 1907.

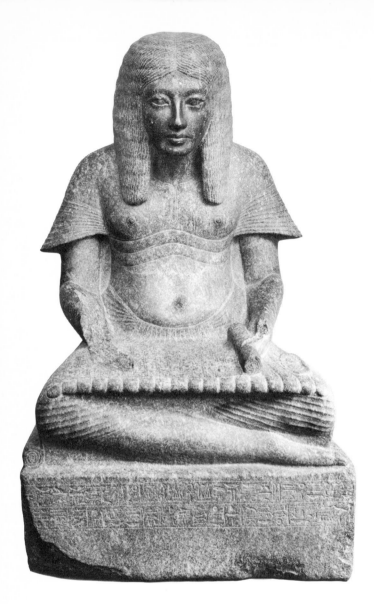

32. General Horemheb as a Scribe

Egyptian, XVIII Dynasty, *ca.* 1355 B.C.
Diorite
Height: 46 inches
From the Temple of Ptah at Memphis

Horemheb, the last king of the Eighteenth Dynasty, is one of the most interesting and enigmatic figures in Egyptian history. Horemheb began his career under Amenophis III, served under Akhenaten, and as general of the army, led successful military expeditions into Palestine and Nubia for Tutankhamun. At the latter's death, and in control of the army, it was probably he who made the aged Eye, Akhenaten's father-in-law, king for a brief spell as a sort of troubleshooter, before seizing the throne for himself. Horemheb's interests, however, were not military but administrative.

Our portrait shows him before he was king, a serene, thoughtful man with an open papyrus roll across his knee. His diaphanous shirt and finely pleated kilt reveal the stout body that always denoted worldly success. The statue has, nevertheless, an additional soft, rather effeminate quality that is not found before the sculptures of Amarneh.

Among the inscriptions on the base is Horemheb's claim that he had suppressed crime and lawlessness, and helped the poor—a claim that he later expanded on his famous stela at Karnak.

This statue of Horemheb is considered the finest single antiquity in the Museum's Egyptian Collection.

Winlock, H. E., "Harmhab, Commander-in-chief of the Armies of Tutankhamon." *The Bulletin of The Metropolitan Museum of Art* (Supplement), Vol. XVIII (October, 1923).

23.10.1 The Metropolitan Museum of Art, Gift of Mr. and Mrs. V. Everit Macy, 1923.

33. A Weight

Egyptian, XVIII–XX Dynasty, *ca.* 1400–1100 B.C.
Bronze with lead
Height: 2⅛ inches; Length: 2¹⁵/₁₆ inches
Said to have been found in the Nile

The Egyptians had a special feeling for the animals that lived close to them in the swamps of the Delta and on the desert plateaus above the Nile. Each creature was associated with a particular characteristic. One of the favorite subjects of both sculptor and painter was the graceful gazelle, whose form, as conceived here, is both beautiful and functional. This bronze dorcas gazelle w a weight. It is solid cast, except for a space left underneath to be filled with the quantity of lead needed to bring the weight up to the amount marked on its back, 3 *deben* (about 260 grams). Weights in the form of animals recall the fact that cattle were an early standard of value.

68.139.1 The Metropolitan Museum of Art, Lila Acheson Wallace Fund Gift, 1968.

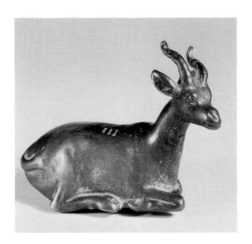

34. Statue of Yuny

Egyptian, XIX Dynasty, *ca.* 1300 B.C.

Indurated limestone

Height: 50¾ inches; Base: 35½ x 21⅝ inches

Deir Durunka, near Asyut

This magnificent statue of Yuny, the secretary of Ramesses II, was found in the tomb of Yuny's father, Amunhotpe, a Chief Physician. Here Yuny kneels, holding before him a shrine containing a small figure of the god Osiris. He wears the fashionable costume of a nobleman of the day, transparent shirt, finely pleated kilts, one of which is doubled in front, a heavy curled wig, and papyrus sandals.

Yuny's jewelry consists of a heavy bracelet on the right wrist, an amulet around the neck, and a necklace of the large beads known as the "Gold of Honor," a decoration given by the king for distinguished service. Two holes at the back of the neck may be for the attachment of real garlands during special festivals. Little figures of Renutet, his wife, stand in relief at the sides of the back pilaster.

Yuny's eyebrows and the rims of his eyes were once of metal that was gouged out by an ancient thief, who probably broke the nose accidentally at the same time.

Winlock, H. E., "Recent Purchases of Egyptian Sculpture." *The Bulletin of The Metropolitan Museum of Art,* Vol. XXIX (November, 1934), pp. 184–86.

33.2.1 The Metropolitan Museum of Art, Rogers Fund, 1933.

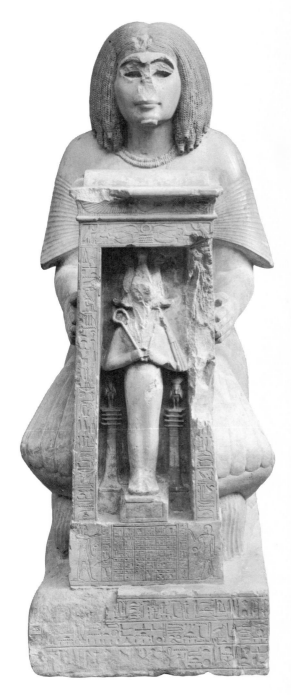

China:
Shang Dynasty, ca. 1523–1028 B.C.
Early Chou Dynasty, ca. 1021–900 B.C.

The Shang Dynasty consolidated and developed the three dominant Neolithic cultures in the Yellow River basin of China and established a capital at An-Yang about 1500 B.C. Shang ritual vessels cast in bronze are the most refined products of any Bronze Age culture. Under the Western Chou Dynasty, which absorbed Shang culture, hunting was gradually replaced by agriculture controlled by a feudal aristocracy of clans.

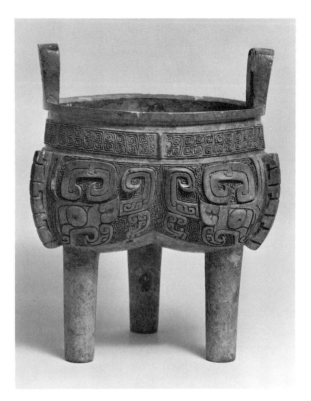

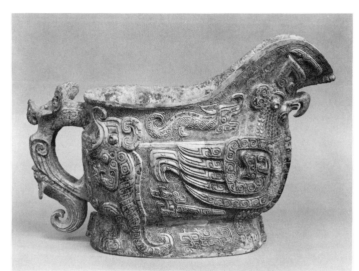

35. Ritual Vessel (Li Ting)
Chinese, Shang Dynasty, *ca.* 1300–1000 B.C.
Bronze
Height: 7½ inches; Width: 5¾ inches

The trilobed body of this vessel is supported by three cylindrical legs placed directly beneath the three large *t'ao-t'ieh* masks in the relief that decorate it. These masks are separated by strong median flanges and set handsomely against a spiral ground. The great simplicity and strength of form are enhanced by the horizontal neckband and a pair of upright handles. The entire surface is covered by a beautiful smooth yellow-green patina.

Loehr, M., *Ritual Vessels of Bronze Age China.* New York, 1968, p. 94 f.

49.136.5 The Metropolitan Museum of Art, Gift of Mrs. John Marriott, Mrs. John Barry Ryan, Gilbert W. Kahn, Roger Wolfe Kahn (children of Addie W. Kahn), 1949.

36. Ritual Vessel (Kuang)
Chinese, Late Shang Dynasty, late II millennium B.C.
Bronze
Height: 8⅞ inches; Length: 13 inches

This bronze ritual vessel is outstanding by virtue of the technical brilliance of the casting and its marvelously inventive ornament. The design motifs are raised in relief against a background of spirals. A bird, surrounded by gaping dragons, bestrides the prow of the vessel under the projecting mouth. His wings are transformed into serpents. Fish, t'ao-t'ieh masks, and dragons ornament the body. The handle is in the shape of a horned bird standing on a serpent-like fish.

Although the kuang form seems to have disappeared early in the first millennium B.C., decorative motifs like those found on this vessel influenced the course of Chinese art for centuries longer, well into the Christian era.

Young, J., *Art Styles of the Ancient Shang.* New York, 1967, Cat. No. 51.

43.25.4 The Metropolitan Museum of Art, Rogers Fund, 1943.

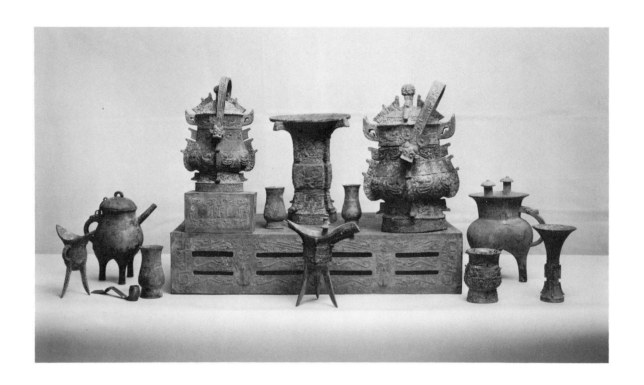

37. Tuan Fang Altar Set
Chinese, Shang and Early Chou Dynasties, mid II millennium-early I millennium B.C.
Bronze
Altar table: Height: 7⅓ inches; Length: 35⅜ inches; Width: 18¼ inches

This ritual bronze altar set, comprising fourteen objects, including an altar table, is extraordinary for its completeness as well as for the quality and vitality of the individual pieces. Tuan Fang, viceroy of Shensi province, purchased the set when it first came to light in 1901. The Museum acquired it from his heirs in 1924.

The excavation of these bronzes is undocumented, but they are believed to have come from Tou-chi T'ai in Shensi, from an early Chou tomb. The vessels themselves probably date from the Shang and Early Chou periods. Cast with superb control of the bronze technique, they are clearly the product of a culture at its peak. The exact nature of the sacrificial and ritual functions which they served is not yet clear. The wealth of motifs (note particularly the *t'ao-t'ieh* masks, dragons, and birds) show a complete mastery of the art of decorating bronze forms.

Li Chi, "The Tuan Fang Altar Set Re-examined." *The Metropolitan Museum Journal*, Vol. III, 1970.

24.72.1-14 The Metropolitan Museum of Art, Munsey Fund, 1924.

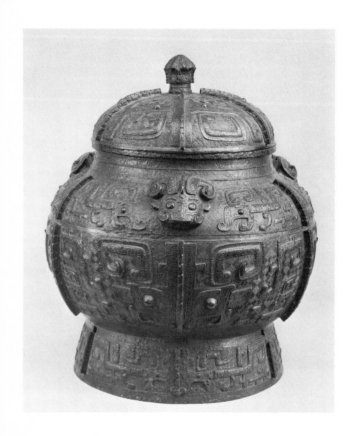

38. Ritual Vessel with Cover (P'ou)
Chinese, Early Chou Dynasty, 1021–*ca.* 900 B.C.
Bronze
Height: 21¼ inches; Diameter: 19½ inches

This P'ou with cover is a heavily cast ceremonial vessel used for food offerings during ancient religious rites. A domed lid fits over the bulbous body which stands on a high sloping foot rim. Vertical flanges bilaterally divide the entire bronze into six zones, covered in many areas with a fine spiral ground.

On the cover, large animal masks surround a center finial, which is an octagonal knob decorated with cicadas.

The body features a shoulder band with three sculptured rams heads between dragons with trunks giving birth to young ones, motifs which are repeated below and again on the base.

The entire surface has been waxed and now shows a dark patina. The P'ou is inscribed inside at the bottom and under the lid.

Umehara, S., *Seika—Obei shucho Shina kodo Seika* (Selected Relics of Ancient Chinese Bronzes from Collections in Europe and America). Vol. I, Pt. I, Osaka, Japan, 1933, Pl. 128.

17.190.524 The Metropolitan Museum of Art, Gift of J. Pierpont Morgan, 1917.

Americas: Olmec, ca. 1200–400 B.C.

Present-day Mexico and Peru were, in pre-Hispanic times, the two centers of high culture in the New World. Olmec has been termed the "mother culture" of Middle America. Situated on the Gulf Coast of Mexico, the Olmecs introduced ceremonial centers, monumental stone sculpture, and luxury arts to the Americas.

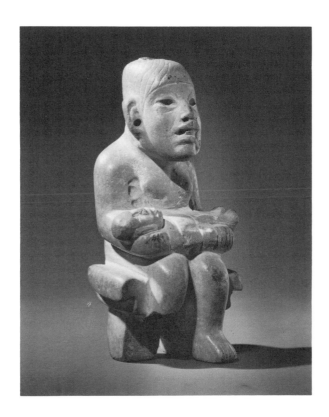

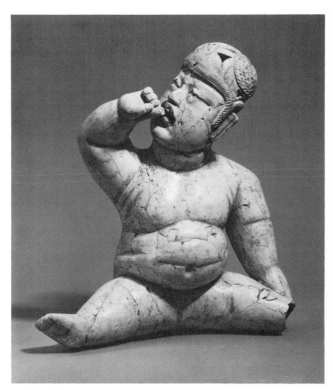

39. Figure Seated on a Bench
Olmec, *ca.* 1000 B.C.
Serpentine
Height: 4½ inches; Width: 2⅜ inches
Mexico, provenance unknown

A recurrent theme in Olmec sculpture is that of a male figure holding a child in a manner of presentation. The child is thought to be the infant rain god. This presentation "scene" is a small carving, one of the few examples in such a size. Small greenstone sculptures, particularly of human figures and of infants, are among the major artistic accomplishments of the ancient Olmec.

Goldwater, R., Jones, J., Newton, D., and Northern, T., *Art of Oceania, Africa, and the Americas from the Museum of Primitive Art.* New York, 1969, Fig. 551.

60.151 The Museum of Primitive Art.

40. Seated Figure
Olmec, *ca.* 1000 B.C.
Whiteware with traces of cinnabar
Height: 13⅜ inches; Width: 12½ inches
Mexico, Puebla, site of Las Bocas

The fat, helmeted baby figures of the Olmec culture may possibly be among the earliest representations of the ancient Mexican rain god. The large figures of this infant in whiteware ceramic are the most naturalistic portrayals in Middle American art. Here, the infant's pose, the bulging flesh, and the small fat finger in its mouth is so realistic that it seems to belie the sacredness of the great rain deity it portrays.

Coe, M. D., *The Jaguar's Children: Pre Classic Central Mexico.* New York, Museum of Primitive Art, 1965, pp. 104–107.

65.28 The Museum of Primitive Art.

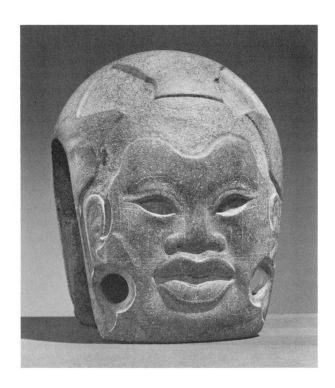

41. Small "Yoke"
Olmec, *ca.* 800 B.C.
Fine grained porphyry
Height: 7½ inches; Width: 5⅞ inches
Mexico, said to be from Guerrero

This carved stone *yuguito*, elaborately and carefully worked, is a permanent and valued copy of a perishable utilitarian yoke used in one of the most ancient forms of the Middle American ceremonial ball games. The small yokes of wood or leather are thought to have been used as hand or knee protectors, against which the hard rubber ball would rebound.

Goldwater, R., Jones, J., Newton, D., and Northern, T., *Art of Oceania, Africa, and the Americas from the Museum of Primitive Art.* New York, 1969, Fig. 561.

58.200 The Museum of Primitive Art.

Iran:
Elamite, ca. 3000–640 B.C.
Western Iranian, ca. 1000–600 B.C.

Elam in western Iran, geographically an extension of the Mesopotamian plain rather than part of the Iranian plateau, maintained close relations with Mesopotamia and struggled with varying success for control of the southern river basin. The Assyrian king Ashurbanipal put an end to Elamite power with the capture of Susa about 640 B.C.

The little-known tribes that lived at the southwest corner of the Caspian Sea are designated the Marlik peoples, after an important excavated site. To the south lived the creators of the famous bronzes of Luristan.

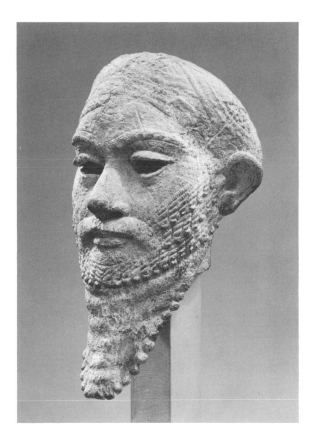

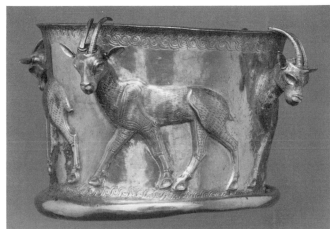

42. Head of a Ruler

Ancient Near East, Elamite, 1300 B.C. or earlier
Copper
Height: 13½ inches
Iran

Although this life-size head cast in solid copper has suffered the ravages of time, it still represents magnificently what is almost certainly the portrait of a royal personage.

It is said to have been found in Northwest Iran; but at the same time it is also usually identified as an Elamite work of art, presumably from the environs of Susa. It is quite possible that both ideas are correct, because there is proof that important objects even larger than this head were moved in ancient times from their original location to other sites, where they were subsequently discovered.

Porada, E., *The Art of Ancient Iran.* New York, 1965, pp. 61–62.

47.100.80 The Metropolitan Museum of Art, Rogers Fund, 1947.

43. Cup with Four Gazelles

Ancient Near East, Iranian, *ca.* 1000 B.C.
Gold
Height: 2½ inches
Southwest Caspian region

The tradition of making vessels with animals in relief with projecting heads has a long history in the Near East, and a number of cups similar to this one have been excavated in Iran. On this cup, four gazelles walk to the left framed by guilloche bands. Their bodies are in repoussé with finely chased details; the heads are in the round and were added separately by skillful soldering. The horns and ears were then added to the heads. The base of the cup is decorated with a chased pattern of seven overlapping six-petaled rosettes against a dotted background.

Wilkinson, C. K., "Art of the Marlik Culture," *The Metropolitan Museum of Art Bulletin,* n.s., Vol. XXIV (November, 1965), pp. 101–109.

62.84 The Metropolitan Museum of Art, Rogers Fund, 1962.

Aegean:
Cycladic, ca. 3000–2000 B.C.
Late Mycenaean, ca. 1400–1100 B.C.

Marble sculptures of extreme simplicity of form are practically all that remains of the Neolithic culture of the Cyclades, a group of islands in the Aegean.

By 1400 B.C. the Mycenaeans, who spoke Greek, had overwhelmed the sophisticated Minoan culture on the island of Crete, and thereafter their influence was evident throughout the eastern Mediterranean. During this period the famous lion gate and beehive tombs were built at Mycenae on the mainland of Greece.

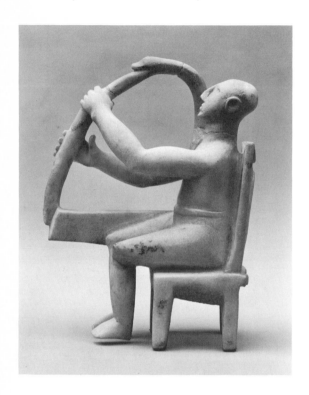

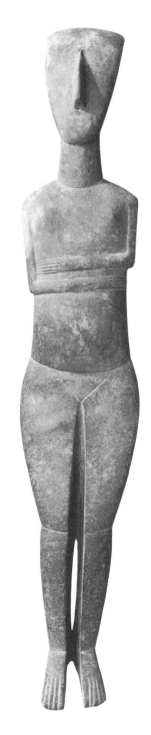

44. Statuette of Seated Man with Harp
Cycladic, Central Aegean, III millennium B.C.
Marble
Height (including harp): 11½ inches

Little is known of the so-called Cycladic culture that flourished in the Central Aegean in the neolithic age, but contemporary art has drawn our admiring attention to these prehistoric forerunners of our own simplicists. Most of the Cycladic sculptures are schematic renderings of women, but in a few cases the sculptor has abandoned the traditional repertory to show musicians or even animals. The seated harp player, his head thrown back in the classical attitude of performing artists, is executed in astonishing detail despite the primitive tools at the sculptor's disposition.

Richter, G. M. A., *Handbook of the Greek Collection.* New York, 1953, p. 15.

47.100.1 The Metropolitan Museum of Art, Rogers Fund, 1947.

45. Statuette of a Woman
Cycladic, III millennium B.C.
Marble
Height: 24¾ inches

This is one of the largest Cycladic statuettes. In type it conforms to the favorite scheme of the period: the woman is naked and her forearms, bent at the elbows at right angles, are held against the body. The knees are bent ever so slightly and the feet are stretched downward. The sculpture was not meant to be standing but rather reclining on its back. In the modeling—if such a term can be used—the body is well articulated. While the forms are drastically simple, they capture the essence of a human body in a highly sophisticated manner.

von Bothmer, D., "Greek and Roman Art." *The Metropolitan Museum of Art Bulletin*, n.s., Vol. XXVIII, 1969–1970, pp. 77–78.

68.148 The Metropolitan Museum of Art, Gift of Christos G. Bastis, 1968.

46. Spouted Jar with Stirrup Handles.
Two Octopuses and Other Denizens of the Deep
Mycenaean, *ca.* 1200–1125 B.C.
Terracotta
Height: 10¼ inches

This exceptionally well-preserved vase splendidly represents the Mycenaean style with its exuberance of ornamentalized creatures. The preference for curves and the fluid lines stand in contrast to the rigid manner of drawing that evolved after the Mycenaean age had come to an end, even though in the technique of potting and painting no break occurs at that time.

"Recent Accessions of Greek and Etruscan Art." *The Metropolitan Museum of Art Bulletin*, n.s., Vol. XIII, 1954–1955, p. 60.

53.11.6 The Metropolitan Museum of Art, Louisa Eldridge McBurney Gift Fund, 1953.

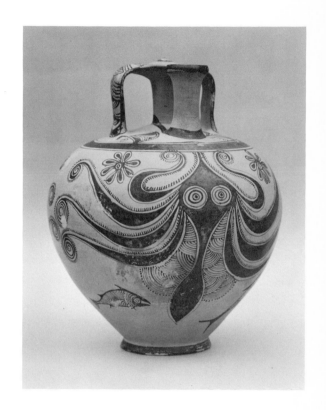

Section II: ca. 1000 B.C.–A.D. 300

ca. 950	Solomon's Temple built in Jerusalem
ca. 800	Homeric epics *Iliad* and *Odyssey* recorded in Greece
776	Founding of Olympic Games in Greece
ca. 753	Rome founded by Romulus
612	Fall of Nineveh, capital of Assyria
604	Birth of Lao-tse, Taoist philosopher
563	Birth of Gautama Buddha in India
551	Birth of Confucius in China
490	Battle of Marathon; defeat of Persians by Greeks marks beginning of Golden Age
447–432	Parthenon erected in Athens
431–404	Peloponnesian War marks end of Golden Age
399	Death of Socrates
332–323	Reign of Alexander the Great
327	Alexander invades India
323	Alexander invades Egypt; brings dynastic Egypt to a close
312	Aqua Appia, first Roman aqueduct, constructed
218	Hannibal crosses the Alps
221–206	Great Wall of China built under Ch'in Dynasty
146	Corinth and Carthage destroyed by Romans
44	Assassination of Julius Caesar
31	Battle of Actium. Octavian defeats Antony and Cleopatra; formation of Roman Empire
B.C. 4	Birth of Jesus of Nazareth
A.D. ca. 30	Crucifixion of Jesus of Nazareth
64	Burning of Rome
72–80	Colosseum built in Rome
79	Mount Vesuvius buries Pompeii and Herculaneum
98–117	Trajan's reign; marks high point of Roman territorial expansion
105	Invention of paper in China
161	Marcus Aurelius becomes Emperor of Rome
226	Beginning of Sasanian Empire

West | Near East | Far East | American

73. Greek,
End of VII century B.C.

80. Greek,
ca. 450–440 B.C.

89. Roman,
17 B.C.–A.D. 2

61. Achaemenian,
VI–V century B.C.

49. Egyptian,
ca. 350 B.C.

96. Egyptian,
II century A.D.

67. Chinese,
770–221 B.C.

65. Chinese,
481–221 B.C.

97. Indian,
I–III century A.D.

70. Peruvian,
700–500 B.C.

Greece: Geometric, ca. 1100–750 B.C.

A fresh departure rather than a development of Mycenaean style, the Geometric Style takes its name from the patterns found on vases which contrast with the more naturalistic ones found in the preceding periods. This cultural break is contemporary with the invasion of Dorians and other Greek tribes about 1100 B.C. In this period an aristocracy gradually displaced kings throughout Greece, the Homeric epics were composed, and Greek pottery began to be shipped throughout the Mediterranean.

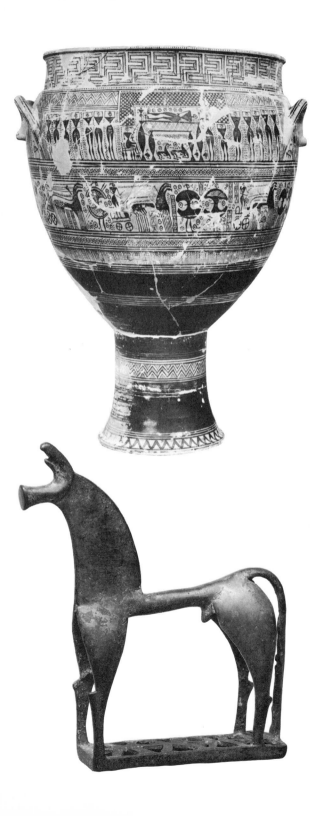

47. Sepulchral Vase
Prothesis (the dead man on a bier surrounded by mourners)
Below: funeral procession of chariots and warriors
Attic, second half of VIII century B.C.
Terracotta
Height: 3 feet, 6⅝ inches;
Greatest diameter of mouth: 28½ inches

This Attic geometric vase was never used in life but was made to be set in or on a tomb. It has no bottom, and libations were poured into it in honor of the dead. The funeral is shown in several stages on the vase itself. Above, in a panel, the lying-in-state of the dead, surrounded by his friends and relatives in the traditional mourning gestures; below, the funerary procession that includes chariots and men in armor, denoting perhaps that the dead for whose tomb this vase was made was a person of rank.

Richter, G. M. A., "Department of Classical Art Accessions of 1914." *The Bulletin of The Metropolitan Museum of Art*, Vol. X (April, 1915), pp. 70–72.
Davidson, Jean, "Attic Geometric Workshops." *Yale Classical Studies*, Vol. XVI, 1961, p. 36.
Himmelmann-Wildschütz, N., "Über einige gegenständliche Bedeutungsmöglichkeiten des Frühgriechischen Ornaments." *Akademie der Wissenschaften und der Literatur*, Abhandlungen der Geistes—und Sozialwissenschaftlichen Klass, Vol. VII, 1968, p. 313.

14.130.14 The Metropolitan Museum of Art, Rogers Fund, 1914.

48. Horse
Greek, VIII century B.C.
Bronze
Height: 6¹⁵⁄₁₆ inches; Length: 5¼ inches

The Geometric Period (*ca.* 800–700 B.C.) saw the regeneration of bronze casting in Greece. Among the bronzes produced were hundreds, if not thousands, of votive offerings in the form of statuettes of animals: horses, cows, stags, and goats. Horses were the most popular, as well as the earliest animals made; large numbers have been found at Olympia, the great Peloponnesian sanctuary. This horse, which stands squarely on a perforated base, is remarkable for its relatively large size, its state of preservation, and brilliant handling of abstract forms, especially on the curves of the legs, neck, and mane.

Richter, G. M. A., *Handbook of the Greek Collection*, New York, 1953, p. 23.

21.88.24 The Metropolitan Museum of Art, Rogers Fund, 1921.

Egypt:
Late Dynastic, ca. 1085–332 B.C.
Ptolemaic, ca. 332–30 B.C.

The XXI and XXII Dynasties suffered the decline of Egyptian authority abroad, while at home the power of the high priests of Amon supplanted that of the pharaoh. The invasion of Kushite kings from the south about 750 B.C., accompanied by a revival of the arts, was followed by a brief occupation by the Assyrians, who sacked Thebes, and a long Persian domination which lasted until the advent of Alexander the Great. Under the Ptolemies, his successors, Alexandria became one of the important centers of the Hellenistic world.

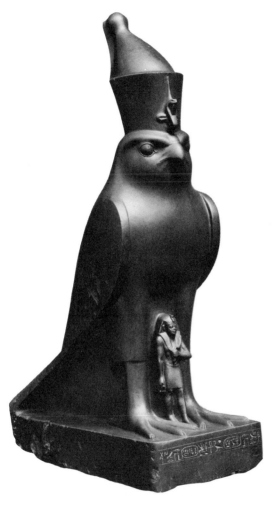

49. Falcon God Horus
Egyptian, XXX Dynasty, *ca.* 350 B.C.
Graywacke
Height: 38⅜ inches
Heliopolis

This statue was erected at the tomb of one of the sacred Mnevis bulls of the god Atum at Heliopolis by Nectanebos, the last native king of ancient Egypt, whose figure stands in front of the falcon. A play on words forming the king's Egyptian name—Nakht-Hor-heb—may be read in the statue: Nakht, the sword in the king's left hand; Hor, the falcon; heb, the symbol in the king's right hand.

The bird wears the Double Crown of Egypt with the cobra in front. The inscription on the base gives the king's titulary and says that he is "Beloved of the Deceased Mnevis."

Yoyotte, J., "Nectanébo II comme faucon divin?" *Kemi*, Vol. XV, 1959, pp. 73–74.

34.2.1 The Metropolitan Museum of Art, Rogers Fund, 1934.

50. Relief Plaque: A Ram-Headed Divinity
Egyptian, Ptolemaic Period, 332–330 B.C.
Limestone
Length: 8½ inches; Height: 6¾ inches

This plaque shows a ram-headed divinity and not a ram, as we see by the shoulder, and the wig which falls down under the horn. The simple, but subtle modeling of the face is enhanced by the elaborately carved scales of the horn.

Plaques of this general type seem to have served several purposes. The finest were apparently sculptors' studies, hung in studios for the benefit of pupils. The least successful were the work of the pupils themselves, trial pieces. And it has been suggested that particularly fine examples, either a master sculptor's or if by pupils, perhaps the works with which they graduated, might have been presented as votive offerings to appropriate gods. Our plaque, however, gives no indication of whether it was a study or a votive gift.

Young, E., "Sculptors' Models or Votives?" *The Metropolitan Museum of Art Bulletin*, n.s., Vol. XXII (March, 1964), pp. 247–56.

18.9.1 The Metropolitan Museum of Art, Gift of Edward S. Harkness, 1918.

Mesopotamia:
Assyrian, 883–612 B.C.
Neo-Babylonian, 625–539 B.C.

Political ascendancy shifted to the north when the Assyrian Empire reached its peak, stretching from Elam to Egypt. Under the Assyrians Babylon continued to be the center of culture, providing direct continuity from Sumerian times. In 612 B.C. the Assyrians fell before the combined forces of Babylonians, Medes, and Scythians.

The Neo-Babylonian Empire reached its zenith during the reign of Nebuchadnezzar II. To this period belongs the famous Tower of Babel. In 539 B.C. Babylon was taken without a fight by the Achaemenian Persian, Cyrus.

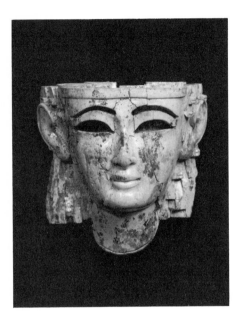 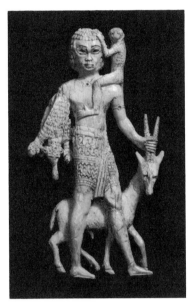 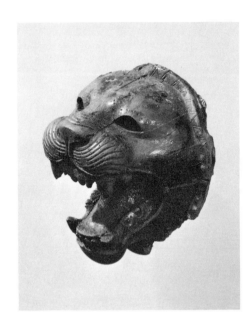

51. Head of a Man (?)
Ancient Near East, Phoenician (?), *ca.* IX or VIII century B.C.
Ivory
Height: 3³⁄₁₆ inches; Width: 3½ inches; Thickness: 2⅛ inches
Fort Shalmaneser, Nimrud

The head, carved with great skill and delicacy, represents a beardless youth. Its style seems to be Egyptian although it may have been made in Phoenicia or Syria. The hair appears to be a wig inlaid with alternating vertical rectangles of ivory and a blue material. The eyes and eyebrows were also originally inlaid, but this material is now missing. The top and back of the head are flat; there is a square tenon at the rear for the purpose of inserting the head into a socket.

Mallowan, M., *Nimrud and Its Remains.* New York, 1966, Vol. II.

62.269.2 The Metropolitan Museum of Art, Rogers Fund, 1962.

52. Figure of a Nubian in the Round
Ancient Near East, Assyrian (?), IX or VIII century B.C.
Ivory
Height: 5⁵⁄₁₆ inches; Greatest width: 2¹³⁄₁₆ inches
Fort Shalmaneser, Nimrud

Six ivory tribute bearers, all carved in the round, were excavated together. A truly remarkable and rare group, the figures, originally standing together upon an ivory plinth, represented a procession of gift bearers. The Museum ivory shows a Nubian carrying a monkey on one shoulder, a leopard skin on the other, and leading an oryx by the horns. The eyes, eyebrows, the armlet and necklace all originally held inlays.

Mallowan, M., *Nimrud and Its Remains.* New York, 1966, Vol. II, pp. 528 ff.

60.145.11 The Metropolitan Museum of Art, Rogers Fund, 1960.

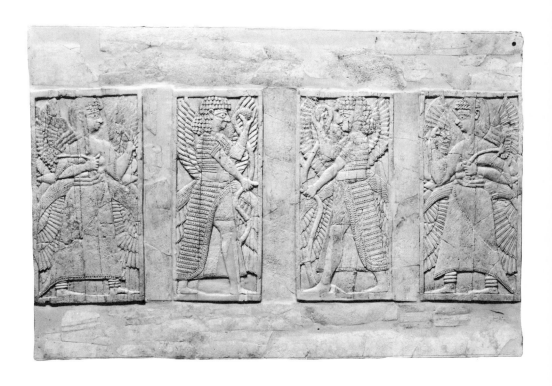

53. Lion's Head
Ancient Near East, Assyrian, *ca.* IX or VIII century B.C.
Ivory
Height: 3³⁄₁₆ inches; Width: 3⅛ inches;
Thickness: 3¹¹⁄₁₆ inches
Fort Shalmaneser, Nimrud

The style of this fine head suggests a sculptor of the eighth or ninth century working in the Assyrian style. The lion is shown snarling and openmouthed, his muzzle wrinkled; his mane, decorated with a zigzag pattern, is raised. The eyes were originally inlaid with another material, now lost, while the darkened color of the ivory indicates that the head was burned in a destruction of Nimrud, probably in the late seventh century B.C.

62.269.1 The Metropolitan Museum of Art, Rogers Fund, 1962.

54. Screen of Four Winged Figures
Ancient Near East, North Syrian (?), IX or XIII century B.C.
Ivory
Height: 11½ inches; Width: 17¾ inches
Fort Shalmaneser, Room SW 7, Nimrud

At least fifteen sets of ivory panels were found neatly stacked in a room in Fort Shalmaneser at Nimrud. Each, consisting of several units of carved ivories, was originally backed with wood. They served as heads of beds or couches or, perhaps, as backs of chairs. Since no traces of legs for furniture were found, it is assumed that they were made of wood that had disintegrated. This large panel, reconstituted from several units found together, depicts two winged unbearded males and two winged females. The males, who wear a long garment over a kilt, seize a tree and its fruit. The females clad in a long dress, girt at the waist. and wearing anklets carry a palmette on a branch. Since they are winged, these barefooted figures must represent deities or spirits. The panels may have been brought from North Syria as regular commercial imports or as booty from military campaigns.

Mallowan, M., *Nimrud and Its Remains.* New York, 1966, Vol. II, pp. 411 ff., 485 ff.

59.107.3 The Metropolitan Museum of Art, Rogers Fund, 1959.

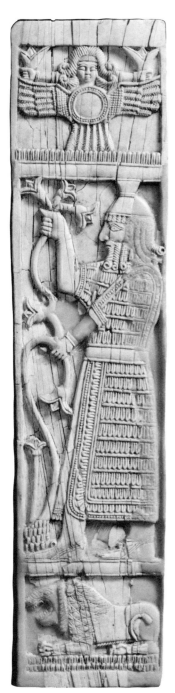

55. Plaque
Ancient Near East, North Syrian (?), IX or XIII century B.C.
Ivory
Height: 11⅜ inches; Width: 2⅝ inches
Fort Shalmaneser, Room SW 7, Nimrud

In this, one of the finer panels (cf. No. 54), a bearded man grasps a tree with both hands. He is clothed in a long garment open at the front. He wears a hat or strange type of helmet on his head and sandals on his feet. In a separate compartment below the man sits a snarling lion and in one above, holding a lotus in each hand, is a winged female, most likely a sun goddess well-known in the mythology of parts of Syria bordering on the Mediterranean to the west. Since the sun deity in Assyria and Babylonia was always a male, this panel may have originated in North Syria.

Mallowan, M., *Nimrud and Its Remains.* New York, 1966, Vol. II, pp. 411 ff., 485 ff.

59.107.7 The Metropolitan Museum of Art, Rogers Fund, 1959.

56. Charging Bull
Ancient Near East, Assyrian, *ca.* VIII century B.C.
Ivory
Height: 1½ inches; Length: 2⅞ inches
The town wall, Nimrud

This is one of five bulls in relief found together in one room of the wall of Nimrud. They are carved so deeply that they appear almost free standing; the backs have been left rough, with a tenon on each for attachment to a circular ring. Four of the bulls walk to the right, one to the left. The excavator, Sir Max Mallowan, at first assumed that they had supported a tray; but a later discovery demonstrated that the bulls were actually placed in procession in two tiers, and decorated an ivory column, which may have had the function of forming an upright for a piece of furniture. A remaining trace of gold in the mane indicates that the bulls were originally gilded.

Mallowan, M., "The Excavations at Nimrud (Kalhu), 1953." *Iraq,* Vol. XVI, 1954, p. 149.

54.117.10 The Metropolitan Museum of Art, Rogers Fund, 1954.

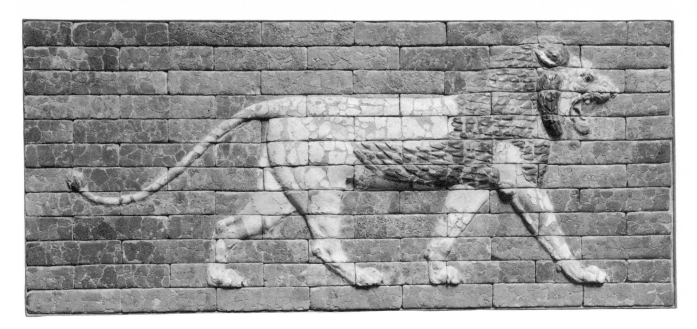

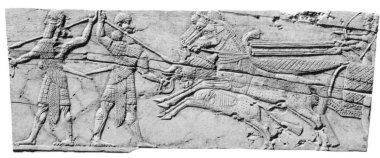

57. Fragment of a Panel
Ancient Near East, Assyrian or Iranian, late VIII–VII century B.C.
Ivory
Length: 6³⁄₁₆ inches; Height: 2¼ inches
Said to come from Ziwiyeh, Western Iran

This flat panel may have been used to decorate a box or a piece of furniture, and several ivories that have been excavated suggest that it was originally gilded. The scene, carved in relief with elegant precision of detail, represents a common Near Eastern motif, that of the hunt. Other ivories, apparently found at the same site, reveal similarities in subject matter, hunters' dress, chariot type, and other decorative details, All elements of the chariot design, especially the large carriage and what must have been, judging from similar ivories, an eight-spoked wheel, point to a date late in the eighth century or seventh century B.C. for the carving.

Wilkinson, C. K., "Treasure from the Mannaean Land." *The Metropolitan Museum of Art Bulletin,* Vol. XXI (April, 1963), pp. 283 f.

51.131.5 The Metropolitan Museum of Art, Fletcher Fund, 1951.

58. Lion
Ancient Near East, Babylon, VI century B.C.
Molded and glazed baked bricks
Height: 3 feet, 2¼ inches; Length: 7 feet, 5½ inches;
Present thickness: 3 inches

Babylon, famous from the Bible as the site of the Tower of Babel, was excavated around the turn of the twentieth century by a German expedition directed by Robert Koldewey. The splendid Ishtar Gate and the Procession Street leading up to it were certainly the most colorful of the architectural remains discovered by this expedition. This lion is one of sixty pairs said to have lined the east and west sides of the processional way. None of the lions were discovered *in situ;* all had fallen down from the walls of which they were originally a part. The lion is made of molded and glazed baked bricks, its colors of blue, yellow, and cream originally much brighter. While lions decorated the Procession Street, bulls and mythical dragon-headed creatures ornamented the Gate. In Babylon today some of these creatures, unglazed, from the lower stages of the Gate, may still be seen *in situ* . . . remnants of the final phase of Babylonian splendor late in the reign of Nebuchadnezzar II (605–562 B.C.).

Strommenger, E., and Hirmer, M., *5000 Years of the Art of Mesopotamia.* New York, 1964, pp. 457–63, Pl. XLIII.

31.13.2 The Metropolitan Museum of Art, Fletcher Fund, 1931.

Iran: Achaemenian, 539–331 B.C.

At its height under Cyrus the Great (550–530 B.C.) and Darius I (521–486 B.C.) the Achaemenian Empire stretched from the Mediterranean to the Indus River, though its attempt to control mainland Greece failed. The adoption of gold and silver coinage by Darius, a network of roads, and the use of the Aramaic tongue as the common language, made commerce easy. The ruins of Achaemenid Persepolis constitute one of the most impressive architectural remains of the ancient world.

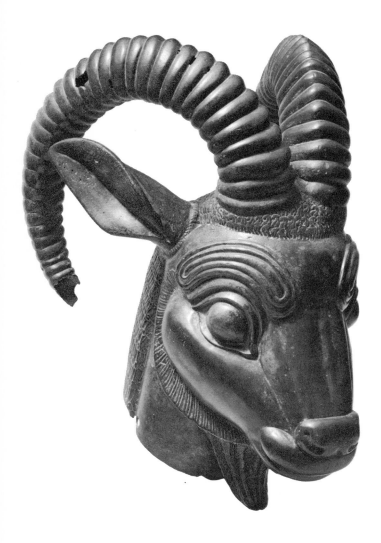

59. Head of an Ibex

Ancient Near East, Achaemenian, VI–V century B.C.
Bronze
Height: 13⅜ inches; Width (at horns): about 9 inches
Iran

The stylization of all forms, human, plant, and animal, is a striking characteristic of the art of the ancient Near East, typified by this huge ibex head with its highly decorative design. The patterns for the eyes, the brows, the horns, the beard, and the curls of the hair are those used again and again by artists of the Achaemenian Period.

Ibexes were a major symbolic motif in the ancient Near East; their exact meaning is hard to ascertain, but probably included fertility as well as royal and divine power. Its massive size and weight suggest that this ibex head was used to decorate a throne or some part of a royal building. The head was cast in a number of separate parts, joined by fusion welding. The piece is an eloquent example of Iranian art of the Achaemenian Period, still untouched by the influence of classical Greece.

Wilkinson, C. K., "An Achaemenian Bronze Head." *The Metropolitan Museum of Art Bulletin*, n.s., Vol. XV (October, 1956), p. 72 ff.

56.45 The Metropolitan Museum of Art, Fletcher Fund, 1956.

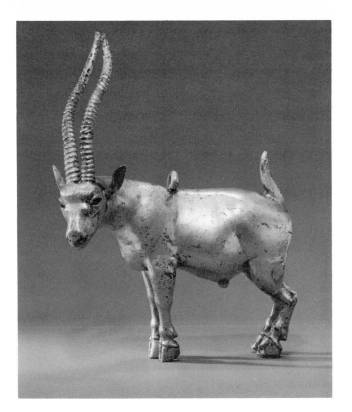

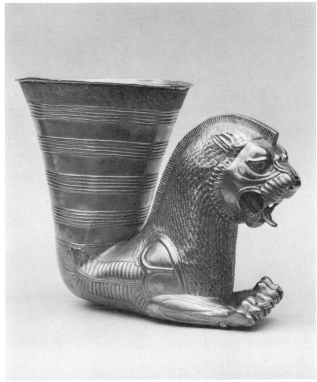

60. Antelope
Ancient Near East, Achaemenian, *ca.* V century B.C.
Silver
Length: 4 inches
Iran

This antelope, sculptured in the round, was made to be
suspended from the loop at the base of its neck. From this ring
the animal would hang in perfect balance, but it is not known
where or for what purpose this small animal was suspended.
The figure is remarkably naturalistic with none of the
stylization of face and body details so common in
Achaemenian art. The modeling of the body and head is subtle,
and the head turns out from the body slightly to the left,
reflecting perhaps the influence of Greek art. The front legs
hang straight, with the hooves pointing downward, a position
characteristic of the Scythian art of the steppes. The head,
horns, and ears of the animal were made separately and fitted
to the body.

Art Treasures of the Metropolitan. New York, The Metropolitan
Museum of Art, 1952, pp. 28, 218.

47.100.89 The Metropolitan Museum of Art, Rogers Fund, 1947.

61. Rhyton Ending in the Forepart of a Lion
Ancient Near East, Achaemenian, *ca.* VI–V century B.C.
Gold
Height: 7 inches; Diameter rim: 5⅜ inches

The rhyton, a cup or vessel terminating in an animal's head,
has a long history in Iran and the Near East, and later, in Greece
and Italy. The earliest examples so far recognized occur in the
second millennium at Kültepe in Anatolia. In the first millennium,
the earliest examples known occur at Hasanlu in northwestern
Iran dating to the ninth century B.C. These early Iranian rhyta
are straight, having the cup and animal head made in a vertical
position. Over a period of time, the animal head was made to
curve, and by the Achaemenid Period, the head was placed at
a right angle to the cup part.

The Museum's rhyton consists of a number of separate pieces.
These include the cup and the forepart of a lion as well as both
legs. In the head the tongue, some of the teeth, and the roof of
the mouth, which is finely ribbed, were also added separately.

Poroda, E., *The Art of Ancient Iran.* New York, 1965, pp. 162–65.

54.3.3 The Metropolitan Museum of Art, Fletcher Fund, 1954.

Iran: Scythian, ca. 700–200 B.C.

The Scythians, nomadic tribes from the northern steppes, were renowned horsemen and warriors who pushed south into Iran and other parts of western Asia as far as the borders of Egypt.

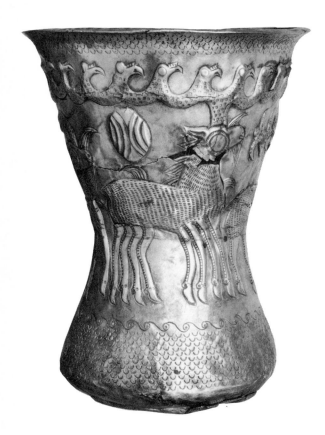

62. Beaker
Ancient Near East, Scythian (?), Greco-Thracian (?),
ca. IV century B.C.
Silver
Height: 11 inches
Danubian region

This beaker, raised from a single piece of silver, has a chased design of stags and goats, birds and fishes. Various symbols, small scales and a running spiral, are placed in the field. The fantastic, decorative fashion in which the animals are represented, the addition of birds' heads to the animal horns, and the pendant position of the hooves are all characteristics of the art of the nomadic peoples who spread across the steppes of Russia into Europe in the first millennium B.C.

It is difficult to give a name to this style, as the component elements of Scythian and Sarmatian art passed, over generations, to many different peoples. A vessel similar in shape and decoration, and a helmet of related design found in 1931 in Dobrudja, Rumania, have been called Greco-Thracian.

Bunker, E. C., Chatwin, C. B., Farkas, A. R., *"Animal Style" Art from East to West,* New York, 1970, pp. 153, 160.

47.100.88 The Metropolitan Museum of Art, Rogers Fund, 1947.

Etruscan, ca. 700–200 B.C.

The Etruscans, a loose confederacy of tribes that appeared in central Italy in the late eighth century B.C., dominated most of Italy until they were engulfed by the more organized Romans in the third century. Exposed to the same eastern influences as their contemporaries the Greeks, the Etruscans showed a marked bias in favor of Greek styles. Many Roman religious cults, institutions, and artistic styles owed a profound debt to the Etruscans.

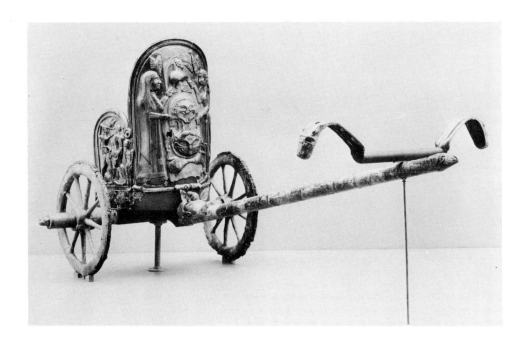

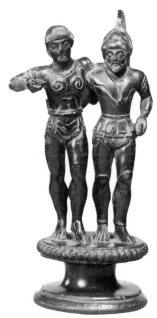

63. Chariot

Etruscan, Late VI century B.C.
Bronze
Height: 4 feet, 3½ inches
Monteleone, Italy

The bronze reliefs in repoussé on this ceremonial chariot, found in a tomb, show Etruscan art at its height in the Archaic Period. Long contact with Greek art, mostly through the import of Corinthian and Attic vases, had established in Etruria an eclectic style that owed as much to the mixed heritage of the Etruscans as it did to the sophisticated adoption of Greek conventions. On this chariot the subject matter is taken from Greek mythology and many of the forms are purely Ionian, but the native workmanship can be seen in the scheme of composition and in some of the details of dress and armor that do not seem to have been fully understood.

Chase, G. H., "Three Bronze Tripods Belonging to James Loeb, Esq." *American Journal of Archaeology,* Vol. XII, 1908, pp. 311 ff.
Richter, G. M. A., *Greek, Etruscan and Roman Bronzes.* New York, The Metropolitan Museum of Art, 1915, pp. 17, 18, 20–29.
———, *Handbook of the Etruscan Collection.* New York, 1940, p. 26.
Hampe, R., and Simon, E., *Griechische Sagen in der frühen etruskischen Kunst.* Mainz, 1964, pp. 53–67.

03.23.1 The Metropolitan Museum of Art, Rogers Fund, 1903.

64. Two Warriors, One of Them Wounded and Supported by the Other

Etruscan, first half of the V century B.C.
Bronze
Height (with base): 5¼ inches

This finial of a candelabre looks earlier than it is, for archaic art did not come to an end in Etruria at the same time as in Greece since the Persian Wars did not have the same effect on the western Mediterranean as in the East. This compact group of two warriors, one supporting the other, has been known and admired since the early eighteenth century. Its economical treatment of detail and its statuesque character are characteristic of the finest Etruscan workshops in the first half of the fifth century.

Gori, A. F., *Museum Etruscum exhibens insignia veterum Etruscorum monumenta.* Florence, 1737, Vol. I, p. 232, Pl. 115.
Richter, G. M. A., "Greeks in Etruria." *Annuario della Scuola Archeologica di Atene,* Vol. XXIV–XXVI, 1950, pp. 79 ff.

47.11.3 The Metropolitan Museum of Art, Rogers Fund, 1947.

China: Middle and Late Chou Dynasty, ca. 900–221 B.C.

The Middle Chou period saw technical innovations in the characteristic Chinese arts of brush painting, lacquer, and pottery glazes. The gradual decline of Late Chou times, aptly described by the Chinese as the Period of Warring States, drew South China into the cultural orbit and produced the philosophies of Confucius and Lao-Tze as a reaction to a time of intellectual, artistic, and political ferment.

65. High-footed Bowl and Cover

Chinese, Period of the Ch'an Kuo or the Warring States (481–221 B.C.), early to middle Ch'an Kuo
Unglazed pottery with painted design
Height: 9¼ inches; Greatest width: 8½ inches
Possibly from Loyang, Honan Province

This painted gray pottery bowl and cover (*tou*) is a particularly fine example of a clay adaptation of a bronze shape. The finely textured gray paste was carefully modeled in horizontal flutings. After the piece was fired, red and white pigment was applied in geometric patterns, but only traces of it remain.

Hochstadter, W., "Pottery and Stonewares of Shang, Chou, and Han."
Museum of Far Eastern Antiquities Bulletin, No. 24, 1952, pp. 81–108.

66. Ritual Vessel
Chinese, Late Chou Dynasty, 770–256 B.C.
Bronze with dark patina
Height: 8⅝ inches

The purpose this bronze served is not known, nor is the name by which it was called. With its spherical body in intricate openwork, supported on three delicately curled legs, it somewhat resembles an incense burner. A hole about the diameter of a pencil at the top of the bronze, through the back of the large bird, is the only opening of a size sufficient for anything to have been inserted.

The main decoration consists of free standing figures in the round of a large bird and four young ones, with their fluttering wings unfurled, perched on the upper part of the vessel. Attached to a horizontal band near the middle are four very unusual animal masks, from which hang four loose rings.

This piece illustrates a late phase in the long development of Chinese bronzes, in which the vessel itself and its pure form are overwhelmed by sculptural details.

Fong Chow, *Animals and Birds in Chinese Art.* New York, The China Institute in America, 1967, p. 20.

47.27 The Metropolitan Museum of Art, Rogers Fund, 1947.

67. Ritual Vessel (Hu)
Chinese, Late Chou Dynasty, 770–221 B.C.
Bronze inlaid with copper
Height: 17½ inches

This wine vessel is an ovoid jar, cylindrical at base and neck, with two ring handles attached to animal masks. The copper inlay decoration is in seven registers, separated from each other by variants of horizontal lozenge bands and divided into four sections by similar vertical bands. Top register: birds; second register: birds; third register: single-horned felines; fourth register: interlaced dragons and monster masks; fifth register: single-horned felines and monster masks; sixth register: birds and single-horned felines; seventh register: stags.

Chinese ritual bronzes inlaid with copper are rare, and this is the only example in the Museum's collection.

Priest, A., *Chinese Bronzes.* New York, The Metropolitan Museum of Art, 1938, p. 17.

29.100.545 The Metropolitan Museum of Art, H. O. Havemeyer Collection, Bequest of Mrs. H. O. Havemeyer, 1929.

Americas:
Chavín and Paracas, ca. 1200 B.C.–A.D. 1
Mochica, ca. 200 B.C.–A.D. 700

Chavín culture in Peru, like the Olmec in Mexico, continued to exert a far-reaching influence on later cultures, such as Mochica and ultimately Inca, down to the time of the Spanish Conquest in the sixteenth century. While other religious motifs were present, the jaguar was dominant in the iconography of each style, probably by no mere coincidence.

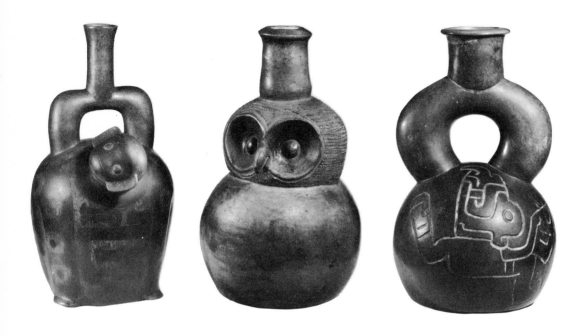

68. Three Ceramic Bottles
Peruvian, north coast, Chavinoid Styles, 1200–300 B.C.
Burnished black (a), black and red (b), and gray ware (c)
Height: 8 inches (a); 11½ inches (b), and 7⅞ inches (c)

From an aesthetic and technical standpoint some of the finest Peruvian stone carvings, goldwork, and ceramics were made in this early period in the north. Named from the highland type site of Chavín de Huántar, they influenced contemporary wares at Cupisnique, Tembladera, Vicús, and other sites on the coast. Heavy but handsomely proportioned monochrome vessels led gradually into lighter ceramics with two-color incised decoration, while modeling and the stirrup-spout form continued to be favored in the north throughout its later history.

67.239.3 (a), 6 (b), 9 (c) The Metropolitan Museum of Art, Harris Brisbane Dick Fund, 1967.

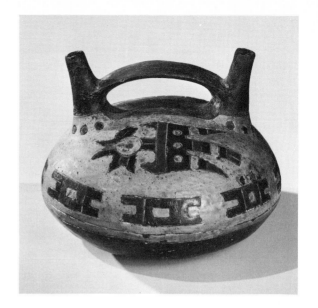

69. Double-Spout Bottle

Peruvian, south coast, Early Paracas style, 700–500 B.C.
Blackware, with yellow, black, red, and green resin paint
Height: 3¾ inches

Chavín influence was strong in contemporary south coast pottery, which was followed by local ceramic styles and the justly famous embroidered textiles of Paracas. In the south, the double-spout form was traditional, with emphasis not on modeling but on painted decoration. Colorful resin paint, applied after firing, preceded the development of true ceramic polychrome, perfected in the early centuries of our era.

Sawyer, A. R., *Ancient Peruvian Ceramics.* New York, 1966, pp. 80–81.

64.228.97 The Metropolitan Museum of Art, Gift of Nathan Cummings, 1964.

70. Bottle, Feline Head

Chavín, 700–500 B.C.
Brownware, resin paint
Height: 12¾ inches; Width: 9⅞ inches
Peru, Jequetepeque valley, site of Tembladera

The early art of ancient Peru is dominated by representations of jungle creatures of which the most important is the big cat, or jaguar. Jaguars, anthropomorphic jaguars, and parts of jaguars are found in a variety of stylized forms. One such stylization appears here where a jaguar head in profile rises vertically on the front of the bottle. A smaller feline head is present to the left, just above the snout of the main head.

Goldwater, R., Jones, J., Newton, D., and Northern, T., *Art of Oceania, Africa, and the Americas from the Museum of Primitive Art.* An exhibition at The Metropolitan Museum of Art, New York, 1969, Cat. No. 474.

67.122 The Museum of Primitive Art.

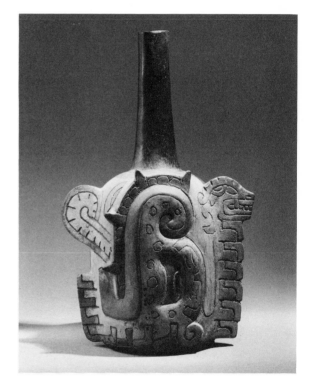

71. Pair of Ear Ornaments

Peruvian, Mochica IV style, A.D. 200–500
Gold, with mosaic of turquoise, chrysocolla, amethystine quartz, Spondylus shell, and gold
Diameter: 4 inches

Inheritors of the Chavín tradition, the Mochica dominated the north Peruvian coast from the third century B.C. through the seventh century A.D. The power and richness of their golden age are reflected in these extraordinary jewels that combine the skill of the goldsmith with the precision and color sense of the mosaic worker. The mythological bird-messengers presented here often appear painted or modeled on Mochica ceramics.

Easby, D. T., Jr., "Pre-Hispanic Metallurgy and Metalworking in the New World." *Proceedings of the American Philosophical Society*, Vol. CIX, 1965, p. 91.

66.196.40, 41 Jointly owned by Mrs. Harold L. Bache and The Metropolitan Museum of Art, 1966.

Greece: Archaic, ca. 700–480 B.C.

Through trade and the establishment of colonies along the coast of Asia Minor and in southern Italy, Greek civilization came into renewed contact with the Near East. Monumental free-standing sculpture appeared, reflecting Egyptian influences, and the techniques of vase painting made rapid advances. On the islands and the mainland city-states formed, of which Athens emerged as most prominent. In 499 B.C. pressure from the Achaemenian Persians erupted in war, concluded in 479 by the decisive expulsion of the Persians from the Greek mainland.

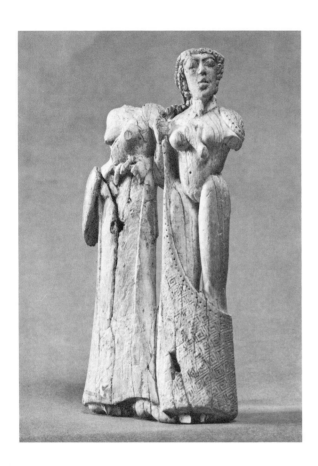

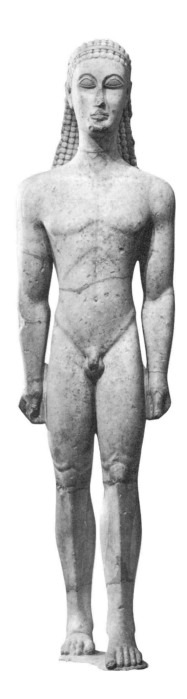

72. Relief of Two Women
Greek, 650–625 B.C.
Ivory
Height: 5⅜ inches

This relief, with holes for attachment, probably originally decorated a wooden chest. The subject—one woman who has let her garment drop below her hips and another who is untying her belt—is baffling. The best explanation relates these figures to the myth of the daughters of King Proitos of Argos who were punished by Hera for having bragged about their beauty and their father's wealth. The goddess struck them with madness, and for ten years they roamed naked through the Peloponnese, lusting for men. In the end they lost both their beauty and their hair.

Dörig, J., "Lysippe und Iphianassa." *Athenische Mitteilungen,* Vol. LXXVII, 1966, pp. 72–91.

17.190.73 The Metropolitan Museum of Art, Gift of J. Pierpont Morgan, 1917.

73. Statue of a Youth (Kouros)

Greek, end of the VII century B.C.
Marble
Height without plinth: 6 feet, 4 inches; Height of head: 12 inches

Greek contact with Egypt after the middle of the seventh century B.C. resulted in the introduction of monumental stone sculpture to Greece. Over-life-size statues of youths, clearly inspired by Egyptian sculpture, were among the earliest works and exemplified by this *kouros* (the Greek word for youth). The blocklike form, the strict, frontal pose, the advanced left foot, and the clenched hands can be matched in Egyptian sculpture. But departures from Egyptian style, testifying to the inventiveness and evolutionary instincts of early Greek artists, are also evident: the space between the elbows and waist is cut away, and the supporting pillar at the back of the figure has been eliminated. Anatomical details are rendered as geometric patterns on the sculptured form. These and other nonnaturalistic conventions disappeared gradually until the acknowledged perfection of Greek art was reached with Phidias in the fifth century.

Richter, G. M. A., *Catalogue of Greek Sculptures in The Metropolitan Museum of Art.* New York, 1954, p. 1.

Harrison, E. B., *The Athenian Agora,* Vol. XI, *Archaic and Archaistic Sculpture.* Princeton, N.J., 1965, pp. 3 f.

32.11.1 The Metropolitan Museum of Art, Fletcher Fund, 1932.

74. Top of a Grave Monument. Sphinx and Acroterion

Greek, *ca.* 530 B.C.
Marble
Height: as shown 56⅛ inches

The sphinx finial and the acroterion on which it sits surmount an Attic grave relief that is the biggest and best preserved of all the archaic funerary monuments. Its remarkable preservation is attributed to the fact that this monument, measuring almost fourteen feet in height, must have been overturned and buried soon after its erection. As seen here, the sphinx is not the evil monster of Theban mythology but the guardian of the dead. The body is that of a lioness with wings added; the neck, head, and hair are those of a woman. Both the sphinx and the relief on the shaft of the stele are by the same sculptor, perhaps Aristokles, known from signed works. As the epitaph ends with the first half of a pentameter, the artist's signature ('εεγον 'Αειδτοκλεους) may have completed it in a separate line.

Richter, G. M. A., *The Archaic Gravestones of Attica.* London, 1961, p. 27.

11.185 The Metropolitan Museum of Art, Hewitt Fund, 1911; Rogers Fund, 1921; Munsey Fund, 1936 and 1938.

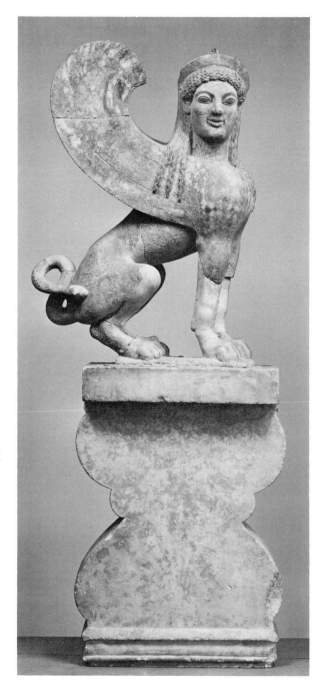

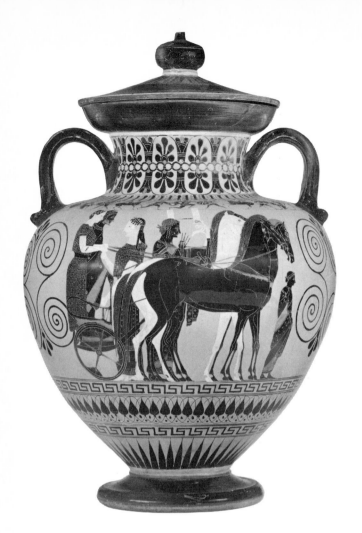

**75. Neck Amphora with Lid. Man and Woman in Chariot.
On the Shoulder: Fights.**

Greek, *ca.* 540 B.C.

Terracotta

Height: 18½ inches; Diameter: 9¾ inches

This neck amphora exemplifies the great technical achievements
of the black-figure vase painters. The figures are painted in
careful silhouettes and the forms are separated and enlivened by
crisp incised lines. Two opaque accessory colors, a white and a
dark red, sparingly introduce polychromy. Exceptionally, this vase
has its original lid preserved.

Tillyard, E. M. W., *The Hope Vases.* Cambridge, England, 1923,
No. 15, pp. 30 f.

Beazley, J. D., "Attic Black-figure." *Proceedings of the British
Academy,* Vol. XIV, 1929, p. 30.

———, *Attic Black-figure Vase-Painters.* Oxford, 1956, p. 144.

17.230.14 The Metropolitan Museum of Art, Rogers Fund, 1917
and Gift of John D. Beazley, 1927.

76. Scaraboid Gem, Archer Crouching, Testing His Arrow

Greek, Late Archaic Period, *ca.* 500 B.C.

Chalcedony

Length: 21/32 inches; Width: ⁹⁄₁₆ inches; Thickness: 9/32 inches

This gem shows in masterly fashion the accomplishment of Late
Archaic Greek art. The anatomy is fully understood and rendered
correctly in spite of the difficult foreshortening. On the evidence
offered by another chalcedony scaraboid in Boston, signed by
Epimenes, J. D. Beazley has attributed this archer gem to the same
master, who was an Ionian, as the letter forms and the trappings
on the horse of the Boston gem indicate.

Richter, G. M. A., *Catalogue of Engraved Gems.* Rome, 1956, Pls. 7,
41.

31.11.5 The Metropolitan Museum of Art, Fletcher Fund, 1931.

Greece: Classical, ca. 480–430 B.C.

The Golden Age of Greece flowered in the brief period between the rout of the Persian invaders and the opening of the Peloponnesian War (431–404 B.C.), in spite of continued rivalry between Athens and Sparta and their allies. Art developed away from Archaic conventions toward a balanced, idealized naturalism, while Greek architecture reached its definitive expression.

77. Amphora (Jar): Youth Singing and Playing the Kithara. Judge or Coach
Attic, *ca.* 490 B.C.
Terracotta
Height: 16⅜ inches; Diameter of mouth: 6½ inches; Diameter of foot: 4⁵⁄₁₆ inches
Attributed to the Berlin Painter

The red-figure technique of vase painting represents a great technical advance over the black-figure technique: the light figures, set against a glossy black background, are highlighted as it were, and the details of anatomy, garments, and accessories are drawn in lines that vary in intensity and thickness. The artist has admirably caught the rapt expression of a citharoedus, and this is one of the most perfect vases in existence.

Beazley, J. D., "Citharoedus." *Journal of Hellenic Studies*, Vol. XLII, 1922, pp. 72–73, Pl. 2.

56.171.38 The Metropolitan Museum of Art, Fletcher Fund, 1956.

78. Pyxis (Cosmetic Box) with Lid: The Judgment of Paris
Attic, *ca.* 465–460 B.C.
Terracotta
Height: 4¾ inches; With cover: 6¾ inches

The drawing on this vase is contemporary with the beginning of mural paintings in Athens. Covering part of the vase with a white slip had been an Attic innovation half a century earlier, but polychromy (within the range of the ceramic colors) had not previously been attempted. Thus most conventional vase paintings resemble colored drawings and it is almost impossible to speak of brushwork. Here, however, in such details as the rock on which Paris sits, outline drawing gives way to an imaginative rendering done exclusively with the brush, while the colors of the different draperies contrast pleasantly with the nude portions of the figures. Some time-honored conventions, however, are retained, such as the common ground line and avoidance of overlap in the composition.

Richter, G. M. A., and Hall, L. F., *Red-figured Athenian Vases.* New Haven, 1936, pp. 101–103, Pl. FF.

07.286.36 The Metropolitan Museum of Art, Rogers Fund, 1907.

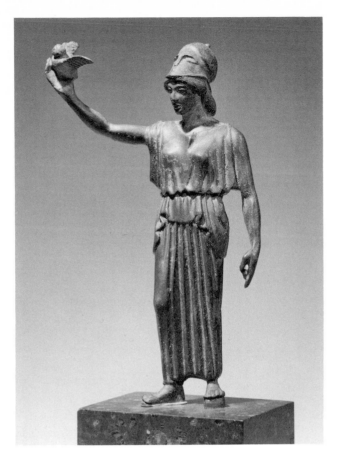

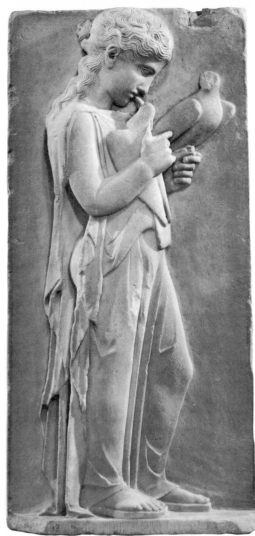

79. Statuette of Athena Flying Her Owl
Greek, *ca.* 460 B.C.
Bronze
Height: 5⅞ inches; Height with owl: 5¹⁵⁄₁₆ inches

Greek art did not undergo a sudden metamorphosis from the rigid forms of the Archaic Period to the freedom of the Classic Age. During the generation following the Persian Wars, the severity of the archaic style was gradually abandoned without, however, losing its majesty and nobility. Though small in size, this perfectly preserved bronze statuette conveys the monumentality of a cult statue and reflects perhaps one of the statues of Athena on the Acropolis at Athens.

Alexander, C., "A Marble Lekythos and the Elgin Athena." *The Metropolitan Museum of Art Bulletin*, n.s., Vol. IX (October, 1950), pp. 57–59.

50.11.1 The Metropolitan Museum of Art, Harris Brisbane Dick Fund, 1950.

80. Grave Relief: Girl with Doves
Greek, *ca.* 450–440 B.C.
Marble
Height: 31½ inches; Width: 15⅜ inches
Probably from Paros

This relief, found on Paros in the Aegean in the eighteenth century, demonstrates the artistic solution to a difficult problem: how to render a child, with its soft forms and incomplete stature, in the demanding manner of a formal representation. The face is not a portrait but rather an artistic projection of what the girl would have looked like had she lived longer, but the genre subject, with its realistic rendering of the arms and feet, subtly convey her age at the time of death.

Worsley, Sir Richard, *Museum Worsleyanum.* London, 1794, Vol. I, Pl. 35.
Richter, G. M. A., *Catalogue of Greek Sculptures in The Metropolitan Museum of Art.* New York, 1954, pp. 49–50.

27.45 The Metropolitan Museum of Art, Fletcher Fund, 1927.

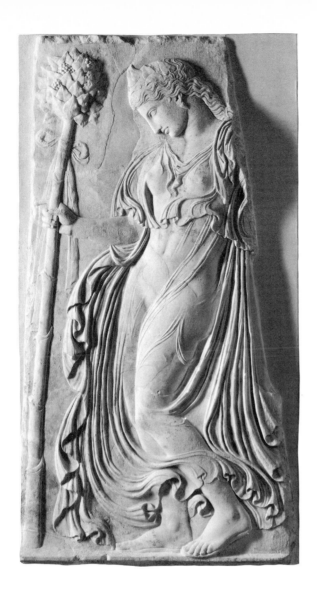

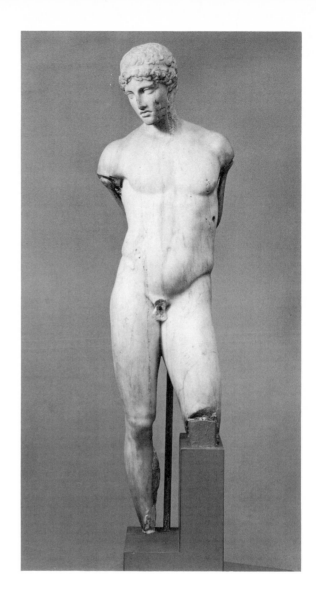

81. Relief of a Dancing Maenad
Roman copy of a Greek original from the late V century B.C.
Pentelic marble: missing parts restored in plaster (from a replica in Madrid)
Height: 55⅝⁶ inches; Greatest width: 29¹⁵⁄₁₆ inches

In a truly classical way, the ecstasy of this figure does not affect either her rather modest stance, or her serene face. It is expressed by the display of the drapery, agitated folds which form a frame for the body. The type of the figure and the transparent drapery, still inspired by the Parthenon sculptures, reflect a new trend in classical art. The maenad belongs to a composition of six similar relief figures, which are attributed to Kallimachos, a famous sculptor active in Corinth and Athens at the end of the fifth century B.C. The work was very popular in Roman times: several replicas exist of single figures, executed with great precision.

Gullini, G., "Kallimachos." *Archeologia Classica,* Vol. V, 1953, pp. 142 ff.
Richter, G. M. A., *Catalogue of the Greek Sculptures in The Metropolitan Museum of Art,* New York, 1954, pp. 39–40.
Fuchs, W., *Die Vorbilder der Neuattischen Reliefs.* Berlin, 1959, pp. 77 f.

35.11.3 The Metropolitan Museum of Art, Fletcher Fund, 1935.

82. Statue of an Athlete
Roman copy of a Greek bronze original, third quarter of V century
B.C. (450–430 B.C.)
Pentelic marble
Height: 45¾ inches

A boy with a fillet in his hair—symbol of an athletic victory—modestly inclines his head. He is not shy about being nude, but because he has won. A modern athlete would not hesitate to appear proud of his victory, but for the ancient Greeks, this would be intolerable hubris. The stance, the treatment of anatomy, and the face find closest parallels in the work of Phidias. This famous sculptor of antiquity is reputed to have created a statue of Pantarkes, his favorite, to commemorate his victory in the athletic contest for boys at Olympia. This statue may perhaps record something of Pantarkes' beauty. There are two other replicas of the head and an inferior but more complete version of the statue.

Lippold, G., *Griechische Plastik.* Munich, 1950, p. 145.
Richter, G. M. A., *Catalogue of Greek Sculptures in The Metropolitan Museum of Art,* New York, 1954, p. 37.

26.60.2 The Metropolitan Museum of Art, Fletcher Fund, 1926.

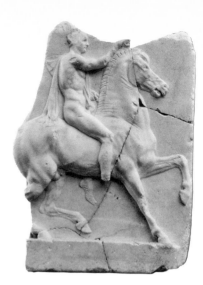

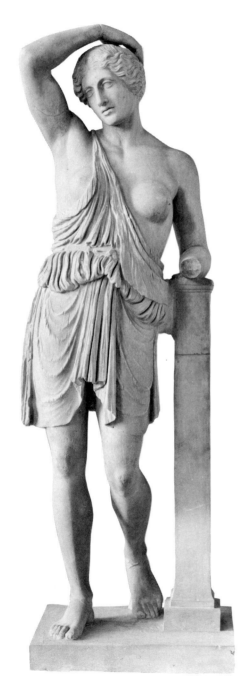

83. Statue of an Amazon
Greek, *ca.* 430 B.C.
Marble
Height (including plinth and hand): 6 feet, 8¼ inches

The Roman writer Pliny tells the story of the four sculptors, Polykleitos, Phidias Kresilas, and Phradmon, who made statues of Amazons for the temple of Artemis at Ephesus; afterward they voted to choose the best—the best being the work the sculptors judged to be the next best after their own. Polykleitos was the winner. Although this anecdote may be apocryphal, Roman copies of three different types of Amazons are known, all after Greek originals. This statue is a copy after the one thought to be by Kresilas. The Amazon is wounded in her right breast where blood flows from a gash, yet all indication of pain and suffering is concealed by her rhythmic pose and serene expression. These qualities, together with the naturalism of the anatomy and drapery, are embodiments of the classical ideal and represent an evolution of almost two hundred years from the earliest archaic marbles.

von Bothmer, D., *Amazons in Greek Art.* Oxford, 1957, p. 219.

32.11.4 The Metropolitan Museum of Art, Gift of John D. Rockefeller, Jr., 1932.

84. Relief of a Horseman
Greek
Marble
Height: 1 foot, 6 inches
Said to be found in Rhodes, *ca.* 100 B.C.

Later Greek artists often turned back for inspiration to the classical period of the fifth century, employing the creations of this period as models for subjects as well as style. This marble relief not only repeats a composition which was common about 400 B.C., but also imitates the style of that period. Both the rider and the horse are still in the tradition of the Parthenon frieze, so that one might be tempted to consider the marble as a classical original. However, some details of this relief are incompatible with an early date. The modeling of the horse's body is too detailed, the sandals of the horseman are not classical, and his face is full of expression, even if not individualized. The relief was intended as a votive offering.

Richter, G. M. A., *Catalogue of Greek Sculptures in The Metropolitan Museum of Art.* New York, 1954, pp. 79–80.

07.286.111 The Metropolitan Museum of Art, Rogers Fund, 1907.

Greece: Hellenistic, ca. 323–31 B.C.

After Sparta defeated Athens in the catastrophic Peloponnesian War (431–404 B.C.), a new power arose in Macedonia. The conquests of Alexander the Great expanded Greek civilization far abroad, much of the ancient world remaining Hellenized until the period of migrations and the Arab conquest. The creative centers, however, were no longer on the Greek mainland, but in Pergamon and Alexandria and on the island of Rhodes. The Hellenistic period spanned the time between the death of Alexander and the battle of Actium (31 B.C.), which marked the emergence of the Roman Empire as the dominant force in the Mediterranean world.

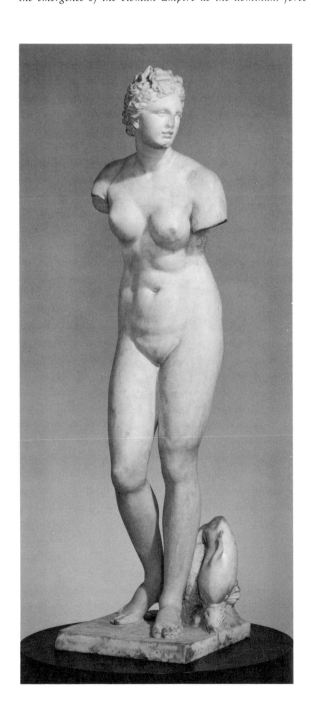

85. Statue of Aphrodite
Roman copy of a Greek original of 300 B.C.
Marble
Height, as restored, with plinth: 5 feet, 2½ inches

Praxiteles was the first sculptor to represent Aphrodite nude. His work, the famous Aphrodite of Cnidus, is lost, but we know the original through Roman copies. It inspired a generation of sculptors and, as a result, several adaptations are known. This Aphrodite is a Roman copy of one of these adaptations, the original of which was made about 300 B.C., some fifty years after Praxiteles' masterpiece. She is shown at her bath, perhaps surprised there; the missing arms would have been placed across her body. The dolphin on the base is an allusion to the miraculous birth of the goddess from the sea. What we see in the "Old Master Copies" is but a reflection of the Greek originals, but the image, as in the case of this Aphrodite, is often excellent.

Alexander, C., "A Statue of Aphrodite." *The Metropolitan Museum of Art Bulletin*, Vol. XI (May, 1953), pp. 241–251.

52.11.5 The Metropolitan Museum of Art, Fletcher Fund, 1952.

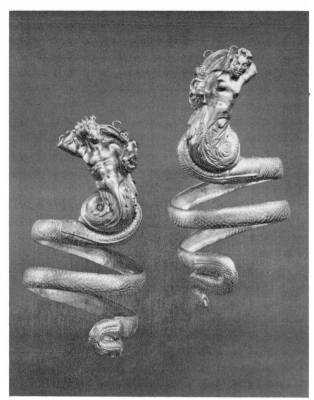

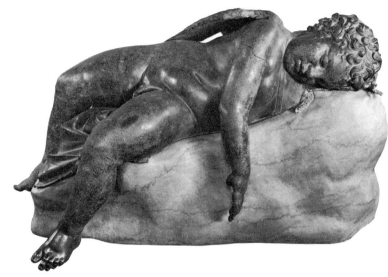

86. Pair of Armlets: Triton and Tritoness, Holding Erotes
Greek, III century B.C.
Gold
Total height after shaping: left, Triton, 5¾ inches; right, Tritoness,
6¼ inches; Height of figures: 2⅞ inches; Width at widest point:
3 inches; Length of spiral if outstretched: left, Triton, 23 inches;
right, Tritoness, 23¾ inches

The armbands are in the form of a Triton and a Tritoness, famed
sea monsters of Greek imagery. Instead of legs they have serpent's
coils, ending in fishtails. Each carries an Eros in the crook of one
arm; and with the free hand they arrange drapery on their shoulders.
The two Erotes are symbolic of the union of the Triton and
Tritoness, which, from the fourth century on, often appear together
as decorative figures in Greek art.

Spiral armbands were worn as early as the fifth century B.C. and
remained fashionable for several succeeding centuries; this pair
dates probably from the third century B.C. They must have been
worn on the upper arm, for only there would the figures stand
upright. Staples visible over the elbow of the Tritoness and
above the drapery of both figures served to attach the armbands
to the wearer's dress at the shoulder.

Oliver, A., Jr., "Greek, Roman, and Etuscan Jewelry." *The
Metropolitan Museum of Art Bulletin,* n.s., Vol. XXIV (May,
1966), p. 279.

56.11.5, 6 The Metropolitan Museum of Art, Rogers Fund, 1956.

87. Statue of a Sleeping Eros
Greek, Hellenistic Period, 250–150 B.C.
Bronze
Greatest length: 33⁹⁄₁₆ inches; Greatest width at feet:
12⅝ inches; Length as placed on rock, 1943, 30¾ inches;
Height as placed on rock, 1943, 17¹⁄₁₆ inches

Sculptors in the Hellenistic Period experimented with a new variety
of subjects: young children, old men and women, deformed persons,
and figures and groups in exaggerated or difficult poses. Such
novelties were within the artists' range because the fundamental
problems of anatomy and expression had already been solved. This
life-size bronze Eros is illustrative of the new trends: a child,
asleep, and in a careless and unconventional pose. More important
still is the fact that the statue may be the Hellenistic original of the
third or second century B.C., a great rarity, of which numerous
replicas and adaptations exist. Whether it is an original or a fine
Roman copy in bronze, the sculpture owes much of its excellence to
the sculptor's careful observation of a sleeping child.

Richter, G. M. A., "A Bronze Eros." *American Journal of Archaeology,*
Vol. XLVII, 1943, pp. 365–78.
Bieber, M. *The Sculpture of the Hellenistic Age.* New York, 1955, p. 145.

43.11.4 The Metropolitan Museum of Art, Rogers Fund, 1943.

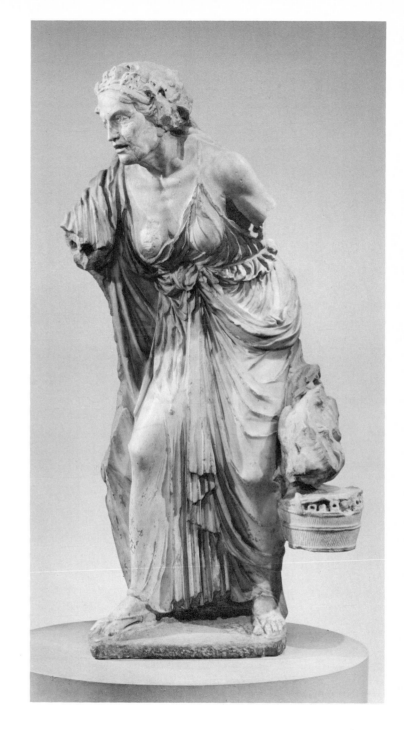

88. Statue of an Old Peasant Woman

Greek. Perhaps an original of the II century B.C.
Pentelic marble. Restorations in plaster on face and breast
Height (including the base): 4 feet, 1⅝ inches; Without the
base: 4 feet

During the Hellenistic Period the noble and impersonal ideals of
classical art were no longer thought attractive. The artists looked
for new subjects, more suited to the sophisticated taste of the
age. Hence the vogue of genre, of which our statue is an excellent
example. This realistic study of an old, tired woman going to
market remains surprisingly fresh and attractive even to the
modern eye.

Lippold, G., *Die Griechische Plastik.* Munich, 1950, p. 378.
Richter, G. M. A., *Catalogue of Greek Sculptures in The Metropolitan
Museum of Art.* New York, 1954, p. 111.
Bieber, M., *The Sculpture of the Hellenistic Age.* New York, 1955,
p. 141.

09.39 The Metropolitan Museum of Art, Rogers Fund, 1909.

Rome: 31 B.C.–A.D. 476

In Europe, the Near East, and North Africa, wherever the Empire extended, Roman monuments and public works left a visual reminder of the legal and institutional inheritance that provided Europe with a common cultural foundation. Rome, always open to influence from the peoples she conquered, interpreted and transmitted Greek civilization to the rest of Europe. Another legacy was Christianity, adopted by Constantine as the official religion of the Empire in 314.

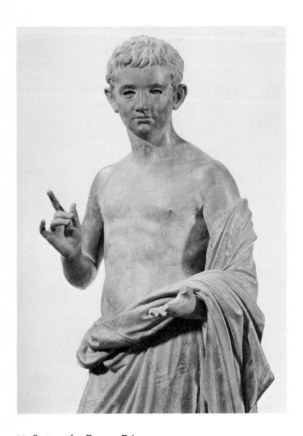

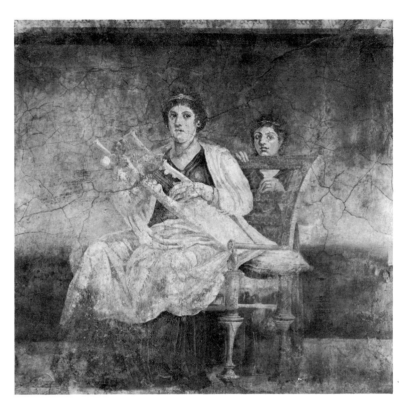

89. Statue of a Roman Prince

Perhaps Gaius Caesar (20 B.C.–A.D. 4) or Lucius Caesar (17 B.C.–A.D. 2),
Roman, late I century B.C.
Bronze
Total Height: 4 feet, ½ inch

This bronze statue of a boy is almost certainly a portrait of a member of the Roman Imperial family. Gaius Caesar and Lucius Caesar, both grandsons of the Emperor Augustus, have been suggested as possible candidates, but definite proof is lacking. In any event, a date in the last years of the first century B.C. is plausible. The boy is about ten or twelve years old and wears a pallium, a rectangular garment, smaller than a toga. A series of parallel grooves, situated at regular intervals on the pallium, were meant to show that the garment was striped. The two lower corners are decorated with knots ending in tassels. It is likely that the boy once held something in each hand, perhaps ceremonial vessels, now lost. The size, the quality of workmanship, and the imperial nature of the statue make this bronze the most important in the Museum's collection of Greek and Roman art.

Richter, G. M. A., *Greek, Etruscan and Roman Bronzes.* New York, The Metropolitan Museum of Art, 1915, pp. 149–52.
West, R., *Römische Porträt-Plastik.* München, 1933, pp. 139 f., Pl. XXXIV, Cat. No. 147.
Hafner, G., *Späthellenistiche Bildnisplastik.* Berlin, 1954, pp. 17 f., 27.
Curtius, L., *Römische Mitteilungen.* Vol. L, 1955, pp. 300 ff.

14.130.1 The Metropolitan Museum of Art, Rogers Fund, 1914.

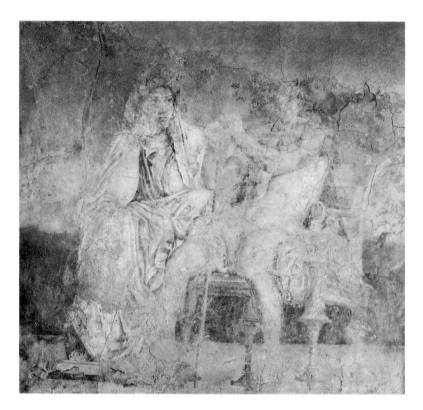
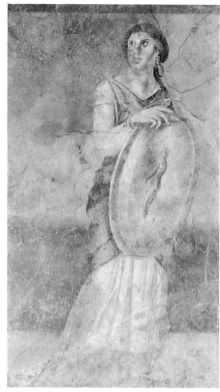

90. Three Sections of a Wall Painting
Roman, I century B.C.
Height: 6 feet, 1½ inches; Width: 6 feet, 1½ inches
Height: 5 feet, 9 inches; Width: 6 feet, 4 inches
Height: 5 feet, 10 inches; Width: 3 feet, 4¼ inches

These three sections of a wall painting are not panels complete in themselves,
but were cut out of a larger wall. They come from a villa built in the mid first
century B.C. at Boscoreale, about a mile north of Pompeii. Like Pompeii, the
villa was buried by the eruption of Vesuvius in A.D. 79, and it is for this
reason that the paintings survived relatively intact. One shows a woman playing
a kithara with a girl standing behind her chair; another shows a man and a
woman seated side by side; the third shows a woman holding a shield. The
figures have been variously interpreted: as members of the Macedonian royal
family; as persons associated with Aphrodite and Adonis; and as portraits of
members of the family that lived in the villa.

Lehmann, P. W., *Roman Wall Paintings from Boscoreale in The Metropolitan Museum
of Art.* Cambridge, Mass., 1953, pp. 182 ff.
Bieber, M., "Notes on the Mural Paintings from Boscoreale." *American Journal
of Archaeology*, Vol. LX, 1956, pp. 171 f.

03.14.5, 6, 7 The Metropolitan Museum of Art, Rogers Fund, 1903.

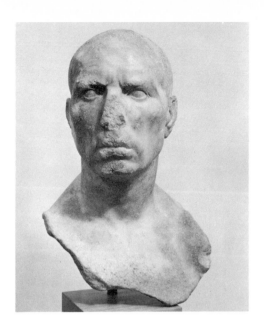

91. Portrait of a Man
Roman, I century A.D.
Marble
Height: 17½ inches

Roman republican portraiture is characterized by realism. In this damaged but striking portrait of a man, every feature of his bony face, whether flattering or unflattering, has been transferred to the marble, perhaps by a process that included the use of life masks. The style of the face is characteristic of the first century B.C., but the large size of the bust suggests that the portrait is a copy made in the first century A.D.

Richter, G. M. A., "Recent Accessions of Classical Sculpture." *The Bulletin of The Metropolitan Museum of Art,* Vol. XXI (November, 1926), pp. 258–59.
——, *Roman Portraits.* New York, The Metropolitan Museum of Art, 1948, Cat. No. 1.

26.60.3 The Metropolitan Museum of Art, Fletcher Fund, 1926.

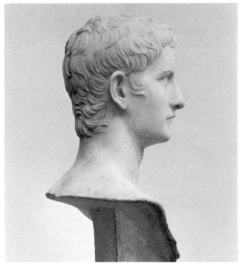

92. Bust of the Roman Emperor Caligula (Ruled A.D. 37–41)
Roman
Marble
Height: 20 inches

Portraits of the Roman emperors abounded in antiquity. Every city and many villages had a portrait of the ruling emperor, the symbol of central and dictatorial authority, set up in a public place. This exceptionally well-preserved bust shows Emperor Caligula, identifiable because of the similarity to his profile portrait on Roman coinage. The smooth skin, regular features, and the treatment of the hair are as much a reflection of the neoclassic style of the period as is the portrayal of the man himself. The bust is reported to have been found at Marino, near the Lake of Albano, Italy.

Richter, G. M. A., *Roman Portraits.* New York, The Metropolitan Museum of Art, 1948, Cat. No. 36.

14.37 The Metropolitan Museum of Art, Rogers Fund, 1914.

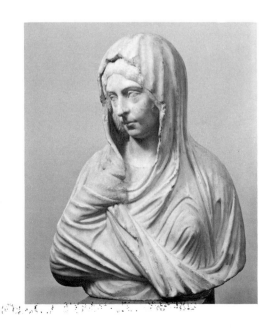

93. Portrait Bust of a Girl
Roman, late II or early III century A.D.
Marble
Height: 26 inches

Portrait sculptors of the late Roman Empire often attempted to suggest the psyche of the sitter. Here, the sculptor has followed the common practice of incising the eyes (the proverbial mirrors of the soul) so as to give added expression. Unusual, however, and more effective, is the enshrouding mantle. Its broadly delineated folds, through which the form of the girl's breast and hand barely show, accentuate her face and contrast with the fine lines of her hair, eye, and mouth. The girl's identity is unknown, but her hair style, similar to that of Julia Domna, the wife of Emperor Septimius Severus (A.D. 193–211), suggests a date in the late second or early third century A.D.

Langlotz, E., *Die Kunstsammlungen Baron Heyl, Darmstadt I.* Munich, Galerie Hugo Helbing, 1930, No. 28.
Richter, G. M. A., *Roman Portraits.* New York, The Metropolitan Museum of Art, 1948, Cat. No. 88.

30.11.11 The Metropolitan Museum of Art, Fletcher Fund, 1930.

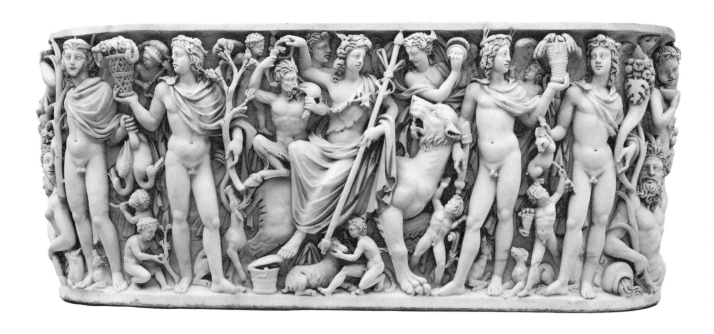

94. The Badminton Sarcophagus

Roman, A.D. 220–230
Greek marble
Height, maximum: 2 feet, 11 inches; Length, maximum: 7 feet, 3¾ inches

Sarcophagi, literally, "flesh eaters," were used for burial throughout antiquity.
In the Roman Imperial Period, especially from the second century A.D. on, a
great quantity of sarcophagi decorated with reliefs were produced with subjects
often taken from traditional mythology, but sometimes imbued with new
symbolical meaning. This one, in the shape of a tub, shows Dionysos and his
followers. The young god is seated on a tiger. Around him are satyrs and
maenads with their children, and the horned god Pan, who hold grapes, a
cornucopia with fruit, vases with wine, and musical instruments. Four winged
youths, on another plane and in another scale, represent the seasons. They are
an allegory of the changing times which no longer touch the heroized dead, who
now participate in the eternal feast, symbolized here by the Dionysiac festival.
The relief still uses classical tradition in many details, but the indications
of space, scale, and the relationship of the figures to one another do not
attempt to reflect reality. It is just a display of forms, a pattern of light and
shadow. The masterpiece is representative of the end of classical antiquity and
is a prelude to a new art.

The sarcophagus was brought from Italy to the collection of the Duke of
Beaufort at Badminton House in Gloucestershire in 1728.

Matz, F., *Ein römisches Meisterwerk der Jahreszeitensarkophag Badminton-New York.*
Berlin, 1958.

55.11.5 The Metropolitan Museum of Art, Joseph Pulitzer Bequest, 1955.

Egypto-Roman, ca. 31 B.C.–ca. A.D. 300

In Egypt, last of the Hellenistic monarchies to succumb to Rome, Hellenistic painting and Roman realism influenced the traditional pharaonic funeral portraits. In Roman times, North Africa and the Near East were a crucible for a variety of oriental religions with a Hellenistic cast, among them Christianity.

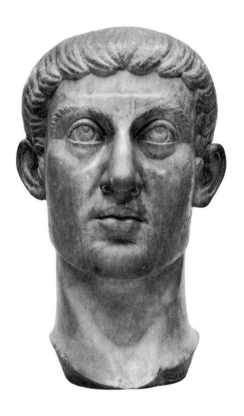

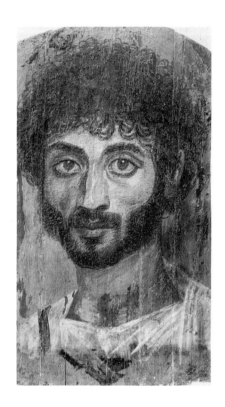

95. Colossal Head of Constantine

Roman, *ca.* A.D. 325
Marble
Height: 37½ inches

In the late Roman Empire, portrait sculpture tended to become less naturalistic and more geometric or blocklike in structure. In the head of Constantine this is evident in the lines of the jaw, chin, and forehead, and in the regular and symmetrical crown of hair. The upward gaze of the eyes with their transcendental seriousness is also characteristic of Roman portraiture of the third and fourth centuries A.D.

The head which was once part of a colossal statue, probably showing the emperor seated, was known as early as the seventeenth century when it was in the Giustiniani collection in Rome. The nose, lips, chin, and parts of the ears are restored.

Vermeule, C. C., "A Graeco-Roman Head of the Third Century." *Dumbarton Oaks Papers*, Vol. XV, 1961, p. 15.

26.229 The Metropolitan Museum of Art, Bequest of Mary Clark Thompson, 1926.

96. Portrait Panel from a Mummy

Egyptian, II century A.D.
Wood
Height: 15 inches; Width: 8½ inches
From the Fayuum (?)

The Egyptian demanded that even when dead he be able to see life, so a mask representing the deceased was slipped over the bound head of his mummy. These masks bore little resemblance to their owner; not until Egypt came under the influence of Hellenistic Greece was there an attempt at real portraiture, when wooden panels such as this were bound over the faces of the intricately wrapped mummies of the time. They are painted in encaustic, a hot wax technique. In both style and material they have replaced the old conventions, and are in fact among the few remaining examples of Greek painting. Yet their eyes looked out, as the eyes of mummy masks always had done, on the living world.

The man is dressed in the Greek fashion of the day. His curly hair shows he was not purely Egyptian, and his enormous eyes could belong to any Mediterranean race, yet they could also have been enhanced by the artist out of some dim realization of the mask's traditional purpose.

09.181.1 The Metropolitan Museum of Art, Rogers Fund, 1909.

India: Kushan Period, including Gandhara, ca. A.D. 50–320

The Kushan Dynasty, Tartars from Central Asia, controlled northern and northwestern India until the advent of the Gupta Dynasty. The Gandhara region, in what is now northernmost Pakistan, had been penetrated by Alexander the Great and retained numerous contacts with the Roman world. Drawing on Greco-Roman style transmitted through Gandhara and on native sculptural traditions, Indian artists devised the first figural representations of the Buddha, perhaps under the stimulus of competition with Hinduism, which was beginning to spread in India.

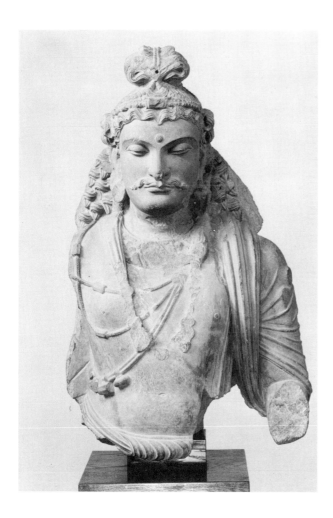

97. Bodhisattva, Possibly Siddhartha
Indian, Gandharan, I–III century A.D.
Gray stone
Height: 30 inches

This magnificent head and torso are reminders of the unique culture that flourished in the northwest corner of India. Gandhara, after the conquest of Alexander the Great and before the Christian era, had many contacts with the West; one result was the profusion of Buddhist monuments in Gandhara, executed by foreign craftsmen imported by the Kushan conquerors. The style created was not a continuation of indigenous art, but a detour, showing influence from the Roman world of the first and second centuries A.D. The content is Indian Buddhist, but the style is much more closely allied to the West.

An image of the Buddha in sandalwood is said to have been made in his lifetime for King Udayana. Except for this possibly apocryphal image, the first representations of the Buddha in anthropomorphic form appear in the Gandharan Period, when new importance is given to the bodhisattva, who sacrificed his own attainment of nirvana in order to save the world. This Gandharan rendering of a bodhisattva shows traces of strong influence from the Roman Empire. This is evident in the drapery, hair, and moustaches. The image is that of an Indian prince in the role of a Buddhist deity. This magnificent sculpture, witness to the Gandharan artists' virtuosity in handling stone, has been called "the summit of this hybrid art."

Lippe, A., "The Sculpture of Greater India." *The Metropolitan Museum of Art Bulletin,* n.s., Vol. XVIII (February, 1960), p. 185.

42.25.15 The Metropolitan Museum of Art, Gift of Mrs. John D. Rockefeller, Jr., 1942.

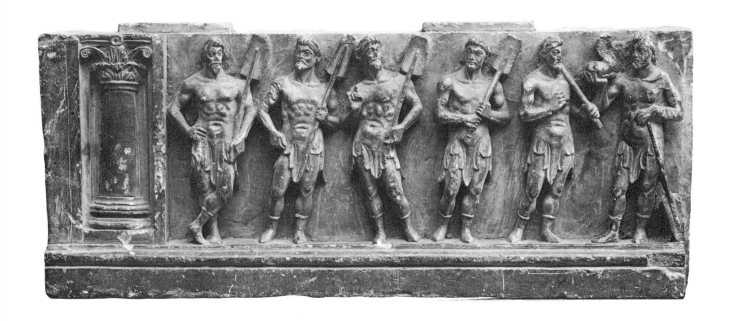

98. Relief: Marine Deities or Boatmen
Indian, Gandharan School, Kushan Period
Stone
Height: 6⅝ inches; Length: 17 inches

This very "Grecian" group of Gandharan figures dates from the Kushan Period, probably at the beginning, in the first century A.D. The subject matter, no doubt boatmen or marine deities, possibly indicates that our stone was part of a set of stair risers made to celebrate or recall some Buddhist holy event. The figures are clearly separated from each other and set against a completely blank backdrop. It has been suggested that this way of carving reliefs is directly derived from Roman reliefs of the first century A.D. The stance of the figures, the leaf garments, the Corinthian column, and the figure at the right with a dolphin (Poseidon?) all indicate a familiarity with Western culture. The carving, despite some difficulty with the musculature, is refined. The foreign influence, so striking in our relief, was soon to cease dominating Gandharan art, as the style evolved toward a more indigenous Indian expression.

Ingholt, H., *Gandharan Art in Pakistan*. New York, 1957, p. 26.

13.96.21 The Metropolitan Museum of Art, Rogers Fund, 1913.

China: Han Dynasty, 206 B.C.–A.D. 220

Following the brief Ch'in Dynasty which produced, most notably, the Great Wall, the Han Dynasty welded China into an empire, drew Korea into the Chinese sphere of influence, and established wide-ranging contacts with Southeast Asia and India. The pattern of Chinese civilization fixed under the Han evolved continuously until modern times.

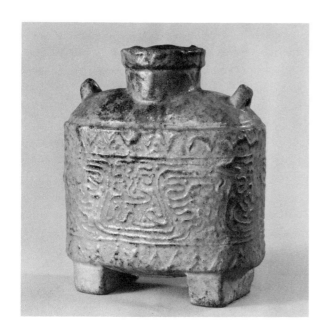

99. Pilgrim Bottle
Chinese, Han Dynasty, 206 B.C.–A.D. 220
Pottery with iridescent glaze
Height: 7½ inches; Width: 6 inches

This sturdy little flask is oval in section, flattened at the ends, and stands on two broad feet. The two loops attached to its shoulder were apparently intended for a cord, which, passing through them, could have held a lid in place or provided a means of suspending the vessel. Broad bands of threadlike ornament raised in relief embellish the sides; a broad band with an abstract meandering design is framed horizontally by two narrow bands of zigzags.

From being buried in the earth, the green lead glaze has acquired a silvery iridescence, which adds an interesting contrast to the sturdy potted shape. It is likely that this charming bit of tomb pottery is a copy of a larger vessel that the owner had used during his lifetime.

29.100.165 The Metropolitan Museum of Art, H. O. Havemeyer Collection, Bequest of Mrs. H. O. Havemeyer, 1929.

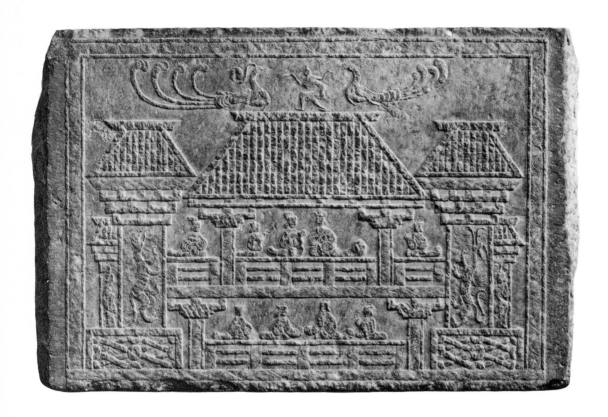

100. Tomb Relief
Chinese, Han Dynasty, *ca.* 114 A.D.
Limestone
Height: 31 inches; Width: 50 inches

The great Han Dynasty (206 B.C.–A.D. 220) produced not only sculpture in the
round but carved pillars and bas-reliefs, such as this fine stone thought to
have been made about A.D. 114 and to have come from the tomb of the Tai
family at Ching-p'ing'hsien in Shantung, where it decorated the "spirit chamber,"
or anteroom in which the spirit of the deceased was believed to dwell. The
composition, framed by a wave pattern repeated in the balustrade and on the
building, is formal and balanced. Realistic elements like the typical Han
architecture are blended here with symbols, such as the two large birds and
the genie on the roof of the house, which probably represent mythological or
Taoist guardian spirits. The carving, a combination of incised lines with varying
degrees of low relief, is so linear that it might be called drawing done with a
chisel—an effect that continues to be a striking characteristic of Chinese
sculpture.

Fong Chow, "Chinese Buddhist Sculpture." *The Metropolitan Museum of Art
Bulletin,* Vol. XXIII (May, 1965), p. 302.

20.99 The Metropolitan Museum of Art, Rogers Fund, 1920.

101. Wine or Storage Jar
Chinese, Han Dynasty (206 B.C.–A.D. 220)
Red pottery with iridescent gray lead glaze
Height: 16¼ inches; Diameter: 13¼ inches

This splendid jar (or *hu*) has many indications that it follows
a bronze prototype: the shape, the molded horizontal bands
with narrow molded zigzags, and the applied animal masks
with immovable handles are all features taken directly
from a bronze vessel of the same period.

The glaze on this *hu* was originally a dark green; but it is
the nature of the lead glazes of the Han Period to acquire
a silvery iridescence when buried. Noticeable, too, are the
many little drops of glaze on the rim of the cup-shaped
mouth, the result of firing the jar upside down.

29.100.170 The Metropolitan Museum of Art, The H. O.
Havemeyer Collection, Bequest of Mrs. H. O. Havemeyer,
1929.

Section III: ca. A.D. 200–ca. 1300

251 Roman Emperor Decius defeated and killed by the Goths

ca. 300 Mayan Calendar in Yucatán
313 Edict of Milan; Emperor Constantine recognizes Christianity
323 Constantinople made capital of Roman Empire

ca. 400 Philosophy of Yoga develops in India
400 Jerome translates Bible into Latin (The Vulgate)
476 Fall of Rome
496 Clovis, King of the Franks, converts to Christianity

523–537 Hagia Sophia, palace church of Justinian, constructed in Constantinople

622 Mohammed's Flight from Mecca; beginning of Moslem era

726–814 Iconoclastic Controversy in Byzantine Empire
732 Battle of Tours; Moslem invasion of Europe stopped

800 Charlemagne crowned Holy Roman Emperor in Rome

932–953 The "Nine Classics" were first printed from woodblocks in China

ca. 1000 Leif Ericsson reaches Vinland in the New World
1027 New Empire of Mayas extends to Mexico
1054 The Great Schism between Greek Orthodox and Roman Catholic churches
1066 William the Conqueror defeats Harold at Battle of Hastings
1099 Crusaders seize Jerusalem
ca. 1120 Angkor Vat, religious sanctuary founded in Cambodia
1163 Notre Dame of Paris begun
1170 Thomas à Becket murdered in Canterbury Cathedral
1187 Moslems conquer Jerusalem

1226–1270 Reign of Louis IX (Saint Louis) in France

West　　　　　　Near East　　　　　　Far East　　　　　　American

200

300

111. Syrian,
A.D. 350–500

400

500

102. Sasanian,
ca. V century A.D.

600

113. Byzantine,
A.D. 613–629/630

106. Central Asian,
IV–VII century

700

103. Sasanian,
VI century A.D.

800

116. Chinese,
A.D. 618–906

110. Mayan,
A.D. 600–850

900

119. Ottonian,
A.D. 962–973

1000

133. Indian,
X century

1100

1200

1300

Iran: Sasanian, 226–651

In the third century A.D. the Sasanians replaced the feudal system of the Parthians with a strong central government and established themselves by their army and particularly their cavalry as worthy opponents of Rome. The influence of their art, the last expression of the pre-Islamic Near East, reached from Europe to China, until the expansion of the Muslim Caliphate brought the Sasanian Empire to an end.

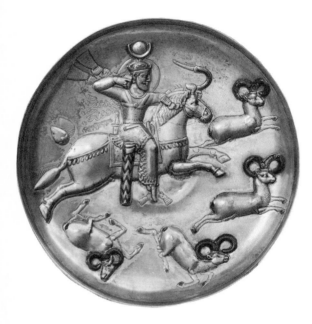

102. Plate with King Hunting Antelopes
Ancient Near East, Sasanian, *ca.* V century A.D.
Silver, niello, mercury gilding
Height: 1⅝ inches; Diameter: 8⅝ inches
Iran

Most Sasanian silver vessels recently acquired by American museums come from Iran, although regrettably none from scientific excavations. This plate is one of the few which has long been known, having entered the Museum's collection in 1934. Its subject is typical of a large number of Sasanian silver vessels. The king mounted on horseback is depicted as an archer. The animals are shown in two pairs: one pair alive and running before the king; the other pair dead beneath the horse's hooves.

The plate is silver, but the raised design is entirely covered with mercury gilding, a combination which was extremely popular during the Sasanian Period. The use of niello is less common on Sasanian vessels; and the technique of modeling it in relief, as is done on the rams' horns and tails and on the king's bow, differs from the practice in Rome and Byzantium where carved areas were usually filled with niello which remained at a level even with the surface of the plate. The raised silver relief on this vessel consists of a number of separate pieces fitted into lips which have been cut up from the background of the plate. Since it is not commonly found on Iranian objects until the Sasanian Period, this technique presumably came to Iran from the Roman West.

The date of the plate is probably the fifth century A.D. It is impossible to identify the king precisely, but judging from comparisons with the coins of the period, the king on this plate is either Peroz or Kavad I, both of whom ruled in Iran in the second half of the fifth century A.D.

This plate is superior in style, in the naturalism of the forms and the delicate modeling of the bodies, to most Sasanian silver objects and belongs in a class almost by itself.

Sasanian Silver. Exhibition Catalogue of The University of Michigan Museum of Art with an Introduction by Oleg Grabar, Ann Arbor, 1967, p. 90.

34.33 The Metropolitan Museum of Art, Fletcher Fund, 1934.

103. Ewer
Ancient Near East, Sasanian, *ca.* VI century A.D.
Silver, mercury gilding
Height: 13⁷⁄₁₆ inches
Iran

Late Sasanian silver vessels, particularly bottles, rhytons, or ewers, were often decorated with female figures. Although they suggest the Dionysiac representations of the Roman West, these scenes may relate to the cult of an Iranian deity, perhaps the goddess Anahita. In general, Sasanian art when using Greco-Roman designs as models changes them to suit the taste and beliefs of Iran. Birds peck at fruit, small panthers drink from ewers; framed by arcades, the females themselves, like maenads, hold branches, torches, or cymbals. The lid of the ewer has exceptionally been preserved and is decorated with a female holding a branch and a bird. The handle terminates at both ends in onager heads. Made in separate parts, our vessel is close in shape to late Roman and Byzantine ewers.

Annual Report, *The Metropolitan Museum of Art Bulletin,* n.s., Vol. XXVI (October, 1967), p. 52.

67.10 ab The Metropolitan Museum of Art, Gift of Mr. and Mrs. C. Douglas Dillon and Rogers Fund, 1967.

India: Gupta Period, 320–647

The Gupta Dynasty, uniting all of northern India after centuries of division, inaugurated the golden age of classical Sanskrit literature and a truly international Buddhist style that reverberated throughout all Asia. This is the last great Indian age of the art of Buddhism, which was crowded out by the advance of Hinduism in the ensuing "Medieval" period.

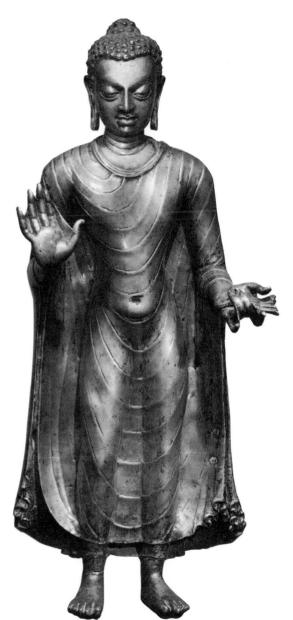

104. Standing Figure of Buddha

Indian, Gupta Period, *ca.* VI century
Bronze
Height: 18½ inches
Probably from Northern India (now Nepal)

This standing Buddha represents the very best of what is considered by many to be India's high point in sculptural development—the Gupta Period.

The Buddha is garbed in a simple monastic cloak that clings in the typical Gupta "wet draped" fashion, revealing the body underneath.

His hands are webbed—the right one in the *abhaya mudra,* or gesture of dispelling of fear. His left hand holds a loop of the flowing garment which ends in little cascades of ruffles at the sides.

Particularly fine and articulate is the balanced modeling of the head, a moving spiritual expression of the Gupta style. The typical face has long thin brows over large downcast almond eyes, a straight nose above a mouth with protruding lower lip. The elongated earlobes are the result of very heavy earrings which Buddha wore as a royal prince. On each cheek there is the unusual decoration of a small rosette made up of seven or eight tiny punched dots. This golden bronze image, executed in metal, skillfully and thinly cast over a clay core, seems to glow from within.

Fong Chow, "Annual Report." *The Metropolitan Museum of Art Bulletin,* n.s., Vol. XXIX (October, 1970), p. 80.

69.222 The Metropolitan Museum of Art, Bequest of Florance Waterbury, 1969.

Central Asia, ca. 300–ca. 800

Central Asian art is the hybrid art of trade and pilgrimage routes linking northwestern India and western China along which Buddhist styles and iconography traveled eastward from shrine to monastery. In this vast area, Romano-Buddhist elements from India coexisted with Sasanian and other Near Eastern elements, and with some Chinese styles.

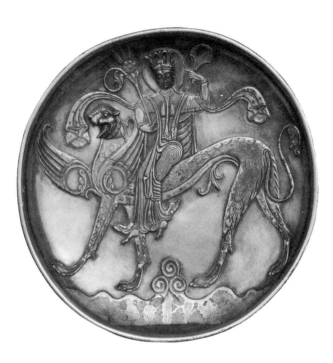

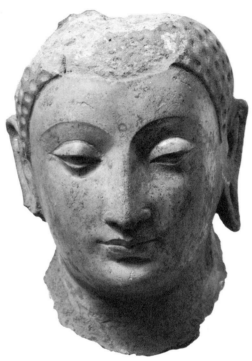

105. Plate
Iran, VIII century
Cast, carved, and chased mercury gilded silver
Height: 1⁹⁄₁₆ inches; Diameter: 8⅛ inches

The conquest of the Sasanian empire by the Muslims in the middle of the seventh century did not cause a cessation of artistic production in the vanquished territories, and, consequently, it is often impossible to differentiate the art produced in the early years of Muslim domination from that made in the preceding period. Even after a new, truly Islamic art form gradually developed in the main urban centers, pre-Islamic styles persisted in the outlying areas or in those provinces that had succeeded in remaining virtually independent.

This silver-gilt plate is a perfect example of such a time lag. Probably made in a provincial center in Iran in the eighth century, it incorporates not only Sasanian iconographical motifs, but also several associated with Byzantine and Central Asian art, and for this reason is a highly important document in the history of art.

Grabar, O., "An Introduction to the Art of Sasanian Silver." *Sasanian Silver: Late Antique and Early Mediaeval Arts of Luxury from Iran,* Ann Arbor, Mich., 1967, pp. 73–136, Pl. 54.

63.186 The Metropolitan Museum of Art, Harris Brisbane Dick Fund, 1963.

106. Head of Buddha, Fragment
Central Asian, Chinese Turkestan, IV–VII century
Stucco with polychrome
Height: 7¼ inches
From the Rawak *stupa* (sacred burial place) in the Taklamakan desert

This stucco head is built up of three layers: First there was a core of chalk or marble dust united with fibers and pebbles. Over this came a layer of similar but finer material, with the form of the finished head. Finally, a very fine layer was applied and polished. Traces of red polychrome may be seen outlining the hairline, the *urna,* on the chin, and around the marvelous eyes, which are indicated in black and slightly protruding. The eyes now slant upward, as Buddhism has come into contact with its Eastern neighbors. The snail-shell curls seen in earlier Buddhist icons have now become mere indentations; the *urna,* one of the Buddha's "major signs of superhuman perfection" and originally conceived as a tuft of hair, is indicated by a red circle drawn in the center of the forehead. The elongated earlobes are a mark of the Buddha's princely life on earth. The serene face, with its introspective gaze, is a compelling devotional image. All outward symbols and details, refined and restrained, seem to be here only to convey the extraordinary power of Buddha as The Compassionate One, The Bringer of Salvation.

Priest, A., *Chinese Sculpture in The Metropolitan Museum of Art.* New York, 1944, p. 38.

30.32.5 The Metropolitan Museum of Art, Rogers Fund, 1930.

China:
Six Dynasties Period, 220–589
(Northern Wei Dynasty, 386–535)

This is a period of ferment and complexity during which Tartars from Central Asia succeeded in establishing supremacy over much of the northern Chinese heartland. Artistic influences from Central Asia were rapidly integrated into an art developing toward the splendors of the T'ang Dynasty. Under the Northern Wei, Buddhism began to be a powerful force in China. Chinese Buddhist art and culture were introduced from Korea into Japan in the sixth century and were enthusiastically received.

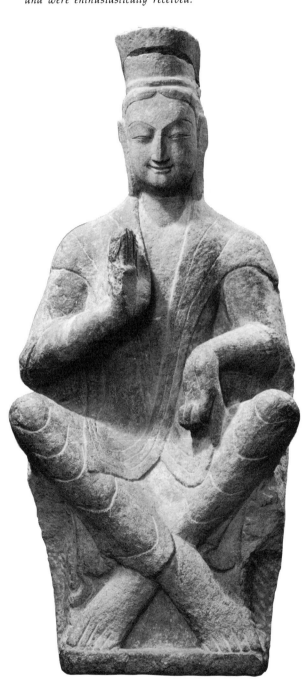

107. Maitreya
Chinese, Northern Wei Dynasty, second half V century
Sandstone, with traces of polychrome
Height: 51 inches
Probably from cave XV Yün Kang, Shansi Province

Central Asian influences are evident in the draping of the robes, the facial structure and expression, and in the colors applied to the stone. But the Chinese artists are beginning to establish their own style. At Yün Kang, naturalism is receding and a formal stylization is taking its place. The body is merely a frame upon which the robe is hung. The famed "archaic smile" has become far more subtle.

Maitreya was a devoutly worshiped bodhisattva, the Buddha-to-be who one day will return to the world and grant salvation. Here he sits in quiet dignity. The figure is executed in a compact manner, arms close to the body, ankles crossed, knees apart. The bodhisattva's right hand denotes absence of fear, his left the fulfilling of the vow.

Mizuno, S., and Nagahiro, T., *Yün Kang—The Buddhist Cave Temples of the Fifth Century A.D. in North China.* Kyoto, 1952.

48.162.2 The Metropolitan Museum of Art, Gift of Robert Lehman, 1948.

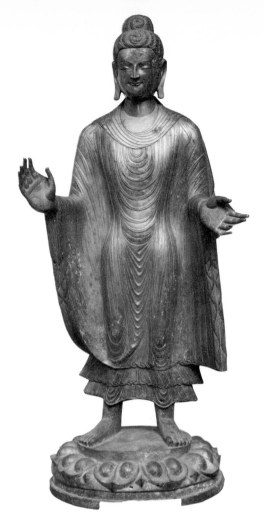

108. Standing Buddha

Chinese, Northern Wei Dynasty, A.D. 386–557
Gilt bronze
Height: 55¼ inches; Width: 19½ inches

This figure is the largest and most important Northern Wei gilt bronze statue yet discovered. Certain Gandharan influences are obvious, but the image is closest to Central Asian figures. The Buddha, standing with outstretched arms on a lotus pedestal, seems to be welcoming worshipers. His plain monastic robe clings in the "wet drapery" manner. The drapery folds swirl around the chest and shoulders and fall in ever-widening ripples. The folds hanging from each sleeve in a diamond pattern and a series of V grooves between the thighs are schematic rendering of drapery.

The cranial protuberance *(usnisha)*, the long earlobes, and the large webbed hands are identifying characteristics of the Buddha.

An inscription around the base dates the piece to 477 and calls the image, Maitreya, Buddha of the Future, but some doubt has been expressed on the authenticity of this inscription. This great image, however, is certainly of the fifth century.

Priest, A., *Chinese Sculpture in The Metropolitan Museum of Art.* New York, 1944, p. 28.

26.123 The Metropolitan Museum of Art, Kennedy Fund, 1926.

109. Altar Shrine with Maitreya

Chinese, Northern Wei Dynasty
Gilt bronze
Height: 30¼ inches
Dated 524
Hopei Province

In this most elaborate and nearly complete Buddhist shrine of the early sixth century, a masterful grouping of many separate elements creates a shimmering Buddhist pantheon. The central figure represents the future buddha, Maitreya, with his right hand raised in the *abhaya mudra,* or fear-not gesture, and his left in the *mudra* called *varada,* signifying charity. He stands in front of a large leaf-shaped mandorla with an openwork surface that gives the effect of flickering flame. Apsarases, each playing a musical instrument, their draperies fluttering upward, alight on rosettes that decorate the edge of the mandorla. The buddha is flanked by two standing bodhisattvas. At his feet sit two others, and on either side of the seated figures are a pair of donors with offerings in their hands. At the center front, a genie supports an incense burner protected by lions and guardians.

The inscription on the back of the stand gives the date of the altarpiece —Cheng-kuang fifth year of the northern Wei Dynasty which corresponds to our year 524. The text also reveals that the image was made at the order of a father to commemorate his dead son.

This shrine and a smaller one also in our collection (38.158.2a–g) are said to have been excavated in 1924 in a small village near Chêng Tingfu, Hopei Province.

Priest, A., *Chinese Sculpture in The Metropolitan Museum of Art.* New York, 1944, p. 28.

38.158.1a–n The Metropolitan Museum of Art, Rogers Fund, 1938.

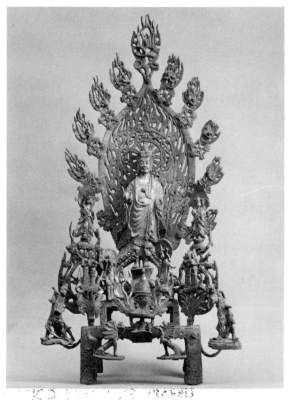

Americas: Mayan, Classic Period, ca. 300–ca. 900

The Maya of southern Mexico and Guatemala were outstanding among the peoples of the Classic Period, a time of prosperity and artistic achievement throughout Middle America. Advanced and flexible hieroglyphic writing accurately recorded historical events, the highly developed Mayan mathematics, and astronomy. After an intrusion from their northern rival Teotihuacán, in the fifth and sixth centuries, the Maya achieved their most magnificent phase, a late bloom before their great ceremonial centers were abandoned mysteriously in the ninth century.

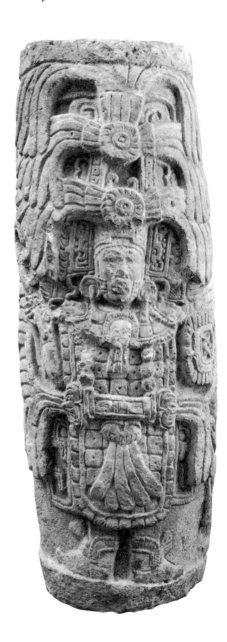

110. Column
Mayan, A.D. 600–850
Limestone
Height: 5 feet, 8¼ inches; Width: 2 feet, 4 inches
Mexico, said to be from Campeche

The principal carved figure is so well integrated into the columnar form that it might properly be termed an Atlantean figure. Elaborately dressed and with an enormous feathered headdress, the figure fills the front and continues around the sides of the column. A hooked scepter is in his right hand and a shield in his left. Farther to the left stands a small attendant figure. Though Atlantean figures exist in Maya art, they are not common. For a similar column see:

"A Great Maya Stone Column." *News Bulletin and Calendar,* Worcester, Mass., Worcester Art Museum, Vol. XXVIII, No. 8, 1963.

62.3 The Museum of Primitive Art.

Europe:
Early Christian, ca. 314–600
Byzantine, ca. 325–1453

Early Christian art, although it relied initially on established Roman forms, developed an increasing dependence on schematic prototypes under the influence of the expressive art of older Christian centers in North Africa and the Near East.

After Constantine established a new capital at Byzantium (renamed Constantinople) in 325, the energy and political power of the Empire flowed to its eastern capital, the seat of a lavish court.

The western emperor had ceased to be an important factor before the fall of Rome (A.D. 476). Though the Greek Orthodox and Roman Catholic churches gradually separated, the Greek traditions and oriental motifs of the Byzantine Empire repeatedly influenced the art of the West. The Empire never fully recovered from the sack of Constantinople during the Fourth Crusade (1204) and fell at last to the Turks in 1453.

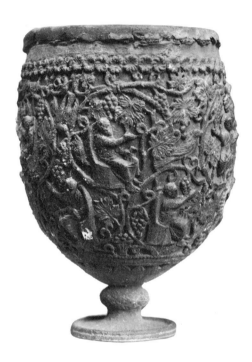
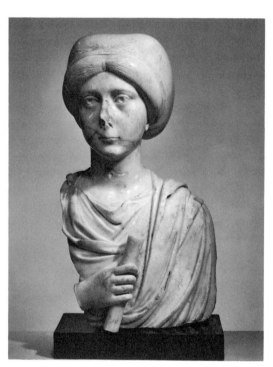

111. The Chalice of Antioch
Early Christian, A.D. 350–500
Silver, parcel gilt
Height: 7½ inches

The chalice consists of a richly decorated outer cup and a plain silver inner cup. On one side Christ is represented, seated with a lamb under his right arm. Under him an eagle, with wings spread, stands on a basket of fruit. On the other side Christ appears, enthroned, holding a scroll. The lower section of the cup depicts Apostles seated in chairs of Late Roman style. The whole is covered with a luxuriant growth of vines.

Some of the elements of the cup are found in Syrian and Roman iconography. The eagle and basket, symbol of eternal life, is a Christian sign of the Resurrection. The chalice is a unique piece with no close comparisons. Since its discovery in a well near Antioch, Syria, in 1910, it has been placed at the extremes of being suspected as a forgery to being considered the Holy Grail. After much debate these extremes have been properly abandoned and the chalice recognized as an outstanding object from Early Christian times.

Ostoia, V. K., *The Middle Ages: Treasures from The Cloisters and The Metropolitan Museum of Art.* New York, 1969, Cat. No. 6.

50.4 The Metropolitan Museum of Art, The Cloisters Collection, 1950.

112. Bust of a Lady of Rank

Byzantine, Second half of V century, or possibly early VI century
White marble
Height: 20⅞ inches
Region of Constantinople

This sculpture, a bust hollowed out in the back as was customary in Greco-Roman periods, may originally have been the upper part of a statue, possibly one that was associated originally with another figure to the right, perhaps of the lady's husband. Such double portraits are found on Byzantine coins and have survived in sculpture from an earlier period.

The surface has been highly polished. The tip and bridge of the nose are missing and when the sculpture was found, there was a diagonal break across the mouth and cheek. The young lady wears a tunic covered by an elegantly draped mantle, her hair carefully covered by a snood-like bonnet of the imperial type. The subtle and delicate modeling of her face still retains a trace of naturalism in spite of her fixed gaze. A recent study of this bust concludes that the person represented enjoyed a high rank in the Byzantine court in the late fifth or early sixth century.

Alföldi-Rosenbaum, E., "Portrait bust of a young lady of the time of Justinian." *The Metropolitan Museum Journal*, Vol. I, 1968, pp. 19–40.

66.25 The Metropolitan Museum of Art, The Cloisters Collection, 1966.

113. The David Plates

Byzantine, Constantinople, A.D. 613–629/630
Silver
(a) David Fights the Lion: Diameter: 5½ inches
(b) David and Jonathan (?): Diameter: 5½ inches
(c) David and Goliath: Diameter: 19½ inches
(d) David Presented to Saul: Diameter: 10½ inches
(e) David Anointed by Samuel: Diameter: 10⅞₁₆ inches
(f) Saul Arming David: Diameter: 10½ inches

These six plates, of which three (c, d, e) are illustrated here, together with four others in the Cyprus Museum, Nicosia, form a cycle showing scenes from the life of David. The ten plates, of various sizes, were made by the court silversmiths of Constantinople during the reign of Heraclius and were perhaps intended as an imperial gift. Probably made to be displayed, the largest dish, showing David fighting Goliath, would have been placed in the center, flanked by dishes of diminishing size. The series of images, as well as the classical style, may be based on fourth century models created under Emperor Theodosius; they appear to be a self-conscious effort to keep alive the Hellenistic forms of antiquity.

Ostoia, V. K., *Treasures from The Cloisters and The Metropolitan Museum of Art*. Los Angeles, 1969, pp. 52–53.

17.190.394–399 The Metropolitan Museum of Art, Gift of J. Pierpont Morgan, 1917.

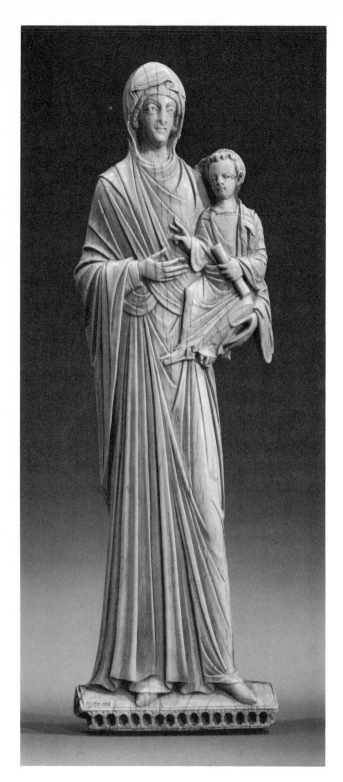

114. Virgin and Child
Byzantine, XI century
Ivory
Height: 9⅛ inches

The Virgin, standing on an arcaded footstool, is dressed in her
accustomed stold (tunic) and maphorion (mantle). She turns slightly
to her left, her right hand reaching toward the Christ Child whom she
holds in the circle of her left arm. The back of the figures was at some
time hollowed out for use as a reliquary.

This image of the Virgin and Child in Byzantium was called the
Hodegetria. She appeared on a famous icon, believed to have been
painted by St. Luke, that hung in her monastery in Constantinople. The
monastery stood on the site of a fifth century shrine with a miraculous
spring to which the blind were led to be healed, hence the meaning of
Hodegetria—she who leads or guides the way.

The Museum's very beautiful ivory belongs to a group of ivory
Hodegetriai in Utrecht, Hamburg, London, and formerly in Liège that have
survived from this period. Our Virgin is more slender and elongated.
Its drapery folds are flatter, with less regard for the softness of the
material where it falls over the Virgin's right arm or from her waist.
These elegant proportions and a flatter design were popular in the
latter half of the twelfth century.

Ostoia, V. K., "Byzantium." *The Metropolitan Museum of Art Bulletin,* n.s.,
Vol. XXVI (January, 1968), pp. 200–203.

17.190.103 The Metropolitan Museum of Art, Gift of J. Pierpont Morgan,
1917.

Europe: Migrations, ca. 300–ca. 600

Following the collapse of the Roman Empire in the West, migrations of northern and eastern tribes—Huns, Goths, and Vandals—into the Romanized world brought on the "Dark Ages" of chaotic upheaval, the abandonment of urban life, and the devastation of large areas of Europe. Art of the migration period, mostly recovered from burial sites, was generally confined to personal adornment and fine weapons.

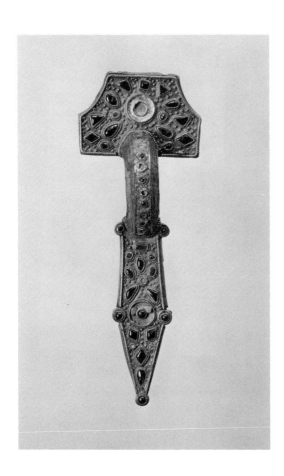

115. Proto Gothic Fibula

Proto Gothic type, late IV or V century
Gold leaf over silver core, and jewels
Length: 6¾ inches

This type of pin, with head and foot plates attached by an arched bow, a heavily gilt silver core decorated with cabochon gems, is found mostly in Hungary and South Russia. Comparative material suggests this piece was made by the Goths in the late fourth century. The lack of documentary evidence in this period of migrations of "barbaric" tribes makes it impossible to be more precise.

Bow fibulae were worn as personal adornment on mantles. The strong geometric pattern of the gem design and the hatched wire used as a heavy outline give the piece a bold shape and substantial feeling.

Ostoia, V. K., *The Middle Ages: Treasures from The Cloisters and The Metropolitan Museum of Art.* Los Angeles, 1969, p. 68.

47.100.19 The Metropolitan Museum of Art, Fletcher Fund, 1947.

China: T'ang Dynasty, 618–907

The T'ang Dynasty, like the Gupta, created a great international Buddhist style, the artistic expression of an empire that stretched from Turkey to Korea. The empire was administered by professionals appointed on the basis of civil service examinations. Literary encyclopedias were compiled and printed from wood blocks. T'ang painters developed calligraphic brushwork and made landscape an independent art form, while sculptors achieved a monumental realism.

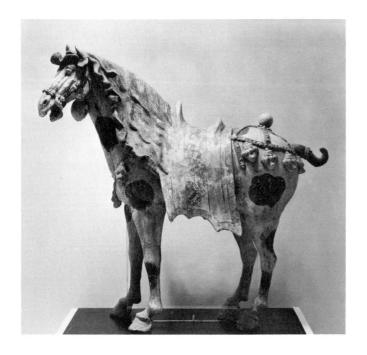

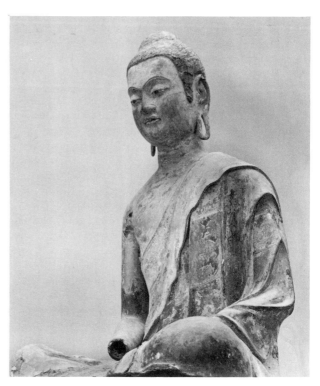

117. Seated Buddha
Chinese, probably late VI century
Dry lacquer
Height: 38 inches
Said to be from the Tai Fu Szu Temple, Hopei Province

Few early Chinese dry lacquer figures have been preserved. The technique calls for numerous layers of lacquer-soaked cloth, which are molded over a wooden armature to the desired thickness and form, and then painted in gesso, polychrome, and gilt.

The simplicity of the cranial protuberance, the squared-off hairline, and the sharply defined facial features of this seated Buddha all indicate a late sixth century date. Touches of orange and gold brighten the somber gray surface of the figure.

Fong Chow, "Chinese Buddhist Sculpture." *The Metropolitan Museum of Art Bulletin*, n.s., Vol. XXIII (May, 1965), p. 320.

19.186 The Metropolitan Museum of Art, Rogers Fund, 1919.

116. Standing Horse
Chinese, T'ang Dynasty, A.D. 618–907
Clay pottery
Height: 28 inches; Length: 33 inches

This handsome horse was buried with his master to serve him in the afterlife. Its large size, its gilded saddle decoration, and the elaborate trappings suggest that it may have come from a royal tomb. It is a well-preserved example and retains much of its original gilt and polychrome, ranging from bold brown spots on the body to delicately painted eyelashes.

Bosch Reitz, S. C., "A Steed of the T'ang Period." *The Bulletin of the Metropolitan Museum of Art*, Vol. XX (March, 1925), pp. 85–86.

25.20.4 The Metropolitan Museum of Art, Rogers Fund, 1925.

Europe:
Early Medieval, ca. 600–1000
Romanesque, ca. 1000–ca. 1200

Fragmented and exhausted by the conflicts among the declining Roman Empire, Germanic tribes, and the Barbarians, Europe embarked on a period of consolidation typified by the temporal and religious expansion of the Papacy and the revival of the Empire under Charlemagne and his immediate successors (800–843). The Church, especially through the amazing spread of monasticism, became the main thrust in conserving and disseminating knowledge.

The Romanesque style, characterized by rounded vaulting and by the solid mass of its architecture, developed within diversified local traditions from about A.D. 1000.

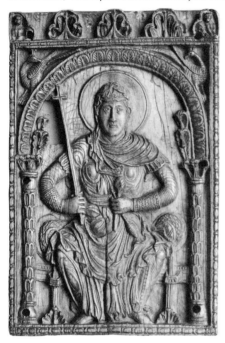 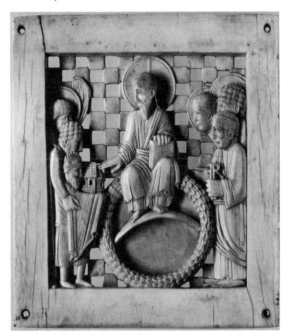

118. Virgin Enthroned
Carolingian (Court School), beginning of IX century
Ivory
Height: 8½ inches; Width: 5½ inches

This ivory is known both as one of the most forceful works of the imperial Carolingian School, and as an unusual medieval depiction of the Virgin Mary. The majestically enthroned figure is identified as the Virgin by the two weavers' distaffs in her left hand. They refer to the legend of the Virgin weaving the temple curtain at the moment she receives the Annunciation of Christ's birth. In addition to the usual cloth tunic and pallium, she wears shoulder strappings and imperial clavi on her forearms, elements of early Byzantine queenly regalia. These, together with the cross staff in her right hand, create an image of the Virgin as a triumphant empress. No other image of this sort is known in Carolingian art, but it is found in Ottonian art, perhaps under the direct influence of this ivory.

Aachen, Rathaus, *Karl der Grosse: Werk und Wirkung.* Exhibition catalog (June 26–September 19, 1965), Aachen, 1965, p. 338 f., No. 524.

17.190.49 The Metropolitan Museum of Art, Gift of J. Pierpont Morgan, 1917.

119. Christ in Majesty
South German or North Italian, A.D. 962–973
Ivory
Height: 5 inches; Width: 4½ inches

The series of ivory plaques to which this belongs was once extensive, but today only sixteen remain and they are dispersed throughout the world. All of them are of identical size and format, and all have the unusual cutout background. The series illustrates the life of Christ and was probably based on a full cycle of the life of Christ several centuries older than the ivories. These plaques probably decorated the front of an altar, perhaps at Magdeburg. Our ivory was most likely the last one in the series, as it shows Christ enthroned, his feet on the arc of the world, accepting a model of the church from the donor, in this case Otto I. In style it is a variant of a well-known Ottonian type, referred to as "Reichenau" but apparently practiced over a wide geographic area.

Goldschmidt, A., *Die Elfenbeinskulpturen aus der Zeit der Karolingischen und Sachischen Kaiser.* Berlin, 1918, No. 16, p. 17, 19 f.

41.100.157 The Metropolitan Museum of Art, Gift of George Blumenthal, 1941.

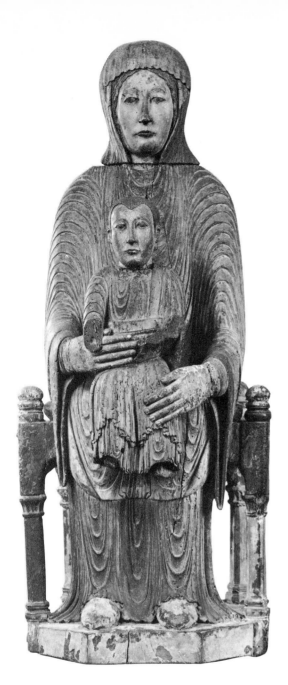

120. Virgin and Child
French, School of Auvergne, second half XII century
Polychromed oak
Height: 31 inches

The rich, regular surface pattern, chiseled from oak as if it were the rapid strokes of a drawing, becomes the circulatory system of this enthroned Virgin and Child. Its deep lines bring both activity and formality to the piece. While the surface vigorously pulsates, it also hardens into an extremely crisp, iconic cult image. This duality—a duality of expression—characterizes the sculpture as a whole. For in spite of its stylized, schematic surface—both active and static—and its hieratic composition, the faces of the two figures are unusually naturalistic; they emerge as compassionate though commanding forms from their cocoon-like bodies.

Forsyth, I. H., "Magi and Majesty: a study of Romanesque sculpture and liturgical drama." *Art Bulletin,* Vol. I (September, 1968), pp. 215, 217.

16.32.194 The Metropolitan Museum of Art, Gift of J. Pierpont Morgan, 1916.

121. The Pentecost
Mosan, Meuse Valley, third quarter of the XII century
Champlevé enamel on copper gilt
4½ inches square

This plaque depicts the descent of the Holy Spirit on the Apostles, as related in Acts 2:1-4. The hand of God appears to the Apostles who are assembled within an architectural setting. The scene has been abbreviated by representing only six Apostles and suggesting the others with partially invisible halos behind them. Each one has a tongue of fire upon his head. While the plaque has many features which link it to earlier Mosan works, several details point to later developments of the style around 1200. The heightened drama within a realistic setting and the variety of individual expressions suggest a departure from the Romanesque. The small chips of enamel, which simulate the marble floor, are to be seen in similar treatment on several of Nicholas of Verdun's plaques for the Klosterneuburg altarpiece of 1181.

Forsyth, W. H., "Around Godefroid de Claire." *The Metropolitan Museum of Art Bulletin,* n.s., Vol. XXIV (June, 1966), pp. 304-15.

65.105 The Metropolitan Museum of Art, The Cloisters Collection, 1965.

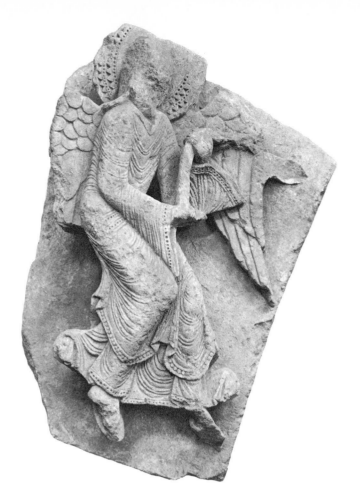

122. Angel
French, Burgundian, Autun, Cathedral of St. Lazare,
XII century, *ca.* 1190
Limestone
Height: 23 inches; Width: 16½ inches

This figure of an angel is almost a drawing in stone. The calligraphic lines of the drapery and of the outstretched wings give it energy and excitement. The line is nervous, punctuated by coils of drapery which retain our attention in a whirlpool of activity.

These vibrant, almost frenetic, qualities are characteristic of the architectural context from which the fragment comes. The angel originally formed part of the sculptural program of the Cathedral of St. Lazare at Autun, with which the name Giselbertus—possibly the sculptor—is associated. It is believed to be a fragment of a voussoir from the north transept portal which pictured the Raising of Lazarus on its tympanum, and Adam and Eve with Satan on the lintel.

The angel may have originally held a censer, which would be likely if it really was near the Lazarus scene. However, the original placement of this piece in the sculptural program of St. Lazare has been disputed, making the identity of the now-missing device questionable.

Ostoia, V. K., *Treasures from The Cloisters and The Metropolitan Museum of Art.* Los Angeles, 1969, pp. 96, 255, Cat. No. 43.

47.101.16 The Metropolitan Museum of Art, The Cloisters Collection, 1947.

123. Cross
England, Bury St. Edmunds (?), 1150–1190
Walrus ivory
Height: 22⅝ inches; Width: 14¼ inches

This ivory cross, rough and treelike, becomes the stage for a dramatic presentation as complex and intricate as the imagery of a medieval sermon. In fact, the cross, embellished with scenes and accompanying inscriptions, is a visual sermon. Each of the figures is involved in some sort of communication, each declaiming simultaneously. Together they present evidence from the Old Testament of the coming of Christ. These are prefigurations, recalled in single events or in personal testimony, of the life and times of Christ.

Hoving, T. P. F., ''The Bury St. Edmunds Cross.'' *The Metropolitan Museum of Art Bulletin,* n.s., Vol. XXII (June, 1964), pp. 317–40.

63.12, 63.127 The Metropolitan Museum of Art, The Cloisters Collection, 1963.

Islam:
Abbasid Caliphate, 750–1258
Fatimid Egypt, 969–1171
Ayyubid Egypt, 1163–1250
Mamluk Egypt, 1250–1517

The Islamic era dates from Mohammed's flight to Mecca in 622. Within a brief time, the consuming zeal of his followers established Islam throughout the Near East and North Africa, from India to Spain. Islamic art, with its origins in the art of the conquered Sasanian and Byzantine provinces, is unified by the decorative uses of Arabic script and a widespread ban on the use of the human figure in religious contexts.

124. Panel or Door
Iraq, Takrit, *ca.* 800
Carved pine wood
Height: 70¾ inches; Width: 15½ inches

The art produced under the rule of the Umayyad Dynasty, 661–750, drew its inspiration, mainly, from two sources: the naturalistic Byzantine and the more stylized Sasanian. The combination of these two differing styles and their elaboration and reinterpretation in the hands of either Muslim craftsmen or craftsmen working for Islamic masters gave rise to the beginning of a new art form—Islamic art.

Although this wooden panel or door was made in Iraq in the early years of the Abbasid Dynasty, it is very much in the Umayyad tradition and an excellent example of the way in which the two stylistic sources were combined, elaborated upon, and reinterpreted in the early centuries of Islam. The vine scrolls are reminiscent of Byzantine models, but the unrealistic depiction of pine cones growing from the leaf scrolls shows an abstraction influenced by the Sasanian tradition.

The object also illustrates what was to become a standard feature of Islamic woodwork which was dictated by the scarcity of wood in most Islamic countries—small pieces fitted together into a larger composition.

Dimand, M. S., "Studies in Islamic Ornament." *Ars Islamica*, Vol. IV, 1937, pp. 293-337.

31.63 The Metropolitan Museum of Art, Rogers Fund, 1931.

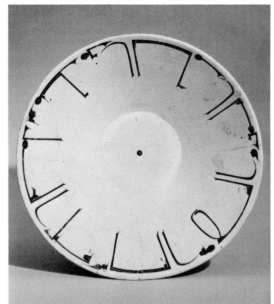

125. Bracelet

Iran, X–XI century
Gold (weight 276.3 grams)
Diameter: 4¾ inches; Width: 1⅞ inches

This bracelet, because it is an outstanding example of the goldsmith's
art, presupposes a long tradition of metalwork prior to its creation. In
addition to its extreme delicacy and intricacy, the bracelet is also
important as one of the few pieces of Islamic jewelry which can be
firmly placed in a historical context by means of a companion piece in
the Walters' Art Gallery, Baltimore. The Baltimore bracelet bears a Kufic
inscription which places its execution within the period of the Daylamites
who ruled a small area at the southwestern corner of the Caspian Sea
and parts of Azerbaijan from the early tenth to the late eleventh
centuries.

65.51 The Metropolitan Museum of Art, Harris Brisbane Dick Fund, 1965.

126. Bowl

Iran, Nishapur, X century
Slip-painted earthenware
Height: 7 inches; Diameter: 18 inches

The single contribution of the conquering Arabs to Islamic art was their
language—the word of God, the language of the Qur'ān; and the men
who wrote the holy word, the calligraphers, were more highly revered
in the Islamic world than the painters.

Because of the sacred aspect of the Arabic language and the design
potential of its various scripts, the use of calligraphy as a decorative
element is prominent in all periods of Islamic art and in all media—on
both secular and religious objects and buildings.

Perhaps the most outstanding examples of the use of calligraphy on
pottery are to be found in the production of Samanid Nishapur and
Samarkand. The sole decoration on this very large, finely potted bowl is
an Arabic inscription in Kufic script stating: "Planning before work
protects you from regret; prosperity and peace."

65.106.2 The Metropolitan Museum of Art, Rogers Fund, 1965.

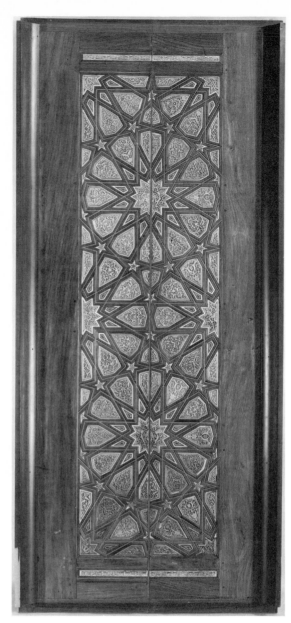

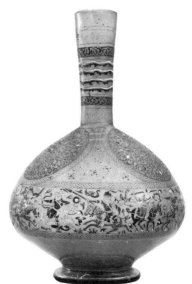

127. Pair of Doors, Probably from a Minbar

Egypt, Mamluk Period, late XIII–early XIV century
Wood inlaid with carved ivory panels
Height: 65 inches; Width: 30½ inches

The predilection for infinite designs has been a prominent feature in Islamic art from the beginning of its history. The preference has been explained as being closely related to the Muslim concept of Allah as expressed in the Qur'ān: "And there will endure forever the person of your Lord, . . ." (Surah 55, verse 27).

This design concept reached its zenith during the Mamluk Period in Egypt (1250–1517), embodied in the most intricate of geometrical patterns (so complex that the aid of mathematicians must have been essential). These doors of wood inlaid with carved ivory, probably from a minbar (pulpit) in a mosque or madrasseh, are outstanding examples of the high achievement of the Mamluk craftsmen.

The complex geometrical patterns of the Mamluk artisans were to exert a strong influence on the later art of North Africa, Spain, and countries within the Ottoman Empire.

Lukens, M. G., *Islamic Art, Guide to the Collections.* The Metropolitan Museum of Art, New York, 1965.

91.1.2064 The Metropolitan Museum of Art, Edward C. Moore Collection, Bequest of Edward C. Moore, 1891.

128. Bottle

Syria, period of Sultan Nasir ad-Din Muhammad ibn Kalaun, *ca.* 1320
Polychrome enameled and gilded glass
Height: 17⅛ inches

What should perhaps be considered the zenith of Islamic glass manufacture was attained in Syria during the Ayyubid and Mamluk periods (1171–1517). This bottle, of polychrome enameled and gilded glass, was produced in the early fourteenth century and is an excellent example of the height attained by Mamluk craftsmen. Its beauty, intricacy of design, and brilliant colors surpass all other examples of Mamluk glass that have been preserved.

European inventories of the late Middle Ages mention the gilded and enameled glass from Damascus—attesting to its popularity outside the Islamic world—and it is assumed that the art of enamel painting and gilding on glass was introduced in Venice by the Syrians in the late fifteenth century. Thus, Syrian glass with its roots in Roman antiquity developed into a purely Islamic product and, as such, influenced the production of Renaissance Italy.

Dimand, M. S., "An Enameled-glass Bottle of the Mamluk Period." *The Bulletin of The Metropolitan Museum of Art,* n.s., Vol. III, 1944, pp. 73–77.

41.150 The Metropolitan Museum of Art, Rogers Fund, 1941.

Islamic Europe:
Sicily, ca. 900–ca. 1200
Islamic Spain, 711–1492

The vigorous Islamic culture left a deep imprint on those parts of Europe that succumbed to the Muslim invaders, notably Spain, which was conquered in 711, and Sicily, which was captured by Muslims from Tunis in 909. The Normans, who wrested Sicily from the Muslims in 1091, established a rich and cosmopolitan monarchy modeled after the Byzantine system, but with influential contacts with the Islamic world.

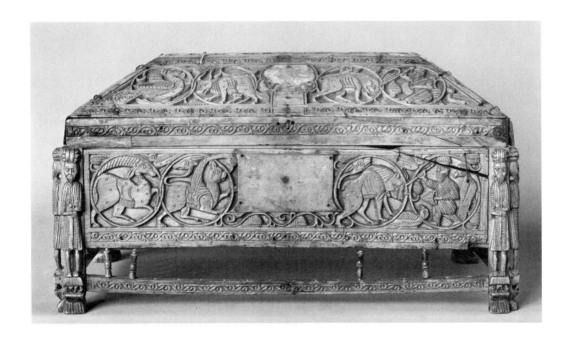

129. Casket
South Italy or Sicily, XI–XII century
Carved ivory
Height: 8¾ inches; Length: 15 inches; Width: 8 inches

When the Normans, already in control of Southern Italy, conquered Sicily in 1091, the island had been under Muslim rule for 265 years—the last dynasty, the Fatimid, having been in power from 909. So strong was the influence of Islamic culture that the new Christian rulers adopted a semi-Muslim way of life and their art was produced by Muslim artisans. Therefore, it is not surprising that the iconography and style of this carved ivory casket reflect a strong dependence on the Fatimid art of Egypt. Thus, this object serves as an excellent as well as a beautiful example of the very important role—second only to that of Spain—that Sicily and Southern Italy played under the Normans, in transmitting the art and culture of the Islamic world to Europe.

Dimand, M. S., *A Handbook of Muhammedan Art*. New York, 1958, p. 129.

17.190.241 The Metropolitan Museum of Art, Gift of J. Pierpont Morgan, 1917.

130. Textile
Spain, first half of the XII century
Brocade of silk and metal threads
Height: 17 inches; G. width: 12 inches
From Reliquary of Saint Librada, Sigüenza Cathedral

131. Textile
Spain, first half of XII century
Brocade of silk and metal threads
Height: 17 inches; Width: 13 inches
From Reliquary of Saint Librada, Sigüenza Cathedral

Only within recent years has a group of outstanding Islamic silk textiles been definitely attributed to Spain during the period of the Almoravid Dynasty of North Africa. The group has in common, in addition to technique, a densely distributed design with a basic pattern of roundels with animal and bird figures.

One of the textiles (130) shows, within the roundel, a pair of addorsed griffons with heads turned to face a central tree of life while a gazelle-like creature is seen between the griffons' fore- and hind legs. In the outer band, between pearl borders, are composite animals, and more gazelles frolic in the intersticial pattern. All of these creatures can be found in the art of the pre-Islamic Near East, as can the tree of life and heraldic poses. Among the features special to Islam are the arrangement of the pattern, the variation in the size of design elements, the counterbalance between natural and stiffly formal figures, and the rhythmic abstraction of form. As with so much of Islamic art there is variety and contrast within a basic unifying concept.

In the second textile (131) within the roundel is a single-headed eagle displayed with composite quadrupeds and harpies in the outer band and a leonine quadruped within a roundel on each shoulder. A pseudo-Latin inscription crosses the wings, while beneath the talons, in Kufic characters, is the Arabic word *barakah*, "blessing" (in mirror image on the left). Outside the roundel, much obliterated, is a repeated inscription requesting God's blessings, succour, and success.

The eagle, symbol of the sun and hence of power (royal or imperial), while borrowed from other cultures, was widely represented in Islamic art. The decorative potential of calligraphy inherent in the Arabic written language was early realized in Islamic lands and the use of inscription bands in all media of art reached a remarkably high level of development.

(130) May, F. L., *Silk Textiles of Spain, Eighth to Fifteenth Centuries.* New York, 1957, pp. 36–39.
(131) Shepherd, D. G., "A Dated Hispano-Islamic Silk." *Ars Orientalis,* Vol. II, 1957, pp. 374–82.

58.85.1,2 The Metropolitan Museum of Art, Funds from Various Donors, 1958

132. Lustreware: Deep Dish; Pharmacy Jug; Plate

Spanish, Provence of Valencia (Manises)

(a) Diameter: 18⅛ inches; (b) Height: 10¾ inches; (c) Diameter: 17⅜ inches

Dated: (a) 1420–1430; (b) 1435–1465; (c) 1435–1465

Lustreware refers to a particular type of earthenware whose surface qualities, through a complicated process of glazing and firing, simulate the rich patina of precious metals. The process reached its height of popularity and perfection during the fifteenth century, and the province of Valencia was the principal center of manufacture. The first example, a deep dish or *brasero,* is distinguished by its decorative patterns of palmettes, pseudo Kufic inscriptions, and geometric strapwork demonstrating the strong influence of the Islamic world on Spain during this period. The second piece, of a slightly later date, is called an *albarelo* and was used to store dried herbs and medicinal compounds. The blue and copper ivy leaf pattern on an acacia blossom background which decorates the *albarelo,* as well as the plate, was very common during the middle of the fifteenth century. The third example, a plate, like the *brasero,* was most likely used for table service. Many examples of lustreware bear the coats of arms of royal and noble commissioners, not only Spaniards but Frenchmen and Italians as well, a tribute to the perfection of the potter's art which made these pieces so sought after.

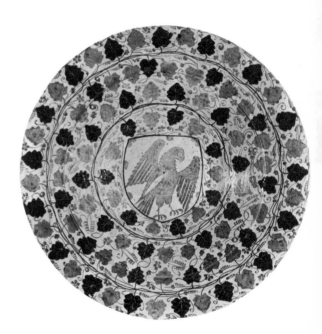

Husband, T., "Fifteenth Century Valencian Lustreware." *The Metropolitan Museum of Art Bulletin,* n.s., Vol. XXIX (Summer, 1970), pp. 11–19.

(a) 56.171.108; (b) 56.171.95; (c) 56.171.127 The Metropolitan Museum of Art, The Cloisters Collection, 1956.

India: Medieval, ca. 600–ca. 1300

"Medieval" India spans the period from the end of the Gupta Dynasty to the advent of the Moghul Empire. India was divided among local dynasties until the late ninth century, when the Chola united the south and Muslims established themselves in the north. Sculpture, deeply influenced by the art of the dance, overwhelmed architecture.

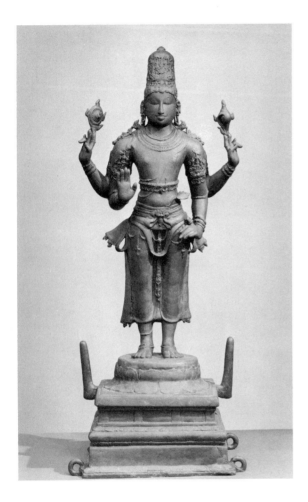 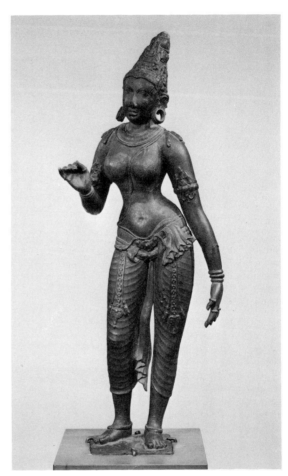

133. Standing Vishnu

Indian, South Indian School, Chola Dynasty, X century
Bronze, with greenish-blue patination
Height: 33¾ inches

The four-armed Vishnu stands on a double lotus base supported by a plinth. His upper right hand holds a flaming disc, the upper left hand a conch shell. His lower right hand is in the *Abhaya mudra*, or the "fear not" gesture, while the lower left hand, with extended fingers, points diagonally downward.

Wearing a cylindrical tapering crown, the figure is heavily decked with earrings, necklaces, bracelets, anklets, rings on fingers and toes, all symbolic of Vishnu's qualities and attributes. The sacred cord consists of three threads, said to represent the three letters of the mystic syllable AUM.

The rings at the four corners of the base held poles by which the image was carried in ceremonial processions. The entire surface is enhanced by a greenish-blue patina.

The monumental style and superb casting of this piece exemplifies the high achievement of early Chola art.

62.265 The Metropolitan Museum of Art, John D. Rockefeller III, Gift, 1962.

134. Standing Parvati

Indian, South Indian School, Chola Dynasty, X century
Bronze
Height: 27⅜ inches

Parvati, the consort of Shiva, stands in the *tribhanga* or three-bends-of-the-body pose. Her lithe left arm rests at her side, and her right hand is partly raised (at one time it probably held a lotus). Her hair is piled high into a conical crown decorated with elaborate ornaments. Curls fall across the back of her shoulder in a loose fan shape. She seems to wear more than the usual amount of jewelry; a rich girdle belt with two long tassels holds the form-revealing *dhoti,* beautifully stylized in a symphony of ridged folds. The lyrical and rhythmic carriage of her body, especially the hips and lower limbs, is characteristic of the masterly achievement of great South Indian bronzes of the early tenth century when the Chola Dynasty began to gain power. The beautiful image was cast by the *cire perdue* or lost-wax process.

Master Bronzes of India. Exhibition catalogue of the Art Institute of Chicago, Chicago, 1965, No. 28.

57.51.3 The Metropolitan Museum of Art, Bequest of Cara Timken Burnett, 1957.

135. Mithuna Couple

Indian, Orissa, XII–XIII century
Stone
Height: 6 feet

On the east coast of India, south of Bengal, lies the state of Orissa. Its well-known medieval temple sites of Bhuvaneshar, Konarak, and Puri were built between the eighth and thirteenth centuries. The sculptural style in the temples attained its maturity in these latter two centuries. Many of the carvings represent celestial beauties as well as loving couples which are close in style to this sculpture. The erotic character of this stone is a manifestation of a facet of Hinduism—a manifestation found not only in Orissa but also at Khajuraho as well.

In the beautifully organized composition, the tree branch on top balances the graceful sway of the embracing figures.

The coarse grain and fissures of the piece are typical of Orissa sculpture. The stone of the region is soft and when exposed to the elements becomes pockmarked.

Rawson, P., *Erotic Art of the East.* New York, 1968.

1970.44 The Metropolitan Museum of Art, Florance Waterbury Fund, 1970.

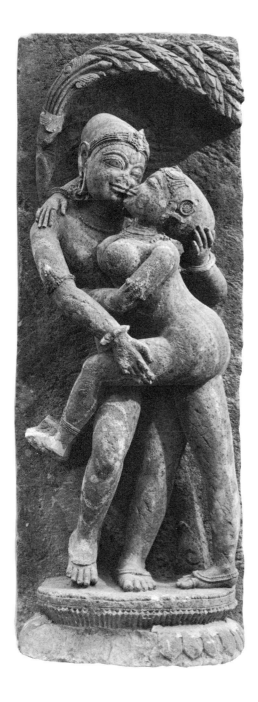

China: Sung Dynasty, 960–1279

Reforms in 1070 and 1071 fixed the organization of central authority in the Chinese Empire in a system that was to last over 800 years. At a time of continual pressure from non-Chinese on the borders (barbarians took the northern capital in 1126), landscape painting entered its golden age under the stimulus of enlightened patronage in an atmosphere of humanism. Porcelain, refined by connoisseurship and cultivated leisure during the later Southern Sung phase, reached an unexcelled subtlety.

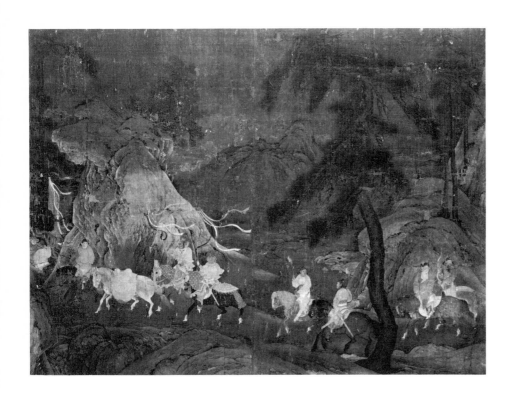

136. The Tribute Horse
Chinese, Sung Dynasty, X–XII century
Ink and colors on silk
Height: 32⅝ inches; Width: 44¾ inches

Scholars have thought that this procession headed by a riderless horse has a particular meaning, but it is impossible to establish with certainty the allusions or narrative. The dark tones of the otherwise typical Sung Dynasty landscape provide a majestic background for the colorful procession—pursuing its imperial way through the mountains. A gold wash provides the lighting effect. Purple, green, red, pale blue, and pale rose appear in the banners, clothing, and horse trappings, with some gold accents. The horsemen and their mounts immediately behind the riderless white horse are richly decked out— gold masks and elaborately decorated saddles on the horses, the riders with glistening helmets and carrying streaming banners. Behind them, possibly the emperor, second from the right, rides with his protectors.

Cahill, J. F., *Chinese Painting*. Geneva, 1960, p. 62.

41.138 The Metropolitan Museum of Art, Rogers Fund, 1941.

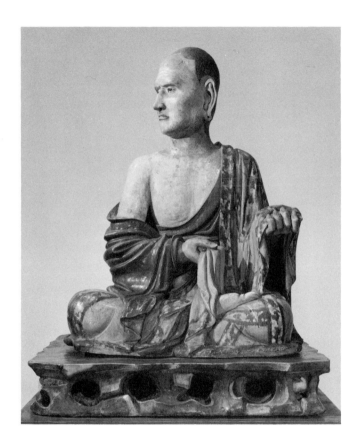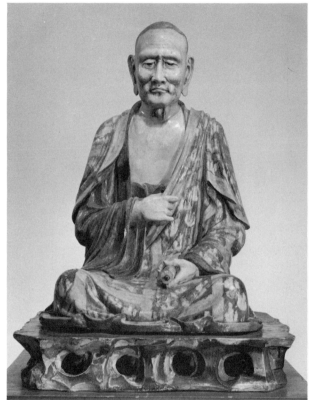

137, 138. Two Seated Lohans
Chinese, Liao-chin Period, 907–1234
Pottery
Height: 48 inches
Height: 50 inches

These figures, as well as a number of similar Lohans now in this country, are said to have come from the Caves of the Eight Lohan Mountain near I Chou, southwest of Peking in the province of Hopei. Two cross-legged Lohans, disciples of the Buddha, are seated on a slab of weathered rock; the older one, in meditation, holds a scroll in his left hand while the younger adjusts his garment with head turned as if about to deliver a sermon.

These figures are in a style of sculpture more realistic than in the work of the T'ang Period, but they follow the T'ang mode of three-color running effects of soft green, brown, and yellow glazes. They can be attributed to the Liao-chin Period.

(137) Bosch Reitz, S. C., "A Large Pottery Lohan of the T'ang Period." *The Bulletin of The Metropolitan Museum of Art,* Vol. XVI, (January, 1921), pp. 15–16.
(138) Chow, F., "Chinese Buddhist Sculpture." *The Metropolitan Museum of Art Bulletin,* Vol. XXIII (May, 1965), pp. 318–19.

(137) 20.114 The Metropolitan Museum of Art, Fletcher Fund, 1920.
(138) 21.76 The Metropolitan Museum of Art, Hewitt Fund, 1921.

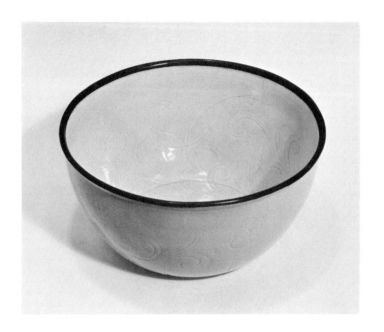

139. Deep Bowl—Ting Ware
Chinese, Northern Sung Dynasty, 960–1127
White porcelain with creamy white glaze, metal band at the rim
Height: 4½ inches; Diameter: 9¾ inches
Hopei Province

The Ting *yao* (wares) were among the finest porcelains of the Northern
Sung Dynasty. Beautifully made of resonant, hard white porcelain, they
were covered with a deep ivory-white glaze that often collected in
tearlike runs.

Bold floral designs are incised with a few swift, sure strokes into the paste.
In deference to the highly aesthetic tastes of the period, the shape and
glaze, not the design, were of primary consideration.

The Ting *yao* were usually fired on their mouthrims, leaving an unglazed
edge that was subsequently capped with a metal band, most often made
of copper.

This bowl is a splendid example of the finest type of white porcelain
of the period.

Lovell, Hin-cheung, *Illustrated Catalogue of Ting yao and Related White
Wares in the Percival David Foundation of Chinese Art.* Sec. 4, London, 1964.

26.292.98 The Metropolitan Museum of Art, Gift of Mrs. Samuel T.
Peters, 1926.

140. Vase—Kuan Ware
Chinese, Northern Sung Dynasty, 960–1127
Porcelaneous stoneware with crackled light-blue glaze
Height: 13⅜ inches; Diameter: 8½ inches

Stately in form, and impressive in size, this splendid pear-shaped vase
representes the *Kuan,* or Imperial, wares of the Sung Dynasty at their
best. The quietly contemplative atmosphere of the court is reflected in
the dignified silhouette—which at once conveys a spirit of grace and
power. The glaze is rich and deep; the unctuous texture is reminiscent
of jade, while the pale-blue tone brings to mind the Chinese term
ch'ing, the color of nature. There is no distraction, except a subtle
crackle in the glaze that complements the total effect of refined
understatement.

Two small rectangular holes in the flaring foot may have been made
to accommodate a cord, which secured the now lost cover to the jar.

26.292.81 The Metropolitan Museum of Art, Gift of Mrs. Samuel T.
Peters, 1926.

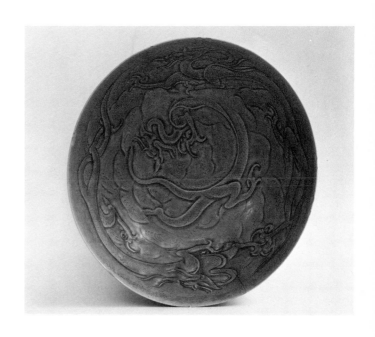

141. Bowl—Yüeh Ware

Chinese, X century
Grayish porcelaneous stoneware with grayish-green glaze
Diameter: 10⅝ inches
From the Shang-lin-hu kilns of Chekiang Province

In the tenth century, the Yüeh kilns of the Shang-lin-hu complex in the Yü-yao-hsien of Chekiang Province—continuing a tradition of green-glazed Chekiang stonewares that reaches back to the third century B.C.—were manufacturing some of the finest products in their entire history. These grayish-green stonewares were so valued that at one point they were reserved for the exclusive use of the princes of Wu-Yüeh at Hangchow, and designated *pi-sê yao* or "prohibited wares."

This magnificent bowl is a splendid example of the *pi-sê yao* and shows well why the tenth century Yüeh ware was so coveted by the local princes. The bowl is beautifully potted of fine gray porcelaneous stoneware, and the simple but strong form is a suitable foil for the exuberant ornamentation on the interior, where three highly spirited, carved dragons race through the clouds with such vigor that they appear alive. A thin, lustrous olive-green glaze accumulated in the intaglio designs, emphasizes every line. The total effect is dynamic yet elegant—a brilliant achievement of the potter's art.

Gray, B., *Early Chinese Pottery and Porcelain.* London, 1953, Pl. 17B.

18.56.36 The Metropolitan Museum of Art, Purchased by curator in Peking, 1917.

Section IV: ca. 1200–ca. 1400

1200	University of Paris founded
1204	Sack of Constantinople by members of the Fourth Crusade
1210	Franciscan Order founded
1215	Magna Carta signed by King John of England
1215	Genghis Khan captures Peking
1241	Mongols burn Moscow and Kiev, invade Danube Valley
1250	Oxford University founded
1274	Death of Thomas Aquinas
1275–1292	Marco Polo travels widely in East in service of Kublai Khan
1291	Crusades end
1305–1306	Giotto paints frescoes in Arena Chapel, Padua
1310–1321	Dante writes *Divine Comedy*
1338	The Hundred Years' War between England and France begins
ca. 1350	Black Plague throughout Europe; Boccaccio writes *Decameron*
1354–1391	Alhambra constructed by Moors in Spain
1368	Ming Dynasty begins; Mongols expelled
1387	Chaucer writes *Canterbury Tales*

West	West	Near East	Far East

1200

147. Mosan,
ca. 1215–1220

146. Southern Italy,
1200–1210

162. Iranian,
early XIII century

1225

1250

149. French (Rhenish)
1247–1252

143. Japanese
1257 (detail)

1275

1300

150. French,
ca. 1300

1325

156. Iranian,
1330–1350 (detail)

1350

152. French,
ca. 1340–1350

1375

1400

Japan: Kamakura Period, 1185–1333

Japan, an outpost of Chinese culture, emerged in this period with a distinctively national style. A military government of great feudal landlords at Kamakura dispensed ruthless justice and dominated the shadow court at Kyoto. The Mongols, successful elsewhere in Asia, were twice repulsed (in 1274 and 1281), but the taxing effort of its military preparations contributed to the collapse of the Kamakura government.

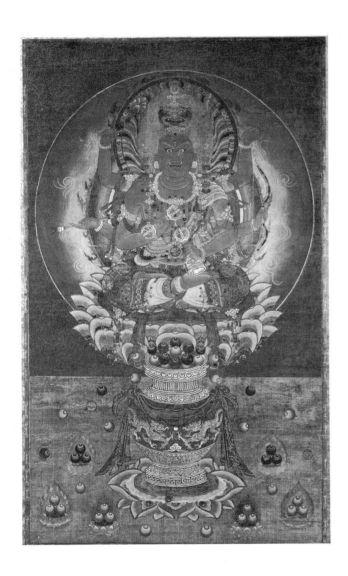

142. Hanging Scroll: Aizen Myo-O
Japanese, Kamakura Period, 1185–1333
Colors, and cut and painted gold on silk
Height: 62 inches; Width: 33½ inches

This Buddhist deity known in India as Raga Raja, controls lust and avarice. He is seated on a lotus pedestal within a circular mandorla. A manifestation of the supreme Buddha Dainichi Nyorai (Vairochana), he is depicted with a lion mask above his head. Five of his six hands hold his attributes; lotus, bow and arrow, vajra, bell. The upper left hand is clenched. The foreground is strewn with what appear to be pearls or magic gems, seeming to emanate from the vase in front of the god. Groups of three jewels surrounded by flames and on lotus bases probably symbolize Buddha, Dharma, and Sangha (Buddha, the Law, the Community).

"Art of Asia Recently Acquired by American Museums, 1966." *Archives of Ancient Art,* Vol. XXI, 1967–1968, p. 84.

66.90 The Metropolitan Museum of Art, Mary Griggs Burke Gift, 1966.

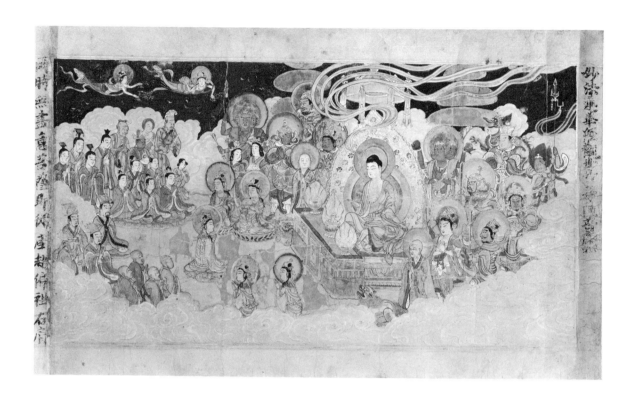

143. Miracle of Kannon
Japanese, Kamakura Period, 1185–1333
Watercolor and gilt on paper
Height: 9½ inches; Length: 32 feet
Dated in concordance with March 29, 1257

In this outstanding example of a handscroll *(emaki)* from the middle of the Kamakura Period, both the sacred text *(sutra)* and the illustrations are modeled after a Chinese printed scroll said to have been made in the Sung Dynasty. The *sutra* text was transcribed by Sugawara Mitsushige, a thirteenth-century calligrapher who signed and dated it 1257 at the very end of the scroll. We do not, however, know the name of the fine painter who illustrated with superb color and gold each section of the thirty-three texts describing the many miracles performed by Kannon in saving men from fire, flood, and other calamities.

The bodhisattva Kannon is the god of mercy who delayed his own attainment of buddhahood in order to bring salvation to mankind. Known in China as Kuan Yin and in India as Avalokitesvara, he is one of the most popular deities in the Buddhist pantheon of the Far East. The title section shown here shows him kneeling before Buddha, surrounded by a retinue of celestial beings.

Several scenes in this scroll exhibit the early Japanese style of painting, with a linear treatment of landscape in which the composition is often interrupted by horizontal cloud bands or pointed hillocks in the foreground that give the picture a curiously two-dimensional effect.

Narazaki, M., "On a Newly Discovered Kannonkyo Picture-scroll." *Kokka,* October, 1951, No. 715. (Article in Japanese with an English summary.)

53.7.3 The Metropolitan Museum of Art, Louisa Eldridge McBurney Gift, 1953.

China: Yüan Dynasty, 1280–1368

*The Mongol Empire under Kublai Khan ruled as the Yüan Dynasty in China. Some
Chinese artists and scholars served the court, while others retreated into isolation in the face
of the seeming triumph of barbarism. Chinese seaports under the Mongols were the busiest
in the world.*

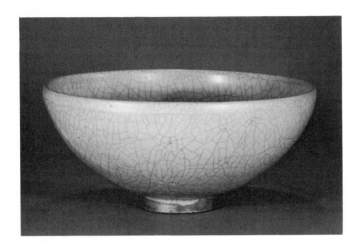

144. Bowl—Chün Ware
Chinese, XII–XIV century
Porcelaneous stoneware, with crackled greenish-blue glaze
Height: 3⅝ inches; Diameter: 8½ inches
Honan Province

The generic term, *Chün yao* is used today to encompass several
varieties of predominantly blue-glazed stonewares produced in or
near Honan Province in the north of China.

In the Northern Sung Dynasty, 960–1127, among the types of Chün
wares manufactured were fine porcelaneous stoneware vessels with
thick, opaque monochromatic glazes of almost sky-blue color. These
wares were undecorated and the total effect was exquisitely simple
with elegant forms enveloped by rich glazes.

Very rarely, a deliberately induced crackle is seen on the Chün
wares, and this bowl is a particularly beautiful example of the
"crackled Chün." The glaze is a soft greenish blue, and the bold
uneven crackle adds an interesting contrast to the rigidly disciplined,
almost stark shape.

Although this bowl is so fine in quality that it compares favorably
with the best Chün ware made before the Sung Court fled south in
1127, its size and certain nuances of potting suggest it might be
slightly later in date.

66.89 The Metropolitan Museum of Art, Mary Griggs Burke Gift
Fund, 1966.

145. Large Underglaze Red Bowl
Chinese, XIV–XV century
Porcelain
Height: 6⅛ inches; Diameter: 15¾ inches

The difficult technique of copper red decoration on white porcelain
ground under a transparent glaze, first attempted during the late
Yüan and early Ming dynasties (fourteenth to fifteenth century), was
not fully mastered until about the early eighteenth century. Many of
the early pieces were misfired and turned an undesirable grayish
pink or dark liver color.

In this impressive bowl the red coloring is nearly perfect. An unusual
combination of scrolling vine and stylized lotus and peony flowers
decorate its interior; chrysanthemum scrolls enhance the exterior.
The unglazed foot rim is burnt orange, a characteristic of this early
type of porcelain.

Lee, Jean, *Ming Blue and White*. Philadelphia, Philadelphia Museum of
Art, 1949, Cat. No. 14, p. 26.

18.56.35 The Metropolitan Museum of Art, Rogers Fund, 1917.

Europe: Gothic, ca. 1135–ca. 1500

The expansion of royal power and the creation of middle-class mercantile empires, as well as the founding of universities, form the background for the development of the Gothic style. The new architectural style, first formulated in 1134 at St. Denis, outside Paris, strove for an open, weightless effect through the use of the pointed arch, ribbed vaulting, and expanses of stained glass windows. Sculpture and decorative arts in turn also played an important role. From its origins in the region around Paris, the Gothic style rapidly spread to England, then to Germany and elsewhere in Europe, usually colored by local traditions.

146. Bird
South Italy, 1200–1210
Bronze gilt
Height: 10¾ inches

Originally gilded, this bird probably represents a gerfalcon, the falcon of kings. The ball clasped in its claws has a large deep hole in it, indicating that the figure at one time was attached to the top of a staff or scepter. Some scholars have speculated that this bird was made for the staff of Frederick II, Holy Roman Emperor and King of Germany, Naples, and Sicily, but an ornament for him would more correctly represent an eagle. It is more probable that this figure was part of an architectural ornament or piece of furniture. Stylistically it can be closely associated with similar representations of birds appearing on various capitals in the cloisters of Monreale Cathedral.

Hoffman, K., *The Year 1200. Vol. I: A Centennial Exhibition at The Metropolitan Museum of Art.* New York, 1970, p. 127.

47.101.60 The Metropolitan Museum of Art, The Cloisters Collection, 1947.

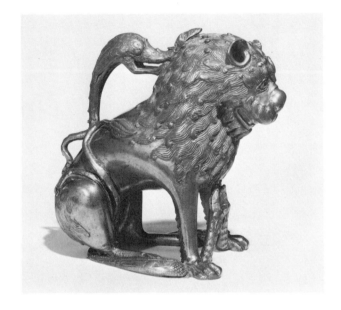

147. Virgin and Child
Mosan, 1215–1220
Oak
Height: 48 inches

This figure of the Virgin and Child is of a type in which
Mary is seen as the Throne of Solomon, or the Seat of
Wisdom—*Sedes Sapientiae*. The style of our piece suggests it
came from the Priory of Oignies in the Meuse River Valley
in (what is now) Belgium.

The formal and hieratic pose is in contrast to the more
fluid draperies and the softer quality of the skin, flesh, and
features. The warmth of the face and the humanity of the
whole figure show that the creator of this piece was
sensitive to the changes that took place in sculpture, led
by the style developed at Chartres around 1215.

Hoffman, K., *The Year 1200*. Vol. I: *A Centennial Exhibition
at The Metropolitan Museum of Art.* New York, 1970, p. 28,
Cat. No. 35.

41.190.283 The Metropolitan Museum of Art, Bequest of
George Blumenthal, 1941.

148. Lion Aquamanile
North German, *ca.* 1200
Bronze
Height: 8¼ inches

Aquamaniles were meant to carry water for the ritual washing of
hands. They are found in many shapes in the Middle Ages. Lions
are common, but dragons, turreted castles and horses, with or
without rider, are well known too. Our lion is seated. A dragon
on its back forms the handle, and vipers reach upward from its
feet.

This is a vigorous rendering of a lion, and an extremely ornamental
one. This can be noted especially in the decorative quality of
the mane. This decorative effect and the seated posture strongly
suggest that our aquamanile is closely related to Chinese art,
perhaps transmitted through Byzantium.

Gómez-Moreno, C., *Medieval Art from Private Collections*. New York,
The Metropolitan Museum of Art, 1968, Cat. No. 100.

Robert Lehman Collection.

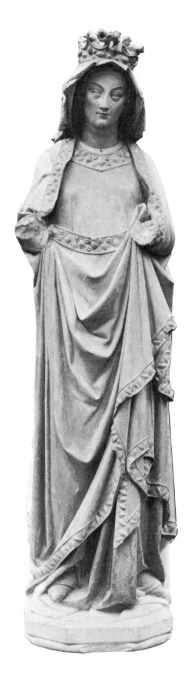

149. Virgin from Strasbourg Cathedral
French, Rhenish, 1247–1252
Sandstone, polychromed and gilt
Height: 58½ inches

The Virgin, calm, self-assured, and majestic, expresses to perfection the idealism of thirteenth-century Gothic sculpture. The statue's strictly perpendicular, blocklike form indicates that, like most monumental sculpture of the thirteenth century, it was part of an architectural unit. The deep angular carving of the drapery folds emphasizes its vertical composition and also gives to it a sculptural quality of weight and solidity. This Virgin is one of those fortunate medieval sculptures that retains at least part of its original polychromed surface. The face is painted in flesh tones, the gown is blue, and the crown, veil, cloak, and jeweled borders are gilded.

The figure was identified as coming from the Strasbourg Cathedral Choir Screen on the basis of dimensions, fixtures, paint tests, and stylistic similarity, and by the existence of a seventeenth-century drawing of the screen that shows her.

Ostoia, V., *The Middle Ages: Treasures from The Cloisters and The Metropolitan Museum of Art.* New York, 1969, pp. 140–41, 257–58.

47.101.11 The Metropolitan Museum of Art, The Cloisters Collection, 1947.

150. Apocalypse
North French (?), *ca.* 1310–1315
Paint on parchment
Miniatures: 5³⁄₁₆ inches x 6½ inches

The Apocalypse or Book of Revelations, was frequently illustrated as a separate book of the New Testament during the Middle Ages. Fortunately, many have survived, and among them there are large families of manuscripts whose members are intimately related to one another in style and in iconography. The Cloisters' Apocalypse is an important member of just such a group, with related manuscripts in the Bibliothèque Nationale in Paris, and the British Museum in London. Each was influenced by an English model of an earlier generation of painters; each has freshly interpreted the struggle between Christ and anti-Christ in up-to-date and forceful terms. The Cloisters' manuscript is distinguished from the other members of its group by the spirited sketches within its margins, by having an introductory cycle of scenes from the infancy of Christ, and by a page that pictures the owners of the manuscript.

68.174 The Metropolitan Museum of Art, The Cloisters Collection, 1968.

151. Double Page: Scene in Chapel and Education of Saint Louis from Book of Hours of Jeanne D'Evreux

Jean Pucelle
French, Paris, 1325–1328
Parchment
3½ x 2⅞₁₆ inches

The drawings in this tiny book of hours are the foremost testimony to the artistry of Jean Pucelle, the painter whose style influenced Parisian manuscript illumination for nearly a full century. His name actually appears in two other manuscripts and in the will of Jeanne d'Evreux, widow of Charles IV, wherein she leaves to Charles V a small book of hours "que pucelle enlumine." The book contains twenty-five full-page miniatures and countless marginal drolleries, all painted in semigrisaille—a technique by which figures are drawn and modeled entirely in black, with only background and flesh tones in color. The scenes illustrate the life and passion of Christ as well as the life of Saint Louis. The appearance in them of architectural interior space, as well as the use of certain iconographic motifs, may reflect the direct influence of Sienese painting. The extraordinary marginal drolleries are comparable in their breadth and invention to English illumination of contemporary date. But most notable is Pucelle's individual mastery: the tightness of his drawing, his freedom in handling near-monumental forms, and the degree of concentration and depth of expression in illustrations so restricted in dimension and color.

La Librarie de Charles V. Paris, Bibliothèque Nationale, 1968, p. 69 f. No. 133.

54.1.1 The Metropolitan Museum of Art, The Cloisters Collections, 1954.

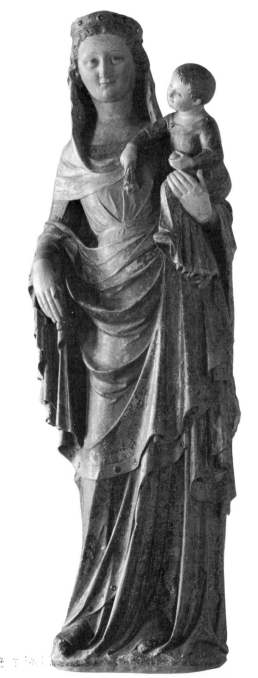

152. The Virgin and Child

French, Ile de France (possibly east of Paris), XIV century, *ca.* 1340–1350
Painted limestone
Height: 5 feet, 8 inches

Of the countless sculptures of the Virgin and Child made in France during the fourteenth century, few today possess so much of their original paint or are in such splendid condition as this imposing figure. Placed high above an altar and lit by myriad rows of candles, she must once have given an impression of great majesty. The tips of the crown, probably leafy fleurons, the top of the Virgin's scepter, and other very small areas are missing but do not detract from the statue's extraordinary condition.

The Museum's statue is clearly related to the best Parisian models, in particular to the Virgin and Child from the Cathedral of Notre Dame, now in the church of St.-Germain-des-Prés. The Museum's Virgin stands almost vertically, her head slightly tilted. The Child holds the end of his mother's veil across her chest. Many other French Madonnas generally follow the same drapery formula. The Museum's statue is probably to be dated in the second quarter of the century, and is roughly contemporary with the Virgins from Notre Dame, from St. Denis (1340), and from Langres (1341).

Demmler, T., *Die Bildwerke des deutschen Museums, 3, Die Bildwerke in Holz, Stein und Ton Grossplastik.* Berlin and Leipzig, 1930, pp. 27, 28.

37.159 The Metropolitan Museum of Art, The Cloisters Collection, 1937.

153. Two Apostles
French, Rouen, second quarter of XIV century
Stained glass
Height: 10⅜ inches; Width: 8⅛ inches

The elegance and charm of these two small figures are characteristic of the stained glass of the School of Rouen in the second quarter of the fourteenth century. A style described as purely French, it is derived from the great book illuminators of the early fourteenth century, Master Honoré and Jean Pucelle. Although the exact provenance of this piece is unknown, the delicacy of the drawing, as revealed in the skillful applications of silver stain for delineation of hair and beard, the intricately worked patterns of ornament, and the sinuous folds of the drapery suggest that Rouen is the source. Small adjunct figures such as these two Apostles were characteristic of Rouen glazing of this period. They appeared in superposed niches flanking large scenes or in the pinnacles above or the socles below the major figures. They serve, within the composition of a window, the same function of enlivenment as do the *bas-de-page* illustrations in contemporary illuminated manuscripts.

Grodecki, L., "Les Vitraux de Rouen." *Les Monuments Historiques de la France,* n.s., No. II, 1956, p. 105.

69.236.1 The Metropolitan Museum of Art, The Cloisters Collection, 1969.

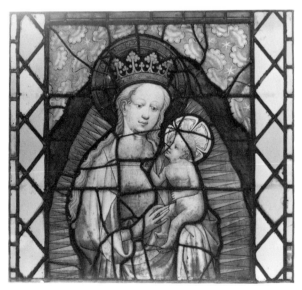

154. Madonna and Child
Follower of the Veronica Master
German, Cologne School, 1420–1430
Stained glass
Height: 62 inches; Width: 46¾ inches
Church of Corpus Christi, Cologne

This Virgin, recently identified as belonging originally to the so-called *Gnadenstuhl* window, is shown as in the Apocalyptic vision of Saint John, robed in the sun with the moon beneath her feet and surrounded by stars. A close stylistic relationship between panel and glass painting is characteristic of the School of Cologne in the fifteenth century. The designer of this window is thought to have been a follower of the Saint Veronica Master, the leading Cologne painter of his time, whose influence is to be seen in the soft trailing folds of drapery and in the delicately modeled features of the two heads. The use of white glass for the figures, derived probably from Flemish panel painting, is another characteristic of the Cologne School. The refinement and elegance of style that the *Gnadenstuhl* master achieved was never to be surpassed in Cologne glass painting.

Hayward, J., "Stained Glass Windows from the Carmelite Church at Boppard-am-Rhein." *The Metropolitan Museum Journal,* Vol. II, 1969, pp. 106–12.

41.170.93 The Metropolitan Museum of Art, Bequest of George D. Pratt, 1941.

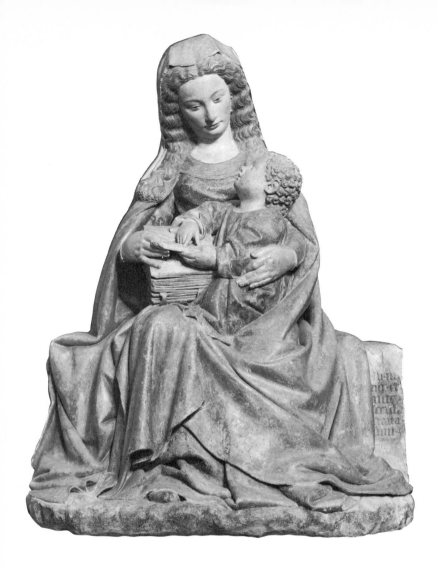

155. Virgin and Child
French, Burgundian School, XV century
Limestone, painted and gilded
Height: 53¼ inches; Width: 41½ inches

The Virgin, seated on a cushioned bench, holds the Christ Child on her left
knee. The Child gazes up at her and touches a page of the open book which
she carries in her right hand. A careful cleaning revealed an inscription at the
right of the bench which translates "from the beginning, and before all ages,
was I created." The group was originally bright with polychromy, and like many
medieval cult statues was probably repainted more than once. The Virgin's
veil was white and her hair gilded. Her blue and gold mantle, lined with red,
falls naturalistically in voluminous folds over a blue gown which shows traces
of a later application of red paint. The Child's dress, originally green, was
repainted with red and blue.

This group shows extremely close stylistic similarities to a large standing
Madonna found in the church of St. Hippolyte in the town of Poligny and may
well be a work by the hand of the same artist. The Museum's group is
distinguished by the convincing naturalism of the figures and the intimacy of
the relationship. The emotional immediacy along with the heavy plasticity of
the drapery are typical of Burgundian sculpture.

Rorimer, J. J., "A Statue of St. John the Baptist Possibly by Claus Sluter."
The Bulletin of The Metropolitan Museum of Art, Vol. XXIX (November, 1934),
pp. 192–95.

33.23 The Metropolitan Museum of Art, Rogers Fund, 1933.

Islam: Miniatures, ca. 1300–ca. 1600

The art of the illustrated book was more highly developed in Persia than in any other Islamic area, developing in the wake of the Mongol invasion of the early thirteenth century. The major schools of Persian miniature painting flourished in successive capitals: Shiraz, Herat, then Tabriz, though there were other regional centers such as Qazvin. The Mughal emperors introduced miniatures in the Persian manner into India, where they were soon adapted to Indian taste.

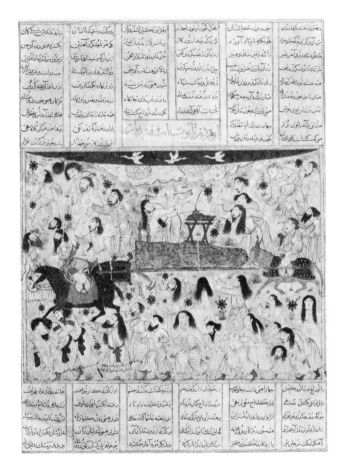

156. Illustration from a Copy of the Shah-Nameh by Firdausi
Iran, Il-Khanid Period, 1330–1350
Gouache on paper
Height: 16 inches; Width: 11⅝ inches

This wash drawing of the funeral of a prince illustrates the end of one of the most dramatic and tragic episodes in the Persian national epic, culminating in the death of Prince Isfandiyar. It is a page from one of the numerous manuscripts of the *Shah-Nameh* or *Book of Kings*, which was composed in the late tenth century by the poet Firdausi. The manuscript from which our page comes was undoubtedly made in Tabriz at the court of the First Mongol Dynasty of Iran before the middle of the fourteenth century.

The wild grief of the mourners for the prince in this miniature of his funeral procession shows an intensity of emotion only found in this manuscript and never again attempted in Persian painting. After this, gesture and stance are used to symbolize emotion, but never facial expression to portray it, and never again is there such individuality or sense of immediacy in the painting of figures as are exhibited here.

The new Mongol overlord had brought to Iran the art of the Far East, and its influence is evident here in the pastel tones and the linear quality of the drawing.

Brian, D., "A Reconstruction of the Miniature Cycle of the DeMotte Shah Namah." *Ars Islamica*, Vol. VI, 1939, No. 22.

33.70 The Metropolitan Museum of Art, Joseph Pulitzer Fund, 1933.

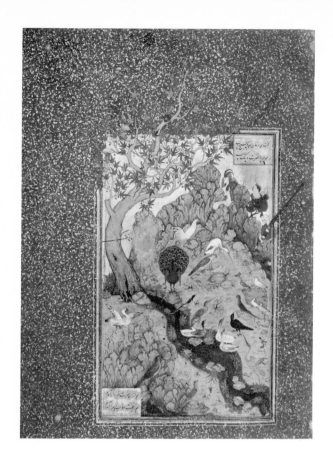
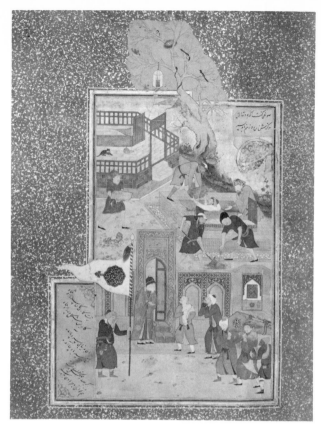

**157. The Language of the Birds and
Funeral Procession and Burial Preparation
from a Copy of the Mantiq al Tayr by Farid al-Din Attar**
School of Bihzad, perhaps by Bihzad
Iran, Herat
Colors, silver and gold on paper
Height: 9¾ inches; Width: 5½ inches
Dated 888 A.H./A.D. 1483

The painters of the School of Bihzad, at Herat, were unsurpassed in the
delicacy of their drawing, pureness of color and attention to detail, while still
incorporating the conventions of Persian painting developed earlier in the
fifteenth century, basic to which was the tilting of the picture plane so that
the distant horizon appeared at the top of the picture space, thus enabling all
the components of the painting—each shown in its most characteristic aspect—
to be equally visible. While thus adhering to the conceptual ideals of their
predecessors, the Bihzadian artists broadened their vision by a new interest in
the workaday world and its inhabitants.

Mourning and funeral scenes were a theme that allowed Persian painters to
express an awareness of the universality of death and, by extension, its
equalizing qualities (see No. 156). The mystic poets, such as the author of the
text illustrated here, by emphasizing the uncertainties of life and the ubiquitous
presence of death, encouraged their readers to turn away from worldly follies
toward the mystic Sufi philosophy.

Lukens, M. G., "The Language of the Birds, the Fifteenth Century Miniatures."
The Metropolitan Museum of Art Bulletin, Vol. XXV, (May, 1967), pp. 317–38.

63.210.11,35 The Metropolitan Museum of Art, Fletcher Fund, 1963.

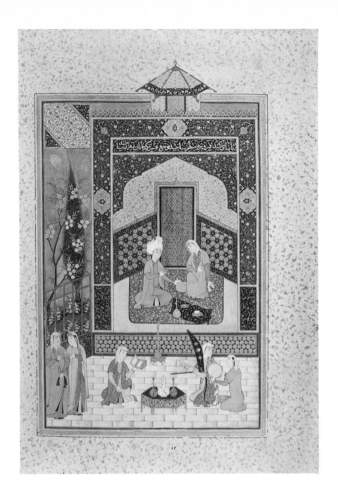

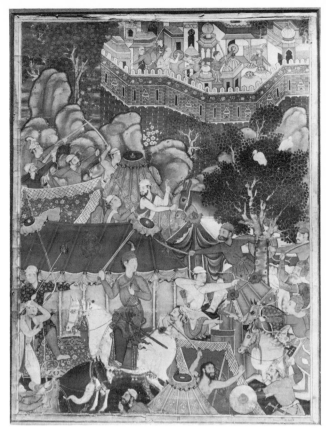

**158. Bahram Gur with the Princess of Khwarezm
in the Turquoise Palace on Wednesday.
From a Khamseh of Nizami**
Iran, Tabriz, Safavid Period
Colors and gilt on paper
Height: 7¼ inches; Height with cupola: 8 inches;
Width: 8⅝ inches
Dated 931 A.H./A.D. 1524–1525

This miniature illustrates a story from the romantic epic, the *Haft
Paykar* or *Seven Portraits*. It concerns the education and deeds of
an ideal ruler modeled on the Sasanian king, Bahram Gur. The
king marries seven princesses and visits each in her separate
pavilion one day a week.

This miniature painting is an exquisite example of the court style
of the first ruler of the Safavid Dynasty of Iran, Shah Ismail (1501–
1524) as it developed in his capital of Tabriz. The essential
ingredients of the Herat School of Bihzad (see No. 157) are
retained while a more lyrical tone and decorative emphasis are
apparent.

Jackson, A. V. W., and Yohannan, A., *A Catalogue of the Collection
of Persian Manuscripts Including some Turkish and Arabic Presented to
The Metropolitan Museum of Art.* New York, 1914, pp. 58–66.

13.228.7, fol. 224 B The Metropolitan Museum of Art, Gift of
Alexander Smith Cochran, 1913.

**159. Assad Ibn Karibe Attacks the Army of Iraj Suddenly
by Night. From the Dastan-I Amir-Hamzeh (Hamzeh-Nameh)**
India, Mughal Period, first half of the period of Akbar,
1556–1605
Tempera colors and gilt on cotton cloth, mounted on paper
Height: 27 inches; Width: 21¼ inches

The relatively few surviving paintings from the original fourteen
hundred illustrations of this manuscript about the adventures of
an uncle of the Prophet are among the most remarkable and
impressive in the whole history of Islamic painting. The manuscript
was illustrated under the auspices of Emperor Akbar (1556–1605),
during whose reign the essentials of the Mughal style of painting
developed as a result of the fusion of styles from existing Indian
cultures (Muslim, Hindu, and Jain) with that imported from Safavid
Iran, modified by an influence from European painting. In
broadest terms, compared to Persian painting, Mughal painting
possesses a greater realism and keener observation of nature,
more vigorous action and more robust forms, a warmer color
range and a love of rich color and sumptuous display.

Comstock, H., "The Romance of Amir Hamzah." *International
Studio*, Vol. LXXX, 1925, pp. 349–57.

18.44.1 The Metropolitan Museum of Art, Rogers Fund, 1918.

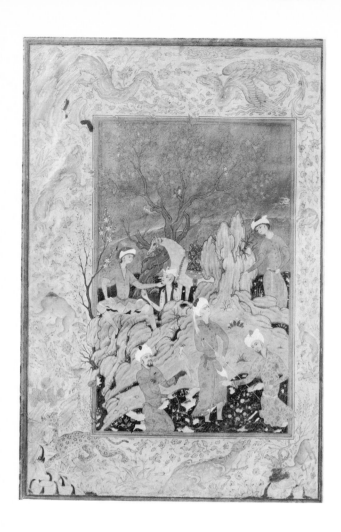

160. Miniature Painting: A Princely Hawking Party in the Mountains
Iran, Qazvin, *ca.* 1580
Colors and gilt on paper
Height: 18⅝ inches; Width: 12¾ inches

In the late sixteenth century, centered in the city of Qazvin, a style developed influenced by the work of the celebrated painter Muhammadi, of which this miniature is a prime example. Elegant and somewhat mannered, the tall and willowy figures seem to sway as they turn in their languorous poses. The landscape, with its softly curving contours of rock, its swaying trees and delicate flowers, echoes the figures. The brilliant coloring of the painting, spilling over into the margin, contrasts with the gold and silver wash drawing of the margin, inhabited by fantastic and real animals and birds amid rocks and foliage. The ferocity implied by their forms and actions contrasts with their soft color tones, as the relaxed and elegant attitude of the resting figures in the miniature proper is in contrast to their pastime—the merciless and swift sport of kings—the falcon hunt.

Gray, B., *Persian Painting.* Geneva, 1961, pp. 158–59.

12.223.1 The Metropolitan Museum of Art, Rogers Fund, 1912.

Iran (Persia):
Saljuq, 1037/1038–1258
Il-Khan, 1206–1353
Timurid, 1369–1500
Safavid, 1502–1736

The Saljuq Turks carved out an empire in Anatolia and the Near East which disintegrated in the hands of local Saljuq commanders. They were defeated by the Mongols whose successors, the Il-Khans, were in turn routed by the usurper Tamerlane (or Timur). Only with the Safavid Dynasty did Persia return to native rule.

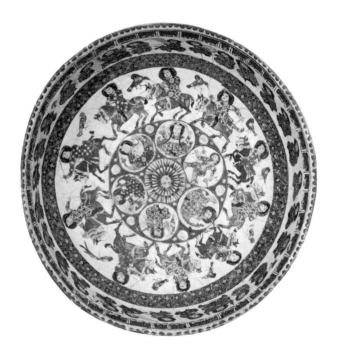

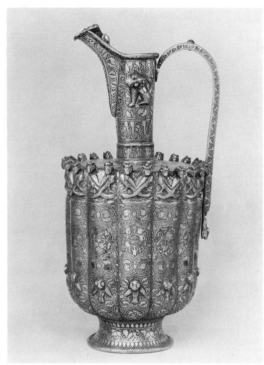

161. Bowl—So-called "Minai" Ware
Iran, XII–XIII century
Polychrome and gilt overglaze painted paste
Diameter: 7⅜ inches; Height: 3¹¹⁄₁₆ inches

In the late twelfth and early thirteenth centuries, Iranian ceramists devised a new technique of pottery decoration which assured them of a wide range of bright, pure colors, and which also permitted much greater delicacy and detail. Practiced in Rayy and Kashan and also perhaps in Sava, this new technique involved subjecting the piece to two firings. Before the first firing, the background glaze and those colors able to withstand high temperatures were applied; then the rest of the design was executed in less stable colors and the vessel was refired at a much lower temperature.

This extremely finely potted bowl is a beautiful example of this so-called "minai" or enameled pottery and its central astrological design, showing representations of Saturn, Jupiter, Venus, Mercury, Mars, the Moon, and the Sun, illustrates a motif that enjoyed great popularity in Muslim art throughout its history.

Pope, A. U., "Ceramic Art in Islamic Times. A History." *Survey of Persian Art,* Vol. II, London-New York, 1939, p. 1565.

57.36.4 The Metropolitan Museum of Art, Gift of the Schiff Foundation and Rogers Fund, 1957.

162. Ewer
Iran, Khorasan, Saljuq Period, early XIII century
Bronze, inlaid with silver and gold
Height: 15½ inches

This outstanding example of inlaid bronze from the Saljuq Period in Iran (1037/8–1258) epitomizes the fine metal workmanship so characteristic of the period.

The body of the ewer is covered with an elaborate interlace design, with animal-headed terminals, serving as a frame for twelve medallions containing the twelve signs of the zodiac—a highly popular motif in Islamic art.

Several inscriptions on the shoulder and neck—all but one executed in human-headed Naskhi script—express good wishes to the owner, a common subject of the epigraphic decoration on Islamic metalwork in all periods.

Dimand, M. S., "Saljuk Bronzes from Khurasan." *The Bulletin of The Metropolitan Museum of Art,* n.s., Vol. IV, 1945, pp. 87–92.

44.15 The Metropolitan Museum of Art, Rogers Fund, 1944.

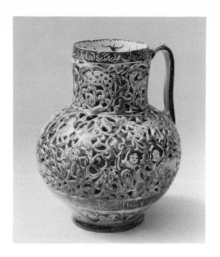

163. Reticulated Jug
Iran, Kashan
Underglaze, painted paste
Height: 8 inches
Dated 612 A.H./A.D. 1215–1216

In the late twelfth century, the potters in Saljuq Iran began making their vessels of an artificial paste and glazing them with an alkaline glaze consisting, basically, of the same ingredients as the body. Since designs painted under an alkaline glaze did not run during firing, this innovation gave rise to the development of free painting under the glaze, which had not been possible with the earlier tin glazes fluxed with lead. Furthermore, since the body and glaze consisted of the same material, there was a complete fusion of the two during firing and thereby any later separation of the glaze from the body was prevented.

Perhaps one of the most technically as well as aesthetically beautiful examples of underglaze painted ware ever created by Muslim ceramists is this double-walled jug with a reticulated outer wall.

Lane, A., *Early Islamic Pottery.* London, 1947. Pl. 83B.

32.52.1 The Metropolitan Museum of Art, Fletcher Fund, 1932.

164. Bowl
Iran, Kashan, XIII century
Glazed and luster-painted paste of glass frit, powdered silica, and white plastic clay
Diameter: 19⅝ inches; Height: 4⅜ inches

One of the greatest discoveries, as well as contributions, of the Muslim craftsmen was the technique of luster painting on pottery, first employed for ceramic decoration in ninth-century Iraq. From here, the technique spread west to Egypt and then east to Syria and Iran, reaching its apogee in twelfth- and thirteenth-century Saljuq Iran in the two pottery-producing centers of Rayy and Kashan. Production of this ware in the latter center continued at least until the middle of the fifteenth century.

Contemporary with this later Kashan production was the luster-painted pottery of Nasrid Spain, from whence the technique spread to France, England, and eventually America. This type of pottery was also produced in seventeenth-century Safavid Iran, but in all of these later production centers, the technique never reached the height attained in Saljuq Iran.

This very large plate, made in Kashan in the thirteenth century, is indicative of the high level of perfection attained by the Iranian ceramists of this period.

Wilkinson, C. K., *Iranian Ceramics.* New York, 1963, Pl. 58.

32.52.2 The Metropolitan Museum of Art, Fletcher Fund, 1932.

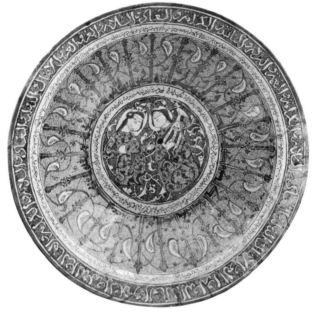

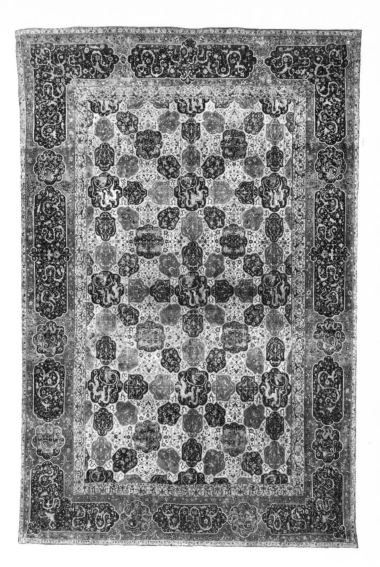

165. Basin

Probably Iran, early XIV century
Brass inlaid with silver and gold
Height: 5⅛ inches; Diameter: 20⅛ inches

This basin with its unusual gadrooned rim and bulbous body is one of
the most ambitious and complex figural pieces of Islamic metalwork.
The entire form was raised from a single sheet of brass, the interior of
which was engraved and inlaid with silver (chased *in situ*) and gold,
creating a polychrome effect. Represented on the interior are 106
well-defined human figures and an equal number of fantastic creatures
(sphinxes and griffins). The overall design radiates from a central
eighteen-pointed star, the arms of which are extended in an interlace
pattern to form a series of medallions and roundels within which are
contained the human figures: enthroned personages, hunters, musicians,
and revelers.

Scerrato, U., *Metalli islamici*. Milan, 1966, pp. 108–18.

91.1.521 The Metropolitan Museum of Art, The Edward C. Moore
Collection, Bequest of Edward C. Moore, 1891.

166. Compartment Rug

Northwestern Iran, probably Tabriz, first quarter XVI century
Cotton and silk warp, silk weft, wool pile
Length: 16 feet, 4 inches; Width: 11 feet, 2 inches
676 knots per square inch

The carpets woven in Safavid Iran have a greater affinity with miniature
painting and manuscript illumination than with the angular, textile-like
patterns of earlier rugs from this country, known to us only from
manuscript illustrations, or with rugs made in Egypt, Turkey, the
Caucasus region, and Turkestan. In fact, their designs are so close to
the art of the book that it seems quite probably that painters were
commissioned to execute the patterns for the Safavid weavers to follow.

This so-called "compartment" rug (of which only one-half or two-thirds
of the original length is preserved here) was probably made during the
period of Shah Isma'il (1502–1524) in the northwestern region of the
country and belongs among the very finest of the Persian rugs of the
early Safavid Period.

Erdmann, K., *Der Orientalische Knüpfteppich*. Tübingen, 1955.

10.61.3 The Metropolitan Museum of Art, Hewitt Fund, 1910.

Section V: ca. 1400–ca. 1600

1415	English defeat French at Agincourt
ca. 1420	Oil paints came into general use
1421	Peking established as capital of China
1431	Joan of Arc burned in Rouen
1435	Alberti writes *della Pittura*, treatise on Renaissance painting

1453	Fall of Constantinople to Mohammed the Conqueror
1456	Gutenberg prints Bible with movable type
1492	Columbus reaches New World
1498	Leonardo paints *Last Supper* in Milan

1511	Vitruvius' *De Architectura* republished
1517	Luther's 95 Theses; beginning of Reformation
1519	Cortez conquers Aztecs
1519–1522	Magellan circumnavigates the world
1526	Mogul Empire founded, end of Medieval Period in India
1527	Sack of Rome by Hapsburg Emperor, Charles V; marks end of High Renaissance
1531–1535	Pizarro conquers Peru
1534	Foundation of Jesuit Order
1542–1543	Portuguese first Europeans to visit Japan
1543	Publication of Copernicus' theory that the planets orbit the sun
1545–1563	Council of Trent begins Counter Reformation
1550	Vasari writes *Lives of Artists*
1573–1615	Momoyama Period; beginnings of military dictatorship and isolationism in Japan
1579	Sir Francis Drake lands in California
1588	Spanish Armada defeated by the English
1597	First opera *Daphne* composed by Rinuccini and Peri
1597	British punitive expedition brings Benin Kingdom to an end

West West West Far East

1400

181. Sassetta,
Italian

204. Campin,
Flemish

253. Chinese,
XV century

1450

239. Dürer,
German

200. Lombardo,
Italian

1500

219. Michelangelo,
Italian

214. Bronzino,
Italian

1550

210. Titian,
Italian

216. El Greco,
Spanish

257. Chinese,
1368–1644

1600

Northern Europe: Late Gothic

Both art and society were in a state of flux toward the end of the Middle Ages. After about 1400, the Gothic trend toward sophistication reached a climax in a phase called the International Style because of its remarkable uniformity throughout northern Europe. A new medium, oil painting, and a growing familiarity with the discoveries of the early Renaissance in Italy made possible the expression of a complex artistic spirit that demanded "picturesque" effects and that fused the emotionalism surviving in German Gothic devotional art with the realism of Flemish and Italian painters.

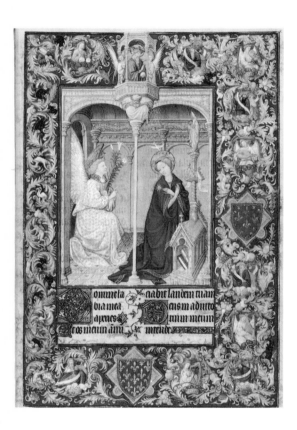
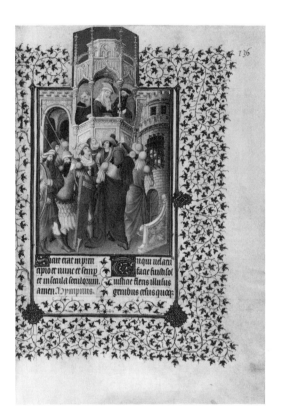

167. Les Belles Heures de Jean de France, Duc de Berry
Paul, Jean, and Herman Limbourg
North France or Netherlands, 1410–1413
Parchment
6⅝ x 9⅜ inches
224 folios

This book is identified by an inscription on the first page as the property of Jean, Duke of Berry, the brother of Charles V of France and perhaps the greatest art patron of the Middle Ages. It contains numerous prayers for use in daily private devotion and for special occasions, and is illustrated by 172 miniatures, of which 94 are full-page pictures. The book was painted by the Limbourg brothers, probably in 1410–1413, or just before they began their best known work for the Duke, the *Très Riches Heures,* today at Chantilly. The high quality demanded by the duke is evident at a glance in the perfect vellum, the exquisite and unusual decoration, and above all in the luminous, vibrant paintings. The Limbourg style, like that of the contemporary Boucicault *atelier,* shows a Parisian basis that integrates selected inventions of contemporary Dutch and Italian painting. As the narrative unfolds page after page, the quiet clarity of disposition and restraint in gesture seen in each picture cumulatively attain an almost awesome religious quality, at once delicate and profoundly moving.

Meister Franke und die Kunst um 1400. Exhibition Catalogue, Hamburg, Kunsthalle, August 30–October 19, 1969, p. 72, No. 38.

54.1.2 The Metropolitan Museum of Art, The Cloisters Collection, 1954.

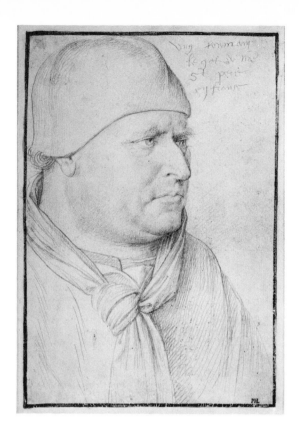

168. Portrait of an Ecclesiastic

Jean Fouquet
French, *ca.* 1415/1420–1481
Metalpoint and a little black chalk on white prepared paper
Height: 7¹³⁄₁₆ inches; Width: 5⁵⁄₁₆ inches

The artist has given us a clue to the identity of the model of this powerful drawing in an inscription that can be translated "A Roman, legate of our Holy Father in France." Henri Boucnot suggested that the legate was Teodoro Lelli, Bishop of Treviso, who in 1464, at the age of forty, accompanied the Bishop of Ostia to France on a mission to Louis XI. Few drawings by Fouquet are known; the only absolutely certain one is the chalk head of Guillaume Jouvenel des Ursins in the Berlin print room. The Metropolitan's is stylistically compatible with the Berlin drawing, and has been almost universally accepted as the master's work.

Ring, Grete, *A Century of French Painting 1400–1500*. London, 1949, No. 319.

49.38 The Metropolitan Museum of Art, Rogers Fund, 1949.

169. Illuminated Page From the Book of Hours of Etienne Chevalier: Pentecost

Jean Fouquet
French, *ca.* 1415/1420–1481
Tempera on parchment
Height: 7¾ inches; Width: 5¾ inches

The book of hours from which this page comes was decorated about 1450–1460 by Fouquet for Etienne Chevalier, the treasurer of France under Charles VII and Louis XI. A vandal in the eighteenth century cut the book apart and the illuminated pages are dispersed in various collections, forty of·them in the Musée Condé at Chantilly. It is evident from the remaining pages that the book must have been a remarkable one, comparable in its wealth of precious illustrations to the great prayer books decorated earlier in the fifteenth century for the Duke of Berry. This page, that once accompanied the liturgy for the Vespers of the Office of the Holy Spirit, or Pentecost, shows the group of Apostles kneeling on the bank of the Seine, in the foreground, and behind them an accurate rendering of the city of Paris, dominated by the Cathedral of Notre Dame, but including many other recognizable· buildings.

Exposition de la Collection Lehman de New York. Paris, Musée de L'Orangerie, 1957, pp. 107 f., No. 152.

Robert Lehman Collection.

170. The Virgin and Child
German School
XV century, *ca.* 1430–1450
Woodcut; hand-colored, heightened with silver and gold
Height: 13 inches; Width: 10 inches

The earliest known woodcuts on paper date from about the first quarter of the fifteenth century. Very few, if any of them, were consciously made as works of art, their function and tradition determining their form. This exquisitely tender Virgin and Child marks one of the high points of folk art, in the best sense of the term. It is typical of the earliest devotional woodcuts that worshipers purchased at local shrines or during a pilgrimage. Since such prints were too cheap and common to preserve, very few of the thousands that were made have come down to us. Our unique impression is an exception of arresting beauty and majesty.

Schreiber, W. L., *Handbuch der Holzschnitte und Metallschnitte des XV Jahrhunderts.* Vol. II, Leipzig, 1926.

41.1.40 The Metropolitan Museum of Art, Gift of Felix M. Warburg and his Family, 1941.

171. Chapel-de-Fer and Bevor
French, Burgundian, *ca.* 1475
Steel
Height of helmet: 10⅜ inches; Length of helmet (front to back): 14⅝ inches; Weight of helmet: 6 pounds, 7 ounces; Weight of bevor: 3 pounds, 6½ ounces

The broadbrimmed *chapel-de-fer*—a translation in steel of a modest felt hat—was an alternative many a knight seems to have adopted when he felt stifled behind the visor of his closed helmet. But the open face necessitated the *bevor:* a special chin defense to protect the vital parts of throat and neck against lance thrusts glancing off and upward from the breastplate.

Fifteenth-century armor is unsurpassed in its functional beauty and aesthetic treatment of steel as material. The terse but free-flowing form combined with the simple embellishment of spiral fluting allow a glittering play of reflected light. It is an admirable example, though by an anonymous artisan, of the elegance of Late Gothic style.

Dean, B., *Catalogue of European Arms and Armor.* New York, 1905, fig. 50G.

04.3.228 The Metropolitan Museum of Art, Rogers Fund, 1904.
14.25.571 The Metropolitan Museum of Art, Gift of William H. Riggs, 1914.

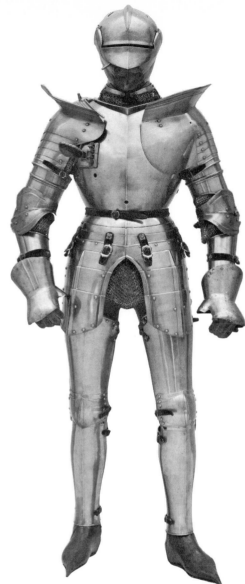

172. Armor

Italian, Milanese, *ca.* 1490
Steel, leather, velvet
Height: about 5 feet, 10 inches; Weight: 60 pounds

Plate armor was developed as a defense against the mail-piercing crossbow bolt and the bone-shattering force of heavy sword strokes. The skill and the ambition of armorers finally created a flexible shell that covered the entire body of the wearer, without impeding his mobility. In order to keep the weight within tolerable limits, the armorers relied less on thickness of metal than on well-designed glancing surfaces that were to deflect and to render harmless the impact of enemy weapons, be it lance, sword, or arrow. As a result, Gothic armor assumed a streamlined appearance that is greatly pleasing to our modern concept of functional beauty.

Milan was the most important armor-making center of the fifteenth century, and it can be safely assumed that a suit of armor of this quality could only come from a major Milanese workshop.

Nickel, H., *Warriors and Worthies; Arms and Armor Through the Ages.* New York, 1969.

14.25.718 a–n The Metropolitan Museum of Art, Gift of William H. Riggs, 1913.

173. Three Helpers in Need

Tilmann Riemenschneider
German, Franconian
Lindenwood
Height: 21 inches; Width: 13 inches
Made *ca.* 1494

Saints Christopher, Eustace, and Erasmus, here represented are three of the so-called Fourteen Helpers in Need. Each saint fulfilled a particular need, and, according to legend, if the faithful turned to them, aid would surely be given. This work has been attributed to one of the greatest late Gothic German sculptors, Tilmann Riemenschneider, primarily on the grounds of its stylistic affinities with documented works by him, particularly those of his early period (1490–1502). The sharp linear quality of the design, the complex interrelation of forms, and the Late Gothic severity of aspect make this piece a fine example of the work of this great master who lived and worked in Würzburg from 1485 until his death. Some scholars associate The Cloisters piece with a commission given Riemenschneider by Johann von Allendorf, the chancellor of the Bishop of Würzburg, to carve Fourteen Helpers in Need.

Ostoia, V. K., *The Middle Ages: Treasures from The Cloisters and The Metropolitan Museum of Art.* New York, 1970, p. 105.

61.86 The Metropolitan Museum of Art, The Cloisters Collection, 1961.

174. Calvary Scene
German, Upper Rhenish, 1495–1500
Carved lindenwood
Height: 37 inches

During the late fifteenth century, elaborate renditions of Christ's crucifixion on the hill of Calvary appeared with considerable frequency, particularly in the regions of Northern France, Belgium, and the Rhine. Because of its style and iconographical peculiarities, this exceptionally fine example, probably a fragment of an altarpiece, must be attributed to a workshop of the upper Rhine. Some scholars have seen a relationship between this Calvary scene and works by or attributed to the great late Gothic sculptor, Hans Wydyz, who was active in this region during the early sixteenth century. Though such a connection is difficult to confirm, The Cloisters' Calvary remains a superb example of late Gothic Rhenish wood sculpture.

Hoving, T. P. F., "In Search of a Rhenish Master." *The Metropolitan Museum of Art Bulletin*, n.s., Vol. XX (June, 1962), pp. 289–302.

61.113 The Metropolitan Museum of Art, The Cloisters Collection, 1961.

175. Eagle Lectern
Attributed to Aert van Tricht the Elder (Arnold of Maastricht)
Mosan
Brass
Height: 6 feet, 7½ inches; Width: 15½ inches
Made in Maastricht, *ca.* 1500

This lectern with its bold forms and original decoration, is traditionally associated with the Collegiate Church of Saint Lourain, in present-day Belgium, for which it is said to have been made about 1500. It is conceived as a tree with tendril-like branches in which we find various figures, including Magi, prophets seated with scrolls above Christ, Saint Peter, and Saint Barbara. The figures constantly direct our view to the eagle and to the book on his back. The king in front of the Virgin and Child, probably a nineteenth-century replacement, isolated from his traveling companions, may represent the donor as well as one of the adoring Magi.

Crab, J., "The Great Copper Pelican in the Choir." *The Metropolitan Museum of Art Bulletin*, n.s., Vol. XXVI (June, 1968), pp. 401–406.

68.8 The Metropolitan Museum of Art, The Cloisters Collection, 1968.

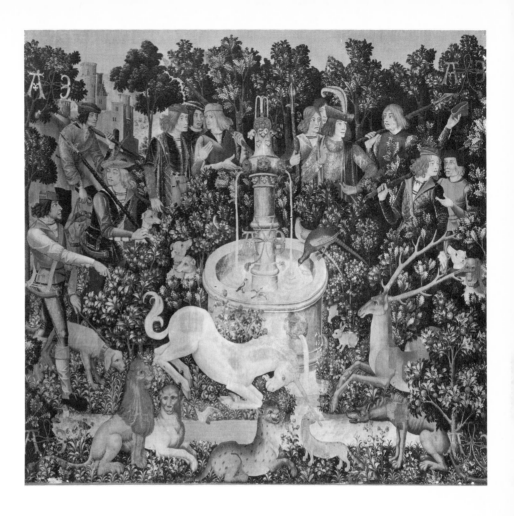

176. The Unicorn at the Fountain

Franco-Flemish, *ca.* 1500
Tapestry
Height: 12 feet, 1 inch; Width: 12 feet, 5 inches

This tapestry showing the unicorn surrounded at a fountain is the second in order in a series of seven devoted to the hunt of the unicorn. The first pictures the beginning of the hunt. The unicorn attempts to escape in the third, and in the fourth defends himself. Only a small fragment of the fifth remains, illustrating the best-known part of the legend, which tells how the beast was captured when he rested his head in the lap of a virgin. The sixth tapestry shows the slain unicorn brought back to the castle, and in the seventh he is resurrected, enclosed in a garden under a pomegranate tree.

The legend of the unicorn was a popular parallel to the Passion of Christ, embodying in its story the elements of rebirth, power, and purity. The kneeling unicorn, dipping his horn into the water, alluded to the popular belief that the horn of the unicorn had the gift of purifying.

The first and the last of the series were made around 1515. Many details have led to the traditionally held belief that the other five were made around 1500 to celebrate the marriage of Anne of Brittany to Louis XII. Anne had been left a widow when her first husband Charles VIII died in 1498, and, since her second royal marriage was looked on with some disfavor, it has been argued that the unicorn as a choice of subject for wedding tapestries was an attempt to associate her directly with the pure mythical creature and thus add an aura of sanctity to the marriage. Anne and Louis, furthermore, are identifiable throughout the series by their colors and pennants and the combination of the letters *A* and *E* joined by a cord, which appears frequently. This motif is associated with Anne and is one that is seen in manuscripts made for her.

Rorimer, J. J., *The Unicorn Tapestries.* New York, 1945.

37.80.2 The Metropolitan Museum of Art, Gift of John D. Rockefeller, Jr., 1937.

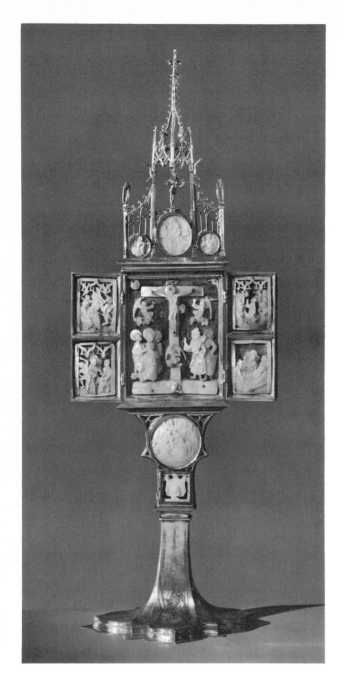

177. Triptych—Tabernacle
Austrian, Salzburg, 1494
Silver, parcel-gilt, mother-of-pearl, enamel
Height: 27⅜ inches; Width (open): 9⅞ inches

The tabernacle is exceptional in its high artistic quality and its full documentation. According to the archives of the Benedictine Monastery of Saint Peter of Salzburg, it was made in 1494 for Rupert Keutzl, abbot of the monastery, by the master goldsmith Perchtold (*Pertoldus aurofaber*). On the molding above the Last Supper is an inscription, RUDBERTI ABBATIS PERSTO EGO IUSSO SUO ("I stand by order of abbot Rupert"). The date 1494 appears below the angel holding the Sudarium, and twice on the base. Also on the base are shields with the arms of the monastery and of Abbot Rupert. Above the Saint Catherine on the base is a Salzburg silver mark. The mother-of-pearl carvings are typically Austrian. Few examples are as successful as these, in which the polished silver background brings out the lively silhouettes.

On the back, the ground behind the silver-gilt traceries at the top and the elegant openwork medallions above the Last Supper is blue enamel. If less spectacular than the front, the back and the base have excellent engravings, stylistically indeed the best work on the tabernacle. The scene of the Last Supper seems to be taken from an engraving by the Master J. A. M. Zwolle. The Flagellation and the Taking of Christ are free copies of engravings by Schöngauer. The tabernacle was most likely a shrine for the abbot's devotions in the privacy of his rooms.

Gómez-Moreno, Carmen, *Medieval Art from Private Collections*. New York, 1968, Cat. No. 145.

69.226 The Metropolitan Museum of Art, Gift of Ruth and Leopold Blumka (in commemoration of the Centennial of The Metropolitan Museum of Art), 1969.

Florence and Siena: Late Gothic

In the first half of the fourteenth century in Italy, advances made by painters set painting in the vanguard of the arts. In central Italy, two trends were set in the rival city-states of Florence and Siena by Giotto and Duccio, founders of two great traditions. Duccio in Siena, inheriting all of the dignity of Byzantine art, humanized it with his exquisite delicacy and his fine sense of decorative color. In Florence, Giotto made a more decisive break with late Medieval painting, bringing to his work a tremendous feeling for solidity and monumentality.

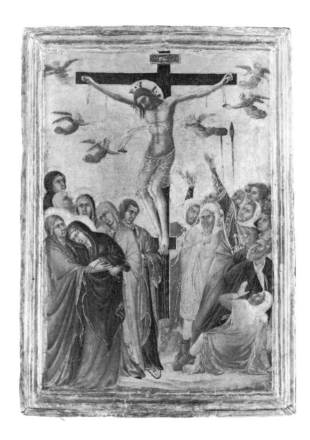 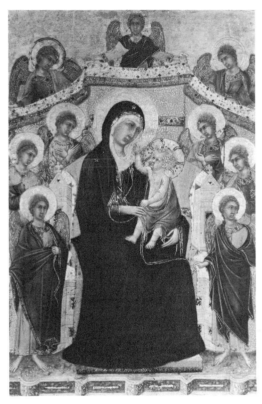

178a. The Crucifixion
A Painter from the Circle of Duccio
Sienese, active in the first quarter of the XIV century
Tempera and oil on wood
Height: 14⅝ inches; Width: 10⅝ inches

178b. The Virgin and Child Surrounded by Angels
A Painter from the Circle of Duccio
Sienese, active in the first quarter of the XIV century
Tempera and oil on wood
Height: 14⅝ inches; Width: 10⅝ inches

These panels form a diptych that most scholars ascribe to a painter who worked in the immediate circle of Duccio. For the tiny angels in The Crucifixion, reverently collecting the blood from the wounds of Christ, he was directly indebted to Duccio, the chief master of the Sienese School. In his own right this follower was an artist of the most exquisite refinement, with a remarkable ability to express concentrated and intense feeling.

Exposition de la Collection Lehman de New York. Paris, Musée de L'Orangerie, 1957, Cat. Nos. 16, 17.

Robert Lehman Collection.

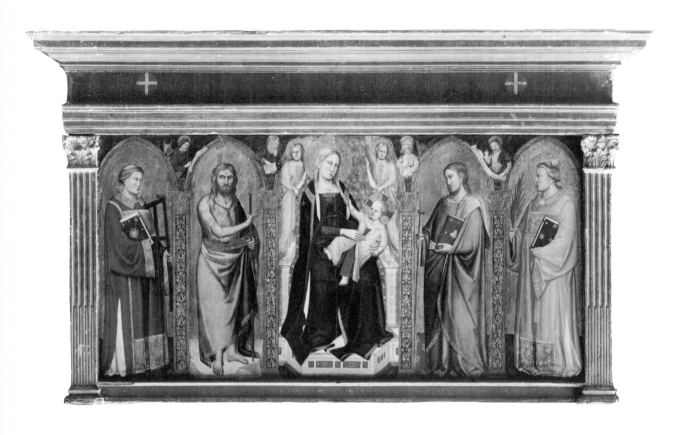

179. The Madonna and Child Enthroned with Saints
Taddeo Gaddi
Italian, active 1334–died 1366
Tempera on wood, gold ground
Height: 43¼ inches; Width: 90⅛ inches

Gaddi was a close follower of Giotto, whom he probably assisted in his late works. The monumental plastic figures of the Madonna and the four saints of this altarpiece, painted about 1340, show how advanced Gaddi was. The figures of the Evangelists in the spandrels, added when the altarpiece was extensively remodeled around the beginning of the sixteenth century, were painted by an unknown artist who had been trained in the workshop of Ghirlandaio.

Zeri, F., *A Catalogue of Italian Paintings.* Vol. I: *The Florentine School.*
New York, The Metropolitan Museum of Art, 1970.

10.97 The Metropolitan Museum of Art, Rogers Fund, 1910.

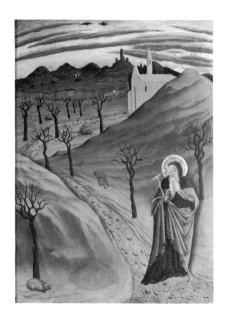
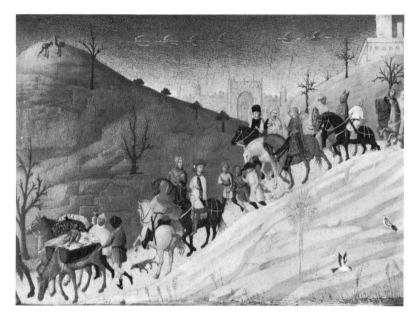

180. Saint Anthony Tempted in the Desert
Sassetta (Stefano di Giovanni)
Sienese, 1392?–1450/1451
Tempera and oil on wood
Height: 17¾ inches; Width: 13⅝ inches

When Saint Anthony retreated into the desert, the devils
tormenting him devised temptations with the glitter of worldly
goods, which are among the less well known of his ordeals. In
this picture he seems to have come upon the platter of silver and,
according to the Golden Legend, knowing that the devil had laid
it there to tempt him, declared that Satan should not have this
power. "Then the platter vanished away as a little smoke."
Sassetta has rendered the desert as a cold and arid Tuscan
landscape, with many small bare trees and a far horizon of low
hills behind Saint Anthony's monastery.

Exposition de la Collection Lehman de New York. Paris, Musée de
L'Orangerie, 1957, Cat. No. 48.

Robert Lehman Collection.

181. The Journey of the Magi
Sassetta (Stefano di Giovanni)
Sienese, 1392?–1450/1451
Tempera on wood
Height: 8½ inches; Width: 11⅝ inches

This panel was originally the upper part of an Adoration of the Magi
which is now in the Chigi-Saracini collection in Siena. The sprightly,
fashionable procession, in which a monkey rides in lordly style along
with the kings, has an anecdotal and intimate quality that declares
Sassetta's loyalty to the Gothic tradition in Siena long after the
Renaissance had captured nearby Florence.

Pope-Hennessy, J., *Sassetta.* London, 1939, pp. 17 ff., 80 ff.

43.98.1 The Metropolitan Museum of Art, Bequest of Maitland
Fuller Griggs, 1943.

182. The Expulsion from Paradise
Giovanni di Paolo
Italian, active from 1420–died 1482
Tempera and oil on wood
Height: 17¾ inches; Width: 20½ inches

Few artists of the fifteenth century worked in a style so personal
and individual as that of Giovanni di Paolo and few continued
at this date to disregard as he did nearly all the Renaissance
scientific discoveries. This panel is the fragment of a predella to
which the Museum's Paradise also belonged. Paradise is represented
at the right as a bright garden of flowers under a grove of trees
rich with fruit. Adam and Eve and the punishing angelic
messenger are delicate, sprightly little nudes, still astonishingly
Gothic almost a quarter of a century after Masaccio had given to
Florentines the majestic sculptural forms of the Brancacci chapel.
The great circle of the universe that the Almighty reveals to them
shows earth ringed round with ocean and the whole enframed
with the signs of the zodiac.

Exposition de la Collection Lehman de New York. Paris, Musée de
L'Orangerie, 1957, Cat. No. 20.

Robert Lehman Collection.

**183. Two Angle Supports Representing Four Angels Blowing the
Trumpets of the Last Judgment and the Tetramorph (Eagle Missing),**
Giovanni Pisano and Assistant
Italian
Carrara marble
Height of the tetramorph: 34¼ inches;
Height of the angle supports: 33½ inches
Probably from the Pulpit of the Cathedral of Pisa, 1302–1310

Giovanni Pisano (*ca.* 1250–1314) was trained by his father, the great sculptor
Nicola, with whom he collaborated in the pulpit of the Cathedral of Siena
(1265–1268) and the Fountain of Perugia (completed in 1278). Giovanni was one
of the great innovators of all time. Among his most important works are the
facade of the Cathedral of Siena, the pulpit for San Andrea, Pistoia, and the
pulpit for the Cathedral of Pisa. His style goes from the powerful, classic-
inspired compositions of the works he did with his father to the deliberate
turmoil in his late works. In these works the figures, contorted in nervous
contrapposto, seem to vibrate in a paroxysm of movement that comes closer in
feeling to the Baroque than to the Gothic style of his northern contemporaries.

The Pisa pulpit, from which these three sculptures are believed to have come,
was commissioned in 1302. It was dismantled in 1602, seven years after a great
fire in the church. When it was finally reassembled in 1926 by Peleo Bacci,
several component parts had been lost or scattered and the original arrangement
forgotten. The 1926 reconstruction as it now appears in the Cathedral of Pisa
is not entirely satisfactory, though the reliefs do correctly follow in chronological
sequence, and attempts have been made to find a more reasonable way of

combining them with the angle supports. The most convincing theory about the original appearance, advanced by G. Jászai (*Die Pisaner Domkanzel*, 1968), introduces some interesting changes. The two angle supports with angels are thought to have been placed at the outer sides of two reliefs in Pisa representing the Blessed and the Damned in the Last Judgment, which are separated by a figure of Christ as Judge. The four angels are worked in a style that emphasized expression and movement more than the form of the human body. Although this is typical of the late manner of Giovanni Pisano, it is very possible that they were finished by an assistant.

The Museum's third sculpture is the tetramorph of the Apocalypse, a symbolic representation of the four evangelists. The winged man symbolizing Saint Matthew is a standing figure, holding the book of the Gospel; at his sides, also holding books, are the lion of Saint Mark and the ox of Saint Luke. The eagle, the attribute of Saint John, would have been at the top to serve as a lectern for the reading of the Gospel during Mass. According to this suggested reconstruction, the winged man with the lion and the ox would have stood between the reliefs, still in Pisa, showing the Adoration of the Magi and the Presentation and the Flight into Egypt. The style of this sculptured tetramorph is quite close to that of the figure of Christ as Judge. This Christ and the tetramorph are a little too soft to be works by the master himself, and the hand of an assistant for both seems more than possible.

Ayrton, M., *Giovanni Pisano, Sculptor*. New York, 1969, pp. 223 ff.

Florence and Umbria: Early Renaissance

Florence flourished at the beginning of the fifteenth century as a center of banking, founded on her domination of the European wool trade. The Medici family, firmly established in power after 1434, were patrons of two generations of painters, sculptors, and architects. The Renaissance, a conscious revival of the aims and forms of antiquity, placed new emphasis on the dignity of the individual and on the role of the artist, no longer regarded as a mere craftsman. Architecture developed a severe and rational clarity, while painters expressed in two dimensions the same coherent volumes and rendered enclosed space by employing the new system of linear perspective. The new style rapidly took hold throughout central Italy. The heroic age of Florence drew to a close in the disorders following the invasion of Italy in 1494 by Charles VIII of France, which initiated four hundred years of foreign domination of the peninsula.

184. The Annunciation
Sandro Botticelli
Italian, *ca.* 1445–1510
Tempera and oil on wood
Height: 9⅜ inches; Width: 14⅜ inches

Botticelli's pronounced originality sometimes obscures the fact that he was a true Florentine, master of the great scientific observations and discoveries of the Renaissance. The architectural perspectives and the enclosed space in the Virgin's little oratory and in the antechamber through which the angel approaches are impeccably rendered. They do not, however, obscure the tense drawing and nervous concentration of the small typical figures exquisitely painted in the style that Botticelli developed about 1490.

Exposition de la Collection Lehman de New York. Paris, Musée de L'Orangerie, 1957, Cat. No. 5.

Robert Lehman Collection.

186. The Birth of the Virgin
The Master of the Barberini Panels
Italian
Tempera and oil on wood
Original size: Height: 57 inches; Width: 37⅞ inches
With added strips: Height: 59½ inches; Width: 39 inches

This panel and its companion piece in Boston representing the
Presentation in the Temple were once part of the decoration of a
wall in the Barberini Palace in Rome. Long ascribed to the
mysterious painter and architect Fra Carnevale, although no sure
works by him are known, they may have been painted by
Giovanni Angelo di Antonio, who is likewise without an identity
except through documents of the middle of the fifteenth century.
The painter of these exquisite panels, who displayed an unusual
interest in architecture and perspective, undoubtedly was
familiar with the works of Piero della Francesca and shows the
strong impression that had been made on him by Domenico
Veneziano and Fra Filippo Lippi.

*Zeri, F., Due dipinti, la filologia e un nome (il Maestro delle
Tavole Barberini).* Turin, 1961, *passim.*

35.121 The Metropolitan Museum of Art, Rogers and Gwynne
M. Andrews Funds, 1935.

185. The Last Communion of Saint Jerome
Sandro Botticelli
Italian, *ca.* 1445–1510
Tempera on wood
Height: 13½ inches; Width: 10 inches

The special character of his linear grace and gentle rhythms makes
Botticelli one of the most individual of the Florentine artists.
Toward the end of his life, he became a follower of Savonarola,
the impassioned reformer and preacher. It was at this time that
he painted this picture for another ardent disciple, imbuing it with
intense religious feeling and devotion.

Zeri, F., A Catalogue of Italian Paintings. Vol. I: *The Florentine
School.* New York, The Metropolitan Museum of Art, 1970.

14.40.642 The Metropolitan Museum of Art, Bequest of
Benjamin Altman, 1913.

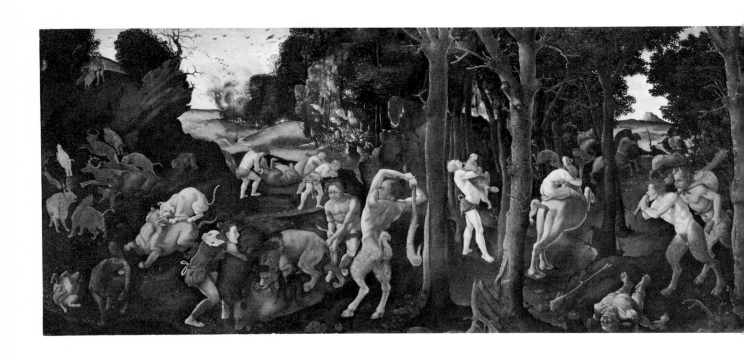

187. A Hunting Scene
Piero di Cosimo
Italian, 1462–1521?
Tempera and oil on wood
Height: 27¾ inches; Width: 66¾ inches

This panel and the *Return from the Hunt*, also in this Museum,
belong to a cycle illustrating the growth of civilization through
the control of fire. The scientific observation of natural forms and
the skill with which they are represented is typically Florentine.
The curious and bizarre aspects of the types and the subject
matter stem from the well-known eccentricity of the painter.

Zeri, F., *A Catalogue of Italian Paintings.* Vol. I: *The Florentine
School.* New York, The Metropolitan Museum of Art, 1970.

75.7.2 The Metropolitan Museum of Art, Gift of Robert Gordon,
1875.

**188a. Panel Showing the Annunciation to Zacharias,
the Visitation, and the Birth of Saint John the Baptist**
Francesco Granacci
Italian, 1469–1543
Tempera and oil on wood
Height: 31½ inches; Width: 60 inches

188b. Panel Showing the Preaching of Saint John the Baptist
Francesco Granacci
Italian, 1469–1543
Tempera and oil on wood
Height: 29¾ inches; Width: 82½ inches

These panels belong to a series that probably once decorated a room in a private house in Florence, quite possibly a house belonging to the famous Tornabuoni family. A third painting of the set, showing the *Childhood of Saint John,* is in the Walker Art Gallery in Liverpool, England, and there were probably two or three more panels with other scenes from the life of the Baptist that are customarily included in a series devoted to this patron saint of the city of Florence.

Francesco Granacci served his apprenticeship in the studio of

Domenico Ghirlandaio, the foremost teacher of his time in Florence. The young Michelangelo was his fellow student there, and both of them assisted their master in his most famous work, the decoration of the Tornabuoni chapel in the church of Santa Maria Novella. Throughout his career, Granacci remained in contact with Michelangelo, who was slightly younger than he, serving as the intermediary who introduced Michelangelo to the school of sculpture in the Medici Gardens and enjoying the distinction of being considered by Michelangelo as a potential helper on the project of painting the Sistine ceiling.

The very high degree of technical excellence imparted to all his pupils by Ghirlandaio is revealed in these panels by their extraordinary clarity and finish. They are superb examples of Renaissance work in an unusually fine state of preservation.

Berenson, B., *Italian Pictures of the Renaissance, Florentine School.* London, 1963, p. 98 (under Cape Town, South Africa).

1970.134.1,2 The Metropolitan Museum of Art, Purchase with special contributions and purchase funds given or bequeathed by friends of the Museum, 1970.

189. Study for a Projected Equestrian Monument to Francesco Sforza
Antonio Pollaiuolo
Italian, 1433–1498
Pen and brown ink, light-brown wash; dark-brown wash in background;
the outlines of horse and rider are pricked for transfer
Height: 11³⁄₁₆ inches; Width: 9⅝ inches

This drawing, executed between 1480 and about 1485, is
presumably a study by Pollaiuolo for the monument Ludovico
Sforza, Duke of Milan, planned to erect to the memory of his
father, Francesco Sforza. Leonardo da Vinci eventually made a clay
model, but it was destroyed during the French occupation of
Milan in 1499 and the bronze was never cast. It is thought that
the present drawing and a related study in the Graphische
Sammlung at Munich were once owned by Vasari.

Berenson, B., *I Disegni dei Pittori Fiorentini*. Milan, 1961, No.
1098A, Fig. 75.

Robert Lehman Collection.

190. A Kneeling Humanist Presented by Two Muses
Francesco di Giorgio di Martino
Italian, 1439–1502
Sienese School
Pen and brown ink, brown wash, and blue gouache, on vellum
Height: 7¼ inches; Width: 7⅝ inches

This drawing was first attributed to Francesco di Giorgio in the
1950's by Philip Pouncey, then Deputy Keeper of Prints and
Drawings of the British Museum.

The central devotional figure brings to mind the figure of Saint Thomas
in Francesco di Giorgio's *Nativity* in the Pinacoteca, Siena, a signed
painting of 1475; the same is true of the female figure on the left in
the drawing and the saint at the right rear of the painting. Pouncey
has proposed that this drawing could have been the model for an
illusionistic painting of a donor to be placed high on a wall opposite
a painting of the Madonna and Child of the donor's benefaction.

Bean, J., and Stampfle, F., *Drawings from New York Collections.*
Vol. I: *The Italian Renaissance.* 1965–1966, Cat. No. 10.

Robert Lehman Collection.

191. Battle of Naked Men
Antonio Pollaiuolo
Italian, 1433–1498
Engraving
Height: 15⅝ inches; Width: 23¼ inches
(sides not squared; largest overall measurement)

The *Battle of Naked Men* is the only known print by the great Florentine painter and sculptor, Antonio Pollaiuolo. One of the most celebrated of all engravings, it is the first print which can be regarded pictorially as a major work of art. While it is perhaps the finest anatomical study of the fifteenth century, displaying the plastic quality of great monumental art, it is at the same time one of the great seminal influences in the history of the decoration of flat surfaces. Its great pattern and the nervous intensity of its draftsmanship entitle it to a position among the extraordinary manifestations of the Florentine spirit.

Richards, L., "Antonio Pollaiuolo: Battle of Naked Men." *The Bulletin of the Cleveland Museum of Art,* Vol. LV (March, 1968), pp. 63–70.

17.50.99 The Metropolitan Museum of Art, Joseph Pulitizer Bequest, 1917.

192. Madonna and Child with Angels
Antonio Rossellino
Italian, 1427–1479
Brownish marble, with partially gilt details
Height: 28¾ inches
Carved about 1455–1460

Antonio Rossellino was trained in the shop of his older brother, Bernardo, along with others of the gifted generation that included Desiderio da Settignano and Mino da Fiesole. The Altman relief is likely to date even before the start of his first large datable work, the tomb of the Cardinal of Portugal in S. Miniato, begun in 1461. It has a certain naïveté in the densely packed surface decoration, which was to be eliminated by subtle changes throughout the later works. The exacting description of surfaces is in fact extraordinary in sculpture at this or any other time: the halos and the Virgin's hem are picked out in gold, and the mottled marble itself works in conjunction with the carving to make the piece wonderfully varied.

Pope-Hennessy, J., *Italian Renaissance Sculpture*. New York, 1958, pp. 38, 301.

14.40.675 The Metropolitan Museum of Art, Bequest of Benjamin Altman, 1914.

193. Lamentation over the Dead Christ
Italian, Faenza
Majolica
Height: 29½ inches; Length: 64 inches
Dated 1487

No other three-dimensional group in majolica as large and fine as this survives, and it is one of the earliest dated works in the history of majolica. It is of unparalleled splendor and interest as sculpture. The high brilliance of its glazes notwithstanding, it was probably not designed by a ceramist, but by a sculptor or painter. The figure style makes one think of the sculptor Sperandio or the painter Ercole de' Roberti. It is related in type to the Lamentation groups in terracotta made in Emilia and the Romagna, and like them expresses popular religious imagery, but with a more courtly tone.

Ballardini, G., *Le Maioliche datate fino al 1530*. Rome, 1933.

04.26 The Metropolitan Museum of Art, Rogers Fund, 1904.

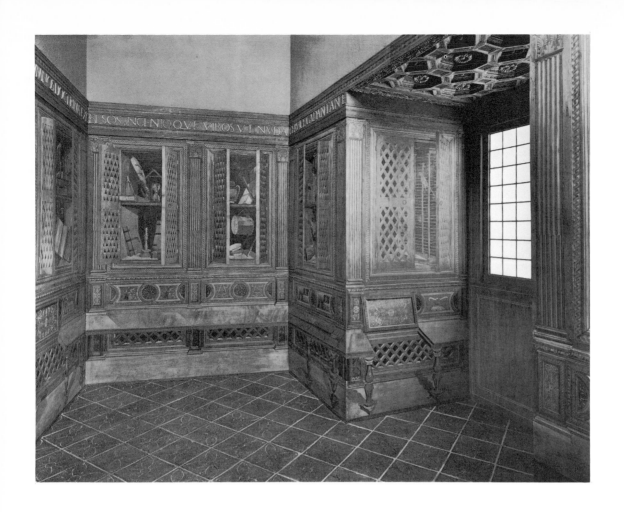

194. Study From the Palace of Duke Federigo da Montefeltro at Gubbio
Possibly designed by Francesco di Giorgio (1439–1502) and others, and
executed by Baccio Pontelli (about 1450–1492) with assistants
Italian, *ca.* 1476–1480
Mosaic of walnut, beech, rosewood, oak, and fruitwoods inlaid on a base of walnut
Overall height: 15 feet, 11 inches; Width: 12 feet, 7 inches; Depth: 17 feet

This small room *(studiolo),* intended for meditation and study, was only large
enough to accommodate a table and chair. Its walls are carried out in a
technique of wood-laying known as *intarsia* in which ingenuity has been
lavished upon a variety of *trompe-l'oeil* images that seem to project from the
flat planes of this paneling. The latticework doors of the cabinets, shown open
or partly closed, are evidence of the great interest taken in linear perspective
at the time. The cabinets contain objects reflecting Duke Federigo's wide-
ranging interests, including many musical instruments, a number of scientific
instruments and tools, and some elements of armor. There are also fourteen
books, recalling the fact that it was Duke Federigo who compiled one of the
great libraries of his time. *Imprese* or emblems of the Montefeltro are also
represented in the *intarsia.* A similar *intarsia* room, still *in situ,* was carried
out for Duke Federigo's palace in Urbino.

Clough, C. H., "Federigo da Montefeltro's Private Study in His
Ducal Palace of Gubbio." *Apollo,* n.s., Vol. LXXXVI (October, 1967), pp. 278–87.

39.153 The Metropolitan Museum of Art, Rogers Fund, 1939.

Venice and Northern Italy: Early Renaissance

The aristocratic republic of Venice continued, throughout the fifteenth century, to draw commercial sustenance from trade with the East. But like all of Italy, it turned to Florence to keep abreast of new developments in art. A short distance from Venice, in the university town of Padua, a school of painting developed which exerted a widespread influence on Florentines as well as Venetians. There the Venetians learned to admire classical antiquity and to draw from it authentic details for the embellishment of their paintings. Architecture in Venice remained persistently Gothic, but her painters created atmospheric landscapes that laid the foundation for all later schools of landscape painting in Europe.

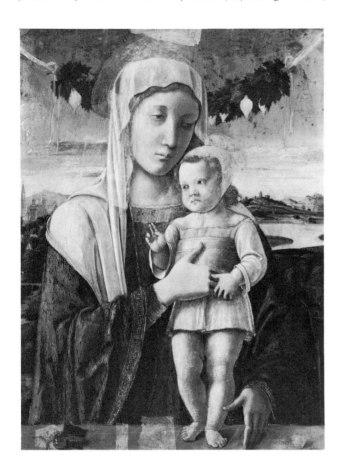

195. Madonna and Child
Giovanni Bellini
Venetian, active *ca.* 1459–1516
Tempera and oil on wood
Height: 21¼ inches; Width: 15⅜ inches

This painting of the Madonna and Child, solemn and moving in its depth of feeling and beauty of expression, is one of the important works from the early part of Giovanni Bellini's career. The decorative swag of fruit behind the Virgin's head and the distant landscape are elements that recall the School of Padua and especially Bellini's brother-in-law Mantegna, who exerted a strong influence on him in these early years.

Exposition de la Collection Lehman de New York. Paris, Musée de L'Orangerie, 1957, p. 2, Pl. XVIII.

Robert Lehman Collection.

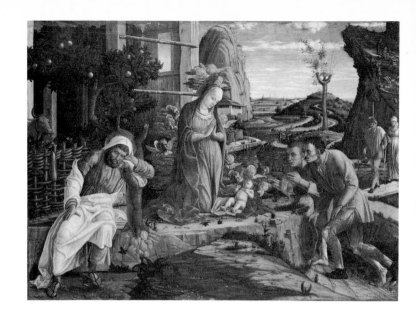

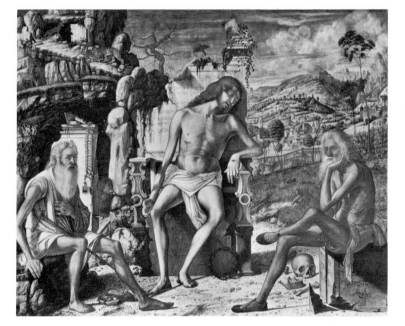

196. The Adoration of the Shepherds
Andrea Mantegna
Italian, *ca.* 1430–1506
Tempera on canvas, transferred from wood
Height: 15¾ inches; Width: 21⅞ inches

Mantegna received a long and careful training in Padua in the workshop of Squarcione, the foremost teacher of the North Italian Renaissance. Through his marriage to the daughter of Jacopo Bellini, he also came under strong Venetian influence. He was probably still a very young artist when he painted this Adoration, which reflects his Paduan training in its fine clear color, its precise drawing, and the decorative invention of its rock and plant forms. It also shows in its balanced monumental arrangement and in the grave, stately figures how much he admired the art of ancient Rome and the sculpture of the Florentine Donatello.

Wehle, H. B., *A Catalogue of Italian, Spanish, and Byzantine Paintings.* New York, The Metropolitan Museum of Art, 1940, pp. 126 f.

32.130.2 The Metropolitan Museum of Art, Anonymous Gift, 1932.

197. The Meditation on the Passion
Vittore Carpaccio
Italian, born *ca.* 1455; died between 1523 and 1526
Tempera on wood
Height: 27¾ inches; Width: 34⅛ inches
Signed (lower right): vjctorjs carpattjj/venetj opus

The dead Christ, reclining on a crumbling throne, is attended at the left by Saint Jerome, the church father who wrote a commentary on the Old Testament Book of Job, who is pictured at the right. This picture, which for many years bore the forged signature of Mantegna, is a late and rich example of Venetian mysticism.

Muraro, M., *Carpaccio.* Florence, 1966, pp. 160 ff.

11.118 The Metropolitan Museum of Art, Kennedy Fund, 1911.

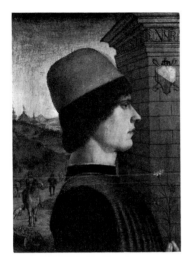
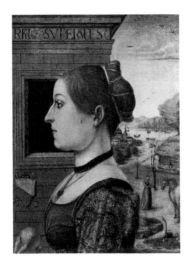

**198. Pair of Portraits: Alessandro di Bernardo Gozzadini
and Donna Canonici da Ferrara**
Attributed to Lorenzo Costa
Ferrarese, 1460–1535
Tempera and oil on wood
Each: Height: 19¾ inches; Width: 14¼ inches

This pair of portraits, formerly attributed to Francesco del Cossa, was undoubtedly painted in celebration of the betrothal or marriage of the young people represented. Both panels carry the coat of arms of the Gozzadini family on the architectural structure that unites the two pictures. The young man holds a spray of flowers and the lady a piece of fruit, probably an apple. The typically North Italian predilection for linear clarity has led the painter to show the two profiles in silhouette against the architecture.

Exposition de la Collection Lehman de New York. Paris, Musée de L'Orangerie, 1957, pp. 6 f., Nos. 7, 8.

Robert Lehman Collection.

199. Venus Embracing Cupid at the Forge of Vulcan
Francesco del Cossa
Italian, *ca.* 1435–1477
Ferrarese School
Pen and brown ink
Height: 11 inches; Width: 15⅞ inches

Since its introduction into literature by Roger Fry in 1906, this North Italian drawing has been most often associated with the frescoes of the Palazzo Schifanoia at Ferrara and the name of Cossa and his assistants. The drawing is thought to have been conceived as a pendant study for this fresco cycle which represents the tale of Venus and Vulcan. Vulcan's enclosure of Venus and Cupid on the little hill can be interpreted as a symbol of the marriage bond; the rabbits, fertility; the guardian peacock, marital fidelity; the embracing *putti,* mutual love. The bull at the upper left is the zodiacal sign of Taurus, which in company with the planet Venus rules the month of April; the infant Zephyrus blowing flowers before him also alludes to the season.

Fry, R. E., *The Vasari Society for the Reproduction of Drawings by Old Masters.* First series, Vol. II, 1906–1907, No. 14.

Robert Lehman Collection.

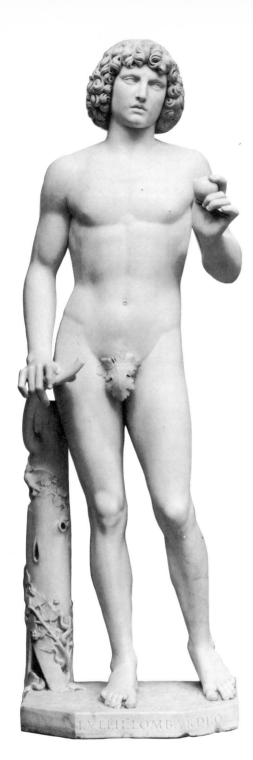

200. Adam

Tullio Lombardo
Italian, *ca.* 1455–1532
Venice, *ca.* 1490–1495
Marble
Height: 6 feet, 3 inches
Made in Venice, *ca.* 1490–1495

The *Adam* belonged to the most lavish tomb-monument of Renaissance Venice, that of Doge Andrea Vendramin, who died in 1478. The base of the *Adam* bears the signature of Tullio Lombardo, generally accredited with the scheme of the monument as a whole. In the *Adam*, Tullio exhibited a kind of proto-neoclassicism. Adam's pose seems to be based on a combination of antique figures of Antinous and Bacchus, interpreted with an almost Attic simplicity. But Tullio intended to make the antique ''live.'' The meaningful glance, the elegant hands, and the tree trunk adorned with the snake and ivy, should be seen as improvements, certainly as refinements, on the antique. The figure is remarkable for the unbelievable purity of its marble and smoothness of its carving, and for the fact that it was the first monumental classical nude to be carved since antiquity.

Remington, P., "Adam by Tullio Lombardo." *The Bulletin of The Metropolitan Museum of Art*, Vol. XXXII (March, 1937), pp. 58–62.

36.163 The Metropolitan Museum of Art, Fletcher Fund, 1936.

201. Parade Sallet in Form of a Lion's Head

Italian, *ca.* 1460
Steel, bronze, gilded, and partly silvered, semiprecious stones
Height: 11⅛ inches; Length: 12½ inches; Width: 8½ inches;
Weight: 8 pounds, 4 ounces

Under the splendid covering of gilt bronze, cast in the form of a lion's head, is hidden a real battle helmet of polished steel painted red around the face opening to simulate the gaping maw of the animal; the teeth of the lion are silvered and its eyes inset with semiprecious stones, apparently carnelian. This parade helmet imitating the headdress of Hercules, who wore the skin of the Nemean lion, is a striking example of the impact of the rediscovered classical world on the unfolding Renaissance. A practically identical helmet is to be found on one of the figures accompanying King Alfonso on his triumphal arch at the Castel Nuovo in Naples.

Dean, B., "A Lion-Headed Helmet." *The Bulletin of the Metropolitan Museum of Art*, Vol. XVIII, 1923, p. 224.

23.141 The Metropolitan Museum of Art, Harris Brisbane Dick Fund, 1923.

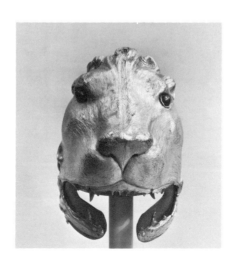

Flanders and Northern Europe: Early Renaissance

Tournai, Bruges, and Ghent, the Flemish cities that were the trading and banking centers of northern Europe at the beginning of the fifteenth century, were also the stage for a revolution in painting comparable to the break with tradition that had taken place in Italy. The rejection of Gothic, however, was less abrupt and less theoretical in the north, and within the new world of ordinary appearances and accurate scenes from daily life, there remained a core of medieval symbolism.

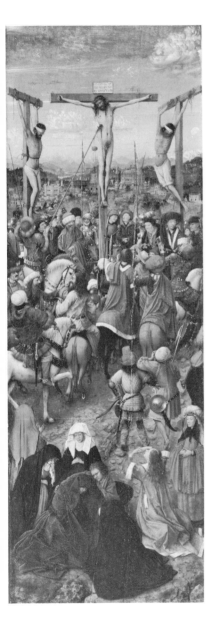 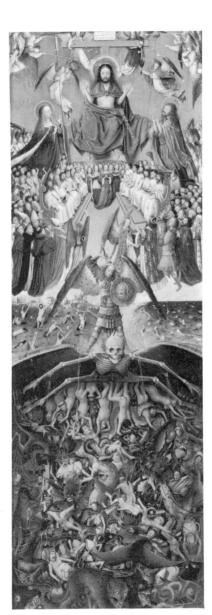

202. The Crucifixion; The Last Judgment

Hubert van Eyck
Flemish, date of birth unknown–died 1426
Tempera and oil on canvas, transferred from wood
Each: Height: 22¼ inches; Width: 7¾ inches

Hubert van Eyck and his younger brother Jan are generally regarded as the founders of the Flemish School of painting and the inventors of the oil technique. They probably began as miniature painters and adhered to medieval conventions in their treatment of religious themes. The careful observation of nature, however, shows the beginning of the Renaissance spirit. The small traveling altarpiece for which the Crucifixion and the Last Judgment originally formed wings is said to have had as center panel an Adoration of the Magi, now unfortunately lost.

Wehle, H. B., and Salinger, M. M., *A Catalogue of Early Flemish, Dutch, and German Paintings.* New York, The Metropolitan Museum of Art, 1947, pp. 2 ff.

33.92 a,b The Metropolitan Museum of Art, Fletcher Fund, 1933.

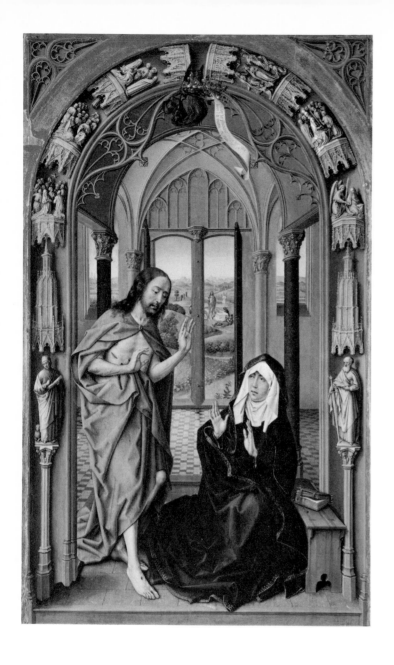

203. Christ Appearing to His Mother
Rogier van der Weyden
Flemish, 1400–1464
Tempera and oil on wood
Height: 25 inches; Width: 15 inches

Rogier van der Weyden studied under Campin and became the chief painter of the city of Brussels, making the style of his master widely known. The intense emotion and restraint of this scene are characteristic of Rogier, as are its extreme refinement and sensitivity. This panel, with two others that are still in Granada, once formed an altarpiece that belonged to Queen Isabella the Catholic of Spain.

Wehle, H. B., and Salinger, M. M., *A Catalogue of Early Flemish, Dutc and German Paintings.* New York, The Metropolitan Museum of Art, 1947, pp. 30 ff.

22.60.58 The Metropolitan Museum of Art, Bequest of Michael Dreicer, 1921.

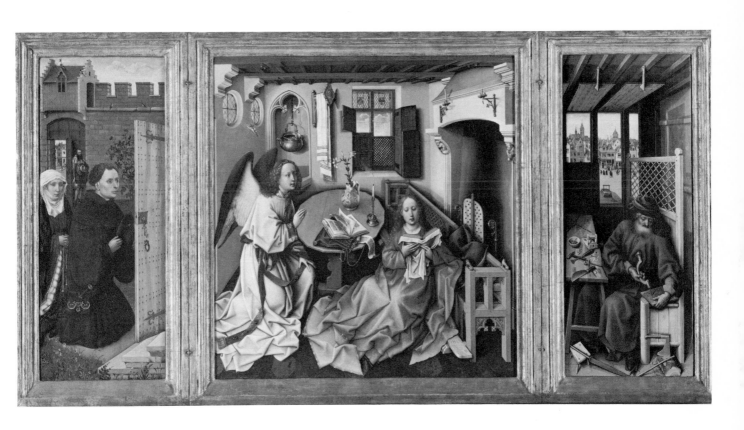

**204. Triptych: The Annunciation, Donors, and Saint Joseph
(The Mérode Altarpiece)**
Robert Campin (The Master of Flémalle)
Flemish, active by 1406–died 1444
Oil on wood
Central panel: Height: 25³⁄₁₆ inches; Width: 24⅞ inches
Left wing: Height: 25⅜ inches; Width: 10¾ inches
Right wing: Height: 25⅜ inches; Width: 10¹⁵⁄₁₆ inches

This painter, who worked in Tournai, was a contemporary of the Van Eycks
and resembled them in adhering to the medieval traditions. He was not,
however, so interested as they in accurately recording impressions of nature,
but constantly strove to endow them with symbolic meaning. Campin and the
Van Eyck brothers are the source of the two separate streams in Flemish
painting in the fifteenth century.

Rousseau, T., Jr., Freeman, M. B., and Suhr, W., "The Mérode Altarpiece."
"The Iconography of the Mérode Altarpiece." "The Restoration of the Mérode
Altarpiece." *The Metropolitan Museum of Art Bulletin*, n.s., Vol. XVI, (December,
1957), pp. 117–44.

The Metropolitan Museum of Art, The Cloisters Collection.

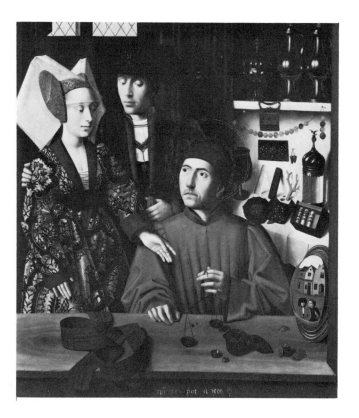

**205. Saint Eligius as a Goldsmith Presenting a Ring
to an Affianced Couple**
Petrus Christus
Flemish, active by 1444–died 1472/1473
Tempera and oil on wood
Height: 39 inches; Width: 33½ inches
Signed (at bottom, center): PETR CRI ME FECIT A 1449

It is very probable that Petrus Christus, a follower of Jan van Eyck, painted this picture for the goldsmith's guild of Antwerp. Saint Eligius was trained in France as a goldsmith and practiced his trade with great proficiency, earning the admiration and respect of the reigning monarch. He led at the same time so saintly a life that he was consecrated a bishop, wrote famous sermons, and went as a missionary to Belgium, Sweden, and Denmark. He is shown in this panel at the open window of his jewelry shop, weighing precious stones or gold destined presumably for the young bride waiting beside her fiancé for her wedding ring. This fashionable lady, without a halo, is surely not, as Weale believed, Saint Godeberte of Noyon. The detailed, genre-like representation of the shop and the display of jewels and metalwork are painted with the precision and clarity for which Petrus Christus is especially famous, and they provide a precious account of bourgeois life in Bruges in the fifteenth century.

Exposition de la Collection Lehman de New York, Paris, Musée de L'Orangerie, 1957, pp. 4 ff, Pl. XIX.

Robert Lehman Collection.

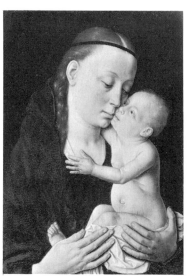

206. The Virgin and Child
Dieric Bouts
Flemish, active by 1457–died 1475
Tempera and oil on wood
Height: 8½ inches; Width: 6½ inches

With a flawless technique, Bouts has concentrated in an extremely small space great depths of tenderness, devotion, and simplicity. He possessed to the highest degree the complete technical mastery that is characteristic of all early Flemish painting.

Wehle, H. B., and Salinger, M. M., *A Catalogue of Early Flemish, Dutch, and German Paintings.* New York, The Metropolitan Museum of Art, 1947, pp. 44 ff.

30.95.280 The Metropolitan Museum of Art, The Theodore M. Davis Collection, Bequest of Theodore M. Davis, 1915.

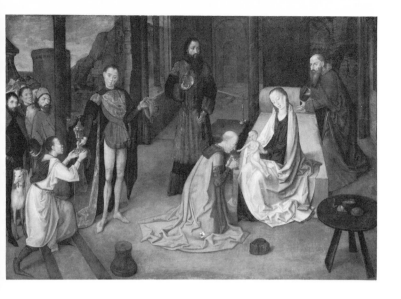

207. The Adoration of the Magi
Joos van Gent
Flemish, active from 1460 to *ca.* 1480
Tempera on linen
Height: 43 inches; Width: 63 inches

The arrangement of the figures and their highly individual poses suggest that this painting on fine linen was made in Ghent before 1473, the date when Joos is known to have been at work in Urbino. The paintings that he subsequently made in Italy reveal a transformation of his originally Gothic style under the broadening and enriching influence of Italian art.

Wehle, H. B., and Salinger, M. M., *A Catalogue of Early Flemish, Dutch, and German Paintings.* New York, The Metropolitan Museum of Art, 1947, pp. 54 ff.

41.190.21 The Metropolitan Museum of Art, Bequest of George Blumenthal, 1941.

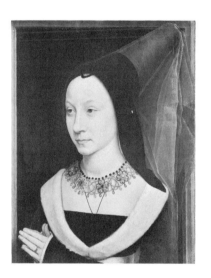

208. Maria Portinari
Hans Memling
Flemish, active *ca.* 1465–died 1494
Tempera and oil on wood
Height: 17⅜ inches; Width: 13⅜ inches

Maria Maddalena Baroncelli was only about fourteen when she married Tommaso Portinari. She is wearing here the same jeweled necklace that is to be seen in Hugo van der Goes's portrait of her.

Wehle, H. B., and Salinger, M. M., *A Catalogue of Early Flemish, Dutch, and German Paintings.* New York, The Metropolitan Museum of Art, 1947, pp. 67 ff.

14.40.627 The Metropolitan Museum of Art, Bequest of Benjamin Altman, 1913.

209. Tommaso Portinari
Hans Memling
Flemish, active *ca.* 1465–died 1494
Tempera and oil on wood
Height: 14⅜ inches; Width: 13¼ inches

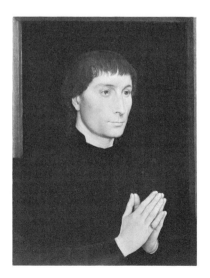

Portinari, a native Florentine, was the representative in Bruges of the banking house of the Medici. He loved Flemish art, commissioning from Memling a religious scene as well as these portraits of himself and his wife (see No. 208) and ordering from the Flemish Hugo van der Goes the famous large Portinari altarpiece now in the Uffizi. Not only were Memling's subjects Italian; the style in which they are painted, though stemming from Rogier van der Weyden's, contrasts with it in its round and mellow quality, which relates to the Renaissance.

Wehle, H. B., and Salinger, M. M., *A Catalogue of Early Flemish, Dutch, and German Paintings.* New York, The Metropolitan Museum of Art, 1947, pp. 65 ff.

14.40.626 The Metropolitan Museum of Art, Bequest of Benjamin Altman, 1913.

Southern Europe: High Renaissance and Mannerism

During the brief period known as the High Renaissance, a mere handful of artists in Rome achieved the classical balance and confident monumentality that were to remain ideals of European art for four centuries. This noble epoch, under way in the 1490's, was brought to a close by Charles VIII's brutal Sack of Rome in 1527. During the rest of the century, Mannerist artists either infused the elements of High Renaissance style with an anguished inner vision and emotionalism or clothed them with a cool sophisticated elegance. Venice, with her native predilection for rich ornament, color, and effects of light, remained apart from the grand manner of Rome.

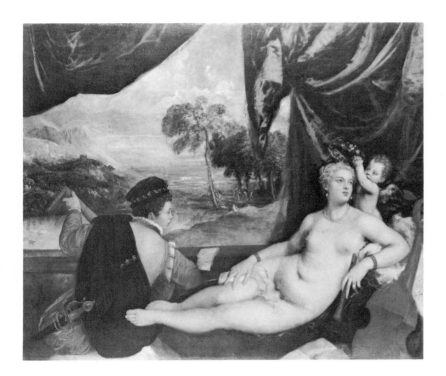

210. Venus and the Lute Player
Titian (Tiziano Vecellio)
Italian, *ca.* 1488–1576
Oil on canvas
Height: 65 inches; Width: 82½ inches

Over a period of thirty years, Titian developed the theme of the reclining Venus, painting a long series of pictures with this neoplatonic subject, of which ours is probably the latest. The statuesque proportions, the serenity, and the free brushwork of the richly poetic landscape are characteristic of his old age.

Pallucchini, R., *Tiziano.* Florence, 1969, Vol. I, pp. 126, 170 f, 316.

36.29 The Metropolitan Museum of Art, Munsey Fund, 1936.

211. Brother Gregorio Belo di Vicenza
Lorenzo Lotto
Italian, 1480–1556
Oil on canvas
Height: 34½ inches; Width: 28 inches

It is altogether typical of Lotto to stress as he does here the most interior and spiritual emotions of the subject. The somber landscape background harmonizes with the solemn mood of the portrait, and the group of the Crucifixion against the night sky is probably a mystical realization of the monk's meditations.

Berenson, B., *Lorenzo Lotto.* London, 1956, pp. 126, 471.

65.117 The Metropolitan Museum of Art, Rogers Fund, 1965.

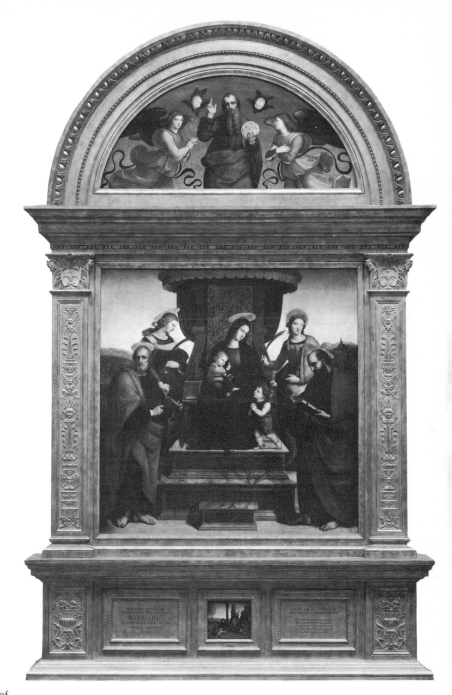

212. Madonna and Child Enthroned with Saints
Raphael (Raffaello Santi)
Italian, 1483–1520
Tempera on wood
Main panel: Height: 66⅝ inches; Width: 66¾ inches
Lunette: Height: 28¾ inches; Width: 66¼ inches

Vasari tells how this picture was ordered for the convent of Saint Anthony of Padua in Perugia, and documents record in detail how the nuns, hard-pressed for money, sold the main panel and the predella in the second half of the seventeenth century. The gentleness of the figures, the pleasing rhythms, and the deep view of landscape reflect Raphael's Umbrian origins and the influence of Perugino, but the monumental firmness and solid strength, learned from Florence, make this a superb example of the High Renaissance style.

Wehle, H. B., *A Catalogue of Italian, Spanish, and Byzantine Paintings.* New York, The Metropolitan Museum of Art, 1940, pp. 117 ff.

16.30ab The Metropolitan Museum of Art, Gift of J. Pierpont Morgan, 1916.

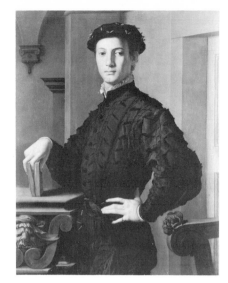

213. The Holy Family
Andrea del Sarto
Italian, 1486–1530
Oil on wood
Height: 53½ inches; Width: 39⅝ inches

The strong composition of this late work by Andrea del Sarto and the dark but intense key of the color make it a typical example of the High Renaissance style. The balanced movement, to which every detail contributes, is characteristic of this artist.

Zeri, F., *A Catalogue of Italian Paintings.* Vol. I: *The Florentine School.* New York, The Metropolitan Museum of Art, 1970.

22.75 The Metropolitan Museum of Art, Maria De Witt Jesup Fund, 1922.

214. Portrait of a Young Man
Bronzino (Agnolo di Cosimo)
Italian, 1503–1572
Oil on wood
Height: 37⅝ inches; Width: 29½ inches

Bronzino is the foremost representative of the sixteenth-century mannerist style in Florence. The haughty elegance of this young aristocrat clothed in black and pictured in contrapposto and a self-consciously casual pose are highly characteristic of this style, as are the strange ornaments and the unclear and puzzling architectural space in which the figure is confined.

Zeri, F., *A Catalogue of Italian Paintings.* Vol. I: *The Florentine School.* New York, The Metropolitan Museum of Art, 1970.

29.100.16 The Metropolitan Museum of Art, The H. O. Havemeyer Collection, Bequest of Mrs. H. O. Havemeyer, 1929.

215. Mars and Venus United by Love
Veronese (Paolo Caliari)
Italian, 1528?–1588
Oil on canvas
Height: 81 inches; Width: 63⅜ inches
Signed (lower center): PAVLVS VERONENSIS. F.

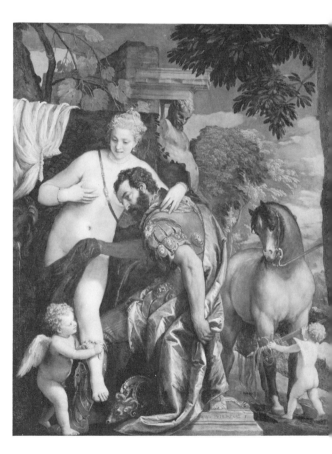

The meaning of this painting is not clear, and beside the interpretation implied by the traditional title, others have been offered. Whatever its subject, the picture is replete with the splendor of Renaissance Venice and a superb example of Veronese's opulence and artistry.

Wehle, H. W., *A Catalogue of Italian, Spanish, and Byzantine Paintings.* New York, The Metropolitan Museum of Art, 1940, pp. 203 ff.

10.189 The Metropolitan Museum of Art, Kennedy Fund, 1910.

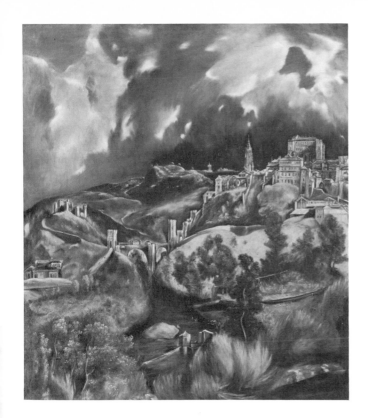 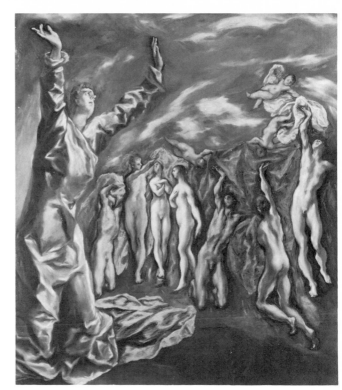

216. View of Toledo
El Greco (Domenicos Theotocopoulos)
Spanish, 1541–1614
Oil on canvas
Height: 47¾ inches; Width: 42¾ inches
Signed in Greek (lower right): "Domenicos Theotocopoulos made it"

El Greco, or The Greek, left his native island of Crete in his youth
and after studying painting in Venice and Rome, settled in Spain and
spent the rest of his life there. This portrait of his adopted city of
Toledo is his only true landscape, but he has sacrificed exactness
to an impassioned exciting interpretation of its spirit.

Aznar, J. C., *Dominico Greco.* Madrid, 1950, Vol. II, pp. 969 ff.

29.100.6 The Metropolitan Museum of Art, The H. O. Havemeyer
Collection, Bequest of Mrs. H. O. Havemeyer, 1929.

217. The Vision of Saint John
El Greco (Domenicos Theotocopoulos)
Spanish, 1541–1614
Oil on canvas
Height: 87½ inches; Width: 76 inches

The scene is dominated by the mysterious and overpowering figure
of the inspired Saint John. The weightless, wraithlike, struggling forms,
more spirit than body, illustrate the mystic vision that enthrall him.
One of El Greco's very latest pictures, this altarpiece was left
unfinished at his death.

Rousseau, T. Jr., "El Greco's Vision of Saint John," *The Metropolitan
Museum of Art Bulletin,* n.s., Vol. XVII (June, 1959), pp. 241–62.

56.48 The Metropolitan Museum of Art, Rogers Fund, 1956.

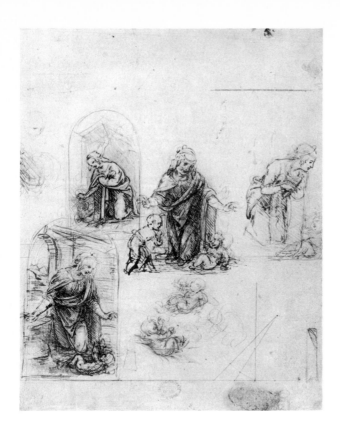

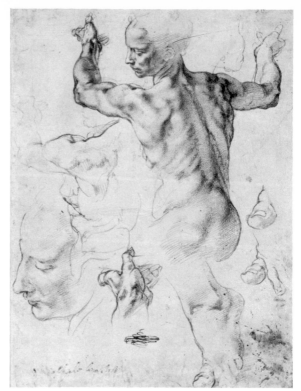

218. Studies for a Nativity
Leonardo da Vinci
Italian, 1452–1519
Emilian School
Pen and brown ink, over preliminary sketches in metalpoint,
on pink prepared paper. Ruled lines added in black chalk.
Verso: Slight geometric sketches in pen and brown ink.
Height: 7⅞ inches; Width: 6⁷⁄₁₆ inches

In these sketches of the Virgin kneeling before the Christ Child,
who lies on the ground, Leonardo explored a theme that was to
emerge as the *Madonna of the Rocks,* where the Virgin kneels
facing the spectator, her right hand raised in benediction over
the seated Infant Jesus. The sketches at the center and at the
lower left corner of the sheet, where the Virgin raises both arms
in devotional wonder, are related to a design by Leonardo that
must have been developed at least to the stage of a complete
cartoon, for several painted copies have survived. The controversy
about the dating of Leonardo's two paintings of the *Madonna of
the Rocks* in Paris and in London, makes it difficult to decide
whether the drawing is to be dated 1483 or considerably earlier,
during Leonardo's first Florentine period.

Berenson, B., *I Disegni dei Pittori Fiorentini.* Milan, 1961, No. 1049C,
Fig. 475.

17.142.1 The Metropolitan Museum of Art, Rogers Fund, 1917.

219. Studies for the Libyan Sibyl
Michelangelo Buonarroti
Italian, 1475–1564
Florentine School
Red Chalk
Height: 11⅜ inches; Width: 8⅜ inches

This celebrated sheet bears on the recto a series of studies
from a nude male model for the figure of the Libyan Sibyl
that appears on the frescoed ceiling of the Sistine Chapel,
commissioned in 1508. In the principal and highly finished
drawing dominating the sheet, Michelangelo has studied
the turn of the Sibyl's body, the position of the head and
arms. The left hand of the figure is studied again below,
as are the left foot and toes. A study of the Sibyl's head,
possibly the first drawing made on the sheet, appears at
the lower left, and a rough sketch of the torso and shoulders
are immediately above it.

Berenson, B., *I Disegni dei Pittori Fiorentini.* Milan, 1961,
No. 1544D.

24.197.2 The Metropolitan Museum of Art, Joseph
Pulitzer Bequest, 1924.

220a. Madonna and Child with the Infant Saint John (recto)
220b. Nude Male Figure (verso)
Raphael (Raffaello Santi)
Italian, 1483–1520
Umbrian School
Red chalk (220a). Pen and brown ink (220b).
Height: 8¹³⁄₁₆ inches; Width: 6¼ inches

This recently discovered drawing is the last in a sequence that Raphael made
in preparation for his painting the *Madonna in the Meadow,* which bears a date
that can be read as 1505 or 1506, in the Kunsthistorisches Museum in Vienna.
In the present design, Raphael is concerned with establishing the general
construction of the composition, where the three figures form a monumental
triangle animated by the Leonardesque turn of the Virgin's torso and the
arrested movement of the Christ Child, who reaches forward to seize the cross.
At the top of the sheet appear studies of the Virgin's drapery and the Infant
Baptist's right arm. The young Raphael has used red chalk with admirable
ease to suggest the subtle contrasts of light and shade that model the figure;
the drawing is one of the earliest examples of the artist's use of this medium.

Raphael's pen study of a nude male figure on the verso of the sheet is
strikingly different in intention and treatment from the red chalk drawing on
the recto. The male figure has been drawn with a forceful pen line and sharp
anatomical observation from a model in the studio, while the red chalk drawing,
certainly not drawn from life, is a composition sketch where the artist is
concerned with overall construction and lighting of a pictorial scheme and not
with exact detail. The nude male figure, with head hanging limply forward
and arms raised behind his back by cords that are barely indicated, may well
be a study for the figure of one of the thieves on the cross.

Bean, J., "A Rediscovered Drawing by Raphael." *The Metropolitan Museum of
Art Bulletin,* n.s., Vol. XXIII (Summer, 1964), pp. 1–10.

64.47 The Metropolitan Museum of Art, Rogers Fund, 1964.

221. Antoninus Pius
Antico (Pier Jacopo Alari-Bonacolsi)
Italian, *ca.* 1460–1528
Bronze, partly gilt and silvered
Height: 23⅛ inches

This bust, with its anatomical detail treated almost as ornament, displays at once the goldsmith's training of its maker, the decorative heritage of Mantegna, and the refined tastes of the Gonzaga court. Beginning in North Italy about 1470, large busts of the Roman emperors became increasingly popular in the art of humanist courts. Not until Antico were they so archaeologically earnest. The present bust should be dated fairly late in Antico's career, about 1510–1520, and is superior in handling to an almost identical version in the Louvre.

65.202 The Metropolitan Museum of Art, Gift of Edward Fowles, 1965.

222. Saint Sebastian
Alessandro Vittoria
Italian, 1525–1619
Bronze
Height: 21¼ inches
Cast in Venice in 1566
Signed on base: ALEXANDER VICTOR T(ridentinus) F(ecit)

Vittoria was the leading Venetian sculptor in the generation after Jacopo Sansovino. The *Saint Sebastian* is a variation on a figure on Vittoria's altar in S. Francesco della Vigna (1563–1564). In the Metropolitan's portrait of him by Veronese, Vittoria holds a wax or plaster of the figure, an invention of which he was evidently proud. His manuscript records state that he had it cast twice, by Andrea da Brescia in 1566 (our bronze), and in 1575 (a more mannered version in Los Angeles). One of Michelangelo's *Slaves* undoubtedly influenced the heroic composition.

Valentiner, W. R., "Alessandro Vittoria and Michelangelo." *Art Quarterly,* Vol. V, 1942, pp. 149–157.

40.24 The Metropolitan Museum of Art, Lee Fund, 1940.

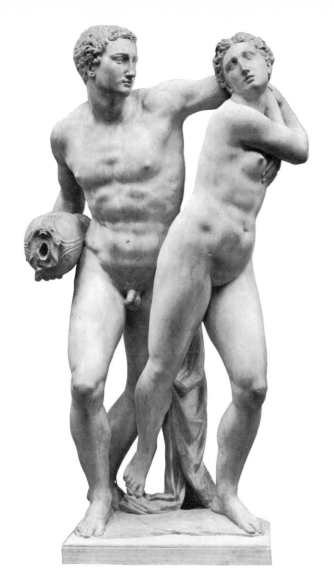

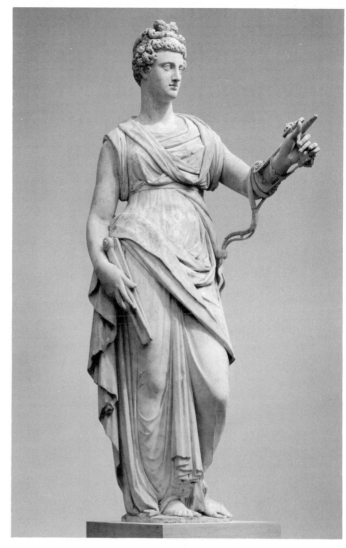

223. Alpheus and Arethusa
Battista Lorenzi
Italian, 1527/1528–1594
Marble
Height: 58½ inches
Carved in Florence ca. 1570–1580

Battista Lorenzi's absolute masterpiece, *Alpheus and Arethusa*, illustrates a tale from Ovid: The wood nymph Arethusa, pursued by the river-god Alpheus, implored Diana to save her at the very moment Alpheus overtook her. Hearing her chaste plea, Diana quickly hid her in a protective cloud of mist, and later transformed her into a fountain. Lorenzi's group was erected in a grotto at the Villa Il Paradiso, belonging to Alamanno Bandini, some time before 1584, when Borghini first mentioned it. The grotto combined water, statuary, and a theatrical setting in a lively and Baroque manner unusual at this early date.

Remington, P., "Alpheus and Arethusa, A Marble Group by Battista Lorenzi." *The Bulletin of The Metropolitan Museum of Art,* Vol. XXXV (March, 1940), pp. 61–65.

40.33 The Metropolitan Museum of Art, The Fletcher Fund, 1940.

224. Temperance
Giovanni Caccini
Italian, 1556–1612
Marble
Height: 72 inches
Made in Florence in 1583–1584

Caccini was one of the busiest and most accomplished of the Florentine followers of Giovanni Bologna. Our figure's cool and stately presence is due to the fact that she personifies the virtue of Temperance and also to the sculptor's own sober nature. Characteristic of his work are the weighty banded draperies which transform and stabilize his model, in this case Giovanni Bologna's bronze *Temperance* in the University of Genoa. Temperance's attributes, the bridle of restraint, and the mathematical instruments of reasoned measure, paid a fitting compliment to Giovanni Battista del Milanese, Bishop of Marsica, for whom it was made, for he had participated at the Council of Trent. The statue can be dated with some precision, since Borghini wrote in 1584 that Caccini was at work on it.

Raggio, O., "The Metropolitan Marbles." *Art News,* Vol. LXVII (Summer, 1968), pp. 45–47.

67.208 The Metropolitan Museum of Art, Harris Brisbane Dick Fund, 1967.

225. Majolica Bowl: Arms of Pope Julius II and Manzoli of Bologna
Giovanni Maria
Italian, Castel Durante
Tin-glazed earthenware
Diameter: 12⁹⁄₁₆ inches
Dated 1508

The decoration of Italian tin-glazed earthenware, which had been evolving since the fourteenth, was revolutionized by the Renaissance at the beginning of the sixteenth century. In this bowl, Giovanni Maria, one of the greatest ceramic painters of the Renaissance, has expressed the rich delicate symmetry of the new "antique" style. The bowl, the earliest dated piece of majolica from Castel Durante, was offered to Pope Julius II by Melchiorre di Giovanni Manzoli in the year the pontiff appointed him senator.

Raggio, O., "The Lehman Collection of Italian Maiolica." *The Metropolitan Museum of Art Bulletin,* n.s., Vol. XIV (April, 1956), pp. 195–96.

Robert Lehman Collection.

226. Majolica Plate: Contest of Apollo and Pan
Nicola Pellipario
Italian, Castel Durante
Tin-glazed earthenware
Diameter: 10¾ inches
Made 1519/1520

Other developments of majolica in the early sixteenth century included the *istoriato* or pictorial style of which Nicola Pellipario, who painted this bowl, is the supreme master. The white tin-glazed body provided an excellent ground for an expanded palette. This plate is one of the surviving pieces from the service made for Isabella d'Este and bears her coat of arms quartered with those of Gonzaga. The incident depicted, the musical contest of Apollo and Pan, has been borrowed from a woodcut illustration in the Italian edition of Ovid's *Metamorphoses* published in Venice by Lucantonio Giunta in 1497. The practice of adapting prints for majolica decoration was widespread and illustrates the power of the printed image in disseminating the new style.

Raggio, O., "The Lehman Collection of Italian Maiolica." *The Metropolitan Museum of Art Bulletin,* n.s., Vol. XIV (April, 1956), pp. 188–99.

Robert Lehman Collection.

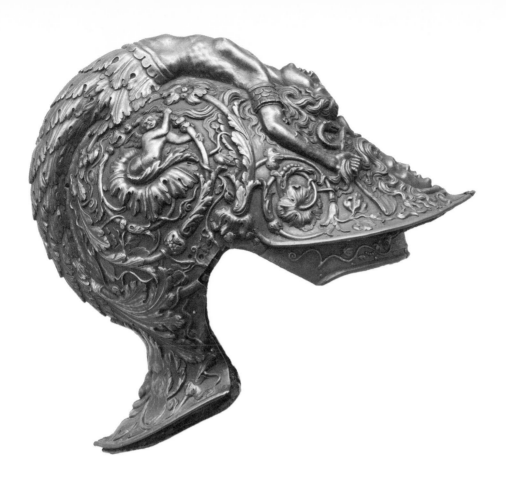

227. Parade Burgonet
Philippo de Negroli
Italian, *ca.* 1500–1561
Steel, gold
Greatest width: 7⁵⁄₁₆ inches; Weight: 4 pounds, 2 ounces
Dated 1543; made in Milan

The bold sweep of the helmet bowl is hammered from a single piece of steel though the rich luster of its surface makes it look as if it was cast in black bronze. A browband, built in for an exact fit on the wearer's head, is damascened in gold with an inscription giving the maker's name and the date. The cheekpieces once hinged to the sides of the helmet bowl are missing.

The embossed decoration is in classicizing Renaissance taste with motifs derived from the decorations—*grotteschi*—in the recently rediscovered ruins of The Golden House of Nero at Pompeii. A mermaid in a classical Roman *lorica,* her fishtail scaly with acanthus, forms the crest of the helmet. Reclining, she holds in her uplifted arms a head of Medusa staring over the helmet's umbril. On the very peak of the umbril is a small shield, originally emblazoned with a device now unfortunately obliterated. The design and decoration of this helmet justify Philippo de Negroli's fame as one of the best of the Milanese clan of master armorers.

Boccia, L. G., and Coelho, E. T., *L'Arte dell'Armatura in Italia.* Milan, 1967, p. 323.

17.190.1720 The Metropolitan Museum of Art, Gift of J. Pierpont Morgan, 1917.

228. Bench (Cassapanca)
Italian, Florentine, third quarter XVI century
Walnut
Height: 66⅜ inches; Length: 91¾ inches;
Depth: 31½ inches

The cassapanca was the most monumental furnishing of the
sixteenth century Florentine city palace, and it is therefore not
surprising that the character of this massive Florentine creation is
essentially architectural. Supports in the shape of mask-ornamented
vases, arms resembling consoles, cornice-like moldings, and a
crowning pediment all reflect details of contemporary architecture.
The cassapanca is stylistically similar to Bartolommeo Ammanzati's
Palazzo Budini-Gatti, begun in 1563. The two languid but elegant
nudes of the ornamental crest flank a heart-shaped cartouche
containing the arms of the Orsini family. The crest is an unusual
feature not often seen in comparable Italian furniture. The seat
of the cassapanca is hinged and opens to reveal a capacious
storage area. With the addition of cushions, it served as a seat
of honor and occasionally even as a bed.

Phillips, J. G., "A Recent Accessions Room." *The Metropolitan
Museum of Art Bulletin*, n.s., Vol. XVII (June, 1959), pp. 263–64.

58.19ab The Metropolitan Museum of Art, Funds from various
donors, 1958.

229. Casket and Key

Italian, Venetian, ca. 1570–1590
Beechwood, lacquered in dark brown and gold with panels of applied gold dust highlighted in red, green, and blue; the handles and keyhole escutcheon of silver gilt; the lock and hinges of iron damascened in gold
Height: 7 3/16 inches; length: 16 3/8 inches; Depth: 11 3/8 inches

In Italian decoration of the second half of the sixteenth century, the floral arabesques and medallions that came from the Near East existed side by side with the prevailing Mannerist ornament of essentially antique origin. Although the arabesque, in its association with the art of damascening, is thought to have been introduced to Europe in the Middle Ages, Venice through her Eastern trading connections repeatedly transmitted waves of Moslem-inspired decoration to Europe. In 1401 a group of refugee metalworkers, fleeing the sack of Damascus, settled in Venice, and later in the second half of the fifteenth century, Egyptian brass workers and bookbinders were employed there. Native Italian craftsmen soon adapted Moslem ornament to their own uses, and also took as models fine bookbindings imported from Persia. It is to leather book covers of the second half of the sixteenth century that the ornamentation of this casket can be most closely compared.

A mirror secured to the inside of the lid with silver-gilt masks suggests that the casket was a vanity case for use in one of the increasingly sumptuous bedchambers of Venetian palaces of the period.

Bode, W., *Italian Renaissance Furniture*. Trans. By M. E. Herrick, New York, 1921, p. 33.

57.25ab The Metropolitan Museum of Art, Rogers Fund, 1957.

230. Rospigliosi Cup

Attributed to Jacopo Bilivert
Dutch, ca. 1550/1555–after 1585
Gold, enamel, and pearls
Height: 7 3/4 inches; Length: 9 inches; Width: 8 1/2 inches
Made in Italy last quarter XVI century

The goldsmith Bilivert went to Florence in 1573, at the invitation of Grand Duke Francesco de' Medici and his name appears repeatedly in the Medici account books, particularly in connection with the gold and enameled setting for Bernardo Buontalenti's famous lapis lazuli vase, dated 1583, at the Museo degli Argenti, Palazzo Pitti, Florence.

The design of this cup owes much to the engraved designs of Cornelis Floris, particularly to his series *Cups and Jugs,* published in Antwerp in 1548. Both artists, Floris and Bilivert, treat imaginary form with astounding realism, thereby displaying the particular trend of taste and its practical application in goldsmith's work which, in Florence, is usually referred to as *alla fiamminga.* This particular quality, and the fact that the Rospigliosi cup has many characteristics in common with the enameled mounts of Buontalenti's lapis lazuli vase, for which Bilivert received payment in 1584, indicate that he was the goldsmith who created the cup. The name of the cup is derived from that of the former owners, the Rospigliosi family of Rome.

Hackenbrock, Y., "Jacopo Bilivert and the Rospigliosi Cup."
The Connoisseur, Vol. CLXXII (November, 1969), pp. 175–79.

14.40.667 The Metropolitan Museum of Art, Bequest of Benjamin Altman, 1913.

Northern Europe: High Renaissance and Mannerism

The humanistic ideals and classical measure that characterized the art of the High Renaissance in Italy were admired and emulated all over Europe by the second half of the fifteenth century. Northern artists educated in Italy returned to their centers north of the Alps with a taste for classical subject matter and Renaissance ornament, while engravings brought the new style to those who were not able to make the trip. Italian artists were summoned by Francis I to decorate his palace at Fontainebleau, and French style was permanently impressed by Italian Mannerism. England, Germany, and the Netherlands, however, transformed these imported elements according to the strong national impulses of vigorous styles rooted in their cultures.

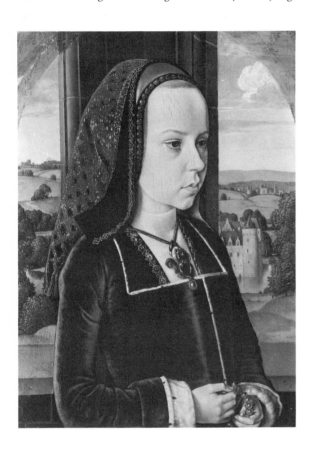

231. Portrait of a Young Girl, Probably Margaret of Austria
Master of Moulins
French, active *ca.* 1480– *ca.* 1500
Tempera and oil on wood
Height: 13⅜ inches; Width: 9⅜ inches

Although attempts have been made to identify this great French artist with Jean Perréal and more recently with Jean Hay, a Fleming who worked in France, he remains anonymous. He surely was the painter of the fine large triptych in the Cathedral of Moulins, from which he takes his name, of the Nativity of Autun, and of this characteristically French portrait of a young girl. She has been said to be Suzanne de Bourbon, who kneels on one of the wings of the triptych of Moulins, but the likeness is not convincing, and it is more probable that we have here a portrait of the Emperor Maximilian's daughter, Margaret of Austria, in her youth. The widow of Philibert the Fair of Savoy, she built the beautiful church of Brou with its famous tombs as a memorial to him. She became the governor of the Netherlands and the guardian of her nephew, the Emperor Charles V, who inherited her fine collection of works of art and acquired his excellent taste under her tutelage.

Exposition de la Collection Lehman de New York. Paris, Musée de L'Orangerie, 1957, pp. 28 f., No. 35.

Robert Lehman Collection.

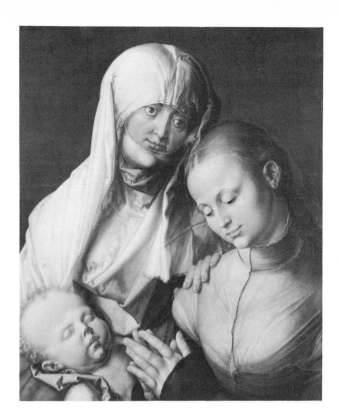

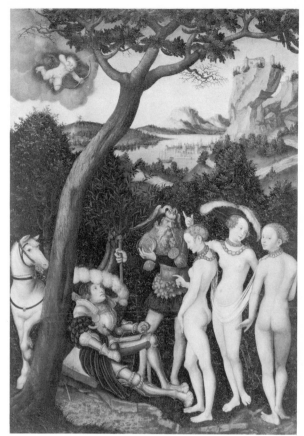

232. The Virgin and Child with Saint Anne
Albrecht Dürer
German, 1471–1528
Tempera and oil on canvas, transferred from wood
Height: 23⅝ inches; Width: 19⅝ inches
Signed and dated (right center): AD (monogram) 1519

This painting, once in the collection of the Elector of Bavaria, is painted in Dürer's mature style and was copied many times, a proof of its popularity. The head of Saint Anne, for which there is a marvelous preparatory drawing now in the Albertina, is an idealized portrait of Dürer's wife Agnes. The monumental masses of the figures and the balanced composition attest to the impact that Italian art made on Dürer's native northern Gothic style.

Wehle, H. B., and Salinger, M. M., *A Catalogue of Early Flemish, Dutch, and German Paintings.* New York, The Metropolitan Museum of Art, 1947, pp. 186 ff.

14.40.633 The Metropolitan Museum of Art, Bequest of Benjamin Altman, 1913.

233. The Judgment of Paris
Lucas Cranach the Elder
German, 1472–1553
Tempera and oil on wood
Height: 40⅛ inches; Width: 28 inches
Signed (on rock, right foreground) with winged snake

The Paris myth was a favorite with Cranach and his large prolific workshop. Painted about 1528, the sprightly narrative and decorative scene, if contrasted with Dürer's *Virgin and Child with Saint Anne* of the same decade, shows how oblivious Cranach was to the lofty monumental concepts of the southern Renaissance.

Wehle, H. B., and Salinger, M. M., *A Catalogue of Early Flemish, Dutch, and German Paintings.* New York, The Metropolitan Museum of Art, pp. 200 ff.

28.221 The Metropolitan Museum of Art, Rogers Fund, 1928.

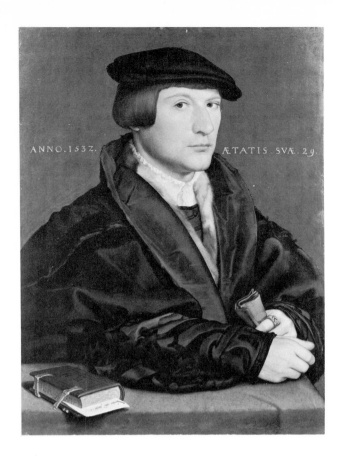

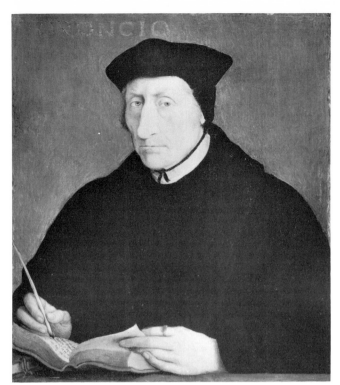

234. Portrait of a Member of the Wedigh Family
Hans Holbein the Younger
German, 1497/1498–1543
Tempera and oil on wood
Height: 16½ inches; Width: 12½ inches
Signed, dated and inscribed
(center): ANNO. 1532. AETATIS. SVAE 29
(on cover of book): H.H.
(on side of book): HER? WID
(on paper in book): Veritas Odiu(m) parit.

One of the many portraits by Holbein of the German merchants
in London, this painting demonstrates admirably why Holbein
is regarded as belonging to the circle of the world's greatest
portraitists. The clarity of color, the precision of drawing, and
the crisp, explicit characterization constitute a great expression of
human personality.

Wehle, H. B., and Salinger, M. M., *A Catalogue of Early Flemish,
Dutch, and German Paintings.* New York, The Metropolitan Museum
of Art, 1949, pp. 214 ff.

50.135.4 The Metropolitan Museum of Art, Bequest of Edward S.
Harkness, 1940.

235. Guillaume Budé
Jean Clouet
French, active by 1516–died 1540.
Tempera and oil on wood
Height: 15⅝ inches; Width: 13½ inches

Jean Clouet and Guillaume Budé were two of the most important
personalities in the realm of arts and letters at the court of
Francis I. Clouet, who probably came to France from the
Netherlands, became chief painter to the king and enjoyed the
high regard of his contemporaries as a painter of portraits and
religious subjects. Budé was famous as a humanist, a scholar of
classical Greek literature, and was not only the founder of the
Collège de France and the first keeper of the royal library that
became the Bibliothèque Nationale, but served as an ambassador
and was chief city magistrate of Paris.

Sterling, C., *A Catalogue of French Paintings, XV–XVIII Centuries.*
Cambridge, Mass., The Metropolitan Museum of Art, 1955, pp.
27 ff.

46.68 The Metropolitan Museum of Art, Maria DeWitt Jesup
Fund, 1946.

236. The Harvesters

Pieter Bruegel the Elder
Flemish, active by 1551–died 1569
Oil on wood
Height: 46½ inches; Width: 63¼ inches
Signed and dated (at lower right): BRUEGEL/(MD) LXV

The casual truthfulness with which the resting peasants are painted, the convincing noonday heat and brilliant light, and the vast panoramic distance rendered with startling effectiveness are all characteristics of Pieter the Elder, who turned painting suddenly in a new direction. This is one of five remaining panels from a series that probably represented the twelve months. Three are in Vienna and one in Budapest.

Wehle, H. B., and Salinger, M. M., *A Catalogue of Early Flemish, Dutch, and German Paintings*. New York, The Metropolitan Museum of Art, 1947, pp. 157 ff.

19.164 The Metropolitan Museum of Art, Rogers Fund, 1919.

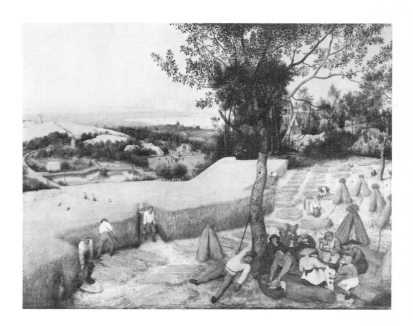

237. The Birth of Cupid

School of Fontainebleau
French, second half of XVI century
Oil on wood
Height: 42½ inches; Width: 51⅜ inches

The School of Fontainebleau is a French and Italian hybrid, founded by the artists Rosso Fiorentino and Primaticcio when they went to France to decorate the great royal château of François Ier. This painting of Venus attended by the Hours and Graces, with its Italian theme, its mannered proportions, and its light color contrasts of pearly flesh and decorative detail, epitomizes the Fontainebleau style.

Sterling, C., *A Catalogue of French Paintings, XV–XVIII Centuries*. Cambridge, Mass., The Metropolitan Museum of Art, 1955, pp. 47 ff.

41.48 The Metropolitan Museum of Art, Rogers Fund, 1941.

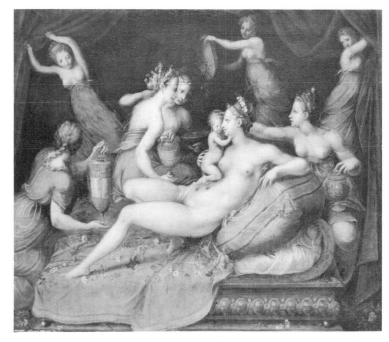

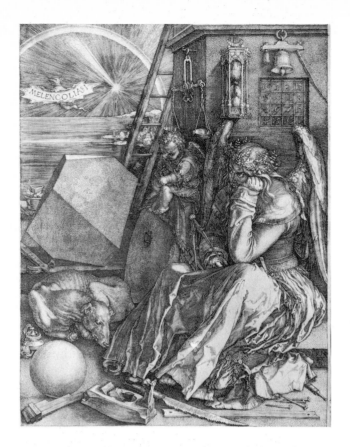

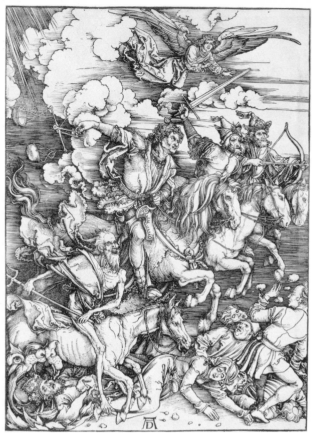

238. Melancholy
Albrecht Dürer
German, 1471–1528
Engraving; 1514
Height: 9½ inches; Width: 7⅜ inches

Melencolia has always been one of the popular favorites among Dürer's works, as much for its enigmatical character as for its accomplished beauty. This impressive, moody figure surrounded by a disorder of bewildering paraphernalia—is it the artist in gloomy meditation?—Human Reason in despair? Dürer's subject, neither borrowed, nor derived from any works that predate it, has inspired a great variety of interpretations and probably more extensive literature than any other engraving.

Panofsky, E., *Albrecht Dürer.* Princeton, 1943, Vol. I, pp. 156–57; Vol. II, pp. 26–27.

43.106.1 The Metropolitan Museum of Art, Harris Brisbane Dick Fund, 1943.

239. The Four Horsemen of the Apocalypse
Albrecht Dürer
German, 1471–1528
Woodcut; proof; 1498
Height: 15¼ inches; Width: 11 inches

Dürer, by common consent the greatest of German artists, was the first German engraver who was also an important painter. This explains more than anything else the solidity of his work and the way in which his prints, as compared with those of his forerunners, are pictures rather than objects of art. He was the only German whose life and work lay in two utterly different climates of thought and opinion. His early work (of which this illustration from the *Apocalypse,* published first in 1498, is an example) is pure Gothic; his later work (for example, the *Melancholy* of 1514) is fully Renaissance. This vast change in attitude is one of the principal reasons for the great fascination Dürer has exercised on later generations.

Panofsky, E., *Albrecht Dürer.* Princeton, 1943, Vol. I, pp. 48, 51–59; Vol. II, p. 36.

19.73.209 The Metropolitan Museum of Art, Gift of Junius S. Morgan, 1919.

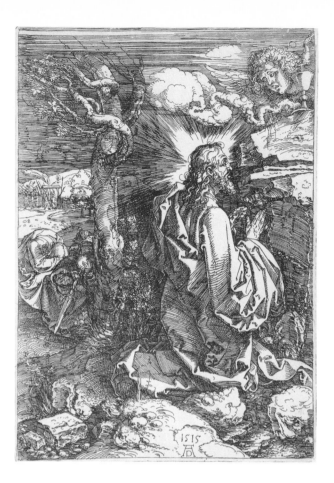

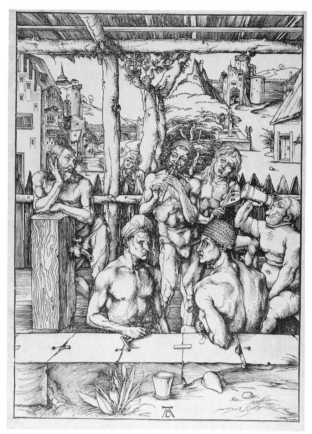

240. Christ on the Mount of Olives
Albrecht Dürer
German, 1471–1528
Etching on iron; early state; 1515
Height: 8¾ inches; Width: 6⅛ inches

Of the great artists of his time, Dürer was the only one who was at home in many different media. He did epoch-making work in pen, silverpoint, and chalk drawing, in watercolor and oil painting, and in engraving, etching, drypoint, and woodcutting. In this sense he was perhaps the most universal artist of whom we have record. One of the earliest experimenters to turn the armorer's technique of decorative etching into a means of producing expressive works of art, Dürer made but six etchings. Among them are several, like the *Christ on the Mount of Olives,* which breathe the most passionate religious and emotional intensity.

Panofsky, E., *Albrecht Dürer.* Princeton, 1943, Vol. I, p. 195; Vol. II, p. 22.

68.793.1 The Metropolitan Museum of Art, Gift of Mrs. George Khuner, The George Khuner Collection, 1968.

241. The Bath House
Albrecht Dürer
German, 1471–1528
Woodcut; *ca.* 1496
Height: 16 inches; Width: 11½ inches

Dürer began as a member of the provincial Gothic School of Nuremberg and ended as one of the most important European artists of the Renaissance. He was early drawn to the new humanism and to classical art and set his sights on mastering the perfect canon for rendering the human figure in all its proportional beauty. Probably the earliest of the large-sized woodcuts published after his return from Italy, *The Bath House* displays the color and character that were to carry Dürer out of the attenuated Gothic tradition of illustration into the full richness of Renaissance representation.

Panofsky, E., *Albrecht Dürer.* Princeton, 1943, Vol. II, p. 42.

19.73.155 The Metropolitan Museum of Art, Gift of Junius S. Morgan, 1919.

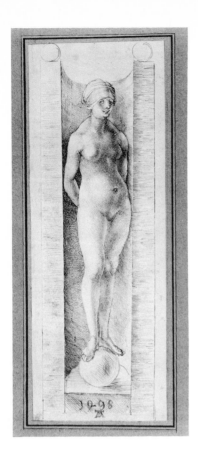

242. Nude Female Figure in a Niche
Albrecht Dürer
German, 1471–1528
Pen and brown ink
Height: 13 inches; Width: 4½ inches

Dürer's preoccupation with the theoretical study of human proportions, so
evident in his later work, is already apparent in this early drawing of 1498.
The stance and anatomical detail of the figure are typical of the northern
notion of the nude figure, to be found in the work of masters such as Van Eyck
and Cranach.

Winkler, F., *Die Zeichnungen Albrecht Dürers.* Berlin, 1936–1939, Vol. I, No. 154.

Robert Lehman Collection.

243. Christ on the Mount of Olives
Lucas Cranach the Elder
German, 1472–1553
Woodcut
Height: 15⅜ inches; Width: 11 inches (trimmed to block line)

It is true of many a German artist, but especially true of Cranach, that in his
woodcuts he is shown to greater advantage than in his paintings. (It is not
improbable that line, the printmakers medium, rather than painting, is on the
whole the most characteristic form of German expression in art.) Cranach, whose
woodcuts are numerous and, at their best, among the finest of their period,
exerted a preponderating influence on North German art. The *Christ on the
Mount of Olives* exemplifies his peculiarly charming and profoundly original
way of looking at strictly scriptural events. So far as we now know, this
impression is the only one in existence.

Hollstein, F. W. H., *German Engravings, Etchings, and Woodcuts,* ca. *1400–1700.*
Amsterdam, 1960, Vol. VI, p. 22.

27.54.3 The Metropolitan Museum of Art, Harris Brisbane Dick Fund, 1927.

245. The Drowning of Britomartis

French, probably Paris, *ca.* 1550
Wool and silk, 16–18 warps per inch
Height: 15 feet, 3 inches; Width: 9 feet, 7 inches

This tapestry is part of a set depicting scenes from the story of Diana of which seven tapestries and part of an eighth are known. The set, probably finished in 1552, was certainly made for the château of Anet, the residence of Diane de Poitiers, mistress of Henri II of France.

The story of Britomartis is told in French verse on the panel at the top of the tapestry. The upper parts of the vertical border show an emblem, an arrow with the words CONSEQVITVR QVODCVMQVE PETIT (It attains whatever it seeks). The device was used by Diane de Poitiers and it, as well as many other details in the tapestry, refer to her. Diana is an idealized portrait of Diane, and the hem of her dress is embroidered with crossed deltas and the HD monogram that links her name with that of her royal lover. She also used all the standard attributes of Diana, such as crescent moons, bows, and hounds. Although it is uncertain where the tapestry was made, it is certain that it is one of the finest examples of the court style in mid-sixteenth-century France, elaborate, intricate, subtle, and refined to an almost febrile elegance.

Phillips, J. G., "Diane de Poitiers and Jean Cousin." *The Metropolitan Museum of Art Bulletin,* n.s., Vol. II, 1943, pp. 109–17.

42.57.1 The Metropolitan Museum of Art, Gift of the children of Mrs. Harry Payne Whitney in accordance with the wishes of their mother, 1942.

244. The Crucifixion

Flemish, Brussels, *ca.* 1520–1525
Wool, silk, and metal thread, 16–17 warps per inch
Height: 8 feet, 3 inches; Width: 8 feet, 2 inches

In this tapestry, the Crucifixion is presented not so much as a historic event, but as an object for pious contemplation. This is shown by the fact that the angels carry symbols of the Passion, instead of the more usual chalices for catching Christ's blood. Jerusalem is seen in the distance on the left, with Christ falling under the cross on the way to Calvary.

Tapestry design in Brussels was revolutionized by the appearance there about 1516 of Raphael's cartoons for the *Acts of the Apostles.* Bernard van Orley, especially, was deeply influenced by these masterpieces and learned from them to open up his designs and to make handsome compositions with a few noble foreground figures, preserving at the same time the wealth of lively detail so faithfully reproduced by the weavers. Similarities in this tapestry to paintings of the Crucifixion by Bernard van Orley suggest that it may have been he, or one of his followers, who designed it.

Rubenstein-Bloch, S., *Catalogue of the Collection of George and Florence Blumenthal.* Paris, 1927, Vol. IV.

41.190.136 The Metropolitan Museum of Art, Bequest of George Blumenthal, 1941.

**246. Scene from the Story of Mercury and Herse:
The Bridal Chamber of Herse**
Flemish, Brussels, *ca.* 1550
Wool, silk, and metal thread, 20–22 warps per inch
Height: 14 feet, 5 inches; Width: 17 feet, 8 inches

The tapestry, from the Mercury and Herse series, describes an incident
in the love affair between these two characters, as it is related in Ovid's
Metamorphoses.

The wefts are fine and closely packed, with an abundance of gold and
silver threads. Very few tapestries of this richness have been preserved.
They show Flemish Renaissance art at its most accomplished. By the
middle of the sixteenth century, tapestry designers had completely
mastered the rules of foreshortening and perspective, as well as the
principles of clarity, breadth, and spaciousness, learned from the Raphael
cartoons. The weaver was the famous Willem van Pannemaker.

Rubenstein-Bloch, S., *Catalogue of the Collection of George and Florence
Blumenthal*. Paris, 1927, Vol. IV.

41.190.135 The Metropolitan Museum of Art, Bequest of George
Blumenthal, 1941.

247. Suit of Armor
Attributed to Martin van Royne (active *ca.* 1510–1540);
decoration designed probably by Hans Holbein (1497–1543)
English, Royal Court Workshop, Greenwich
Steel, etched and gilded; brass, leather, green velvet
Height: 6 feet, ½ inch; Weight: 80 pounds, 4½ ounces
Dated 1527

Though the armor is complete as is, there are indications that it was
originally the basic part of a garniture for all requirements of field and
tournament. Technically and stylistically this armor displays a number
of the characteristic features of works from the English Royal Court
Workshop, established by Henry VIII in 1514 with Flemish and German
workmen under the master armorer Martin van Royne. It is the earliest
known dated work of this school, and represents an extremely important
stage in its development. The splendidly etched decoration shows the
hands of two masters; many of its motives are derived from German
model books and book illustrations. The finest craftsmanship suggests
the style of Hans Holbein, whose first stay in England was 1526–1528.

Gamber, O., "Die Königlich Englische Hofplattnerei Martin van Royne
und Erasmus Kirkener." *Jahrbuch der Kunsthistorischen Sammlung in Wien*,
1963, Vol. LIX, pp. 7–38.

19.131.1 The Metropolitan Museum of Art, Rogers Fund, 1917.

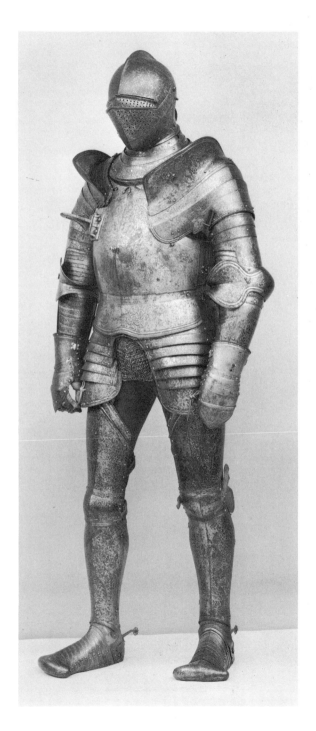

248. Parade Shield
Designed by Étienne Delaune, court artist of Henri II
French, 1518/1519–1583
Royal Court Workshop
Steel, damascened with gold and silver
Length: 25 inches; Width: 19 inches; Weight: 7 pounds
Made *ca.* 1555

This shield with its rich strapwork, trophies, garlands, and figural decoration is a spectacular example of the refinement the classical taste of the Renaissance underwent in court art. The subject of the central scene is the last stand of the Consul Lucius Aemilius Paulus in the Battle of Cannae (216 B.C.), as recorded by Livy in his *History of Rome.* This theme is part of the intricate iconography of Triumph and Fame that Henri II had arranged around his person by his court artists. The gold and silver damascening on the decorative strapwork incorporates the monogram of King Henri II (1519–1559), composed of *H* for Henri, *D* for Diane de Poitiers (his mistress), and *C* for Catherine de' Medici (his wife). Interspersed with the monograms are crescents, chosen by Henri for his personal badge, as a reference to the moon goddess Diana and her namesake Diane de Poitiers.

The composition of the battle scene is partly derived from a medal, School of Moderno, 1504 or 1505, and from designs by Hans Burgkmair the Elder (1473–1531). Delaune's original drawings for this shield are in the Graphische Sammlungen, in Munich.

Nickel, H., "The Battle of the Crescent." *The Metropolitan Museum of Art Bulletin,* n.s., Vol. XXIV, 1965, pp. 11–27.

34.85 The Metropolitan Museum of Art, Harris Brisbane Dick Fund, 1934.

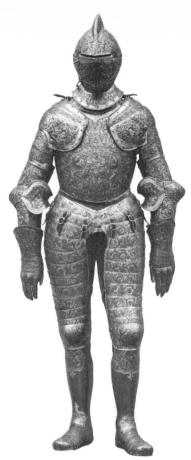

249. Suit of Armor

Designed by Étienne Delaune
French, 1518/1519–1583
Steel, embossed and gilded, damascened with gold and silver;
brass, leather, red velvet
Height: approximately 5 feet, 9 inches; Weight: 53 pounds, 4 ounces
Made *ca.* 1550–1559

This armor was designed purely for dress or parade wear, as the magnificent embossing of its surface defeats the original purpose of plate armor—to deflect the points of enemy weapons and send them glancing off. The iconographical details of the decoration, bound captives, female genii presenting weapons wreathed with laurel to a hero, and other similar motives illustrate the theme of Triumph and Fame.

Étienne Delaune's designs for this particular suit of armor and other original drawings by him are in the Graphische Sammlungen, Munich. It has been estimated that it would have taken a skilled metalworker about two years to fashion this armor. However, there are at least three different hands recognizable in the decoration alone, which would have speeded up the process considerably, and much of the decoration must have been done by a goldsmith.

This armor, as indicated by the crescent badges, was made for Henri II personally, and must have been kept in the royal armory after his death (which, incidentally, occurred in a tournament), because later it was presented by Louis XIII (1601–1643) to Bernhard, Duke of Saxe-Weimar (1604–1639), a famous general of the Thirty Years' War (1618–1648).

Grancsay, S. V., "A Harness of a King of France." *The Bulletin of The Metropolitan Museum of Art*, Vol. XXXV, 1940, pp. 12–17.

39.121 The Metropolitan Museum of Art, Harris Brisbane Dick Fund, 1939.

250. Suit of Armor (with Exchange Pieces) Made for Sir George Clifford, 3rd Earl of Cumberland, K. G.

Master Jacobe (Jakob Halder)
Active 1555–1607
English, Royal Court Workshop, Greenwich
Steel, blued, etched and gilded; brass, leather, velvet
Height (as mounted): 5 feet, 9½ inches; Weight (as mounted): about 60 pounds
Made *ca.* 1590

This armor is thought to be the one worn by the Earl of Cumberland when he took over the office of Champion of Queen Elizabeth from Sir Henry Lee, in 1590. The chief duty of that office appears to have been presiding over the jousts and tournaments held every Queen's Day, November 17, at Westminster, behind the present Horse Guards, then, as now, known as the Tilt Yard.

The Royal Workshop at Greenwich, where this armor was made, was established by Henry VIII for his personal use and for the manufacture of presentation pieces of princely magnificence. For a knight to have his armor made in this workshop was a special privilege granted by the sovereign. The Earl of Cumberland's armor is the best preserved and most complete Greenwich armor in existence.

The main motives of the decoration are Tudor roses and fleur-de-lis tied together by double knots, and, repeated on the ornamental gilded bands filled with strapwork, a cipher of two addorsed E's (for Elizabeth) interlaced with annulets (a Clifford badge).

In his miniature portrait by Nicholas Hilliard (1547–1619), now in the Starr Foundation, Kansas City, and in an oval portrait, formerly belonging to the Duke of Devonshire, the Earl of Cumberland is represented wearing this armor. Sir George Clifford was the prototype of the Elizabethan gentleman-courtier, soldier, scholar, and pirate. He studied mathematics and geography at Cambridge and Oxford, and fitted out ten expeditions against the Spaniards, personally leading four of them.

Grancsay, S. V., "A Miniature Portrait of the Earl of Cumberland in Armor." *The Metropolitan Museum of Art Bulletin*, n.s., Vol. XV (January, 1957), pp. 120–22.

32.130.6 a–y The Metropolitan Museum of Art, Rogers Fund, 1932.

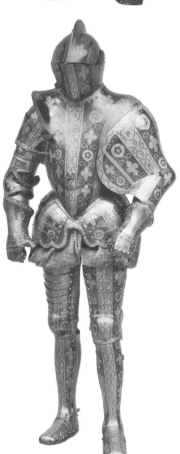

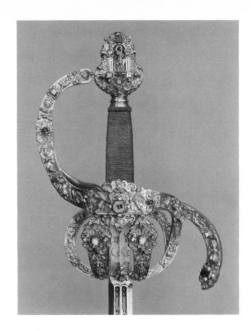

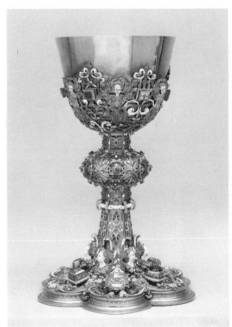

**251. Parade Rapier, Made for Christian II,
Duke of Saxony and Elector of the Holy Roman Empire**
Israel Schuech, German, Dresden, active *ca.* 1590–1610,
swordcutler and hiltmaker to the Electoral court of Saxony
Juan Martinez, Spanish, Toledo, active in the late XVI century,
bladesmith to the King of Spain
Steel, gilt bronze, various jewels and seed pearls, traces of enamel
Total length: 48 inches; G. width: 6¾ inches;
Length of blade: 41¼ inches; Width of blade: ⅞ inch
Blade signed
IVAN MARTINEZ EN TOLEDO (reverse)
IN TE DOMINE SPERAVI NON (obverse)
ESPADERO DEL RE (on ricasso)
Stamped fourteen times with three armorers' marks
Hilt signed
ISRAEL SCHVECH 1606 M.

Sir Guy Francis Laking, one of the greatest authorities in the field of arms and
armor, has said of this sword "that nothing could exceed [it] in splendour."
Indeed, its magnificently cast and chiselled bronze hilt, lavishly covered with
decorative detail of elaborate strapwork and exquisitely sculptured allegorical
figurines of diminutive size, dazzling in its rich gilding, and sparkling with
forty-odd multicolored jewels and pearls, gives us a fitting impression of pomp
and circumstance of the early Baroque. However, as if to indicate that under
all this pageantry lurked the troubles of religious and dynastic strife that
ultimately led to the Thirty Years' War (1618–1648), as if to show that in
these troubled times a man, even a rich and powerful man, might have to use
the edge of the sword to defend his life, there is attached to this splendidly
overdecorated hilt a blade by the most renowned master of the celebrated
swordsmiths of Toledo.

Hayward, J. F., "Studies on Ottmar Wetter." *Journal of the Royal Swedish
Armoury,* Vol. V, Stockholm, 1949, pp. 8–9.

1970.77 The Metropolitan Museum of Art, Rogers Fund, 1970.

252. Chalice
South German
Gold, enamel, and precious stones
Height: 9 inches
Dated 1609

The base of the cup, the stem, and foot are overlaid with pierced work and
appliqués of gold enameled in opaque and translucent colors of white,
emerald, ruby, and sapphire blue. The decoration comprises scrolls, angels'
heads, and precious stones, including emeralds, rubies, and diamonds. The
coat of arms of Wolff-Metternich appears on one lobe of the foot; opposite is a
cross set with table-cut diamonds.

The chalice, which is inscribed underneath the foot ADOLPHUS WOLFF
DICUTS METTERNICH DECANUS SPIRENSIS ANNO 1609, is said to have
belonged to Adolph Wolff-Metternich who became Dean of Speyer in 1608.
According to Luthmer (see ref. below), it was presented, in the following
century, by Karl Friedrich von Baden (1728–1811) to one of his city's churches.

Despite its size and religious associations, the style of decoration of the
chalice is far more akin to secular jewelry than to ecclesiastical plate. In its
profusion of vivid color, its sculptural elements and intricate patterns of
moresques and C-scrolls *(Schweifgrotteske),* it displays the characteristic richness
of South German jewelry around 1600. Cups and chalices similarly decorated
span a long period, from about 1560 to 1630. This particular type of
Schweifgrottesken and the prominence of table-cut stones, including diamonds,
which did not become an integral part of such decoration until about 1600,
reflects a style developed at the turn of the sixteenth century and disseminated
through the engraved designs of Hans Collaert, Daniel Mignot, and others.

Luthmer, F., *Der schatz . . . meisterwerke alter goldschmiedekunst aus dem 14–18
jahrhundert.* Frankfort a/m, Vol. II, 1883–1885.

17.190.371 The Metropolitan Museum of Art, Gift of J. Pierpont Morgan, 1917.

China: Ming Dynasty, 1368–1644

After the Mongols had been driven out, China was united once more under a native dynasty, the Ming. The stimulus of imperial patronage on a stupendous scale encouraged porcelain and the other decorative arts such as lacquer. Ming potters perfected the underglaze blue and white porcelain that is the most familiar production of this period. Academic scholar-painters officially ranked those masters considered worthy of imitation and deepened the split between painter and artisan.

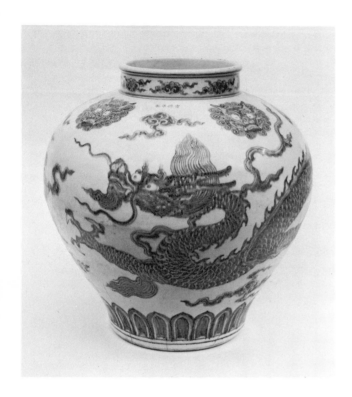

253. Large Jar
Chinese, Ming Dynasty, XV century
Blue-and-white porcelain
Height: 19 inches
Ching-te-chen, Kiangsi Province

This storage jar is decorated with a sprawling three-clawed dragon flying amid cloud forms, painted in typical "heaped and piled" underglazed Muhammadan cobalt blue on white ground. On the shoulder inscribed under the glaze is a four character mark: *Hsüan-tê nien chih,* meaning, "made in the period of *Hsüan-tê,* that is in the reign (1426–1435) of one of the most important emperors of the Ming Dynasty. Also on the shoulder are clouds and large animal masks, probably of lions. A continuous band of stylized lotus petals surrounds the lower portion of the jar near the foot.

Lee, Jean, *Ming Blue and White.* Philadelphia, 1949, Cat. No. 47.

37.191.1 The Metropolitan Museum of Art, Gift of Robert E. Tod, 1937.

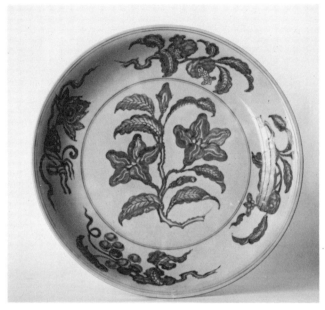

254. Vase (Mei P'ing)
Chinese, Ming Dynasty, early XV century
Porcelaneous stoneware with mottled cobalt-blue glaze
Height: 13 inches
Probably from Ching-te-chen, Kiangsi Province

Cobalt blue was used in monochrome glazes on Chinese pottery as early as the T'ang Dynasty (618–907). This splendid *mei p'ing* illustrates how skillfully the potter could still use his cobalt blue in monochromatic effects centuries later.

Intended to hold one lovely branch of prunus blossoms, the small mouth of the vase is admirably designed to support the spray in an upright position; while the strong base provides support for the weight of the fairly heavy stalk.

This elegant yet imposing shape serves as a fitting foil for the deep blue glaze which covers it; and the small accumulations of color add decorative, even if unintentional, interest to the total effect.

25.13 The Metropolitan Museum of Art, Rogers Fund, 1925.

255. Dish
Chinese, Ming Dynasty
Mark and period of Hung-chih, 1488–1505
Porcelain decorated in underglaze blue and overglaze yellow enamel
Diameter: 10¼ inches
Ching-te-chen, Kiangsi Province

This dish is an example from a series, possibly an Imperial table service, which began in the early fifteenth century and continued until the late sixteenth century.

The dish was first painted with cobalt blue on the paste, then glazed and fired at a temperature sufficiently high to vitrify the clay. The yellow enamel was then applied, carefully outlining the flowers; and the piece then refired at a lower temperature.

The central flower on the dish has been identified as a gardenia; the sprays in the cavetto of the piece are loquat or peach, grapes, lotus, and pomegranate. There is a floral scroll on the underside.

Garner, Sir H., "Blue and White of the Middle Ming Period." *Transactions of the Oriental Ceramic Society,* 1951–1953, Vol. XXVII, pp. 68–70.

19.28.10 The Metropolitan Museum of Art, Rogers Fund, 1919.

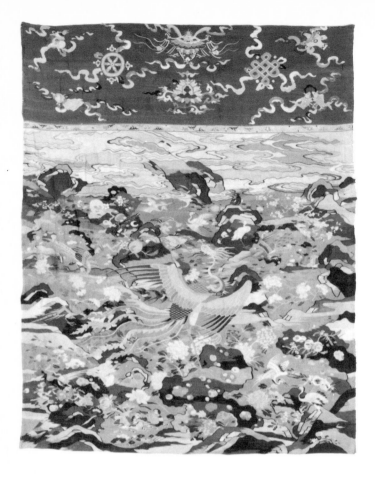

256. Hanging or Screen-Panel: Fêng Huang in a Rock Garden
Chinese, early XVII century
Silk tapestry (k'o-ssu) with details in gold-wrapped silk thread
Height: 7 feet, 4¼ inches; Width: 5 feet, 11 inches

An ancient Chinese writing, the *Mountain and Seas Classic* or *Shan Hai Ching,* describes in detail the bird depicted on this tapestry. It is a *fêng huang,* chief of the birds and symbol of happiness. It is shaped like a cock and has five colors and stripes. "The stripes on the head are called virtue; the stripes on the wings, justice; on the back, politeness; those on the breast are called humanity; those on the stomach, honesty. This bird drinks and eats, sings and dances, by itself. When it appears, the world enjoys peace." It is pictured here encircled by the Hundred Birds of its entourage.

By the first half of the seventeenth century, when this silk and metal screen panel was made, the *fêng huang,* like the five-clawed dragon, had become an imperial emblem, so it is probable that the hanging was used in the apartments of the empress. The dark-blue woven valance across the top is set with the Eight Precious Things of Buddhism *(Pao Pa),* a frequent decoration in many media employed by this date more for general good auspices then for religious reasons.

The kind of weaving that is seen in this panel was practiced in wool and linen for many centuries B.C. in the Near East. In China, it is described as *k'o-ssu* or "carved silk" in sources from the Sung Period (A.D. 960–1279), and examples surviving from this epoch are so skillful that we must conclude the technique had already been in use for some time before they were made. It was very widely used in the Ming Period (1368–1644). The flat decorative treatment of our woven panel recalls the cloisonné enamels which also became popular in China in the seventeenth century.

Mailey, J., "A *Fêng Huang* in a Rock Garden." *The Metropolitan Museum of Art Bulletin,* n.s., Vol. XX (Summer, 1961), pp. 20–24.

60.1 The Metropolitan Museum of Art, Seymour Fund, 1960.

257. Figure of Bodhidharma
Chinese, Late Ming Dynasty (1368–1644)
Porcelain with colorless glaze *(Blanc de Chine)*
Height: 11½ inches; Width: 7½ inches
Te-hua, Fukien Province

This statuette represents Bodhidharma, said to be the twenty-eighth Buddhist patriarch and the first patriarch of the Ch'an sect of Buddhism.

The kilns of Te-hua in Fukien Province had at their disposal a particularly fine clay of extremely plastic nature which lent itself admirably to the modeling of small figures. The lustrous ivory-toned glaze melts into the dense, pure white porcelain body to form objects known as *Blanc de Chine,* of which this serene and graceful figure is an especially fine example.

63.176 The Metropolitan Museum of Art, Gift of Mrs. Winthrop W. Aldrich, Mrs. Arnold Whitridge, and Mrs. Sheldon Whitehouse, 1963.

Japan:
Muromachi Period, 1392–1573
Momoyama Period, 1573–1615

In the Muromachi Period, Japan disintegrated into feudal fiefs that carried on bitter and incessant warfare. Under the influence of Zen Buddhism, itself initially imported from China, Japan was once more dominated by Chinese art, especially that of the Southern Sung Period. Garden design and the tea ceremony, emphasizing contemplation and humility as did Zen, supplied an escape from a violent world.

During the Momoyama Period a military dictatorship was imposed upon the feudal structure—a combination that was to provide the basis of Japanese government until after the middle of the nineteenth century. Although toward the end of the sixteenth century some Japanese ports were opened to European traders, the spirit of isolationism was growing in Japan.

258. Portrait of a Zen Priest, Abbot of a Monastery
Japanese, Muromachi Period, 1392–1573
Lacquered wood
Height: 36½ inches; Width: 22½ inches; Diameter: 17½ inches

Zen Buddhism was a religious phenomenon peculiarly suited to the Japanese people in the Muromachi Period. The great teachers and patriarchs, rather than the luminaries in the Buddhist hierarchy, were subjects for sculptors and painters of the day.

The sculptured portrait here exhibited is strong and simple and highly realistic in its conception. The abbot sits with legs crossed, the drapery of his robe falling over his knees. His hands form a gesture denoting concentration. The quiet expressive face leads one to believe that this Zen priest did indeed achieve enlightenment—and release.

Kuno, T., ed. *A Guide to Japanese Sculpture.* Tokyo, 1963.

63.65 The Metropolitan Museum of Art, John D. Rockefeller, III, Gift Fund, 1963.

259. Pair of Six-fold Screens: Battles of the Heiji and Hogen Eras
Japanese, Momoyama Period, 1573–1615
Ink and colors on gold paper
Height: 60⅞ inches; Width: 140⅛ inches

The Momoyama Period (1573–1615) in which we place these screens
saw the reestablishment of warrior control of the country. These men
were not interested in the refinements of court life, but in decorating
their large dark castles with warm color. This is the period when the
Japanese screen came into its own. Strong thick colors against a ground
of gold leaf were the fashion.

In our screens, the drama of the two insurrections is set before us,
scene by scene. The locale for most of the action is Kyoto, but the
artist did not hesitate to switch to Mount Fuji. Nor are the scenes placed
chronologically; rather the artist distributed his incidents as suited him
best. The viewer gets a bird's-eye view of the action because of the
Japanese technique of looking down from above at an oblique angle.
Sliding doors and roofs are miraculously pulled back so that we see the
scene inside the palace as well as outside. The painting is meticulous
in detail, making use of strong greens, reds, and blues against the gold.

Murase, Miyeko, "Japanese Screen Paintings of the Hogen and Heiji
Insurrections." *Artibus Asiae,* Vol. XXIX, 1967, pp. 193–228.

57.156.4,5 The Metropolitan Museum of Art, Rogers Fund, 1957.

260. Two-Fold Screen: Waves
Ogata Korin
Japanese, 1658–1716
Ink and colors on paper
Height: 57⅞ inches; Width: 65⅛ inches

Ogata Korin was born in the mid-seventeenth century into a wealthy merchant-class family in Kyoto. After squandering his inheritance, he turned to painting as a serious vocation. This screen was painted by him at a period when Japan was enjoying peace and prosperity. Having assimilated foreign influences, she was ready now with her own native genius to pursue her artistic progress. The Japanese feeling for nature is obvious here, as is Korin's ability to transpose it into a rhythmic bold stylization. The design is really the abstract essence of a wave, and Korin expresses this imaginative design with supremely controlled brushwork. The subtle gradations of color, with gold and blue predominating, enhance the extraordinary ink strokes with a remarkable fusion of decorative and realistic elements. The theme of this painting is a universal one, but this particular expression of it is characteristically Japanese.

Tanaka, I., ed. *The Art of Korin.* Tokyo, 1959.

26.117 The Metropolitan Museum of Art, Fletcher Fund, 1927.

261. Suit of Armor
Yoshihisa Matahachiro, 1532–1554 (signed on left greave)
Japanese, Muromachi Period
Steel, blackened and gold-lacquered; flame-colored silk braid, gilt bronze, stenciled deerskin, bear pelt, gilt wood
Height: about 66 inches; Weight: approximately 48 pounds
Made *ca.* 1550

The flame color of the braid and the gold lacquer of the steel scales indicate the rank of the owner, a general under the *daimyo* of Sakai (Izumi). The body armor consists of over 4,500 lacquered steel lames, almost 1,000 rivets (not counting the links of mail, of course) and 265 yards of silk braid. The flexibility of the defense is in striking contrast to the rigidity of European plate armor.

Grancsay, S. V., "The New Galleries of Oriental Arms and Armor." *The Metropolitan Museum of Art Bulletin,* n.s., Vol. XVI (May, 1958), pp. 254–55.

04.4.2 The Metropolitan Museum of Art, Rogers Fund, 1904.

Section VI: ca. 1600 – ca. 1700

1601–1602	Shakespeare writes *Hamlet*
1604	Cervantes writes *Don Quixote*
1609	Hudson sails up Hudson River in search of Northwest Passage
1611	King James Bible published
1618–1648	Thirty Years' War between Protestants and Catholics in Europe
1619	First Negro slaves in English North America
1620	Pilgrims settle at Plymouth
1626	Peter Minuit buys Manhattan
1632	Taj Mahal built as tomb for wife of the Mogul emperor
1642	Rembrandt paints *Nightwatch*
1642	Death of Galileo
1644–1912	Manchurian Ch'ing Dynasty established at Peking
1653	Oliver Cromwell becomes Lord Protector of England, Scotland, and Ireland
1660	Rise of the Bambara Kingdoms on the Upper Niger
1663	Milton writes *Paradise Lost*
1666	Fire of London
1669	Palace of Versailles begun
1683	Siege of Vienna, farthest advance of Turks into Europe
1687	Sir Isaac Newton publishes *Mathematical Principles of Natural Philosophy*
1689	Bloodless Revolution, England; final victory of Parliamentary rule

West West West Africa

1600

271. Caravaggio,
Italian

262. Benin,
ca. 1550

1610

1620

276. Rubens,
Flemish

1630

293. Poussin,
French (detail)

1640

1650

279. Rembrandt,
Dutch

1660

283. Vermeer,
Dutch

297. Anguier,
French

1670

1680

1690

298. Coysevox,
French

1700

Africa

The court art of the city of Benin in Nigeria stands apart from most traditional African art. The techniques used by Benin bronze-casters to render their royal subjects were undoubtedly introduced by Muslim traders from beyond the Sahara. The indigenous art of other tribes in western Africa, from the Guinea Coast to the far reaches of the Congo, revolves around the religious ceremonies of village life and displays a more typical African preference for abstract forms carved in wood.

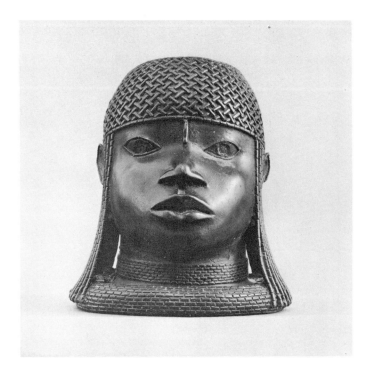

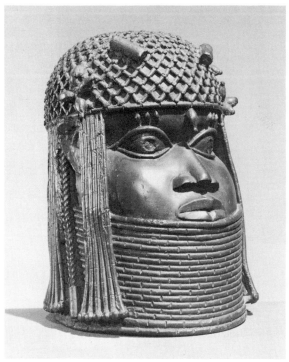

262. Head (Uhumwelao)
Nigeria, Court of Benin: Bini People, *ca.* 1550
Bronze
Height: 8¾ inches

This head is said to have come to America in 1885, prior to the famous British Punitive Expedition of 1897, when a great many pieces were taken out of Benin City and sold to collections in England and Germany. Before this, the art was virtually unknown to Europeans. Such heads were placed with other ritual and commemorative objects, on altars where the spirit of a deceased *Oba* (the divine ruler) was honored and invoked. Each past *Oba* had an altar dedicated to him. It was the first duty of the new *Oba*, the eldest son and heir, to erect an altar to his recently deceased father. This was one of a pair from such an altar.

This handsome head, which is the earliest of the Benin bronzes in our exhibition, still retains the naturalism of the medieval style of Ife where the technique of bronze casting originated. Its thinness, as well as the rectangular strips of iron inlay, suggests that it is one of the earliest Benin pieces known. The serene face, with its softly curving modeling, renders an idealization of the features of a specific individual, probably a young princess or high noblewoman.

Fagg, W., *Nigerian Images.* New York and London, 1963, Pl. 12.

58.181 The Museum of Primitive Art.

263. Head (Uhumwelao)
Nigeria, Court of Benin: Bini People, *ca.* 1550–1680
Bronze
Height: 10¾ inches

Made for the altar of an *Oba*, this head shows the special bead cap and coral and agate ornaments of his ritual regalia. The weight of the casting indicates that it was used as a base for a carved elephant tusk inserted in the aperture at the top. The tusks were carved in low relief, depicting the *Oba*, his attendants, warriors, and various historical and mythological figures.

Forman, W., and Dark, P., *Benin Art.* London, 1960.

58.218 The Museum of Primitive Art.

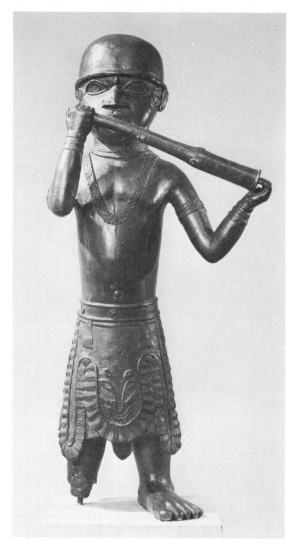

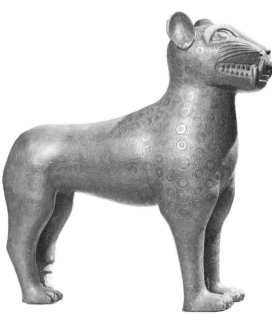

264. Standing Figure of Horn-Blower

Nigeria, Court of Benin: Bini People, *ca.* 1550–1680
Bronze
Height: 24⅞ inches

The figure is wearing a leopard skin kilt trimmed with feathers, a coral collar, necklace, and bracelets. Originally it stood on a royal ancestor altar. About five such figures are known. Traditionally, a horn-blower was part of the royal retinue which also included important chiefs and warriors, figures frequently pictured on the numerous bronze plaques that adorned the *Oba's* palace.

Forman, W., and Dark, P., *Benin Art*. London, 1960.

57.225 The Museum of Primitive Art.

265. Leopard

Nigeria, Court of Benin: Bini People, *ca.* 1750
Bronze
Height: 15½ inches

Leopards were sacred in Benin, symbolic of the royal power. The *Oba* kept tame ones in his palace as pets and led them in royal parades. Originally this was an altar figure, perhaps one of a pair. Although an aperture in the top of the head has been plugged, the figure was probably an aquamanile, with the nostrils serving as the spout, used to pour water over the *Oba's* hands prior to some ceremony.

Fagg, W., *Nigerian Images*. New York and London, 1963.

58.90 The Museum of Primitive Art.

266. Rooster
Nigeria, Court of Benin: Bini People, XVIII century
Bronze
Height: 17¾ inches

Wooden images of roosters commonly were placed on the altars of the mothers of chiefs. Only those on the altars of the queen-mothers were of bronze, a royal monopoly in Benin. Like the other dozen and a half known examples, this one stands on a square base decorated with an angular guilloche. The heavy, geometric form of the rooster's body identifies him as being later than the elegant, thin roosters of the middle period. Upon the modeled masses, thin-lined patterns of feathers are incised into the wax model before casting, giving the figure the characteristic division between regular surface pattern and high-relief definition of the major forms. Only the three main tail feathers emerge in relief.

50.145.47 The Metropolitan Museum of Art, Bequest of Mary S. Harkness, 1950.

267a. Head for a Reliquary (Great Bieri)
Gabon: Fang
Wood, metal
Height: 18¼ inches

267b. Figure for a Reliquary
Gabon: Fang
Wood, metal
Height: 25¼ inches

Bieri is the Fang word for a bark container that holds the skulls of lineage ancestors, and is guarded by a carved figure, half-figure, or head that surmounts the container. Although the carving may not specifically represent the ancestors, it suggests the concept of lineage ties and solidarity. Because the making of such figures is a widespread practice among a number of linguistic subgroups, the figural type exhibits a broad variety of substyles. A "stem," extending below the spine of the full figures, enables them to be set on the edge of the *bieri* receptacle. These carvings were formerly in the collections of the sculptor Sir Jacob Epstein, an early collector of African art, and Paul Guillaume, who acquired them in the twenties when such art was beginning to cause a considerable stir in the Western art world.

(a) Perrois, L., "Aspects de la sculpture traditionelle du Gabon." *Anthropos*, Vol. LXIII/LXIV, 1968–1969, pp. 869–91.
(b) Siroto, L., "Notes on the Bakota, Pangwe, and Balumbo Sculpture of the Gabon and the Middle Congo." *Masterpieces of African Art*, New York, The Brooklyn Museum, 1954.

61.283, 284 The Museum of Primitive Art.

268. Seated Mother and Child Figure
Mali, Bougouni district: Bambara
Wood
Height: 48⅝ inches

The Bambara of Mali have long been known for their masks, small figures, door locks, and especially the graceful and highly stylized antelope headpieces. Recently, a number of larger figures have come to light. Carved in a very dense wood, usually weathered and considerably eroded by insects, they are often, but not exclusively, female figures—sometimes holding a child, as in this example, and almost invariably wearing the high, crested cap common to Bambara figures. While there are no ethnographic data to justify the name "Queen" figure frequently given them, the elegance of the style, particularly of this piece, seems to merit the term. They are probably some type of ancestor figure carved as a representation of a person of high status.

Goldwater, R., *Bambara Sculpture from the Western Sudan*. New York, The Museum of Primitive Art, 1960.

59.110 The Museum of Primitive Art.

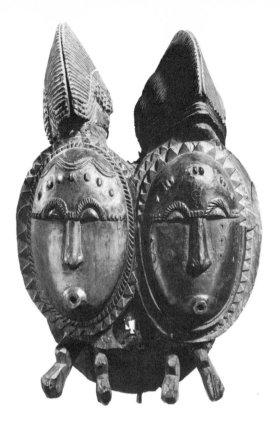

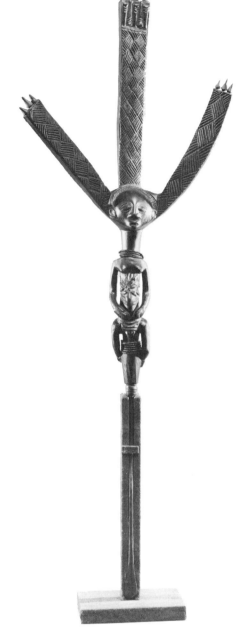

269. Double Face Mask
Ivory Coast: Baule
Wood, metal, stain
Height: 13¼ inches

This double face mask exemplifies the principle of duality signified among the Baule by the colors red (female, beautiful) and black (male, awesome) and may refer to *Nyamye,* god of heaven, and *Assye,* goddess of the earth. Unlike many African peoples, the Baule portray some of the gods of their elaborate pantheon in their sculpture. The high, crested coiffure, delicate facial markings, protruding mouth, and overall refinement of line and detail are elements characteristic of Baule figure carving and also are found in the sculpture of the neighboring Guro tribe.

Siroto, L., "Baule and Guro Sculpture of the Ivory Coast." *Masterpieces of African Art,* New York, The Brooklyn Museum, 1954.

65.128 The Museum of Primitive Art.

270. Bow Stand
Congo, Kinshasa: Luba
Wood, metal, beads
Height: 38½ inches

An aristocratic society organized under a single chief in the late fifteenth century, the Luba developed a distinctive and refined art in which figure sculpture and objects denoting the prestige and status of their owners predominate. Female caryatid figures, carved in rounded forms with curved lines that tend to turn back on themselves, are often the central element of staffs, stools, neckrests, and bow stands, such as this one. Scarification marks on the torso and, less frequently, on the arms and face, indicate that such pieces belonged to the king or to high-ranking members of the society.

Leuzinger, E., *The Art of the Negro Peoples.* New York, 1960.

63.112 The Museum of Primitive Art.

Southern Europe: Baroque

Baroque art—illusionistic, sensual, dynamically occupying space—was developed during the early seventeenth century, primarily by northern Italian artists drawn to Rome by a flood of new papal projects. The culmination of Roman Baroque is contemporary with the balance of power established between Protestant and Catholic monarchies in Europe after 1648, when the religious struggles in Germany ended. Catholic southern Germany and Austria, in fact, were the setting for the final flowering of Baroque art after 1690.

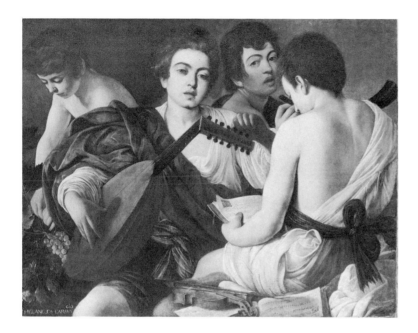

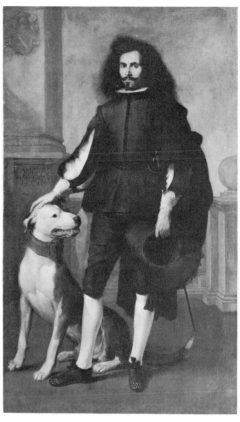

271. The Musicians
Caravaggio (Michelangelo Merisi da Caravaggio)
Italian, 1573–1610
Oil on canvas
Height: 36¼ inches; Width: 46⅝ inches

Probably no artist has ever had so widespread and decisive an effect on the course of European painting as Caravaggio. Trained in Milan in the traditional techniques of the sixteenth century, he went as a young man to Rome, where the force of his personality and his revolutionary way of painting rapidly brought him both notoriety and appreciation. Idealized classical subject matter like that of this picture, painted soon after his arrival in Rome, soon gave way to completely naturalistic interpretations, even of conventional religious subjects, all illuminated with very strong contrasts of light and dark.

Mahon, D., and Rousseau, T., Jr., "On Some Aspects of Caravaggio and His Times." *The Metropolitan Museum of Art Bulletin*, n.s., Vol. XII (October, 1953), pp. 33–45.

52.81 The Metropolitan Museum of Art, Rogers Fund, 1952.

272. Don Andres de Andrade y la Col
Bartolomé Estaban Murillo
Spanish, 1618–1682
Oil on canvas
Height: 79 inches; Width: 47 inches

Murillo, who spent almost all his life in Seville, is best known for paintings of the Virgin and Child and the Immaculate Conception, popularized by countless copies that convert his southern warmth and tenderness into facile sentimentality. Portraits like this one of the verger of the Cathedral of Seville, however, reveal him as one of the most gifted artists of the seventeenth century in Spain.

Wehle, H. B., *A Catalogue of Italian, Spanish, and Byzantine Paintings.* New York, The Metropolitan Museum of Art, 1940, pp. 243 ff.

27.219 The Metropolitan Museum of Art, Collis P. Huntington Bequest, 1927.

273. Bust of Cardinal Scipione Borghese
Alessandro Algardi
Italian, Bolognese 1598–1654
Marble
Height (with pedestal): 39 inches
Made in Rome soon after 1633

Algardi, nourished in the greatest period of Bolognese art, the time of the Carracci, arrived in Rome in 1625 at the beginning of Gianlorenzo Bernini's ascendancy. Algardi's greatness lies in his resolution of an apparent contradiction between classicism and the Baroque. This is manifest in his portraits which, from 1630 onward, suggest psychological complexity within relatively static poses. There could hardly be a greater contrast than that between Algardi's and Bernini's portraits of the powerful but genial Scipione Borghese, nephew of Pope Paul V. Bernini's two nearly identical portraits of 1632, in the Borghese Gallery, show a robust and beaming countenance. Algardi's slightly later vision, no less intense but far calmer, required a simpler format to expound the cardinal's character. Within the regular shape of the bust, the face is smoothed into an infinitude of tiny planes, so that the play of light has more subtlety, if less variety. The sagging features shown by Algardi may well be the more accurate. It is probably a commemorative work made after Scipione's death in 1633, which would further account for its brooding appearance.

Raggio, O., "A Rediscovered Portrait: Alessandro Algardi's Bust of Cardinal Scipione Borghese." *Connoisseur*, Vol. CXXXVIII (December, 1956), pp. 203–208.

53.201 The Metropolitan Museum of Art, Louisa Eldridge McBurney Gift, 1953.

274. Harpsichord
Italian, Rome, XVII century
Heigth: 8 feet, 9 inches; Width: 2 feet, 9 inches

This allegorical gilded harpsichord, decorated with a frieze depicting the triumph of Galatea and supported by three tritons, originally belonged to one of the earliest museums of musical instruments, Michele Todini's Galleria Armonica in Rome. The flanking figures of Polyphemus playing a bagpipe and Galatea, who probably held a lute, formed part of the original display, as shown by the reassembly of fragments of a small terracotta model of the instrument that was discovered in the storerooms of the Palazzo Venezia in Rome and by the description of the instrument given in a special chapter of Todini's catalogue of 1676. The rock supporting the figure of Polyphemus is hollow and originally contained the silver pipes of a small organ that provided the sound for his bagpipes.

Winternitz, E., "The Golden Harpsichord." *The Metropolitan Museum of Art Bulletin*, n.s., Vol. XIV (February, 1956), pp. 149–56.

89.4.2929 The Metropolitan Museum of Art, The Crosby Brown Collection of Musical Instruments, 1889.

Flanders and Holland

While Flanders remained Catholic and royalist, Holland, Protestant and bourgeois, proclaimed its independence from Spain in 1579. During the seventeenth century, painting was the single art of international significance produced in both regions. Rubens, thoroughly Italianized, dominated Baroque painting in Antwerp, the old commercial center of Flanders. Amsterdam became the commercial capital of Europe, as the Dutch competed with the Portuguese in the Eastern trade. Caravaggio's realism and his concern with the focusing power of light provided a starting point for Dutch painters, who developed a wide variety of styles in portraiture, landscape, still life, and genre scenes, spurred on by the first middle-class private collectors.

275. The Triumphal Entry of Henry IV into Paris
Petrus Paulus Rubens
Flemish, 1577–1640
Oil on wood
Height: 19½ inches; Width: 32⅞ inches

In the spring of 1594, four years after his decisive victory at Ivry, Henri IV took Paris, riding down the Rue St. Honoré to the royal residence in the Louvre.

This sketch is one of the fragments of the work Rubens had already done when the Queen Mother Marie dé Medici was obliged to abandon the imposing project of a companion cycle for the great series now in the Louvre. Combining as it does unfinished passages with others completed in color, it gives precious indications of his working methods and a forecast of the splendor of the painting for which it was a preparation.

Wehle, H. B., "The Triumph of Henri IV by Rubens." *The Metropolitan Museum of Art Bulletin,* n.s., Vol. I, 1943, p. 213.

42.187 The Metropolitan Museum of Art, Rogers Fund, 1942.

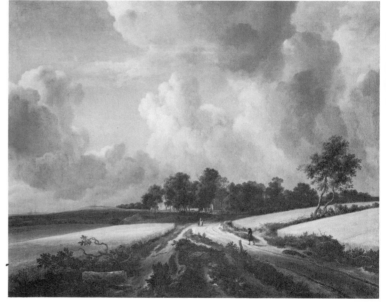

276. Venus and Adonis
Petrus Paulus Rubens
Flemish, 1577–1640
Oil on canvas
Height: 77½ inches; Width: 94⅝ inches

As in many of the paintings of the glorious last decade of his career, Rubens has drawn the subject matter from the *Metamorphoses* of Ovid and used his beautiful young wife Hélène Fourment as model. The rich color, the superb technical ability, the throbbing vitality and human warmth of his best works are all united here.

Wehle, H. B., "Venus and Adonis by Rubens." *The Bulletin of The Metropolitan Museum of Art*, Vol. XXXIII, 1938, pp. 193 ff.

37.162 The Metropolitan Museum of Art, Gift of Harry Payne Bingham, 1937.

277. Wheatfields
Jacob van Ruisdael
Dutch, 1628–1682
Oil on canvas
Height: 39⅜ inches; Width: 51¼ inches
Signed (lower right): J VRuisdael

Coming from a family of artists who trained him, Ruisdael himself taught Hobbema and many other well-known Dutch painters. Better than any other Dutch artist, he expressed with his low horizon lines and deep wide vistas of sand and dunes the look and feel of his country.

Rosenberg, J., *Jacob van Ruisdael.* Berlin, 1928, pp. 58 ff., 76.

14.40.623 The Metropolitan Museum of Art, Bequest of Benjamin Altman, 1913.

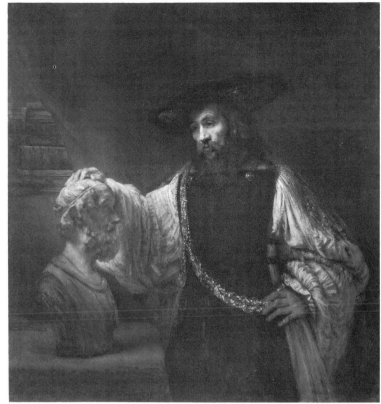

279. Aristotle Contemplating the Bust of Homer

Rembrandt Harmensz. van Rijn
Dutch, 1606–1669
Oil on canvas
Height: 56½ inches; Width: 53¾ inches
Signed and dated (lower left on base of bust): Rembrandt f./1653

Rembrandt painted this picture for a Sicilian nobleman, Don Antonio Ruffo, his only patron outside of Holland, who received it in 1654 and ten years later ordered from him two others, a Homer and an Alexander. The Homer is surely preserved in the beautiful painting now in the Mauritshuis in The Hague. Since we have not got the original commission, only conjecture is possible about the program desired from Rembrandt, or invented by him. One thing is certain, the three great men of antiquity are closely merged in the Museum's *Aristotle,* where the great thinker of ancient Greece is shown laying his hand on Homer's head, and also wearing across his body a golden chain with a medallion bearing the image of Alexander. The solemn stillness and solitude of the philosopher's study, the tenderness and eloquence of the fingers laid on the head of the blind poet, and above all the brooding mystery in the face of Aristotle unite to communicate some universal human emotion, of great power, though unclear.

Held, J. S., "Rembrandt's *Aristotle. "Rembrandt's Aristotle and Other Rembrandt Studies,* Princeton, 1969, pp. 3 ff.

61.198 The Metropolitan Museum of Art, Principally from funds given or bequeathed by Stephen C. Clark, Charles B. Curtis, Harris Brisbane Dick, Isaac D. Fletcher, Maria DeWitt Jesup, Henry G. Keasbey, Henry G. Marquand, Joseph Pulitzer, Alfred H. Punnett, and Jacob S. Rogers, as well as special contributions made by Robert Lehman, Mrs. Charles S. Payson, The Charles B. Wrightsman Foundation, and other Friends of the Museum, 1961.

278. The Smokers

Adriaen Brouwer
Flemish, 1605/1606–1638
Oil on wood
Height: 18 inches; Width: 14⅓ inches
Signed (lower left): Brauwer

A Flemish artist who spent about five years in mid-career in Holland, Brouwer painted at the beginning and end of his life in Antwerp, where he died at the early age of thirty-two. The Flemish and Dutch elements of his style blend in this little picture with an effect of refinement, subtlety, and brilliance that justifies the many critics who regard it as his masterpiece. The central figure is a self-portrait, according to an old source, the man gazing upward is probably the painter Jan Cossiers, and the well-dressed gentleman at the right seems to be Jan Davidsz. de Heem, another painter.

Knuttel, G., *Adriaen Brouwer.* The Hague, 1962, pp. 23 ff.

32.100.21 The Metropolitan Museum of Art, The Michael Friedsam Collection, 1931.

 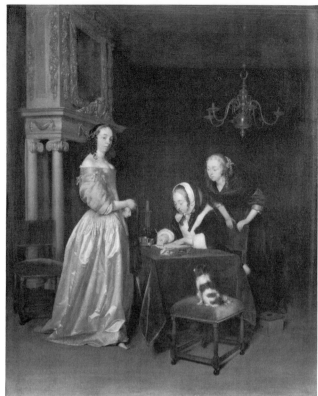

280. The Noble Slav
Rembrandt Harmensz. van Rijn
Dutch, 1606–1669
Oil on canvas
Height: 60⅛ inches; Width: 43¾ inches
Signed and dated (lower right): RL van Rijn/1632

The old traditional title for this picture is misleading, for neither the type nor the costume are distinctively Slavic. What we seem to have here is a Dutchman of Rembrandt's time, possibly a member of his family, dressed up in an Oriental costume, placed in a impressive monumental pose, and used by Rembrandt as model for one of his great imaginative inventions.

It was especially in his early successful years in Amsterdam that he acquired a mass of studio properties, indulging his voracious enthusiasm for rich stuffs, armor, and bizarre costumes. Unlike the sober exigencies of contemporary Dutch dress, these exotic garbs provided him with splendid opportunities to exercise his growing power to evoke magic with a loaded brush and passages of thick impasto.

Bredius, A., *Rembrandt, The Complete Edition of the Paintings.* Revised by H. Gerson, London, 1969, pp. 144, 561.

20.155.2 The Metropolitan Museum of Art, Bequest of William K. Vanderbilt, 1920.

281. Curiosity
Gerard Terborch
Dutch, 1617–1681
Oil on canvas
Height: 30 inches; Width: 24½ inches

The very personal style of Terborch, so completely exemplified in this picture, combines elegance and exquisite refinement with an extraordinary mastery of technique in the rendering of textures and light-touched surfaces. In his best pictures there is often, as here, an effect of seclusion and privacy and a very delicately implied wit.

Gudlaugsson, S. J., *Gerard ter Borch.* The Hague, 1959–1960, Vol. I, p. 314, Vol. II, p. 168.

49.7.38 The Metropolitan Museum of Art, The Jules S. Bache Collection, 1949.

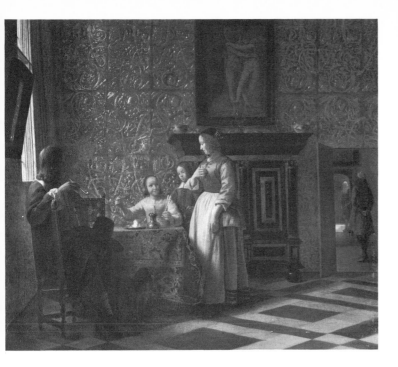

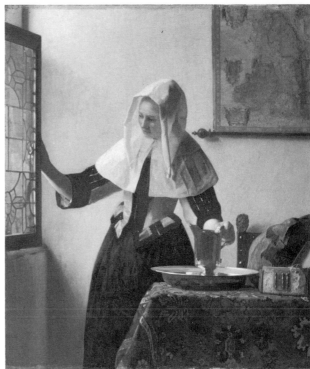

282. Conversation
Pieter de Hooch
Dutch, 1629–after 1684?
Oil on canvas
Height: 23 inches; Width: 27 inches
Signed (at left, on the chair): P D Hooch

Pieter de Hooch's finest genre scenes, like this one, give a more accurate and circumstantial account of daily life in seventeenth-century Holland than the similar but more idealized scenes that his contemporary, Jan Vermeer, painted. This picture is probably to be dated about 1665, in Pieter de Hooch's first period in Amsterdam, before he had begun to concentrate on the extremely fashionable settings that are typical of his last years.

Exposition de la Collection Lehman de New York. Paris, Musée de L'Orangerie, 1957, p. 21, No. 26.

Robert Lehman Collection.

283. Young Woman with a Water Jug
Johannes Vermeer
Dutch, 1632–1675
Oil on canvas
Height: 18 inches; Width: 16 inches

The perfect balance of the composition, the cool clarity of the light, and the silvery tones of blue and gray combine to make this consciously studied glimpse of an interior a very typical work by Vermeer. One of the most prized of painters, he is rivaled only by Leonardo in the rarity of his authentic works.

de Vries, A. B., *Jan Vermeer van Delft.* Trans. by R. Allen. London and New York, 1948, pp. 36 ff.

89.15.21 The Metropolitan Museum of Art, Gift of Henry G. Marquand, 1889.

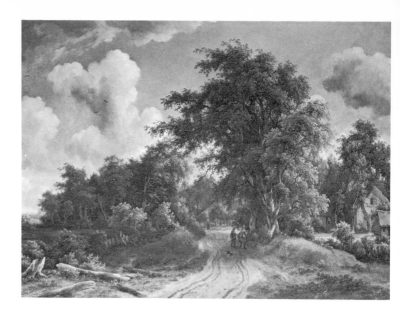

284. A Woodland Road

Meyndert Hobbema
Dutch, 1638–1709
Oil on canvas
Height: 37¼ inches; Width: 51 inches
Signed (lower right): M. Hobbema

The luxurious foliage, the lively play of light and shadow, and the figures that animate this country scene give to it a more immediate and particular defining of place than in the landscapes by Jacob van Ruisdael, who was Hobbema's teacher.

Broulhiet, G., *Meindert Hobbema.* Paris, 1938, pp. 166, 394.

50.145.22 The Metropolitan Museum of Art, Bequest of Mary Stillman Harkness, 1950.

285. The Garden of Love

Petrus Paulus Rubens
Flemish, 1577–1640
Pen and brown ink, brown and green wash, heightened with light-blue gouache, over black chalk (both drawings)
Height: 18¾ inches; Width: 27¹³⁄₁₆ inches

These magnificent drawings were made by Rubens as models for the woodcuts executed in reverse by Christoffel Jegher. The two "halves" of both drawings and woodcuts are in themselves balanced, self-contained designs, and they combine to form a complete composition of great richness and complexity. Rubens first conceived of the composition in a painting now at Waddesdon Manor. The theme was so popular that about 1630–1632 he executed the present drawings for the woodcuts, which were subsequently widely distributed. Rubens painted a final version of the subject immediately thereafter, a work now in the Prado.

Held, J. S., *Rubens, Selected Drawings.* London, 1959, No. 152.

58.96.1,2 The Metropolitan Museum of Art, Fletcher Fund, 1958.

286. A Cottage Among Trees
Rembrandt Harmensz. van Rijn
Dutch, 1606–1669
Pen and brown ink, brown wash, on brownish paper. Vertical strip
added to sheet at right and drawing continued in the artist's hand
Height: 6¾ inches; Width: 10¹³⁄₁₆ inches

With keen observation Rembrandt manipulates his sharp quill
pen to record an isolated clump of trees in a broad, flat landscape.
His pen notes precisely the shady undergrowth, the airy foliage of
the treetops, and the dense thatch of the roof of the cottage
half-hidden in their midst. This drawing belongs to a group that
culminates with Rembrandt's etching of 1652, *Clump of Trees with
a Vista.*

Benesch, O., *The Drawings of Rembrandt.* London, 1954–1957, Vol.
VI, p. 355.

29.100.939 The Metropolitan Museum of Art, The H. O.
Havemeyer Collection, Bequest of Mrs. H. O. Havemeyer, 1929.

287. Nathan Admonishing David
Rembrandt Harmensz. van Rijn
Dutch, 1606–1669
Pen and brown ink, brown wash, and white gouache
Height: 7⁵⁄₁₆ inches; Width: 10 inches

Rembrandt represents King David listening in penitent sorrow as
the aged prophet Nathan announces the Lord's judgment on him
by telling the parable of the Ewe Lamb. David is thus brought to
realize how grave a crime he has committed in causing the death
of Uriah in order to take the widowed Bathsheba as his own
wife (II Samuel 12:1–14). A preliminary drawing for this
composition is in the Berlin print room, and drawings in
Amsterdam and London are earlier and independent studies of
the same theme. The present drawing is a particularly brilliant
example of Rembrandt's virtuosity as a draftsman; a broad reed
pen, a fine quill pen for the finer notations of the heads, and
brush and wash have been used to achieve a design that is
unsurpassed in coloristic radiancy.

Benesch, O., *The Drawings of Rembrandt.* London, 1954–1957, Vol.
V, pp. 274–75.

29.100.934 The Metropolitan Museum of Art, The H. O.
Havemeyer Collection, Bequest of Mrs. H. O. Havemeyer, 1929.

288. Rocky Landscape with a Plateau

Hercules Seghers

Dutch, *ca.* 1589–1635/1638

Etching printed in green ink on tinted green paper; touched with green and red oil paint, and gray-brown ink.

Height: 4⅛ inches; Width: 5⅜ inches

Dated 1632

A veil of mystery has always surrounded the rare beauty of Seghers' etchings. In technique they are so conspicuously different from anything created before or after, and in handling, so personal and distinctive; they hold us spellbound today, as they did Rembrandt (who prized them in his own print collection) over three hundred years ago. Seghers' extant work remains extremely limited in number, but his reputation as an uncommon pioneer in printing processes and pictorial imagery is universally recognized.

Springer, J., *Die Radierungen des Herkules Seghers.* Berlin, 1910–1912, No. 17.

23.57.3 The Metropolitan Museum of Art, Harris Brisbane Dick Fund, 1923.

289. The Three Crosses

Rembrandt Harmensz. van Rijn

Dutch, 1606–1669

Drypoint and burin; second state, printed on vellum

Height: 15 inches; Width: 17¼ inches

Dated 1653

One of the greatest painters, Rembrandt was also, in printmaking, one of the greatest innovators, reforging and reworking the medium of etching until he had not only completely altered its aspect but shown how it could deal with things that previously lay beyond its scope. Where earlier etchings were translucent and in general rather bodiless, Rembrandt's have structure and richness of surface approximating oil paintings. Moreover, they are illumined by an expressive power which never fails to pierce to the heart of things, whether the subject be, as here, a momentous scene from Scripture, or the slightest study of still life.

Hind, A. M., *A Catalogue of Rembrandt's Etchings.* London, 1923, No. 270.

41.1.31 The Metropolitan Museum of Art, Gift of Felix M. Warburg and his Family, 1941.

290. Landscape with Three Gabled Cottages Beside a Road

Rembrandt Harmensz. van Rijn
Dutch, 1606–1669
Etching and drypoint; third state
Height: 6⅜ inches; Width: 8 inches
Dated 1650

Rembrandt was never tempted, like Dürer and most northern artists, to visit Rome and the sites of the classical past. His own beloved Dutch countryside was inspiration enough. From such humble elements as a muddy road, some straw-roofed peasant houses, and a clump of old trees, he could make a vivid, vital, almost impressionistic picture full of warmth and a magnificent atmospheric light such as had never before been seen in prints. Rembrandt's little landscape is as haunting as any nude, as majestic as any king, and universal, timeless in its appeal.

Hind, A. M., *A Catalogue of Rembrandt's Etchings.* London, 1923, No. 246.

29.107.33 The Metropolitan Museum of Art, The H. O. Havemeyer Collection, Bequest of Mrs. H. O. Havemeyer, 1929.

291. Saint Francis Beneath a Tree Praying

Rembrandt Harmensz. van Rijn
Dutch, 1606–1669
Etching and drypoint; second state
Height: 7⅛ inches; Width: 9⅝ inches
Dated 1657

Like all great talents, Rembrandt makes the difficult seem easy. His *Saint Francis Beneath a Tree Praying* exhibits that understatement and economy of means which are the special mark of genius. Here Rembrandt's subject, because it is unself-consciously formed of spontaneous and swiftly defining line, is made immediate, believable. It is born of a new brand of realism, one that is not staged or posed, but fully alive and closer to the truth than fancy church art.

Hind, A. M., *A Catalogue of Rembrandt's Etchings.* London, 1923, No. 292.

41.1.70 The Metropolitan Museum of Art, Gift of Felix M. Warburg and his Family, 1941.

France

French Baroque Classicism developed in the course of the century and culminated at Louis XIV's palace at Versailles, which expressed the glory of his absolute power. The particular qualities of official French art, deriving as much from the French Renaissance as from contemporary art of Rome, can be seen in the intellectual and rhetorical paintings of Nicolas Poussin. Under the artistic dictatorship of the French Academy, Paris began to eclipse Rome as the cultural capital of Europe.

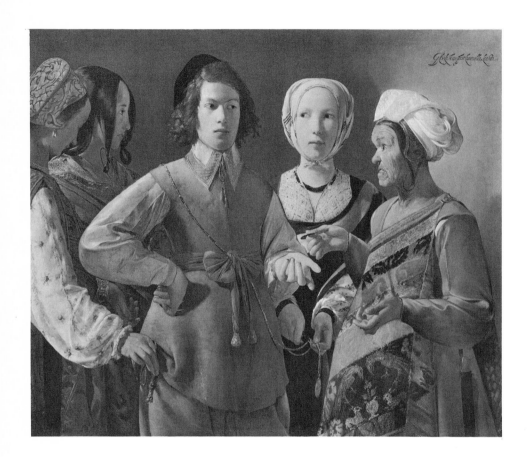

292. The Fortune Teller
Georges de la Tour
French, 1593–1652
Oil on canvas
Height: 40⅛ inches; Width: 48⅝ inches
Signed (upper right): G. DeLaTour Fecit Luneuilla Lothar

The smooth precision and refinement of drawing, the high-keyed color, and the effect of unnaturally bright light make this picture stand out among the works of La Tour. He probably painted it near the beginning of his career in Lunéville in Lorrain after a study period in Italy, where he must have seen the works of Caravaggio, who popularized such themes as fortunetelling and cheating at cards, and formulated a manner of painting in strong contrasts of light and dark that was soon widely imitated all over Europe.

Pariset, G., "A Newly Discovered La Tour: The Fortune Teller." *The Metropolitan Museum of Art Bulletin*, n.s., Vol. XIX (March, 1961), pp. 198–205.

60.30 The Metropolitan Museum of Art, Rogers Fund, 1960.

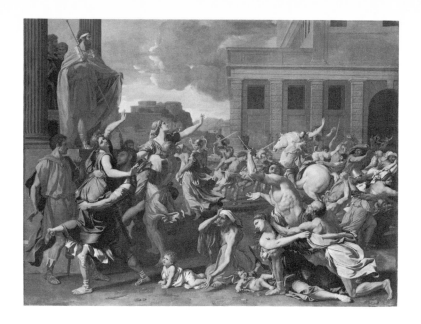

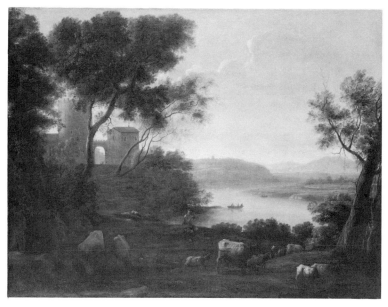

293. The Rape of the Sabine Women
Nicholas Poussin
French, 1594–1665
Oil on canvas
Height: 60⅞ inches; Width: 82⅝ inches

This story from the early days of the Roman republic is told by
Plutarch, who recounts how Romulus, seen at the left in the
painting, devised a ruse to populate his newly founded city of
Rome. This is a brilliant example of Poussin's deliberate creation
of a specific style for each variety of subject matter. Settled in
Rome at the age of thirty, this French artist found in antique
history and mythology great resources of subjects for his austere
and noble art.

Sterling, C., *A Catalogue of French Paintings, XV-XVIII Centuries.*
Cambridge, Mass., The Metropolitan Museum of Art, 1955,
pp. 70 ff.

46.160 The Metropolitan Museum of Art, Harris Brisbane Dick
Fund, 1946.

294. Pastoral Landscape—The Roman Campagna
Claude Lorrain (Claude Gellée)
French, 1600–1682
Oil on canvas
Height: 40 inches; Width: 52½ inches
Signed (lower center): CLAVdio Gillee f.

Like Poussin, Claude was a Frenchman who spent almost all of his
working life in Italy. He made countless studies of nature in
preparatory drawings and sketches, and his finished landscapes,
sought after by all the great collectors of his time, are distinguished
by their poetic grandeur and the magic quality of their subtle,
pervading light.

Röthlisberger, M., *Claude Lorrain.* New Haven, 1961, Vol. I,
pp. 173 ff.

65.181.12 The Metropolitan Museum of Art, Bequest of Adele
L. Lehman, in memory of Arthur Lehman, 1965.

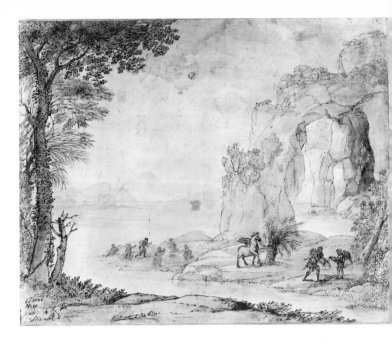

295. The Origin of Coral

Claude Lorrain (Claude Gellée)
French, 1600–1682
Pen and brown ink, brown wash
Height: 9¹⁵⁄₁₆ inches; Width: 12¹⁵⁄₁₆ inches

This drawing is Claude's earliest known study for a picture painted in the 1670's for one of his most important clients, Cardinal Carlo Camillo Massimi, and now in Holkham Hall, Norfolk.

Claude here represents a rare mythological episode drawn from Ovid's *Metamorphoses*. At early morning Perseus, having slaughtered the dragon that was about to devour Andromeda, washes the monster's blood from his hands. He has placed on a bed of seaweed the severed head of Medusa, won in a previous exploit, and now one of his deadliest weapons. At the left a circle of amazed nymphs watch the soft seaweed transformed into hard coral by Medusa's petrifying power. Pegasus' presence is explained by his earlier birth from the blood that gushed from Medusa's neck.

Roethlisberger, M., *Claude Lorrain, The Drawings.* Berkeley and Los Angeles, 1968, No. 1064.

Robert Lehman Collection.

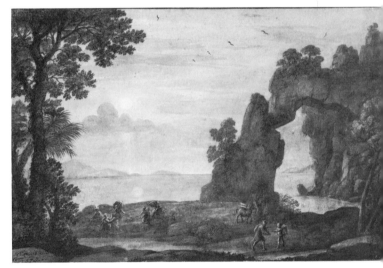

296. Landscape with the Origin of Coral

Claude Lorrain (Claude Gellée)
French, 1600–1682
Pen and brown ink, gray, brown, and blue wash, heightened with white, over black chalk
Height: 9¾ inches; Width: 15 inches

Also related to Claude's picture at Holkham Hall, this sheet is closest of the six surviving preparatory drawings to the finished work. There is an assuredness and brilliant finish to the drawing that gives the impression not of a working sketch, but of a *modello*, probably presented by the artist to his patron before proceeding with the painting itself. Claude achieves marvelous effects of color and light by the use of blue paper and extensive white heightening.

Roethlisberger, M., *Claude Lorrain, The Drawings.* Berkeley and Los Angeles, 1968, No. 1066.

64.253 The Metropolitan Museum of Art, Mr. and Mrs. Arnold Whitridge Gift, 1964.

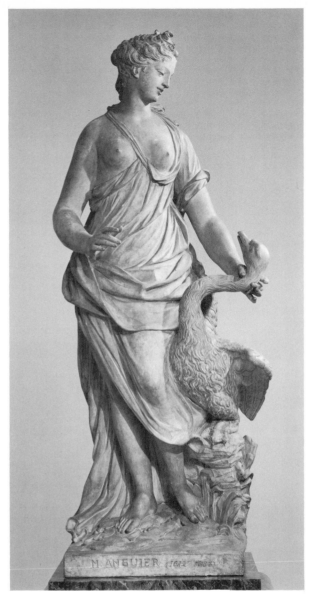

297. Leda and the Swan
Michel Anguier
French, 1614–1686
Limestone
Height: 86 inches
Dated 1654

A hypnotic and rapturous smile crosses Leda's face as she begins to stroke the neck of the swan, who is the clever and enamored Jove in disguise. Although Leda was not technically a divinity, the sculpture belonged with thirteen other large stone figures of gods and goddesses carved by Michel Anguier in the mid-1650's for the gallery of the Château Saint Mandé. Located just outside Paris, Saint Mandé was a residence of Nicolas Foucquet, the learned finance minister who was later banished by Louis XIV, in part for his building extravagances.

Michel Anguier studied with Algardi in Rome, returning to France in 1651 with copies after Roman antiquities. At home, his classicism grew increasingly lyrical and occasionally florid, dependent not only on the antique, but also on Renaissance traditions, as in the charming Leda, who recalls Leonardo and Bandinelli.

Charageat, M., "La Statue d'Amphitrite et la Suite des Dieux et des Déesses de Michel Anguier." *Archives de l'art français*, n.s., Vol. XXIII, 1968, pp. 111–23.

1970.140 The Metropolitan Museum of Art, Funds given by The Josephine Bay Paul and C. Michael Paul Foundation, Inc., and the Charles Ulrick and Josephine Bay Foundation, Inc., 1970.

298. Bust of Louis de France, the Grand Dauphin
Charles Antoine Coysevox
French, 1640–1720
Bronze
Height (without base): 28⅞ inches
Probably made soon after 1669

Louis XIV was preceded in death by his eldest son and heir, the Grand Dauphin known always as "Monseigneur." The sitter's identity offers no problem—he wears on his armor a badge with a dolphin, a reference to his title.

The present bust is part of a court formula for the representation of Monseigneur and is close to the appearance of the Dauphin in an engraving after Girardon. Speaking clearly for the authorship of Coysevox, however, are the powerful movement, the marvelously fluid but concise features, the tumultuous and circular treatment of the wig, and the technical brilliance of the cast. Even within the formula, Coysevox is the most immediately sympathetic of Louis XIV's extraordinarily gifted sculptors.

Keller-Dorian, G., *Antoine Coyzevox*. Paris, 1920, Vol. II, p. 62.

41.100.243 The Metropolitan Museum of Art, Gift of George Blumenthal, 1941.

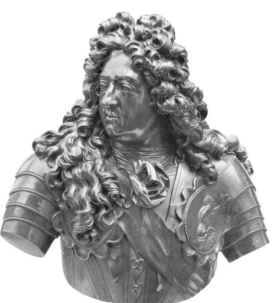

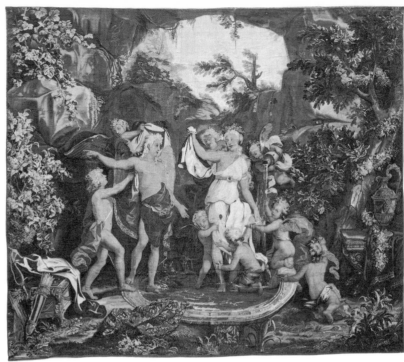

**299. Embroidered Hanging: Fire,
with the Count du Vexin as Mars**
French, Paris, *ca.* 1683
Wool, silk and metal thread
Height: 14 feet; Width: 9 feet

This hanging, which features the Count du Vexin, son of
Louis XIV and Madame de Montespan, is one of a set that
included presumably eight pieces, of which there are three
others also in the Metropolitan's collection. All the
embroideries were certainly designed in the workshop of
Charles LeBrun and were probably worked in the convent
of Saint-Joseph-de-la-Providence in Paris, which was under
the patronage of Madame de Montespan. The magnificent
Baroque designs and the impeccable, professional
workmanship make these hangings outstanding examples
of seventeenth-century French embroidery.

Standen, E. A., "The Roi Soleil and Some of his Children."
The Metropolitan Museum of Art Bulletin, n.s., Vol. IX, 1951,
pp. 133–41.

46.43.3 The Metropolitan Museum of Art, Rogers Fund,
1946.

300. Cupid and Psyche in the Bath
French, Paris (Gobelins), 1689–1700
Wool, silk, and metal thread, 20–28 warps per inch
Height: 12 feet, 2 inches; Width: 14 feet, 3 inches

This tapestry is one of sixteen from the series *Sujets de la Fable.* The design is
known to be derived from a drawing in the collection of Louis XIV connected
with a fresco by Giulio Romano and his assistants in the Palazzo del Te in
Mantua. The tapestry was made in the workshop of Jean Jans the Younger
between 1692 and 1700. Between 1699 and 1703 additional drapery was added
to the figures to cover their nudity, alterations usually attributed to the
influence that Madame de Maintenon exerted over Louis XIV.

The *Sujets de la Fable* series was the first made at the Gobelins manufactory
after the death of Colbert; it was part of the campaign to discredit his protégé
Charles LeBrun. All the artists concerned, however, had been closely associated
with LeBrun, and the tapestries are still very much in his style. Lacking all
iconological coherence, they have become pure decorations instead of the
tightly organized allegorical or historical subjects, always glorifying Louis XIV,
that were produced under LeBrun's strict supervision. As such, they foreshadow
the less solemn art of the Régence and Rococo periods.

Standen, E. A., "The Sujets de la Fable Gobelins Tapestries." *Art Bulletin,*
Vol. XLVI, 1964, pp. 143–57.

53.225.10 The Metropolitan Museum of Art, Gift of Julia A. Berwind, 1953.

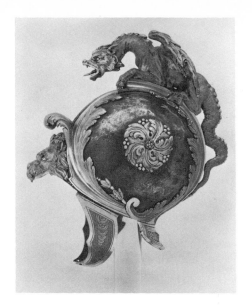

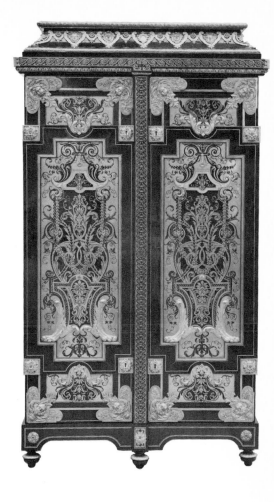

301. Parade Helmet, Made for Louis XIV of France

French, second half of XVII century
Bronze, partly gilded and partly silvered
Height: 15 inches; Width: 8⁵⁄₁₆ inches; Depth: 13⅛ inches;
Weight: 13 pounds

Both its heavy weight and its material—blued silver to simulate
steel—indicate that this helmet was designed not as military
equipment but as an accessory of truly royal dimensions for a
state pageant. It has a companion shield *en suite* decorated with
the head of Medusa.

A similar helmet and shield are represented on the statue of
Louis XIV by Jean Warin in the Musée de Versailles. And in a
tapestry of *ca.* 1683 in our Museum, the king, costumed as
Jupiter, is holding a shield nearly identical to the companion of
this helmet.

Thomas, B., Gamber, O., Schedelmann, H., *Arms and Armor of the
Western World.* New York and Toronto, 1964.

04.3.259, 260 The Metropolitan Museum of Art, Rogers Fund,
1904.

302. Armoire (Wall Closet)

Attributed to André-Charles Boulle
French, 1642–1732
Macassar and Gabun ebony, brass and tortoise shell veneer on oak with
gilt-bronze mounts
Height: 7 feet, 8 inches; Width: 4 feet, 4 inches; Depth: 1 foot, 9¾ inches
Made early XVIII century

André-Charles Boulle, cabinetmaker to Louis XIV, adapted the complexities
of Italian marquetry and perfected the technique that now bears his name.
Boulle-work consists of a pattern made by cutting out a design on a layer of
tortoise shell glued to one of brass. These two layers were separated, then
recombined to veneer two surfaces with a result looking like the negative and
positive of a photograph. The veneer in which the pattern figures brightly in
brass and the dark tortoise shell forms the background—as is the case in this
armoire—was considered the superior *première-partie.* The *contre-partie,* having a
tortoise-shell pattern on a brass ground, was deemed slightly less valuable.

The sculptural quality characteristic of the work of André-Charles Boulle can
be seen in the fine modeling of the female masks along the hood and windgods
at the corners of the doors. The grandiose nature of the Louis XIV style is
seen in the imposing dimensions of this armoire, its rich surface decoration,
and the classical allusions of its gilt-bronze mounts.

"The Recent Accessions Room." *The Metropolitan Museum of Art Bulletin,* n.s.,
Vol. XVIII (January, 1960), pp. 174–75.

59.108 The Metropolitan Museum of Art, Fletcher Fund, 1959.

Section VII: ca. 1700–ca. 1800

1702–1713	War of Spanish Succession
1707	Union of England and Scotland
1710	Meissen produces first true porcelain in Europe
1721	Bach composes *Brandenburg Concertos*
1741	Handel composes *Messiah*
1749	Excavation of Pompeii begins
1753	Foundation of British Museum
1754	Chippendale publishes *Cabinet Maker's Director*
1759	Voltaire writes *Candide*
1769	Watt invents steam engine
1776	Declaration of Independence
1783	First balloon flight, Paris
1789	Storming of the Bastille, French Revolution
1789	George Washington becomes President
1790–1833	Goethe writes *Faust*
1793	Grand Gallery of Louvre opened

1700

1710

1720

346. English,
ca. 1690

334. German,
ca. 1725

1730

303. Watteau,
French

1740

311. Lemoyne,
French

1750

304. Boucher,
French

305. Greuze,
French

1760

316. French,
ca. 1760

1770

320. Riesener,
French

338. Gainsborough,
English

1780

1790

1800

France: Régence and Rococo

At the death of Louis XIV in 1715, France had become bankrupt in expensive wars. Under the Régence during the minority of Louis XV (1715-23), Paris became once more the focus of society. Building activity there concentrated on intimate decorations in aristocratic town houses. With the personal reign of Louis XV (1723-1774), the Rococo asserted itself; sensuous, worldly, playful objects of luxury reached a refinement unparalleled in the history of Europe. In painting, color and atmosphere triumphed over drawing.

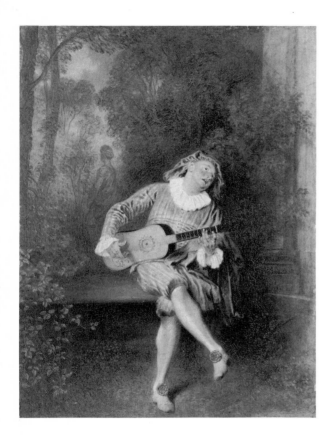 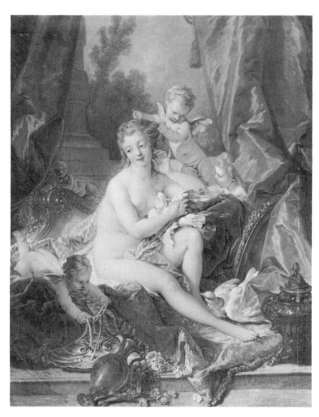

303. Mezzetin
Antoine Watteau
French, 1684-1721
Oil on canvas
Height: 21¾ inches; Width: 17 inches

Mezzetin, playing the role of a confidential agent and an incurably disappointed lover, was a stock character, perfectly familiar to the many French admirers of the *commedia dell'arte*, the Italian theatrical troupe that was recalled to Paris in 1716, after the death of Louis XIV, who had banished them. Watteau, too, was apparently enthusiastic about these comedians and made many paintings and drawings of his friends dressed up in the costumes of this popular theater. He painted this exquisite and wistful picture, full of allusive autobiographical overtones, very near the end of his short life.

Sterling, C., *A Catalogue of French Paintings, XV-XVIII Centuries.* Cambridge, Mass., The Metropolitan Museum of Art, 1955, pp. 105 ff.

34.138 The Metropolitan Museum of Art, Munsey Fund, 1934.

304. The Toilet of Venus
François Boucher
French, 1703-1770
Oil on canvas
Height: 42⅝ inches; Width: 33½ inches
Signed and dated (at lower right): F. Boucher, 1751

Boucher's success and influence were unlimited in the France of his day and he owed them to the patronage of Madame de Pompadour, Louis XV's mistress. This picture and its pendant, *Venus Bathing Cupid,* in the National Gallery in Washington, were painted to adorn her bathroom in her château at Bellevue. Both are richly painted, seductive in subject matter, and opulent in decorative detail.

Sterling, C., *A Catalogue of French Paintings, XV-XVIII Centuries.* Cambridge, Mass., The Metropolitan Museum of Art, 1955, pp. 136 ff.

20.155.9 The Metropolitan Museum of Art, Bequest of William K. Vanderbilt, 1920.

305. Broken Eggs
Jean-Baptiste Greuze
French, 1725–1805
Oil on canvas
Height: 28¾ inches; Width: 37 inches
Signed and dated (lower right): GREUZE f. <u>Roma</u>/1756

Unlike Watteau, who analyzed the subtleties of aristocratic life and feeling in the France of his day, Greuze drew his subject matter from the didactic current in French thought of the time, and in many of his very original and beautifully painted genre scenes pointed out a moral lesson.

Sterling, C., *A Catalogue of French Paintings, XV–XVIII Centuries.* Cambridge, Mass., The Metropolitan Museum of Art, 1955, pp. 174 ff.

20.155.8 The Metropolitan Museum of Art, Bequest of William K. Vanderbilt, 1920.

306. A Shady Avenue
Jean-Honoré Fragonard
French, 1732–1806
Oil on canvas
Height: 11½ inches; Width: 9½ inches

In October of 1773, Fragonard set out on his second voyage to Italy in the company of his patron, the financier Bergeret de Grandcour, who entertained the artist for two weeks at his château near Montauban. It was very possibly there that Fragonard made the drawings on which he based this small delightful landscape. Although the trees are clearly recognizable in one of the drawings as the plane trees common in the south of France, in the painting they have been transformed into an airy rococo decoration.

Sterling, C., *A Catalogue of French Paintings, XV–XVIII Centuries.* Cambridge, Mass., The Metropolitan Museum of Art, 1955, pp. 155 f.

49.7.51 The Metropolitan Museum of Art, The Jules S. Bache Collection, 1949.

308. Le Billet Doux (The Love Letter)
Jean-Honoré Fragonard
French, 1732–1806
Oil on canvas
Height: 32¾ inches; Width: 26⅜ inches

Fragonard's most delightful qualities are combined in this romantic vignette of love and femininity in the eighteenth century. With lightness and suggestive grace, his rapid scintillant brushstrokes adumbrate in delicious color the knowing coquette, her curtained writing alcove by a bull's-eye window, her elegantly decorative table and stool, and her possessive, slightly wary pet.

Sterling, C., *A Catalogue of French Paintings, XV–XVIII Centuries.* Cambridge, Mass., The Metropolitan Museum of Art, 1955, pp. 157 ff.

49.7.49 The Metropolitan Museum of Art, The Jules S. Bache Collection, 1949.

307. The Cascade
Jean-Honoré Fragonard
French, 1732–1806
Oil on canvas
Height: 11½ inches; Width: 9½ inches

This painting has been a companion piece of *A Shady Avenue* ever since the eighteenth century, when both pictures belonged to the Strogonoff Collection. Perhaps it, too, is a souvenir of a particularly charming spot in Bergeret's gardens.

Sterling, C., *A Catalogue of French Paintings, XV–XVIII Centuries.* Cambridge, Mass., The Metropolitan Museum of Art, 1955, p. 157.

49.7.50 The Metropolitan Museum of Art, The Jules S. Bache Collection, 1949.

309. View of the Pincio, Rome
Jean-Honoré Fragonard
French, 1732–1806
Pen and brown ink, brown wash
Height: 11¼ inches; Width: 15⅜ inches

Fragonard would have been familiar with this Italian park scene, for he made extended stays in Rome in 1753 and 1773. Many such views of Italian parks and villas, brilliantly executed in pen and delicate, transparent brown wash have survived.

Exposition de la Collection Lehman de New York. Paris, Musée L'Orangerie, 1957, No. 96.

Robert Lehman Collection.

310. Study of a Man's Head
Antoine Watteau
French, 1684–1721
Red and black chalk (surface of sheet slightly damaged at center)
Height: 5⅞ inches; Width: 5⅛ inches

The close and convincing correspondence between this head and the head of Mezzetin in the Museum's painting makes it certain that the drawing is a preparatory study for the painting. Although attempts have been made to identify Mezzetin as Angelo Constantini or Luigi Riccoboni, well-known Italian actors, it is much more likely that the model was an unidentified friend or a professional model who posed for Watteau as Mezzetin. The drawing is sensitive and fine, and its style is entirely compatible with the late date, 1719, usually given the picture.

Parker, K. T., and Mathey, J., *Catalogue de l'oeuvre dessiné d'Antoine Watteau.* Paris, 1957, Vol. II, p. 339.

37.165.107 The Metropolitan Museum of Art, Rogers Fund, 1937.

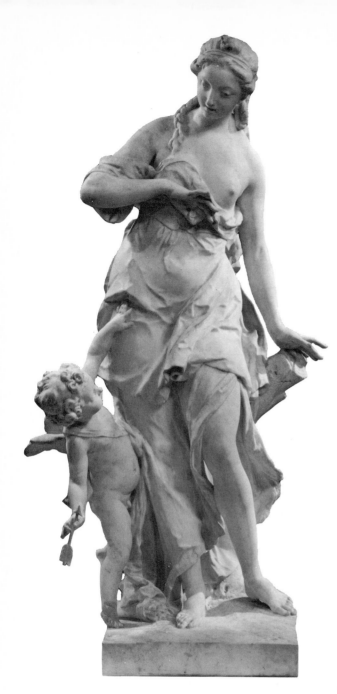

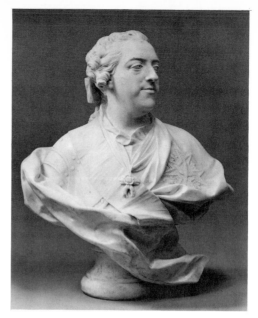

311. La Crainte des Traits de l'Amour (Fear of Cupid's Darts)
Jean-Louis Lemoyne
French, 1665–1755
Marble
Height: 68 inches
Carved between 1735 and 1742

In this lightly erotic group, a nymph reacts with a startled, protective gesture to the sudden appearance of Cupid, who is about to cast an arrow into her breast. The technique, in which the marble seems sketched all over with flickering light, contributes to the Rococo sculptor's pictorial viewpoint. Louis XV ordered the marble delivered to Lemoyne in 1735, but in 1742 Lemoyne was still pressing for payment. In 1762, the king gave the sculpture to Pompadour's brother, the Marquis de Marigny, for his château at Ménars.

Raggio, O., "The Metropolitan Museum Marbles." *Art News,* Vol. LXVII (Summer, 1968), p. 48 ff.

67.197 The Metropolitan Museum of Art, Funds given by the Josephine Bay Paul and C. Michael Paul Foundation, Inc., and Charles Ulrick and Josephine Bay Foundation, Inc., 1967.

312. Bust of Louis XV
Jean-Baptiste Lemoyne
French, 1704–1778
Marble
Height: 34¼ inches
Signed and dated 1757

Jean-Baptiste Lemoyne was the son of Jean-Louis Lemoyne and the greatest and most frequently engaged portraitist during the long reign of Louis XV. For forty years, Lemoyne virtually held a monopoly on recording the benign royal features. There are at least six Lemoyne busts of the king documented, almost all now lost. Ours, shown in the Salon of 1757, was delivered to Madame de Pompadour at the Château de Champs in December of 1757. Still as late as 1768, Cochin wrote to Pompadour's brother, the Marquis de Marigny, that Lemoyne was "the only artist who is now free to model after the King and who, consequently, is able to represent him as he actually is, with the greatest fidelity."

Raggio, O., "Two great portraits by Lemoyne and Pigalle." *The Metropolitan Museum of Art Bulletin,* n.s., Vol. XXV (February, 1967), pp. 219–29.

41.100.244 The Metropolitan Museum of Art, Gift of George Blumenthal, 1941.

313. Mercury

Jean-Baptiste Pigalle
French, 1714–1785
Terracotta painted the color of bronze
Height: 22 inches
Probably made in Rome between *ca.* 1737 and 1739

This terracotta has long been considered the original model for Pigalle's
youthful masterpiece, the *Mercury Fastening His Winged Sandals,* his reception
piece offered for admission to the Academy in 1744. It does seem at once more
supple and more accurate than other existing terracotta versions. The spiraling
shapes of Pigalle's virtuoso *Mercury* made it enormously popular as a model
of design long after its invention.

Le Corbeiller, C., "Mercury, Messenger of Taste." *The Metropolitan Museum of
Art Bulletin,* n.s., Vol. XXII (Summer, 1963), pp. 23–28.

14.40.681 The Metropolitan Museum of Art, Bequest of Benjamin Altman,
1914.

314. Pair of Armchairs

Signed by Nicolas-Quinibert Foliot
French, 1706–1776
Gilded beechwood covered with wool tapestry (Beauvais)
Height: 3 feet, 5⅞ inches; Width: 2 feet, 6½ inches;
Depth: 2 feet, 1½ inches
Made 1753–1756

These armchairs and their Beauvais tapestry coverings are part of a set ordered
by Count John Hartvig Ernst Bernstorff, Danish ambassador to the court of
Versailles. The ensemble was shipped to Copenhagen and remained at the
Bernstorff Palace during the nineteenth century when it became the residence
of Ferdinand, hereditary Prince of Denmark.

For the cartoons of the tapestries the Beauvais manufactury employed
Jean-Baptiste Oudry (1686–1755), the most fashionable painter of animal and
hunt scenes. A leading Parisian joiner of the day, Nicolas-Quinibert Foliot,
assembled the frames. The chairs are remarkable for the richness of their
contours, the depth of their carving, and the brilliance of their gilding. The
quality of design and execution manifest in these chairs goes far to explain
the export and imitation of the products of French workshops throughout
Europe in the eighteenth century.

Molinier, E., "Le mobilier français des XVIIIe siècle dans le collections
étrangères." *Les Arts,* Vol. I, 1902, pp. 19–23.

(Tapestries) 35.145.9, 11 The Metropolitan Museum of Art, Gift of John D.
Rockefeller, Jr., 1935.
(Chair frames) 66.60.1, 2 The Metropolitan Museum of Art, Gift of Mrs.
John D. Rockefeller, Jr., Fund, 1966.

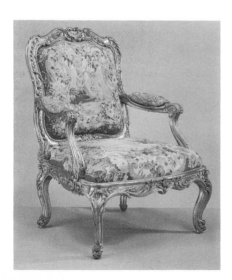 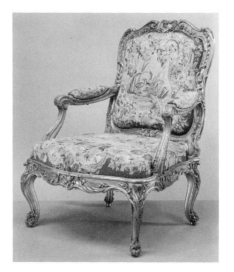

315. Pair of Figures

French, Saint Cloud, *ca.* 1735
Soft-paste porcelain
Height: 8⅛ inches and 7⅞ inches respectively

Few of the early French porcelain factories were able to achieve results comparable to those of Meissen with soft-paste material, and this pair of figures from Saint Cloud is particularly rare.

With their theatrical gestures and unmistakably Western pastel-colored robes, these two figures are perfectly evocative of Europeans playacting at being Chinese. While Oriental porcelain was treated seriously enough in the West, the Chinese themselves were the target of a whimsical distortion that produced a most original and delightful fantasy world of chinoiserie. Figures such as these, for which the Chinese prototypes were lacking, undoubtedly derive from the chinoiserie plays popular at the end of the seventeenth century, and from such widely circulated costume designs as those of Jean Bérain and Antoine Watteau. It was perhaps this theatrical element that endowed this type of figure with a popularity that survived by some decades the full bloom of chinoiserie in the first quarter of the eighteenth century.

Alfassa, P., and Guérin, J., *Porcelaine française.* Paris, 1931, p. 7.

54.147.10, 11 The Metropolitan Museum of Art, Gift of R. Thornton Wilson, in memory of Florence Ellsworth Wilson, 1954.

316. A Covered Vase and Pair of Jardinières with Rose Ground and Painted Reserves in the Manner of Dodin and Morin

French, Sèvres, 1757 and 1763
Soft-paste porcelain
Vase height: 19 inches; *Jardinières* height: 11½ inches; Width: 9 inches

The bell-shaped vase is called *vase Boileau* after Sieur Boileau, director of the Sèvres porcelain factory from 1753 to 1772. The *jardinières* are of a type called *vase hollandais nouveau* (to distinguish them from an earlier slightly different model). The upper part is intended for cut flowers, while the lower has four openings for narcissus bulbs and short-stemmed flowers. It also is the reservoir for water necessary to both parts. The surface of all three pieces is paneled and covered with a rose-pink glaze reserved in white for miniature painting in polychrome enamels.

The rose ground color was the invention in 1757 of Xhrouet *père*, a flower painter at the factory. The administration had encouraged his experiments and supplied the gold that was essential to the formula. The color became the envy of other *porcelainiers* and was soon imitated abroad, nowhere really successfully, although an interesting attempt was made at Chelsea.

The reserves of all three pieces are painted with flowers, military trophies, and cherubs playing with military equipment. They are the work of various decorators though generally in the style of Dodin and Morin, two important artists in the decorating atelier. The tooled and burnished gilt frames round the reserves are noteworthy examples of the gilder's art.

These porcelains which embody new achievements in design and technical experimentation illustrate the surge of inventive genius at the Sèvres factory during the period of the Seven Years' War, when its great rival, the Meissen porcelain factory, suffered a crippling reverse.

Seidel, P., *Les collections d'oeuvres d'art française du XVIIIe siècle appartenant a sa majeste L'Empereur d'Allemagne, roi de Prusse, Histoire et catalogue.* Berlin, 1900, p. 183.

50.211.156ab, 157ab, 158ab The Metropolitan Museum of Art, Gift of R. Thornton Wilson, in memory of Florence Ellsworth Wilson, 1950.

France: Louis XVI and Early Neoclassicism

Toward the middle of the century, excavations at the buried Roman towns of Herculaneum and Pompeii and the activities of the French Academy at Rome spurred interest in a revival of classical Roman forms in reaction to the anti-architectural excesses of the Rococo style. Thus the Neoclassical movement was well begun before Louis XVI came to the throne in 1774. In its initial stages Neoclassicism grafted the vocabulary of ancient Rome onto characteristically eighteenth-century forms.

 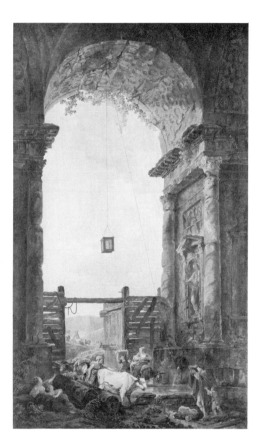

317. The Portico of a Country Mansion
Hubert Robert
French, 1733–1808
Oil on canvas
Height: 80¾ inches; Width: 48¼ inches
Signed (on block of stone in right corner): ROBERT/PINXT L./PARISIORUM/ANNO 1773

318. The Return of the Cattle
Hubert Robert
French, 1733–1808
Oil on canvas
Height: 80¾ inches; Width: 48 inches

These two grandly romantic scenes are companion pieces and were exhibited together in the Paris Salon of 1775. An old title for *The Portico* indicates that the country mansion represented, though imaginative in effect, was supposed to be near Florence and the arching ruin in the other painting seems to be Roman. Both paintings, like so many of the other decorative landscapes by Hubert Robert, were undoubtedly based on drawings he had made during the long stay in Italy that formed his style.

Sterling, C., *A Catalogue of French Paintings, XV–XVIII Centuries.* Cambridge, Mass., The Metropolitan Museum of Art, 1955, pp. 160 ff.

35.40.1, 2 The Metropolitan Museum of Art, Bequest of Lucy Work Hewitt, 1935.

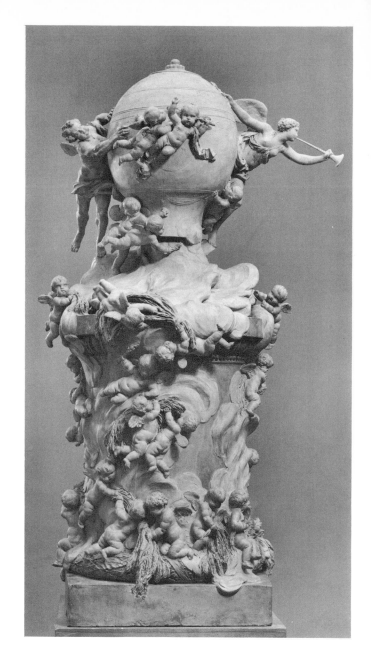

319. Model for a Proposed Monument to Commemorate the Invention of the Balloon

Clodion (Claude Michel)
French, 1738–1814
Terracotta
Height: 43½ inches
Signed twice, probably executed in 1784 in Paris

Balloon ascensions devised by the Montgolfier brothers and Jacques Charles in 1783 opened the history of modern aeronautics. In December of 1783, Louis XVI invited artists of the Academy to submit models for a monument to the "aeronautic machine," to be raised in the Tuileries Gardens. The monument, unlike its proposed subject, never got off the ground, and two Clodion models alone survive.

In this airy tour de force, Clodion conceived the project in terms of the symbolic idea of flight, with *putti* aviators and allegorical figures appropriate to classical scenes of apotheosis. He depicted the hot-air kind of ascension. The swarm of *putti,* occupied in building a fire upon the column, wing their way to the top with bundles of straw. Billowing clouds of smoke push the balloon from the column, as it is guided by Aeolus puffing behind and led in advance by trumpeting Fame.

Remington, P., "A Monument Honoring the Invention of the Balloon." *The Bulletin of The Metropolitan Museum of Art,* n.s., Vol. II (April, 1944), pp. 241–48.

44.21 a,b The Metropolitan Museum of Art, Rogers Fund aided by anonymous gift, 1944.

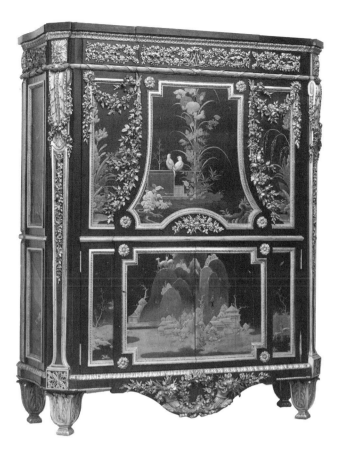

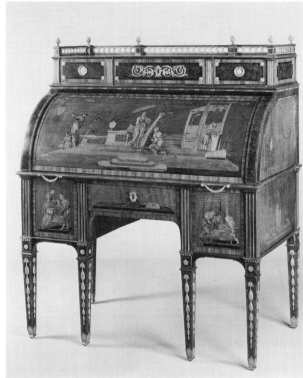

320. Secretary

Jean-Henri Riesener

French, 1734–1806, master, 1768

Ebony veneer with Japanese lacquer panels. Interior veneered in tulipwood and purplewood. Oak carcass. Gilt-bronze mounts and (modern) marble top

Height: 4 feet, 9 inches; Width: 3 feet, 7 inches; Depth: 1 foot, 4 inches

Made 1783–1787

The secretary bears the stamp of the Garde-Meuble de la Reine, Marie Antoinette's personal furniture registry. Inventory marks of the Château of Saint Cloud indicate that it and a commode also in the Museum's collection furnished the Queen's *Cabinet Intérieur,* one of her private apartments. Her monogram *MA* appears in the friezes of each. The delicate refinement of this secretary is a direct response of the maker, Riesener, to the taste of his royal client, Marie Antoinette. Garlanded and cascading down each piece are exquisitely chased gilt-bronze versions of the flowers with which Marie Antoinette loved to fill her rooms. The cornucopia mounts at the center of the aprons pour out, in addition to the usual fruits, wheat, and flowers, symbols of Princely Glory—coins, crowns, laurel wreaths, and the order of the Saint-Esprit. Marie Antoinette owned more than eighty small boxes of Oriental lacquer. The black and gold panels of this secretary, also in Japanese lacquer, are a further expression of her fondness for this material. These panels may have been among those stripped from outmoded chests and cabinets at her order to be recombined to form new pieces more to her taste.

Verlet, P., *French Royal Furniture.* London, 1963, pp. 158–60.

20.155.11 The Metropolitan Museum of Art, Bequest of William K. Vanderbilt, 1920.

321. Rolltop Desk

Signed by David Roentgen

German, 1743–1807

Marquetry of satinwood, boxwood, white mahogany, ebony, and mother-of-pearl in panels of sycamore, veneers on burled walnut with tulipwood and greenwood. Cedar and oak carcass. Brass and gilt-bronze mounts

Height: 4 feet, 5½ inches; Width: 3 feet, 7½ inches;

Depth: 2 feet, 2½ inches

Made in Neuwied, *ca.* 1780

This rolltop desk perfectly represents the inventive talents of its maker, David Roentgen, who inlaid his initials below the keyhole of the lower drawer. The Chinese marquetry scenes have a painterly effect that Roentgen alone attained, using minute pieces of variously colored exotic woods. His mechanical ingenuity is exemplified by the workings of the lower section of the desk; when the key of the lower drawer is turned to just the right position, the side drawers spring open. If a button is pressed on the underside of these drawers, each swings aside to reveal three other drawers.

Although Roentgen maintained his workshop at Neuwied, his French clientele became so important that he opened an outlet in Paris and joined the Parisian guild in 1780.

Remington, P., "An XVIII Century German Desk Showing Chinese Influence." *The Bulletin of The Metropolitan Museum of Art,* Vol. XXXVI (June, 1941), pp. 130–34.

41.82 The Metropolitan Museum of Art, Rogers Fund, 1941.

322. Side Chair
Signed by Georges Jacob
French 1739–1814, master, 1765
Gilded walnut covered with embroidered silk of the period
Height: 3 feet, 2⅜ inches; Width: 2 feet, ¼ inches;
Depth: 2 feet, ¼ inches
Made *ca.* 1780

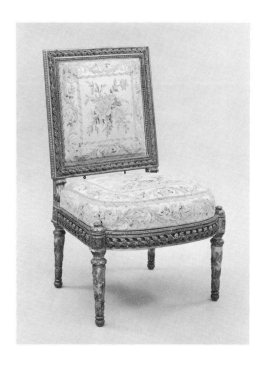

On the underside of this chair (and another in the Museum's collection, 58.75.25), besides the signature of Jacob, there are various marks pertaining to the inventory systems of their owners. The earliest inscription "de Pvre Paris chambre à Balus . . ." indicates that the two chairs were made for the Duc de Penthièvre, a wealthy cousin of Louis XVI. They furnished his townhouse, the Hôtel de Toulouse, near the Place des Victoires in Paris. The "Chambre à Balus . . ." where the chairs stood was his state bedroom. In such public apartments the bed was customarily separated from the rest of the room by a balustrade.

The finesse of ornament typical in the best works of the period is shown here in the bay leaf garlands that spiral in low relief around the legs, and in high relief along the seat rail and back. The chain-stitch embroidery of the upholstery follows designs by Phillipe de la Salle (1723–1804) who interpreted the Louis XVI style in the silks of Lyon.

Dauterman, C. C., Parker, J., and Standen, E. A., *Decorative Art from the Samuel H. Kress Collection at The Metropolitan Museum of Art.* New York, 1964, pp. 61–75.

58.75.33 The Metropolitan Museum of Art, Gift of the Samuel H. Kress Foundation, 1958.

323. Tureen
Jacques-Nicolas Roettiers
French, 1736–1778/1779?, master, 1752
Silver
Height: 13⅞ inches
Marked for Paris 1770/1

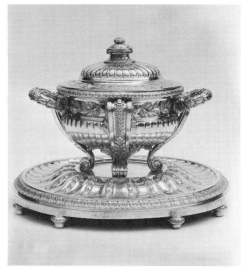

The circular stew tureen, or *pot à oille,* is one of eight made for Catherine II of Russia as part of a table service ordered by her from Jacques-Nicolas Roettiers, the most fashionable and accomplished of the Parisian silversmiths. In addition to Roettiers, Edme Pierre Balzac, Louis Lenhendrick, and Claude Pierre Deville also contributed to the service, which comprised an estimated 3,000 pieces. Begun in 1770, it was not completed until 1773, when the empress decided to present it to Prince Gregory Orloff.

While there is considerable variation of decorative detail among the individual pieces, the prevailing style of the Orloff service is thoroughly neoclassical, and involves elements of design that can be seen in almost every form of Western art—from the largest building to the smallest silver cup—of the period.

Le Corbeiller, C., "Grace and Favor." *The Metropolitan Museum of Art Bulletin,* n.s., Vol. XXII (February, 1969), pp. 289–98.

33.165.2 The Metropolitan Museum of Art, Rogers Fund, 1933.

Italy, Central Europe, and Spain

The last practitioners of the coloristic and atmospheric tradition of Venice worked in landscape and executed decorations as far afield as Germany and Spain. Germany remained politically even more fragmented than Italy. In south German churches, a fusion of architecture, sculpture, and painting achieved a characteristic synthesis of Baroque movement and Rococo ornament. At Meissen, near Dresden, the first true porcelain in Europe was produced in the years following 1710. Spain, regarded as a cultural backwater by the rest of Europe, produced one artist of genius, Goya.

324. The Glorification of Francesco Barbaro
Giovanni Battista Tiepolo
Italian, 1696–1770
Oil on canvas
Height: 96 inches; Width: 183¾ inches

Based on the luxuriant tradition of Venice in the High Renaissance, the style of Tiepolo exerted a widespread influence through all of Europe, especially on the development of Rococo. This ceiling decoration, which he painted for the Palazzo Barbaro in Venice, glorifies the eminent scholar Francesco Barbaro, who defended Brescia against Milan and became procurator of St. Mark in Venice, and served as *Podestà* in several cities of North Italy.

Morassi, A., *A Complete Catalogue of the Paintings of G. B. Tiepolo.* London, 1962, p. 33.

23.128 The Metropolitan Museum of Art, Anonymous Gift in memory of Oliver H. Payne, 1923.

325. Saint Thecla Praying for the Plague-stricken
Giovanni Battista Tiepolo
Italian, 1696–1770
Oil on canvas
Height: 32 inches; Width: 17⅝ inches

Through the intercession of Saint Thecla, the town of Este near Padua was delivered from the plague in 1630. This is the sketch for the great altarpiece over the high altar of the cathedral of Este that Tiepolo painted in 1758–59 to commemorate this event. Three years later he went to work in the Royal Palaces of Aranjuez and Madrid and died in Spain.

Morassi, A., *A Complete Catalogue of the Paintings of G. B. Tiepolo.* London, 1962, p. 33.

37.165.2 The Metropolitan Museum of Art, Rogers Fund, 1937.

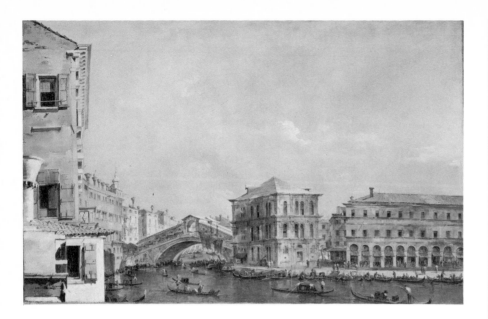

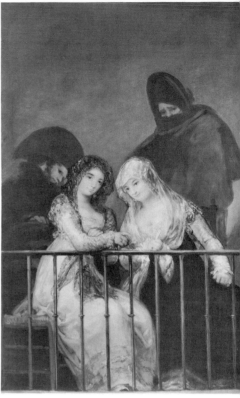

326. The Grand Canal Above the Rialto
Francesco Guardi
Italian, 1712–1793
Oil on canvas
Height: 21 inches; Width: 33¾ inches

Guardi's fame rests chiefly on the many pictures he painted of scenes in
Venice like this one and its companion piece showing the church of Santa
Maria della Salute. His deep familiarity with the city and his affection for it
render them truthful, and his poetic imagination and graceful impressionistic
brushwork give them character and individuality. Englishmen living in Venice
were his chief admirers and patrons.

Moschini, V., *Francesco Guardi*. Milan, 1952, p. 18.

71.119 The Metropolitan Museum of Art, Purchase, 1871.

327. Majas on a Balcony
Francisco de Goya y Lucientes
Spanish, 1746–1828
Oil on canvas
Height: 76¾ inches; Width: 49½ inches

The two young women posed behind the railing of a balcony, supposedly
above the street, are wearing the flamboyantly ornamented costumes that
originated as holiday dress of young Spanish working people, *majos* and *majas*,
but were soon adopted by all classes, even the nobles and the Queen. The two
men are painted without detail, and with their dark cloaks and hats, the
shadowy figures inject something menacing and sinister into the scene.

Wehle, H. B., *A Catalogue of Italian, Spanish, and Byzantine Paintings*. New York,
The Metropolitan Museum of Art, 1940, pp. 248 ff.

29.100.10 The Metropolitan Museum of Art, The H. O. Havemeyer Collection,
Bequest of Mrs. H. O. Havemeyer, 1929.

328. Don Sebastián Martínez

Francisco de Goya y Lucientes
Spanish, 1746–1828
Oil on canvas
Height: 36⅝ inches; Width: 26⅝ inches
Inscribed, signed, and dated (on letter):
Dn Sebastián/Martínez/Por su Amigo/Goya/1792

The sitter was a friend of Goya's whom the artist visited in
his house in Cádiz in 1793, during the illness that resulted
in Goya's permanent deafness. Martínez collected books
and engravings as well as paintings, and beside this portrait
of himself, owned three overdoors by Goya. With his
customary dexterity, Goya has made the striped coat a
thing of beauty in itself. Though characterized by the
artist's infallible originality, his painting of Martínez belongs
nevertheless to the tradition of the eighteenth-century
portrait and presents an interesting contrast to the powerful
modernity of such pictures as the Museum's portrait of
Pérez, another friend of Goya's whom he painted in 1820.

Trapier, E. du G., *Goya and His Sitters*. New York, 1964,
pp. 8 f.

06.289 The Metropolitan Museum of Art, Rogers Fund,
1906

329. Portrait of the Artist

Francisco de Goya y Lucientes
Spanish, 1746–1828
Point of brush and gray wash
Height: 6 inches; Width: 3⁹⁄₁₆ inches

The artist, who wears at his lapel a locket inscribed with his name, stares at the
spectator with an intensity that suggests that the portrait is a mirror image.
Goya reveals in this small and powerful work a technical virtuosity that was
later to enable him to dash off an extraordinary series of miniatures on ivory.
The drawing figures as the first page of an album of fifty Goya drawings
dating from several periods of the artist's activity, purchased by the
Metropolitan Museum in 1935.

Wehle, H. B., *Fifty Drawings by Francisco Goya*. New York, 1938, p. 7.

35.103.1 The Metropolitan Museum of Art, Harris Brisbane Dick Fund, 1935.

330. The Swing

Francisco de Goya y Lucientes
Spanish, 1746–1828
Brush and gray wash
Height: 9⁵⁄₁₆ inches; Width: 5¾ inches

The spontaneity of Goya's brush, washed easily over the page, reinforces the
buoyant mood of his subject. Far removed in feeling from Goya's later
devastating graphic commentaries on human frailty and vice, this witty drawing
has the carefree air of an eighteenth-century country outing.

Wehle, H. B., *Fifty Drawings by Francisco Goya*. New York, 1938, Pl. III.

35.103.2 The Metropolitan Museum of Art, Harris Brisbane Dick Fund, 1935.

331. The Giant
Francisco de Goya y Lucientes
Spanish, 1746–1828
Aquatint, first state
Height: 11⅛ inches; Width: 8⅛ inches

Goya, the most bitter of satirists, often concealed his messages in disturbing and nightmarish images. His haunting *Giant* stands out amidst the shocking drama of his etchings as the most monumental and powerfully sculptured single figure. More than any other print by Goya, it resembles the "black paintings" which the aging artist, by that time stone-deaf, painted on the walls of his house near Madrid. One of only six known impressions, our *Giant*, in his brooding and somber vision, announces not only nineteenth-century Impressionism, but also twentieth-century Surrealism and Expressionism.

Mayor, A. H., "Goya's Giant." *The Bulletin of The Metropolitan Museum of Art*, Vol. XXX, 1935, pp. 153–54.

35.42 The Metropolitan Museum of Art, Harris Brisbane Dick Fund, 1935.

332. The Prisons (plate 10)
Giovanni Battista Piranesi
Italian, 1720–1778
Etching; first state
Height: 16¼ inches; Width: 21⅜ inches

An architectural draftsman and amateur archaeologist, Piranesi became the most influential member of the Roman group which brought about the eighteenth-century classical revival. His absolute conviction and impassioned imagination made him the greatest of all etchers of architectural subjects, particularly the decaying ruins of ancient Rome. Among Piranesi's greatest achievements are the incredible *Prisons*, works of pure surrealist fancy, foreshadowing abstract art, even Cubism, and somehow destined to influence countless scenic designers in preparing their sets of dungeons and torture chambers.

Mayor, A. H., *Giovanni Battista Piranesi*. New York, 1952, pp. 6–7.

37.45.3(33) The Metropolitan Museum of Art, Harris Brisbane Dick Fund, 1937.

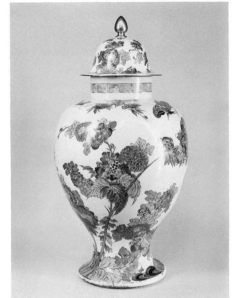

333. Commode

Designed by François de Cuvilliès (1695–1768) and probably executed by Joachim Dietrich (court carver, 1736–1753)

Pine, painted and gilded, with gilt-bronze mounts. The top is of white lumachella marble

Height: 33¼ inches; Width: 51½ inches; Depth: 24½ inches

Made in Munich, 1735–1740

Born in the Netherlands, the architect François de Cuvilliès was trained in France, but spent the greater part of his working life in Germany. One of his important commissions was for the redecoration of the state apartments in the Residenz, Munich, between 1730 and 1737. He was also responsible for the building and decoration of the Amalienburg Pavilion in the park of Schloss Nymphenburg between 1734 and 1739. Among his associates in these enterprises was the wood-carver, Joachim Dietrich, who may have carried out the Museum's commode from Cuvilliès' designs. This commode, a sturdy example of early Bavarian Rococo, falls into the period of Cuvilliès greatest commissions, when the architect and carver were working together.

Feulner, A., and Remington, P., "Examples of South German Woodwork in the Metropolitan Museum." *Metropolitan Museum Studies*, Vol. II, 1929–1930, pp. 152–66.

28.154 The Metropolitan Museum of Art, Fletcher Fund, 1928.

334. Vase with Cover

German, Meissen, *ca.* 1725

Hard-paste porcelain

Height: 22½ inches

The vast collections of Oriental porcelain amassed by European princes at the turn of the seventeenth century were important sources of inspiration for European, particularly German, porcelain factories. In shape, choice of decorative motifs, and palette, the early Meissen porcelains remain close to their Chinese and Japanese prototypes. Augustus the Strong was particularly fond of the sets of large vases painted in *famille verte* colors with sprawling flower sprays, characteristic of the late K'ang Hsi Period, and he ordered numerous versions of them to be made at Meissen. By about 1725, under the directorship of J. G. Herold, the Meissen factory had perfected a wide range of new enamel colors, including several, for example, the mauve purple and lemon green shown on this piece, not known in China.

The vase, like most examples of its type dating between 1720 and 1731, is marked on the underside with the royal monogram AR, generally accepted as a mark reserved for pieces ordered by or intended for Augustus II.

50.211.240 ab The Metropolitan Museum of Art, Gift of R. Thornton Wilson, in memory of Florence Ellsworth Wilson, 1950.

335. Pair of Porcelain Sculptures of Goats
Modeled by Johann Joachim Kaendler
German, Meissen, XVIII century
Hard-paste porcelain
(a) Female with kid: Height: 19⅜ inches; Length: 25½ inches
(b). Buck: Height: 20½ inches; Length: 23½ inches

These two sculptures cast from models by Johann Joachim Kaendler have a special significance for the Meissen factory, as they appear to be the only examples among the life-sized figures of animals and birds that were made to complement each other. They belong to a series of white porcelains begun in 1731 at the order of Augustus the Strong and intended as furnishings for his "Japanese Palace." They far exceed the normal capacity of the porcelain medium, as can be seen from the large fissures that developed in the first firing. They were left in the white because an additional firing to affix color decoration was considered too risky. After the death of Augustus, in 1733, only a few other large figures were completed, and the factory turned to making birds and animals of a more workable scale. The models, however, survived and there is reason for thinking that our figure of the goat was a recasting from the original model made in the 1760's.

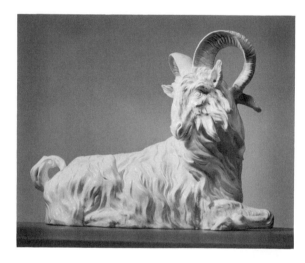

Dauterman, C. C., "Colossal for the Medium." *The Metropolitan Museum of Art Bulletin*, n.s., Vol. XXII (Summer, 1963), pp. 1–8.

(a) 62.245 The Metropolitan Museum of Art, Gift of Mrs. Jean Mauzé, 1962.
(b) 69.192 The Metropolitan Museum of Art, Rogers Fund, 1969.

336. An Artist and a Scholar Being Presented to the Chinese Emperor
German, Höchst, *ca.* 1765
Hard-paste porcelain
Height: 15⅞ inches

The enthroned emperor is backed by a rococo structure surmounted by a turquoise blue canopy hung with gold bells. Standing beside him on the stepped and marbleized dias, a court official presents an artist wearing a laurel chaplet and a scholar holding an open scroll.

This group is an ambitious blending of chinoiserie with elements of the Rococo. This formula, originally French, was extensively applied in Germany where it survived, as it did in England, several decades after the Rococo had become outmoded in the land of its origin.

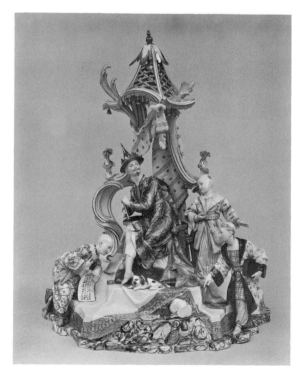

The group is thought to have been designed as the central attraction of a dessert service supplemented by single figures of Chinese musicians and children. The practice of employing porcelain sculptures as table decorations was a German conceit that had its origin several centuries earlier when figures made of barley sugar and other materials were made for this purpose. Such decorations often expressed the activities and interests of the court, and therefore featured incidents of the hunt as well as fetes and pageants of the day.

Smith, H., "Two Examples of Ceramic Sculpture in The Metropolitan Museum of Art." *Céramique*, Vol. I, 1954, pp. 99, 103–105.

50.211.217 The Metropolitan Museum of Art, Gift of R. Thornton Wilson, in memory of Florence Ellsworth Wilson, 1950.

England

England, stable and prosperous, ran a course largely independent of the rest of Europe. A classical revival in architecture, based on the work of the sixteenth-century Italian Palladio, gained acceptance in the 1720's and remained in favor until the Neoclassical movement of the 1760's. The outlet for English painting remained almost entirely confined to portraiture, in which Rubens' aristocratic tradition, introduced to England by his pupil Van Dyck, infused the dashing portraits of the later eighteenth century.

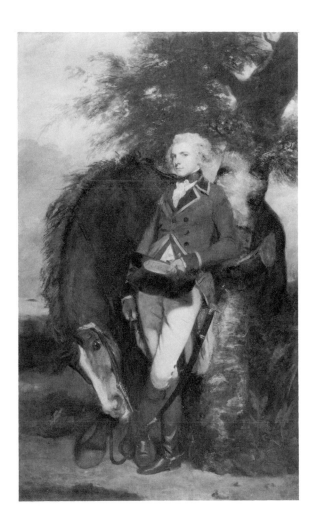

337. Colonel George K. H. Coussmaker, Grenadier Guards
Sir Joshua Reynolds
British, 1723–1792
Oil on canvas
Height: 93¾ inches; Width: 57¼ inches

Sir Joshua Reynolds was the first president of the newly founded Royal Academy and the author of fourteen discourses on painting which have become English classics on the theory of art. As a young man he spent more than two years in Italy, intently studying the works of the High Renaissance masters, especially Michelangelo, as well as Roman antiquities. On such studies he founded his own style, raising the art of portrait painting in England to a level comparable to that elsewhere in the great periods.

In this portrait of 1782, the mature Reynolds has presented his well-born and elegant subject leaning against a tree in a pose of casual but studied negligence, the line of his slender and graceful body repeated in the long and curving neck of his equally well-bred horse. The summer before he painted the picture, he had made a study trip to the Low Countries and had profited by the possibilities he observed in Rubens' works, especially in the creation of a free and painterly surface treatment.

Graves, A., and Cronin, W. V., *A History of the Works of Sir Joshua Reynolds, P.R.A.* London, 1899, Vol. I, p. 199, and London, 1901, Vol. IV, p. 1287.

20.155.3 The Metropolitan Museum of Art, Bequest of William K. Vanderbilt, 1920.

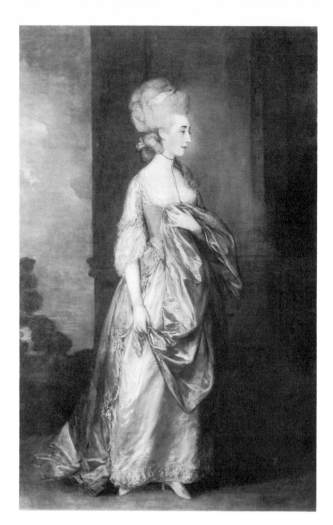

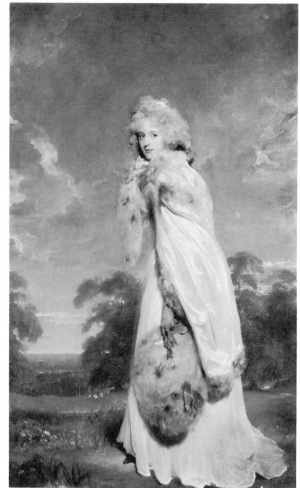

338. Mrs. Grace Dalrymple Elliott
Thomas Gainsborough
English, 1727–1788
Oil on canvas
Height: 92¼ inches; Width: 60½ inches

This portrait was probably painted not long before 1778, when Gainsborough sent it to be exhibited at the Royal Academy, of which he was a founding member. It is an excellent example of his fashionable portrait style, which he built upon his awareness of the great English likenesses by Van Dyck, modifying their monumental quality with the grace and elegance of Watteau.

When very young, Mrs. Elliott made an aristocratic marriage, which was followed by a slightly lurid romantic career in London, and during the French Revolution in Paris. George IV and the Marquess of Cholmondeley were among her admirers, and her little daughter, whose portrait by Reynolds is also in the Museum, is said to have been the King's child.

Waterhouse, E., *Gainsborough.* London, 1958, p. 66.

20.155.1 The Metropolitan Museum of Art, Bequest of William K. Vanderbilt, 1920.

339. Elizabeth Farren, Countess of Derby
Sir Thomas Lawrence
British, 1769–1830
Oil on canvas
Height: 94 inches; Width: 57½ inches

The verve and freshness that make this portrait so appealing are congruous with the youthfulness of Lawrence when he painted it. The knowing composition and the construction of the figure, however, and especially the virtuosity and variety of the brushwork—now dry, now loaded—would ordinarily presume a degree of experience that he had not yet had. Lawrence had been admitted as a student to the Royal Academy in 1787, three years before this portrait was exhibited there, indicating a very early attainment of the freedom and elegance that made him a popular portrait painter for forty years. Miss Farren was a hugely admired, spirited young actress when she was painted in this unconventional, spontaneous pose. Seven years later, becoming the second wife of the twelfth Earl of Derby, she retired from the stage.

Great Paintings from the Metropolitan Museum of Art. New York, 1959, No. 48.

50.135.5 The Metropolitan Museum of Art, Bequest of Edward S. Harkness, 1940.

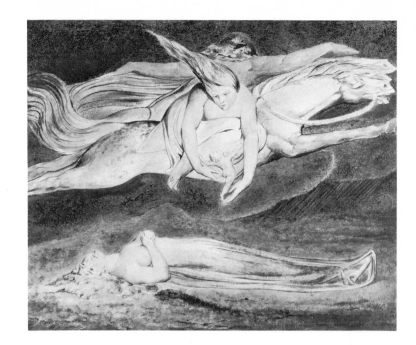

340. Pity, Like a Naked Babe

William Blake
British, 1757–1827
Watercolor printed from varnished cardboard; pen and ink
Height: 16⅝ inches; Width: 20⅞ inches

Blake grew up in the London portrayed by Hogarth and Rowlandson, but his art could not be further from their coffeehouses and gambling halls, for his world was that of the solitary, symbolist, and visionary. *Pity, Like a Naked Babe* is one of the largest and grandest compositions of Blake's divine inspiration. A free flight of fancy suggesting darkness, wind, and speed, it is based on lines from Shakespeare's *Macbeth:*

Pity, like a naked, new-born babe,
Striding the blast, or Heaven's cherubim horsed
Upon the sightless couriers of the air
Shall blow the horrid deed in every eye.

Blunt, A., *The Art of William Blake.* New York, 1959, pp. 36, 60–62.

58.603 The Metropolitan Museum of Art, Gift of Mrs. Robert W. Goelet, 1958.

341. Sideboard Table

Designed by Matthias Lock
English, active 1740–1770
Pine, painted and gilded. The top is of white Carrara marble
Height: 35¾ inches; Length: 68¼ inches; Depth: 34½ inches
Made *ca.* 1740

The pencil drawing from which this table derives is part of a folio scrapbook acquired by the Victoria and Albert Museum in 1863 from Matthias Lock's grandson. The table belongs to a heavy, classical type of furniture associated with the architect William Kent (1685?–1748), who designed furniture for English Palladian houses. The drawing that inspired the table is dated among the earliest works of Matthias Lock, a carver and furniture designer best known as a practitioner of the English Rococo style. As such tables were intended to stand in dining rooms, marble slabs were provided in place of wooden tops to withstand the effects of spilled wine and the undersides of hot dishes.

Ward-Jackson, P., *English Furniture Designs of the Eighteenth Century.* London, 1958, pp. 38–40.

26.45 The Metropolitan Museum of Art, Rogers Fund, 1926.

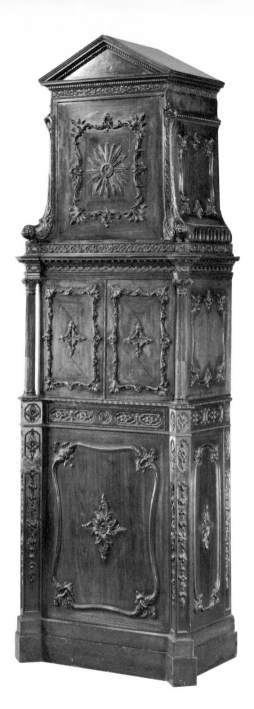

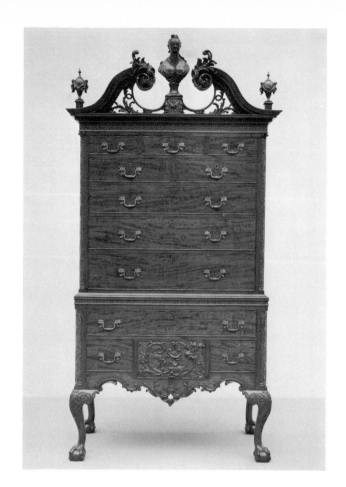

342. Medal Cabinet

William Vile
English, active 1740–1765
Mahogany; much of the carved ornament is applied
Height: 6 feet, 7 inches; Width: 27 inches; Depth: 17¼ inches
Made 1758–1761

In recent years the cabinetmaker William Vile has received credit for some of the finest achievements of English eighteenth-century furniture making. Going into partnership with John Cobb, another cabinetmaker, in 1750 they were appointed by George III as joint "Upholsterers in Ordinary to his Majesty's Great Wardrobe" in January, 1761.

The medal cabinet was, in all likelihood, an end section of a tripartite piece of furniture. The other end section is in the Victoria and Albert Museum, London; the middle section, if it exists, has not been identified. One hundred and thirty-five shallow drawers for coins and medals are enclosed behind the doors of the cabinet, allowing space for over 6,000 items from the King's collection. The top door is carved with the star of the Order of the Garter to which George III was elected, while he was Prince of Wales, in 1750.

Shrub, D., "The Vile Problem." *The Victoria and Albert Museum Bulletin*, Vol. I, (October, 1965), pp. 26–35.

64.79. The Metropolitan Museum of Art, Fletcher Fund, 1964.

343. High Chest
Philadelphia
Cuban mahogany with secondary woods of cedar and yellow poplar
Height: 91½ inches; Width: 46¾ inches; Depth: 24¼ inches
Made *ca.* 1770

Popularly known as "the Pompadour Highboy" because of the French character of the bust surmounting it, this extraordinary chest was made in Philadelphia about 1770, when American arts still showed a strong cultural dependence on Europe. Although the basic form of double chest on high cabriole legs is a distinctively American innovation, the pediment and carving are drawn almost directly from the great English pattern books of Thomas Johnson, Thomas Chippendale, and Abraham Swan. Plates in Chippendale's *Director* undoubtedly furnished the inspiration for the center bust, the draped urns, and even the interpretation of the French fable carved on the base, La Fontaine's *Les Deux Pigeons.* It is not surprising that in Philadelphia, a city where the most skillful cabinetmakers of the period bore names like Benjamin Randolph, Thomas Tufft, Jonathan Gostelowe, and James Gillingham, the finest cabinetwork should be inspired by English models. What is surprising is the fact that in this city founded by Quakers—"plain people"—the sophisticated styles of mid-eighteenth-century Europe reached their highest degree of elaboration in America.

Downs, J., "A Philadelphia Lowboy." *The Bulletin of The Metropolitan Museum of Art,* Vol. XXVII (December, 1932), pp. 259–62.

18.110.4 The Metropolitan Museum of Art, Kennedy Fund, 1918.

344. Tripod Stand with Kettle and Lampstand
Simon Pantin
Silver
Height: 40¾ inches
Made in London, 1724

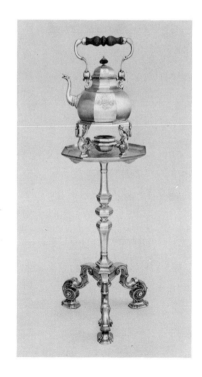

This extraordinary tripod stand with detachable tray, a lampstand, and the hexagonal kettle with bail handle and swan-neck spout, is the work of Simon Pantin, a great London silversmith of Huguenot origin. He registered his mark in 1701, and established himself at "the Peacock," a house and sign to which the bird in his maker's mark alludes. This mark is to be found on each separate part, as are the achievement or crest of the original owners, George Bowes of Streatham Castle and Gibside and his wife, Eleonor Verney, whom he married in 1724. This set, probably a wedding present, is distinguished by superb unity of design and execution; silver has been used with extraordinary skill, both in the kettle and in the tripod stand, which adopts the form of contemporary mahogany furniture. Only one other set of this kind, but without the tray, is known to exist. The original owners, it may be noted, were ancestors of Her Majesty Queen Elizabeth, the present Queen Mother of England.

Dennis, J. McN., *English Silver.* New York, 1970.

68.141.81 The Metropolitan Museum of Art, The Irwin Untermyer Collection, 1968.

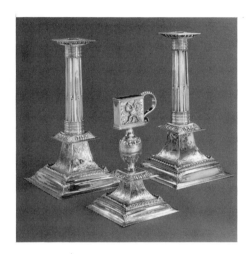

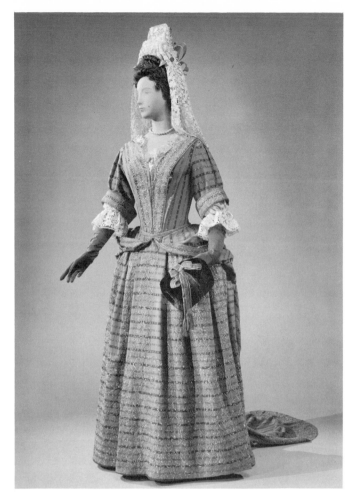

345. Candlesticks and Snuffer Stand
Cornelius Kierstede
Silver
Candlesticks (a): Height: 11½ inches; (b) Height: 11¾ inches;
Snuffer stand (c): Height: 8 inches
Made in New York

A seventeenth-century blending of cultures is evident in the history and style of this pair of candlesticks and matching snuffer stand from the very early eighteenth century. Made about 1705 in England's most cosmopolitan American colony, New York, they are by a silversmith of Dutch ancestry, Cornelius Kierstede. The flat-chased decoration on the bases represents not only scenes similar to those illustrating North European fables of the period, but also stylistically a kind of chinoiserie that reflects the seventeenth-century European "vision of Cathay." Although such chinoiserie is found on fashionable English Restoration silver, it is unique in early American silver.

Glaze, M., "Some Leading Examples of American Silver in The Metropolitan Museum of Art." *The Connoisseur*, Vol. CLXXII (November, 1969), pp. 189–95.

(a) 57.153 The Metropolitan Museum of Art, Gift of Robert L. Cammann, 1957.
(b) 64.83ab The Metropolitan Museum of Art, Gift of Mrs. Clermont L. Barnwell, 1964.
(c) 23.80.21 The Metropolitan Museum of Art, Gift of Mr. and Mrs. William A. Moore, 1923.

346. Gown
English, *ca.* 1690
Wool, embroidered with gilt silver yarns
Height: 92¼ inches (center back, including train)
Said to have come from Kimberley Hall, Norfolk, England

This gown, with its matching petticoat, appears to be the only civilian costume of its kind known to have survived in this country or in Europe. It shows the archetypal form of late seventeenth-century fashionable dress for women; it embodies also the prototype of eighteenth-century gowns. Although it was made of a handsome striped woolen fabric (of a type probably then called "stuff"), this gown was not necessarily worn only in winter. The accessories shown here did not belong with this gown originally; however, the headdress and sleeves, which were reconstructed recently, use laces of the period.

Cavallo, A. S., "The Kimberley Gown." *The Metropolitan Museum Journal,* Vol. III, 1970.

33.54ab The Metropolitan Museum of Art, Rogers Fund, 1933.

China: Ch'ing Dynasty, 1644–1912

The Manchu from the north of China established themselves at Peking as the Ch'ing Dynasty in 1644. Virtuoso performances in landscape painting are echoed by brittle technical excellence in the decorative arts. After 1800, Chinese art, having exhausted traditional themes and techniques, declined as rapidly as the political system. The Manchu were overthrown in the revolution of 1912.

347. Bodhidharma Crossing the Waves on a Reed (Screen)
Chinese, Ch'ien-lung Period, 1736–1795
Nephrite
Diameter: 12 inches

For centuries in China, jade has been a treasured gem in both its forms—the valuable jadeite and the less costly mineral nephrite. This circular disc or screen depicts in high relief the Buddhist monk and patriarch, Bodhidharma. Legend relates that Bodhidharma presented his message of salvation (the Ch'an or Zen concept that enlightenment is achieved only through meditation and self-knowledge) to the Chinese court (sixth century A.D.). The emperor, however, remained unenlightened, and the monk left. Thereafter the emperor regretted Bodhidharma's departure and tried to recall him. When the emissary caught up with the patriarch at the banks of a river, he saw the Bodhidharma crossing the turbulent waves on a reed. The subject has been a favorite of Chinese artists. It may also have been a favorite of Emperor Ch'ien-lung whose inscription appears above the scene. On the reverse is an engraved outline picture of an island and above it an ode, also by Emperor Ch'ien-lung, recalling the island's beauty. The engraved lines of the island, the ode, and inscription are filled with gold.

Hansford, S. H., *Chinese Carved Jades.* London, 1968.

02.18.688 The Metropolitan Museum of Art, Gift of Heber R. Bishop, 1902.

Section VIII: XIX Century

1804–1815	Napoleon Emperor of France
1805–1807	Beethoven's *Fifth Symphony* composed
1815	Wellington defeats Napoleon at Waterloo
1818	Byron begins *Don Juan*
1825	First railway line in England
1837–1901	Reign of Queen Victoria
1839	Opium wars break out with China
1848	Marx and Engels write *Communist Manifesto*
1851	Crystal Palace in London, first international exhibition
1853	Commodore Perry opens Japan to rapid Westernization
1858	First transatlantic telegraph cable
1859	Darwin writes *Origin of Species*
1860	Japanese prints appear on Paris art market
1861–1865	American Civil War
1861	Dickens writes *Great Expectations*
1869	U.S. transcontinental railway completed
1871	Germany united; France surrenders to Prussians
1874	Wagner completes *Ring Cycle*
1876	Bell invents telephone
1879	Edison invents incandescent light
1883–1884	Nietzsche writes *Thus Spoke Zarathustra*
1895–1899	Freud writes *The Interpretation of Dreams*
1900	Boxer Rebellion in China

West	West	Far East	Oceania

1800

359. Canova,
Italian

350. Utamaro,
Japanese

1810

1820

352. Hokusai,
Japanese

1830

1840

364. Delacroix,
French

367. Courbet,
French (detail)

354. Gambier Islands

1850

1860

374. Manet,
French

1870

1880

383. Cézanne,
French

386. Van Gogh,
Dutch

1890

1900

Japan: Color Woodcuts

Japanese color woodcuts represent a late flowering of the Far Eastern calligraphic tradition of brush painting. These prints, in which the artist reproduces his brushstroke directly on the wood block, are produced from a series of color tone sketches, one for each color. At Edo, the residence of the imperial shogun, color woodcuts were first appreciated as works of art rather than as popular illustrations, and were aimed at an increasingly sophisticated middle class. They were first seen in Europe after 1860 and had an electrifying influence on the techniques of composition of French painters.

348. Courtesan
Anchi Kaigetsudo
Japanese, active 1700–1716
Woodcut
Height: 22¾ inches; Width: 12¾ inches
Artist's seal: Anchi
Signed Nihon Giga Kaigetsu Matsuyo Anchi zu

Ukiyo-e, or pictures of the floating world, depicted the everyday life of the common man. Love, the theater, the pleasure district, home scenes, and landscapes were the subjects that inspired these prints.

There are six men identified with the name Kaigetsudo, and practically nothing is known about them. This print, signed by Anchi Kaigetsudo (Yasutomo), is possibly the work of the second artist of the line. It is the only known impression of this design. There are in all of the Kaigetsudo group only thirty-nine impressions known (with twenty-two subjects among them).

The courtesan pauses to fix a pin in her hair. Her robe, itself a picture of chrysanthemums and waves, complements the dignified grace of this stately figure. The print is done on two sheets of paper, in ink only.

Wehye, E., *Japanese Prints of the Primitive Period in the Collection of Louis V. Ledoux.* New York, 1942, No. 19.

Japanese print no. 3106 The Metropolitan Museum of Art, Harris Brisbane Dick Fund, 1949.

349. Dancer
Attributed to Torii Kiyonobu I
Japanese, 1664–1729
Woodcut
Height: 21¾ inches; Width: 11½ inches

Torii Kiyonobu I is known for his superb actor prints. He is considered credited with being the first *Ukiyo-e* print designer to realize the possibilities of portraits of actors as fascinating subject matter. His sure sweeping line coupled with the adroit composition give balance and boldness to this print. The robe designs arrest the eye, yet do not overpower the figure itself, with wand in one hand and fan in the other. The yellow and orange pigment have been added by hand.

Stern, H. P., *Master Prints of Japan—Ukiyo-e Hanga.* New York, 1969.

Japanese print no. 3098 The Metropolitan Museum of Art, Harris Brisbane Dick Fund, 1949.

350. The Teahouse Maid, Naniwaya Okita
Kitagawa Utamaro
Japanese, 1753–1806
Woodcut
Height: 14⁵⁄₁₆ inches; Width: 9½ inches

Little is known about Utamaro's life, but this entrancing portrait justifies his fame as an artist devoted to portraying women of all ranks. The poem at the upper left extols the prettiness of Okita, a waitress at the Naniwa teahouse. The lady's charms were such that she enticed travelers into the teahouse, and looking at this print one understands why. The focus is entirely on the lovely young woman. The half-length portrait is done in ink and soft colors on a silvered mica background.

Narazaki, M., *The Japanese Print: Its Evolution and Essence.* Tokyo, 1966.

Japanese print no. 1668 The Metropolitan Museum of Art, The H. O. Havemeyer Collection, Bequest of Mrs. H. O. Havemeyer, 1929.

**351. Night Rain at Karasaki from the series
"Eight Views of Lake Biwa"**
Ando Hiroshige
Japanese, 1797–1858
Woodcut
Height: 8⅞ inches; Width: 13¾ inches

Hiroshige is considered the last great landscape print artist of the
Ukiyo-e era. A quiet lyric tone pervades his views of landscape.
Here the great pine tree of Karasaki is seen in a drenching rain.
The colors are confined to blue and black.

The poem in the upper-left-hand corner has been translated by
one admirer:
 "Hushed stands the giant pine in the night rain,
 Elsewhere now the evening breeze that murmured of it
 sings its fame."

Stern, H. P., *Master Prints of Japan—Ukiyo-e Hanga.* New York, 1969.

Japanese print no. 2476 The Metropolitan Museum of Art, Rogers
Fund, 1936.

352. Kajikazawa, one of the series "The Thirty-six Views of Fuji"
Katsushika Hokusai
Japanese, 1760–1849
Woodcut
Height: 10 inches; Width: 15⅛ inches

Hokusai's keen observation of his country's landscape was a new
and vital element in the print designer's repertory. Here is a view
from Kajikazawa. A fisherman and a companion huddling beside
him perch on a lonesome wave-lapped rock. In the distance at
the upper right, the sacred mountain Fuji looms through mist
with quiet splendor, effectively contrasted with the turbulent
foreground of craggy rock and sea.

Narazaki, M., *The Japanese Print: Its Evolution and Essence.*
Tokyo, 1966.

Japanese print no. 2581 The Metropolitan Museum of Art,
Rogers Fund, 1936.

Oceania

Oceania, encompassing Australia and the islands of the South Pacific, embraces a wide variety of races and cultures. The last area of the earth to be inhabited and the last civilizations to be discovered by Europeans (largely through the voyages of Cook, 1768–1780), Pacific archipelagos produced religious art and ceremonial paraphernalia that missionaries of the early nineteenth century zealously destroyed. Only in our own century have these works of art begun to be appreciated.

353. Fly Whisk Handle
Tahiti, probably late XVIII century
Whale ivory, sennit cord
Height: 11¾ inches

This fly whisk handle, and another in our exhibition, were used by the rulers of Tahiti on such occasions as their inaugurations and were probably hereditary heirlooms.

They were presented in October, 1818, to the Reverend T. Hawles by Pomare II, King of Tahiti, and were apparently among the last surviving Tahitian regalia.

In common with other decorative arts of Polynesia, these handles exhibit repeated abstracted images of the human body.

Wardwell, A., *The Sculpture of Polynesia.* Chicago, The Art Institute of Chicago, 1967, pp. 32–33.

65.80 The Museum of Primitive Art.

354. Figure of a God
Gambier Islands, Mangareva
Wood
Height: 38¾ inches

This figure probably represents the god Rogo or Rongo, symbolized by the rainbow, who sent rain to nourish the islands' breadfruit trees. It is one of seven known to have survived a mass destruction of carvings that took place, at the instigation of missionaries, in April, 1835.

Buck, P., "Ethnology of Mangareva." *Bishop Museum Bulletin,* No. CLVII, 1938, p. 460.

57.91 The Museum of Primitive Art.

355. Female Figure Pendant (Niho Palaoa)
Hawaiian Islands
Bone
Height: 2⅜ inches

This figure is unique, and the type is otherwise only known from a description by a member of Captain Cook's third expedition (1779). It is carved on the model of the well-known hook-shaped pendants of whale ivory.

It exhibits characteristics that are purely Hawaiian in style: a muscular form engaged in dynamic action with grotesque facial distortions emphasizing deeply sunken eyes and large jutting jaw.

This tiny figure has a power usually only associated with monumental sculpture set up around the ceremonial centers.

Wardwell, A., *The Sculpture of Polynesia.* Chicago, 1967, No. 86.

61.35 The Museum of Primitive Art.

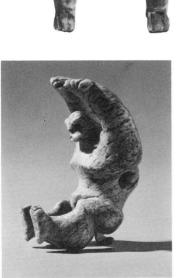

International Neoclassicism

Neoclassicism, one of several concurrent Romantic revival styles, was accepted in the late eighteenth century as the expression of revolutionary nostalgia for the austere virtues of the Roman Republic. In the decade of the French Revolution (1789–1799) Neoclassical art grew archeologically more correct, drawing from Greek as well as Roman sources for the desired clarity of outline and for nobility of action, expressed in cool colors. The French Empire (1804–1815) introduced Neoclassicism throughout Europe. During the nineteenth century this style, vying with Romanticism, became arid and reactionary, and was retained by the French Academy as the only officially acceptable style.

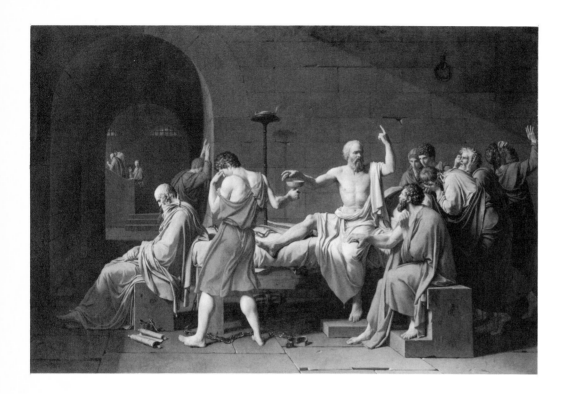

356. The Death of Socrates

Jacques-Louis David
French, 1748–1825
Oil on canvas
Height: 51 inches; Width: 77¼ inches
Signed (on bench at lower right): L. David
Initialed (on bench near bed at lower left): L.D.
Dated (lower left corner): MDCCLXXXVII

The man who commissioned this picture died by the guillotine seven years after it was completed, and indeed the subject that he chose to have David paint was full of implied political protest against the injustices of the old regime—the self-sacrifice of Socrates, who had been an avowed and bitter critic of Athenian society. The calculated and disciplined style in which the picture is painted accords completely with its stoical subject matter.

Sterling, C., *A Catalogue of French Paintings, XV–XVIII Centuries.* Cambridge, Mass., The Metropolitan Museum of Art, 1955, pp. 192 ff.

31.45 The Metropolitan Museum of Art, Catharine Lorillard Wolfe Fund, 1931.

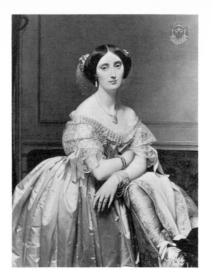

357. Princess of Broglie
Jean-Auguste-Dominique Ingres
French, 1780–1867
Oil on canvas
Height: 41¾ inches; Width: 34⅝ inches
Signed: J. Ingres Pit 1853

Ingres worked on this superb portrait for more than a year and completed it in June, 1853. He was occupied at the same period with the portraits of two other beautiful women, Madame Moitessier and Madame Gonse. The portrait of the princess is a triumph of the painter's taste and discretion, in concentrating the decorative detail of jewels and accessories and the tactile charms of the blue silk skirt in the lower half of the picture, and leaving the severely plain wall as the background for the aristocratic and slightly melancholy dark head and the gracefully slender neck and sloping shoulders.

Rosenblum, R., *Jean-Auguste-Dominique Ingres.* New York, 1967, p. 158.

Robert Lehman Collection.

358. La Frileuse
Jean-Antoine Houdon
French, 1741–1828
Bronze
Height: 56½ inches
Signed and dated 1787

Houdon modeled a *Frileuse* ("the chilly one" or *Winter*) and a companion *Summer* in 1781. Between 1783 and 1785 he finished the life-size marble figures of the two, now in Montpellier. Forced to evacuate his state-owned studio in 1787, he cast the bronze *Frileuse* himself before leaving.

The *Frileuse* is not obviously a season, but rather an amusing girl whose shawl emphasizes her naked beauty. A philosophic visitor to the 1791 Salon, where the bronze was exhibited, noted that "it seems to want reason. When one is chilled, one seeks . . . to cover one's body instead of one's head." Another observer was more blunt, describing the work as a "a Frileuse who covers her head and puts her behind in the air." Houdon stated that it was owned by "the late Orléans" and the revolutionary register of confiscated goods confirms that it belonged to that cultivated *débauché,* Philippe-Égalité.

Phillips, J. G., "Monsieur Houdon's Frileuse." *The Metropolitan Museum of Art Bulletin,* n.s., Vol. XXII (Summer, 1963), pp. 29–36.

62.55 The Metropolitan Museum of Art, Bequest of Kate Trubee Davison, 1962.

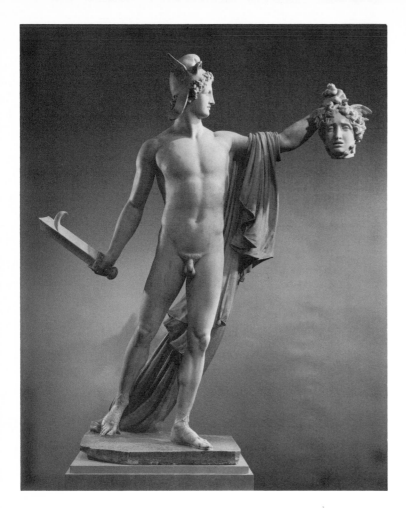

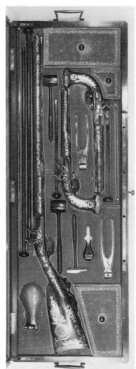

359. Perseus Carrying the Head of Medusa

Antonio Canova
Italian, 1757–1822
Carrara marble
Height: 86⅝ inches
Made between 1804 and 1808

Among the art treasures removed from Italy to France by Napoleon's army was the antique Vatican *Apollo Belvedere.* Between 1790 and 1800 Canova executed the first version of his *Perseus,* based obviously on the antique *Apollo.* When it was seen by the public in his studio, the *Perseus* achieved the merit of a manifesto, the last word in the continuing purification of the neoclassic style, and it was bought by Pius VII to replace the *Apollo Belvedere.* The Metropolitan *Perseus* was ordered by a Polish countess, Valeria Tarnowska. The Museum owns as well the contract written in Canova's hand on April 14, 1804. The work, with refinements that perfect the first version, was completed about 1808.

For his contemporaries, the genius of Canova lay in his ideal fusion of the beauties of the antique with those of "nature"; to be sure, a nature of a highly personal sort. His lyric abstraction of natural forms was more influential than would have been admitted a few years ago, when his reputation was in decline; and Canova may now be seen to have had a serious impact on the subsequent history of sculpture.

Raggio, O., ''Canova's Triumphant Perseus.'' *The Connoisseur,* Vol. CLXXII (November, 1969), pp. 204–12.

67.110 The Metropolitan Museum of Art, Fletcher Fund, 1967.

360. Cased Garniture of Presentation Firearms

Nicolas Noël Boutet
French, active 1792–1818
Steel, blued and gold inlaid; walnut stocks; silver mountings
Length of rifle: 27¼ inches; Length of pistol: 17 inches
Made at Versailles *ca.* 1810–1815

This magnificent set of a hunting rifle and a brace of matching pistols is one of the finest products of the celebrated workshop in Versailles that—under the directorship of Boutet—was founded to provide Napoleon Bonaparte with appropriately splendid gifts to lavish on royalty, diplomats, and generals.

This particular garniture was acquired by the Russian Field Marshal Count (later Prince) von der Osten-Sacken, the Allied military governor of Paris, in 1814. It bears several later inscriptions in Russian and one commemorative of the Paris World Exhibition, 1900.

Loan Exhibition of European Arms and Armor. The Metropolitan Museum of Art, August 3–September 27, 1931, Cat. No. 390.

1970.179.1 The Metropolitan Museum of Art, Fletcher Fund, 1970.

Romanticism and Realism

After the 1820's, when the Industrial Revolution began to change the face of Europe, art and contemporary life moved apart. Romantic artists in America and England, as well as on the Continent, revolted against the classical dogma of the French Academy. They invested their vision of sublime awe and terror with the theatrical and coloristic qualities of Baroque painting, broadening their subject matter to include Gothic and the Near East.

Meanwhile, a few artists focused on simple domestic subjects, while a small group painted landscapes in the open air at Barbizon, near Fontainebleau.

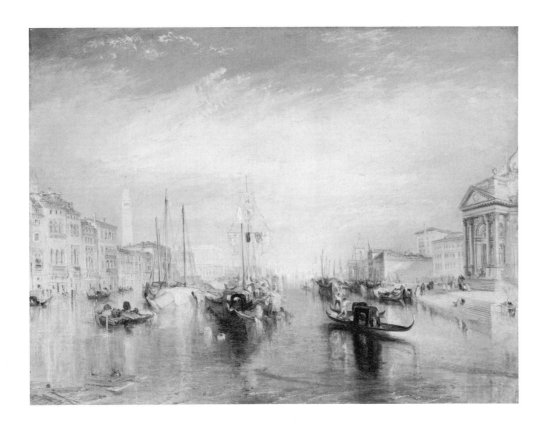

361. The Grand Canal, Venice
Joseph Mallord William Turner
English, 1775–1851
Oil on canvas
Height: 36 inches; Width: 48⅛ inches

Venice, probably more than any of the other cities that he visited on his constant travels, provided Turner with especially congenial subject matter. This painting is a view from the Grand Canal at a spot near the church of Santa Maria della Salute, which can be seen at the right, looking toward the Doge's Palace and the exit to the sea. It dates from 1835, when he was at the height of his powers, and is a splendid expression of his ability to render solid architectural forms in firmly constructed compositions, all bathed in shimmering light and pearly atmospheric glow. The Museum also owns a pencil drawing of the scene, one of the preparatory sketches he customarily made from scenes that he was later to work up in the studio into finished pictures.

Finberg, A. J., *The Life of J. M. W. Turner, R.A.* Oxford, 1961, p. 499.

99.31 The Metropolitan Museum of Art, Bequest of Cornelius Vanderbilt, 1899.

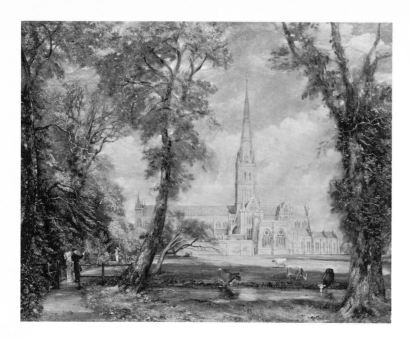

362. Salisbury Cathedral from the Bishop's Garden
John Constable
English, 1776–1837
Oil on canvas
Height: 34⅝ inches; Width: 44 inches

Constable was a friend of the Archdeacon of Salisbury, John Fisher, whose uncle was bishop of the diocese, and recorded many times between 1820 and 1830 the aspect of the great Gothic cathedral that presented itself to an observer standing in the bishop's garden. Beside three sketches and a drawing, there are at least five paintings, all but one of them about the same size as the Museum's. These pictures are very similar in composition, though ours and the one in the Frick Collection differ from all the others in showing at the top of the picture above the spire an area of sky not enclosed by arching trees.

Steegman, J., "Constable's Salisbury Cathedral from the Bishop's Garden." *The Art Quarterly*, Vol. XIV, 1951, pp. 195–205.

50.145.8 The Metropolitan Museum of Art, Bequest of Mary Stillman Harkness, 1950.

363. Study of a Nude Man
Jean-Louis-André-Théodore Géricault
French, 1791–1824
Oil on canvas
Height: 31¾ inches; Width: 25¼ inches

The making of studies from living models was a current practice in the ateliers of the early nineteenth century. This one by Géricault is just as precisely drawn as the usual studies by his contemporaries, but has a power and a muscular force not often found in them, which gave direction to many later artists.

Sterling, C., and Salinger, M. M., *French Paintings.* A Catalogue of the Collection of The Metropolitan Museum of Art, Vol. II, New York, 1966, p. 20.

52.71 The Metropolitan Museum of Art, Rogers Fund, 1952.

364. The Abduction of Rebecca
Ferdinand-Victor-Eugène Delacroix
French, 1798–1863
Oil on canvas
Height: 39½ inches; Width: 32¼ inches
Signed and dated (lower right): Eug. Delacroix/1846

In spite of his frequent reversion to a realism so intense that it anticipates Courbet, Delacroix is generally regarded as the chief of the Romantic painters. The intense color, the violent movement animating each section of the unified composition, the very source of its subject matter in Sir Walter Scott's romance, *Ivanhoe*, make this picture a brilliant and typical example of the Romantic movement in painting.

Sterling, C., and Salinger, M. M., *French Paintings*. A Catalogue of the Collection of The Metropolitan Museum of Art, Vol. II, New York, 1966, pp. 24 ff.

03.30 The Metropolitan Museum of Art, Catharine Lorillard Wolfe Fund, 1903.

365. A Woman Reading
Jean-Baptiste-Camille Corot
French, 1796–1875
Oil on canvas
Height: 21⅜ inches; Width: 14¾ inches
Signed (lower left): COROT

Corot's traditional popularity was based on the silvery sentimental landscapes, especially the late ones, which were often by imitators and followers, but all through his life his figure pieces reveal the true depth of his artistic mentality. This is a late example of these lyrical and brooding paintings of young women and one of the few that Corot exhibited at the Paris Salon.

Sterling, C., and Salinger, M. M., *French Paintings*. A Catalogue of the Collection of The Metropolitan Museum of Art, Vol. II, New York, 1966, pp. 63 ff.

28.90 The Metropolitan Museum of Art, Gift of Louise Senff Cameron, in memory of Charles H. Senff, 1928.

366. Fur Traders Descending the Missouri

George Caleb Bingham

American, 1811–1879

Oil on canvas

Height: 29 inches; Width: 36½ inches

On the evening of December 19, 1845, at a lottery conducted by
the American Art-Union, the president of the union, William
Cullen Bryant, noted: "We see a numerous generation of painters
rising up around us, in every part of the country. . . . We have
painters beyond the Mississippi; some of their works, which any
of us might be glad to possess, will be distributed this evening.
The canvas is stretched and the pencil dipped amid the solitude
of the prairies." Bingham's painting of the *Fur Traders Descending
the Missouri,* acquired by the American Art-Union directly from
the artist for a sum of seventy-five dollars, was one of the works
in that evening's lottery. A unique document of river life in
the Midwest, *Fur Traders Descending the Missouri* is also one of the
masterpieces of American genre painting. The work reveals
Bingham's strong classical feeling for form and composition and
a concern with atmospheric effects and qualities of light that
demonstrates an affinity with his luminist contemporaries.

Gardner, A. T., and Feld, S. P., *American Paintings.* A Catalogue of
The Metropolitan Museum of Art, Vol. I, New York, 1965,
pp. 251–52.

33.61 The Metropolitan Museum of Art, Morris K. Jesup Fund,
1933.

367. Young Ladies from the Village (Les Demoiselles de Village)

Jean-Désiré-Gustave Courbet

French, 1819–1877

Oil on canvas

Height: 76¾ inches; Width: 102¾ inches

Signed (lower left): G. Courbet

The three graceful figures are Courbet's sisters, and the setting is
a composite of scenes around his native Ornans in the Franche-
Comté. The cliff in the background, which is known as the Roche
de Dix Heures, appears in many pictures by Courbet. He asserted
that in painting this realistic work he had made a deliberate
attempt to be acceptable and attractive; the critics nevertheless
continued treating him with harshness and ridicule.

Sterling, C., and Salinger, M. M., *French Paintings.* A Catalogue of
the Collection of The Metropolitan Museum of Art, Vol. II,
New York, 1966, pp. 106 ff.

40.175 The Metropolitan Museum of Art, Gift of Harry Payne
Bingham, 1940.

368. Peace and Plenty

George Inness
American, 1825–1894
Oil on canvas
Height: 77⅝ inches; Width: 112⅜ inches
Signed and dated (at lower left): Geo. Inness 1865

Peace and Plenty was completed by George Inness in 1865, the year that saw the end of the Civil War. The painting remained unsold and eventually served as partial payment for a house in Eagleswood, New Jersey, for the artist and his family.

The vast idyllic landscape, showing the Charles River near Medfield, Massachusetts, reveals traces of the Hudson River style that characterized Inness' early works. The broad handling of pigment, however, reveals the influence of contemporary French painting and the artist's contact with the works of the Barbizon School during his European travels in the 1850's.

Ireland, L., *The Works of George Inness, An Illustrated Catalogue.* Austin, Texas, and London, 1965, p. xx, pp. 78–79.

94.27 The Metropolitan Museum of Art, Gift of George A. Hearn, 1894.

369. The Gulf Stream

Winslow Homer
American, 1836–1910
Oil on canvas
Height: 28⅛ inches; Width: 49⅛ inches
Signed and dated (at lower left): HOMER/1899

The Gulf Stream was based on watercolor studies Homer made during his trips to the West Indies. It is one of his most powerful works and demonstrates his accomplishments as a colorist. It was exhibited at the National Academy of Design in 1906 and acquired by the Museum on the recommendation of the Academy's. jury. Numerous inquiries about its subject provoked a characteristic response from Homer: "I regret very much that I painted a picture that requires any description . . . The subject . . . is comprised in *its title* . . . I have crossed the Gulf Stream *ten* times and I should know something about it."

Goodrich, L., *Winslow Homer.* New York, 1944, pp. 90, 161–62, 186, 187.

06.1234 The Metropolitan Museum of Art, Catharine Lorillard Wolfe Fund, 1906.

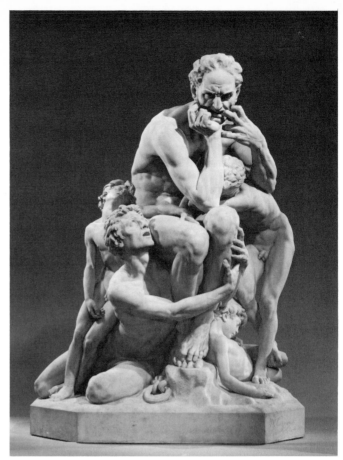

370. Salome
Henri-Georges-Alexandre Regnault
French, 1843–1871
Oil on canvas
Height: 63 inches; Width: 40½ inches
Signed and dated (at left center): *HRegnault/Rome 1870*

This painting began as a study of the head of a young
Italian peasant. The artist enlarged it first to a bust length
and then, with added canvas, to a full figure. The brightly
colored painting of this girl, to whom the artist tried to
give a "caressing ferocity" and a "panther" quality, was
a dazzling success when it was shown at the Salon of 1870.
The admirers of official art, who found the works of
Manet and Monet at best ludicrous and at worst offensively
immoral, were able to admire its solid craftsmanship and
to understand its direct statement and liveliness.

Sterling, C., and Salinger, M. M., *French Paintings*. A
Catalogue of the Collection of The Metropolitan Museum
of Art, Vol. II, New York, 1966, pp. 201 ff.

16.95 The Metropolitan Museum of Art, Gift of George F.
Baker, 1916.

371. Ugolino and His Sons
Jean-Baptiste Carpeaux
French, 1827–1875
Saint Béat marble
Height: 77 inches; Width: 57 inches; Diameter: 37¼ inches
Executed in 1865–1867

The subject of this intensely Romantic work is derived from Canto XXXIII
of the *Divine Comedy* in which Dante describes how the Pisan traitor,
Count Ugolini de' Gherardeschi, together with his sons and grandsons,
was imprisoned in 1288 and died of starvation. Carpeaux's visionary
statue reflects his passionate reverence for Michelangelo, specifically for
the *Last Judgment* of the Sistine Chapel in Rome, as well as his own
painstaking concern with anatomical realism. It was realized in plaster
during the year 1860, Carpeaux's last year in residence at the French
Academy in Rome. The marble was completed in time for the Universal
Exposition at Paris in 1867.

Raggio, O., "The Metropolitan Museum Marbles." *Art News,* Vol. LXVII,
1968, No. IV, pp. 45 ff.

67.250 The Metropolitan Museum of Art, Funds given by the Josephine
Bay Paul and C. Michael Paul Foundation, Inc., and the Charles Ulrick
and Josephine Bay Foundation, Inc., and the Fletcher Fund, 1967.

Impressionism

The Impressionists were so labeled at the time of their first group showing in 1874. Impressionist technique involved a mosaic of juxtaposed patches of color applied at maximum intensity. By focusing attention on the surface of the canvas the Impressionists broke away from the Renaissance perspective that had governed European art since the fifteenth century.

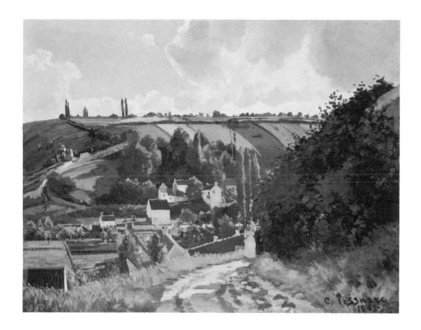

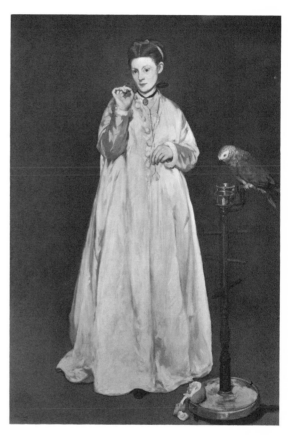

372. Jallais Hill, Pontoise (La Côte du Jallais, Pontoise)
Camille Pissarro
French, 1830–1903
Oil on canvas
Height: 34¼ inches; Width: 45¼ inches
Signed and dated (at lower right): *C. Pissarro/1867*

Although Pissarro became one of the most loyal and devoted members of the Impressionist group, when he painted this picture in 1867 he had not yet adopted their way of painting. There are echoes in it of Corot and Courbet, but the fresh bright color with its contrasts of light and shadow are characteristic of Pissarro's most successful pictures.

Sterling, C., and Salinger, M. M., *French Paintings.* A Catalogue of the Collection of The Metropolitan Museum of Art, Vol. III, New York, 1967, pp. 15 ff.

51.30.2 The Metropolitan Museum of Art, Bequest of William Church Osborn, 1951.

373. Woman with a Parrot
Édouard Manet
French, 1832–1883
Oil on canvas
Height: 72⅞ inches; Width: 50⅝ inches
Signed (lower left): Manet

Manet created a special sort of picture in which an elegant single motif like this is treated with the effect of credibility that belongs to genre, and this original approach to subject matter is perhaps his major contribution to Impressionism. It is typical of the overheated criticism of his day that even this attractive painting was violently attacked by contemporary writers when it was shown at the Salon.

Sterling, C., and Salinger, M. M., *French Paintings.* A Catalogue of the Collection of The Metropolitan Museum of Art, Vol. III, New York, 1967, pp. 40 ff.

89.21.3 The Metropolitan Museum of Art, Gift of Erwin Davis, 1889.

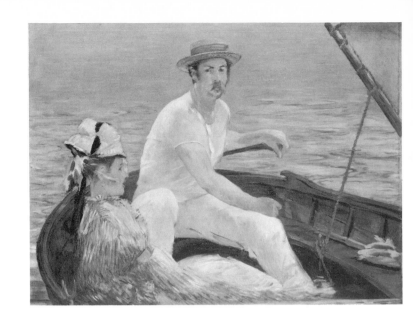

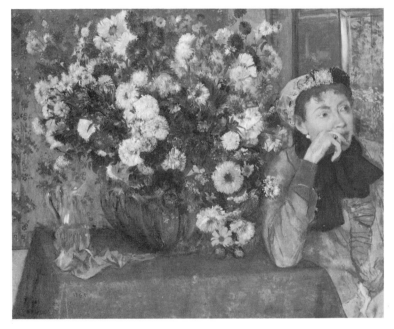

374. Boating
Édouard Manet
French, 1832–1883
Oil on canvas
Height: 38¼ inches; Width: 51¼ inches
Signed (lower right): Manet

Until 1874 when he painted this picture, Manet had not approached subject matter in the Impressionist way nor subscribed to the idea of painting out-of-doors, directly before the subject as Monet did. In the summer of that year, however, he and Renoir worked with Monet at Argenteuil, and this is one of the pictures that show him adopting Monet's working method. The abrupt cutting of forms at the edges of the picture reflects Manet's interest in Japanese prints.

Sterling, C., and Salinger, M. M., *French Paintings.* A Catalogue of the Collection of The Metropolitan Museum of Art, Vol. III, 1967, pp. 45 ff.

29.100.115 The Metropolitan Museum of Art, The H. O. Havemeyer Collection, Bequest of Mrs. H. O. Havemeyer, 1929.

375. A Woman with Chrysanthemums
Hilaire-Germain-Edgar Degas
French, 1834–1917
Oil on canvas
Height: 29 inches; Width: 36½ inches
Signed and dated (lower left): 1865/Degas

It is clear that Degas has made a penetrating study of the qualities of the unknown woman in this painting, and the strong impression that he gives of her personality and mood is deepened rather than lessened by the restricted space allotted her at the side of the composition. The atmosphere in Degas's portraits is always complex and puzzling and always interesting.

Sterling, C., and Salinger, M. M., *French Paintings,* A Catalogue of the Collection of The Metropolitan Museum of Art, Vol. III, New York, 1967, pp. 57 ff.

29.100.128 The Metropolitan Museum of Art, The H. O. Havemeyer Collection, Bequest of Mrs. H. O. Havemeyer, 1929.

376. Dancers Practicing at the Bar
Hilaire-Germain-Edgar Degas
French, 1834–1917
Oil colors freely mixed with turpentine on canvas
Height: 29¾ inches; Width: 32 inches
Signed (at left center): *Degas*

Degas's interest in the problems of expressing movement, especially the movement of the muscles of the human body, led him to make countless studies of dancers at work and in their well-earned periods of relaxation. None of these is so simplified and so concentrated as this famous picture, which belonged to the artist's friend, Henri Rouart. The diagonal lines of the flooring, the baseboard, and the bar make an abstract pattern in the hollow space of the practice room and serve as a cold impersonal foil for the controlled vitality of the two small disciplined figures.

Sterling, C., and Salinger, M. M., *French Paintings.* A Catalogue of The Metropolitan Museum of Art, Vol. III, New York, 1967, pp. 78 ff.

29.100.34 The Metropolitan Museum of Art, The H. O. Havemeyer Collection. Bequest of Mrs. H. O. Havemeyer, 1929.

377. Arrangement in Flesh Colour and Black: Portrait of Theodore Duret
James Abbott McNeill Whistler
American, 1834–1903
Oil on canvas
Height: 76⅛ inches; Width: 35¾ inches
Signed (at right center): with butterfly monogram

James Abbott McNeill Whistler, one of America's most illustrious expatriate artists, painted this picture about 1883. Like his celebrated portraits of his mother and of Thomas Carlyle, this painting is striking and demonstrates Whistler's use of portraiture as a vehicle for the investigation of formal problems of design and color. Duret was a well-known French author, art critic, Orientalist and one of Whistler's biographers. Whistler's interest in Japanese prints and the paintings of Velásquez and Courbet shaped his artistic development. A restricted palette, subtle tonalities and color effects, and the reduction of content to essential forms characterizes the style, which made Whistler one of the most avant-garde and controversial painters of the nineteenth century.

Duret, T., *Whistler.* trans. by F. Rutter, London and Philadelphia, 1917, pp. 10–11, 68–72.

13.20 The Metropolitan Museum of Art, Catharine Lorillard Wolfe Fund, 1913.

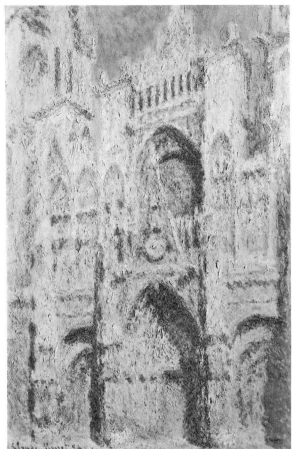

378. Terrace at Sainte-Adresse
Claude-Oscar Monet
French, 1840–1926
Oil on canvas
Height: 38⅝ inches; Width: 51⅛ inches
Signed (lower right): Claude Monet

A prime mover among the artists who came to be known as Impressionists, Monet worked always out-of-doors before his subject and developed a daring technique for the representation of light and color. This convincingly natural scene is an early work combining smooth traditionally rendered areas with sparkling passages of rapid separate brushwork and spots of pure color.

Salinger, M. M., "Windows Open to Nature," *The Metropolitan Museum of Art Bulletin,* n.s., Vol. XXVII (Summer, 1968), pp. 1–4.

67.241 The Metropolitan Museum of Art, Purchased with special contributions and purchase funds given or bequeathed by friends of the Museum, 1967.

379. Rouen Cathedral
Claude-Oscar Monet
French, 1840–1926
Oil on canvas
Height: 39¼ inches; Width: 25⅞ inches
Signed and dated (at lower left): *Claude Monet* 94

In the 1890's, after a quarter of a century of experimentation with effects of color and light, Monet worked intensively on his series of paintings—minute examinations of the same subjects under different conditions of atmosphere and light at varying times of the year and even at different hours of the day. The many cathedral paintings are the most important of these studies in series; they were made from a room on the second floor of a building opposite the facade of the great Gothic church and then reworked from memory at Giverny.

Sterling, C., and Salinger, M. M., *French Paintings.* A Catalogue of the Collection of the Metropolitan Museum of Art, Vol. III, New York, 1967, pp. 138 ff.

30.95.250 The Metropolitan Museum of Art, The Theodore M. Davis Collection, Bequest of Theodore M. Davis, 1915.

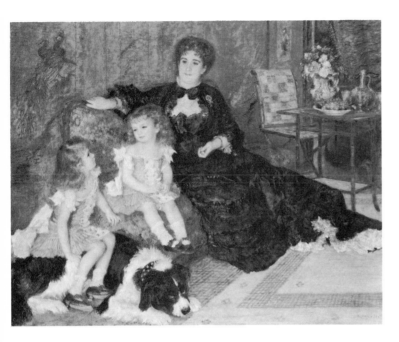

380. Madame Charpentier and Her Children

Pierre-Auguste Renoir
French, 1841–1919
Oil on canvas
Height: 60½ inches; Width: 74⅞ inches
Signed and dated (lower right): Renoir. 78

The pretty children, the indulgent dog, and the amiable grace and serenity of
Madame Charpentier in her opulent setting and her black gown by Worth make
this fine painting agreeable and popular. It brought Renoir luck, after years of
courageous struggle, for with this patroness his success was assured.

Sterling, C., and Salinger, M. M., *French Paintings.* A Catalogue of the Collection
of The Metropolitan Museum of Art, Vol. III, New York, 1967, pp. 149 ff.

07.122 The Metropolitan Museum of Art, Catharine Lorillard Wolfe Fund,
1907.

381. Portrait of Edmond Duranty

Hilaire-Germain-Edgar Degas
French, 1834–1917
Charcoal, heightened with white chalk, on blue paper
Height: 12⅛ inches; Width: 18⅝ inches

A somewhat forgotten naturalistic novelist, Edmond Duranty
knew all the members of the Impressionist circle, but he seems
to have been particularly close to Degas. Duranty sought the
subjects of his novels in everyday life, and he recognized in
Degas's analytical realism a pictorial counterpart to his literary
program. Degas's finished portrait of Duranty, now in the Glasgow
Art Gallery, is dated 1879. The present drawing and a study of
bookshelves alone, also in the Museum's collection, record Degas's
search for the linear structure of the picture; the solution arrived
at here satisfied the very exigent draftsman and was used with
little change in the portrait.

19.51.9a The Metropolitan Museum of Art, Rogers Fund, 1919.

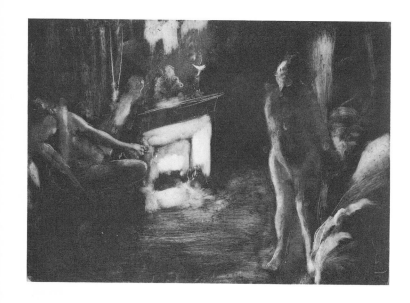

382. The Fireside (Le Foyer)
Hilaire-Germain-Edgar Degas
French, 1834–1917
Monotype; *ca.* 1880
Height: 16¼ inches; Width: 23⅛ inches

Degas started in the classical tradition, but soon found contemporary life as exciting as anything in antiquity. He strove constantly to demonstrate that the human figure in unrehearsed postures was superior to the posed models of the Academy, and that prostitutes in a brothel were as suitable for art as the heroines of fable. Unorthodox in technique as in vision, Degas showed extraordinary independence as a printmaker. *Le Foyer* is one of more than three hundred monotypes that he produced between 1870 and 1893. No other major artist has made so many monotypes or employed so much versatility and imagination in this painterly technique which, by definition, yields but one impression.

Janis, E. P., *Degas Monotypes.* Cambridge, Mass., 1968, Cat. No. 37.

68.670 The Metropolitan Museum of Art, Harris Brisbane Dick Fund, The Elisha Whittelsey Fund, and C. Douglas Dillon Gift, 1968.

Post-Impressionism

This bland term suggests the variety of directions taken by artists working in highly personal styles. Rejected by a hostile public, Post-Impressionist painters were basically interested in color theory, symbolic content and subjective expression. Cézanne's remark that he wanted "to make of Impressionism something solid and durable" suggests renewed concern with essential structures underlying reality rather than with transient appearances.

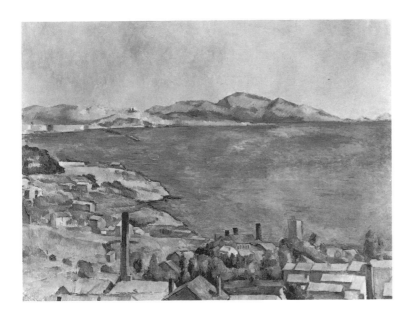

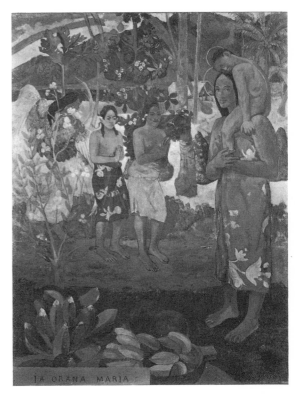

383. The Gulf of Marseilles Seen from L'Estaque
Paul Cézanne
French, 1839–1906
Oil on canvas
Height: 28¾ inches; Width: 39½ inches

For almost a decade during the seventies and eighties, Cézanne used as a motif for landscapes the expanse of blue water and the distant encircling hills that could be seen from L'Estaque, a tiny resort village on the coast slightly northwest of Marseilles. He probably painted this picture around 1883–1885. The clear rectangular form of the roofs and smokestacks massed in the foreground are a first step toward the geometrical abstractions of architecture that he was to make soon after this at Gardanne, in paintings that are now regarded as the earliest formulations of Cubism.

Sterling, C., and Salinger, M. M., *French Paintings.* A Catalogue of the Collection of The Metropolitan Museum of Art, Vol. III, New York, 1967, pp. 105 f.

29.100.67 The Metropolitan Museum of Art, The H. O. Havemeyer Collection, Bequest of Mrs. H. O. Havemeyer, 1929.

384. Ia Orana Maria
Eugène-Henri-Paul Gauguin
French, 1848–1903
Oil on canvas
Height: 44¾ inches; Width: 34½ inches
Signed and dated (lower right): P. Gauguin, 91.

The Polynesian title Gauguin gave this picture—meaning I hail thee Mary—makes it clear that it is a representation of the Christian theme of the Annunciation. Only the halos and the angel behind the flowering tree, however, coincide with the traditional west European treatment of the scene. The picture is the most impressive work painted by the artist during his first stay in Tahiti.

Sterling, C., and Salinger, M. M., *French Paintings.* A Catalogue of the Collection of the Metropolitan Museum of Art, Vol. III, New York, 1967, pp. 170 ff.

51.112.2 The Metropolitan Museum of Art, Bequest of Samuel A. Lewisohn, 1951.

385. The Arlésienne (Madame Ginoux)
Vincent van Gogh
Dutch, 1853–1890
Oil on canvas
Height: 36 inches; Width: 29 inches
Painted in 1888

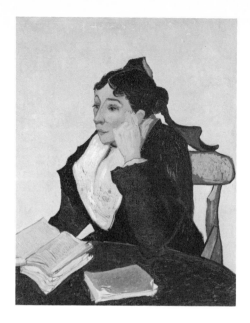

The strong color, confined in clearly separate areas, and the extreme simplification of the composition give this picture a strong poster-like and very original effect. It is extraordinary that Vincent van Gogh, who was active as a painter for little more than ten years, could manage to go from the Courbet-like realism of his early somber pictures to Impressionism and then on to a painting of such complete modernity as this.

Sterling, C., and Salinger, M. M., *French Paintings.* A Catalogue of the Collection of The Metropolitan Museum of Art, Vol. III, New York, 1967, pp. 185 ff.

51.112.3 The Metropolitan Museum of Art, Bequest of Samuel A. Lewisohn, 1951.

386. Irises
Vincent van Gogh
Dutch, 1853–1890
Oil on canvas
Height: 29 inches; Width: 36¼ inches

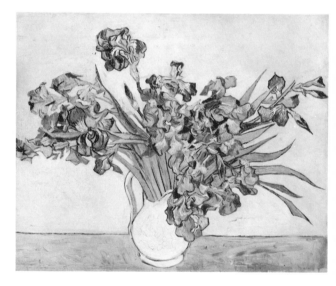

This joyous picture was painted by Vincent between attacks of madness at the end of his stay at the Hospital of Saint Rémy, a little more than two months before his death. At this time he wrote to his brother of the return of all his "lucidity for work," a functioning state of mind to which we are indebted for this eminently successful painting.

Sterling, C., and Salinger, M. M., *French Paintings.* A Catalogue of the Collection of The Metropolitan Museum of Art, Vol. III, New York, 1967, pp. 191 ff.

58.187 The Metropolitan Museum of Art, Gift of Adele R. Levy, 1958.

387. Invitation to the Side-Show (La Parade)
Georges-Pierre Seurat
French, 1859–1891
Oil on canvas
Height: 39¼ inches; Width: 59 inches

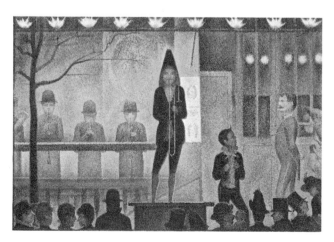

Seurat's life was unnaturally short, but in the course of it he produced a small number of major works, carefully planned and in most cases prepared for with drawings and preliminary trials. Unlike the Baignade and the Grande Jatte, this painting seems to have been made deliberately flat, and where they simulate outdoors light and sunshine, this scene is distinguished by its carefully created theatrical effect of gaslight.

Sterling, C., and Salinger, M. M., *French Paintings.* A Catalogue of the Collection of The Metropolitan Museum of Art, Vol. III, New York, 1967, pp. 197 ff.

61.101.17 The Metropolitan Museum of Art, Bequest of Stephen C. Clark, 1960.

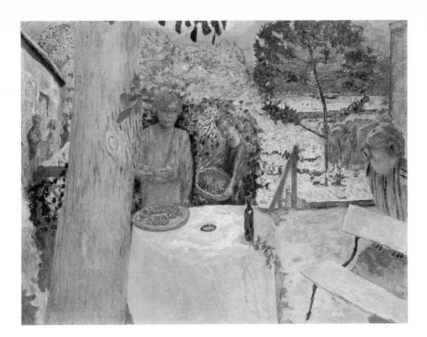

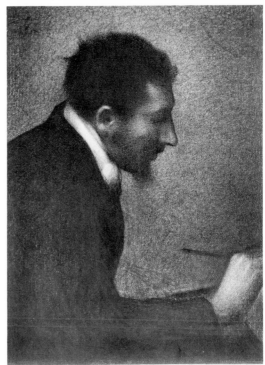

388. Terrace at Vernon
Pierre Bonnard
French, 1867–1947
Oil on canvas
Height: 56¹¹⁄₁₆ inches; Width: 76½ inches
Painted in the 1930's

As a young artist Bonnard and his close friend Edouard Vuillard
came under the influence of Gauguin's paintings and his theories
about representing things symbolically in strong patterns and colors.

Because Vuillard and Bonnard preferred to paint everyday scenes in
a quiet and gently casual style, they are often referred to as
"Intimists." Bonnard, unlike his friend, however, chose more and
more to stress pure joyous color, giving it an authority that defied
composition and form.

His painting of the terrace of his house, in the Seine Valley, reveals
his long familiarity with the outdoor scene, which he records with a
warmth and effect of seclusion usually achieved only in interiors.
With the grapes and wine on the table and the Maenad-like figure
on the right, the three figures in the foreground convey an atmosphere
of classical allegory.

Soby, J. T., Elliott, J., and Wheeler, M., *Bonnard and His Environment.*
New York, The Museum of Modern Art, 1964, pp. 82 f.

68.1 The Metropolitan Museum of Art, Gift of Mrs. Frank Jay
Gould, 1968.

389. Portrait of Edmond-François Aman-Jean
Georges-Pierre Seurat
French, 1859–1891
Conté crayon
Height: 24½ inches; Width: 18¾ inches

Signed and dated in conté crayon at upper right: Seurat 1883
(signature visible only under ultraviolet light)

A finished work rather than a preparatory study for a painting,
Seurat's masterful portrait of his artist friend Aman-Jean is his
largest and most important drawing. Seurat here exploits his medium
to the fullest, meticulously applying the conté crayon to render a
complete range of values, the gradation from velvety black through
soft, elusive grays to the white of the paper itself. That he attached
great importance to his drawings, regarding them as independent
works of art, is attested to by the fact that this drawing was the first
work that Seurat exhibited publicly, in the Salon of 1883.

De Hauke, C. M., *Seurat et son oeuvre.* Paris, 1961, Vol. II, p. 166.

61.101.16 The Metropolitan Museum of Art, Bequest of Stephen C.
Clark, 1961.

Section IX: XX Century

1903 Wright brothers' first successful flight
1905 Einstein presents his Special Theory of Relativity
1909 Ford produces first Model T's
1909 Admiral R. E. Perry reaches North Pole

1912 End of Ch'ing Dynasty; Republic of China formed
1913 Armory Show; modern art introduced in New York
1914 *Ulysses* by James Joyce published
1914–1918 World War I
1914 Panama Canal completed
1917 Bolshevik Revolution
1919 Bauhaus, school of design, founded by Gropius
1922 T. S. Eliot's *The Waste Land* published
1927 Lindbergh flies New York to Paris
1929 Stock market crash

1933 Hitler becomes Chancellor of Germany
1934 Television invented
1937 Pablo Picasso paints *Guernica*
1939–1945 World War II

1943 Sartre writes *Being and Nothingness*
1945 First atomic bomb
1945 United Nations organized
1948 Gandhi assassinated
1949 Formation of People's Republic of China under Mao Tse-tung

1953 Salk discovers polio vaccine
1957 Russians put first satellite into orbit

1963 J. F. Kennedy assassinated
1966 Flood in Florence
1968 Martin Luther King assassinated
1969 First man on moon

Europe and America

1900

1910

391. Picasso,
Spanish

1920

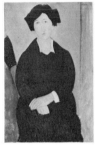

394. Modigliani,
Italian

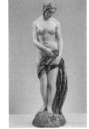

401. Maillol,
French

1930

393. Demuth,
American

1940

1950

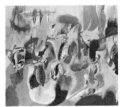

395. Gorky,
American

396. Pollock,
American (detail)

1960

397. Louis,
American

1970

Europe and the United States

Two World Wars and the Western technological revolution have effected an irreconcilable break with the humanistic traditions of the Renaissance. Cubism, in which the image was dissected into faceted planes, was formulated in Paris just before World War I, and provided the most decisive artistic rupture with the past. Dream images and abstractions often characterize the experimental and theoretical art of the twentieth century. After World War II, the Abstract Expressionists in New York established American painting for the first time as a major international influence.

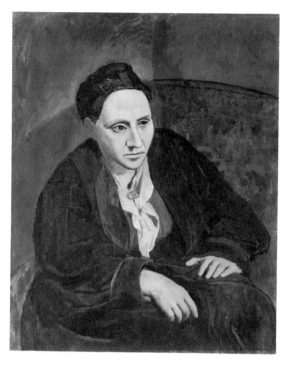

391. Gertrude Stein
Pablo Picasso
Spanish, 1881–
Oil on canvas
Height: 39⅜ inches; Width: 32 inches
Painted in 1906

Picasso's portrait of the American Gertrude Stein bridges his momentous and significant development from simplified naturalism, as in the works of his Rose Period, to the revolution declared in the *Demoiselles d'Avignon,* the painting in which this astounding artist issued a fundamental challenge to all the Western assumptions about pictorial space.

In her book *Picasso,* Gertrude Stein describes the portrait's evolution: "I posed for him all that winter (1905-1906), eighty times and in the end he painted out the head, he told me that he could not look at me any more and then left once more for Spain. It was the first time since the Blue Period and immediately upon his return from Spain he painted in the head without having seen me again and he gave me the picture and I was, and I still am, satisfied with my portrait, for me, It is I, and it is the only reproduction of me which is always I, for me." In reply to the question that Miss Stein did not seem to resemble the portrait very closely, Picasso is said to have replied: "She will."

Sterling, C., and Salinger, M. M., *French Paintings.* A Catalogue of the Collection of The Metropolitan Museum of Art, Vol. III, New York, 1967, pp. 233 ff.

47.106 The Metropolitan Museum of Art, Bequest of Gertrude Stein, 1946.

390. Veluti in Speculum
Hans Hofmann
American, 1880-1966
Oil on canvas
Height: 85¼ inches; Width: 73½ inches
Dated 1962

One of the great teachers of the century, Hofmann produced, in the last six years of his life, a body of work so energetic and exploratory, so aware of the physical and sensuous properties of oil paint, that one suspects that he, like Titian, became younger in his old age. In *Veluti in Speculum* he did not rely on linear perspective nor even on a cubist grid to control our reading of depth; only the chromatic strength and physical areas of the individual colors are used to achieve the final balance of form and color.

Geldzahler, H., *American Painting in the Twentieth Century.* New York, 1965, p. 194.

63.225 The Metropolitan Museum of Art, Gift of Mr. and Mrs. Richard Rodgers and the Francis Lathrop Fund, 1963.

393. I Saw the Figure 5 in Gold
Charles Henry Demuth
American, 1883–1935
Oil on canvas
Height: 35½ inches; Width: 30¾ inches
Dated 1928

A member of the small group of artists who frequented Alfred Stieglitz's pioneering gallery 291, Charles Demuth assimilated radical European stylistic concepts while adhering to the group's determination to create both a unique and modern American art.

The hard edges and staccato perspective of *I Saw the Figure 5 in Gold* have the impact of the best poster art, and preserve at the same time the poetic intimacy of Demuth's watercolors. The painting was dedicated to his friend, the American poet, William Carlos Williams, one of whose poems provided the title:

The Great Figure
Among the rain
and lights
I saw the figure 5
in gold
on a red
firetruck
moving
tense
unheeded
to gong clangs
siren howls
and wheels rumbling
through the dark city.

Ritchie, C. A., *Charles Demuth.* New York, 1950, p. 15.

49.59.1 The Metropolitan Museum of Art, The Alfred Stieglitz Collection, 1949.

392. The Lighthouse at Two Lights
Edward Hopper
American, 1882–1967
Oil on canvas
Height: 29½ inches; Width: 43¼ inches
Dated 1929

Edward Hopper has given meaningful continuity to the American tradition of objective painting—the matter-of-fact quality of Homer and Eakins—in the broader simplified terms of contemporary art. While the range of his subject matter is wide, Hopper's essential subject is light: the depiction of light and the definition of scene and mood by light. His paintings, whether or not they contain figures, share a common mood of isolation and loneliness.

Goodrich, L., *Edward Hopper.* New York, 1964.

62.95 The Metropolitan Museum of Art, Hugo Kastor Fund, 1962.

394. Italian Woman
Amadeo Modigliani
Italian, 1884–1920
Oil on canvas
Height: 40⅜ inches; Width: 26⅜ inches
Dated 1917

Modigliani was an Italian who had had considerable training in his own country before he moved early in 1906 to Paris, one of a host of emigrant artists who in the first decade of this century were attracted to the French capital as the major cultural center of all Europe. In Paris he made carvings in stone and wood as well as paintings, perfecting a style in which his native Italian traditions were blended with the exciting new influences of Cubism and African sculpture. In his paintings Modigliani combined the linear and the sculptural in a peculiarly personal way. Perhaps the large and placid woman whom he represented here was Rosalia, the keeper of a little Parisian restaurant where he frequently ate.

Sterling, C., and Salinger, M. M., *French Paintings*. A Catalogue of the Collection of The Metropolitan Museum of Art, Vol. III, New York, 1967, pp. 241 ff.

56.4 The Metropolitan Museum of Art, Gift of the Chester Dale Collection, 1956.

395. Water of the Flowery Mill
Arshile Gorky
American, 1904–1948
Oil on canvas
Height: 42½ inches; Width: 48¾ inches
Dated 1944

Gorky, who came to the United States in 1920, is a key figure in the understanding of the origins of Abstract Expressionist painting in America. While in his early work he shows the strong influence of Cézanne and Picasso, the automatism of the surrealists ultimately allowed him to loosen the cubist grid and let his brush flow freely over the canvas. *Water of the Flowery Mill* is an ambiguous landscape filled with biomorphic forms, brushed loosely with thin paint, in places close to watercolor. The forms and paint seem to slide gently across the surface. We see here a moment of process, not a finished picture in any traditional sense.

Seitz, W., *Arshile Gorky: Paintings, Drawings, Studies.* New York, 1962.

56.205.1 The Metropolitan Museum of Art, George A. Hearn Fund, 1956.

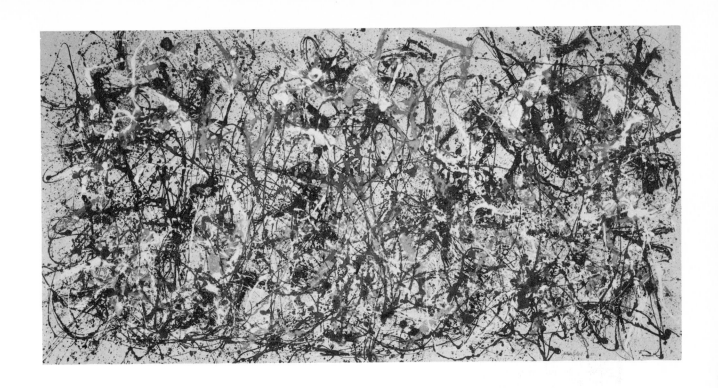

396. Autumn Rhythm
Jackson Pollock
American, 1912–1956
Oil on canvas
Height: 105 inches; Width: 207 inches
Dated 1950

Having abandoned the specific image, Pollock produced in his bold technique of dripped paint the most original and influential paintings ever done by an American. As in so many of his large paintings of the late forties and fifties, there is a choreographic quality to *Autumn Rhythm* with the slow movement of the paint across the surface. In the period since it was painted, the picture has changed for many viewers from the arbitrary to the inevitable, from what seemed like a diatribe against art to an elegant statement about the possibilities of art.

O'Conner, F. V., *Jackson Pollock.* New York, 1967.

57.92 The Metropolitan Museum of Art, George A. Hearn Fund, 1957.

397. Beth Chet
Morris Louis
American, 1912–1962
Acrylic on canvas
Height: 92 inches; Width: 137 inches
Dated 1958

The monumental symmetry of Morris Louis's form in his "veil" paintings is achieved by his rigid control of the paint thinned to the consistency of watercolor and stained directly into unsized cotton duck laid out flat on the floor. Except for a marginal "halo" at the top of the picture, the initial layer of diluted acrylic paint of brilliant hues is virtually obscured by the successive layer of secondary colors absorbed by the canvas itself. The single field thus created has the transparent luminosity and the palpable density of an atmospheric condition.

Fried, M., *Morris Louis: 1912–1962*. Boston, 1967.

69.276 The Metropolitan Museum of Art, Gift of Mrs. Abner Brenner, 1969.

398. Portrait of Ambroise Vollard

Pablo Picasso

Spanish, 1881–

Lead pencil

Height: 18⅜ inches; Width: 12⁹⁄₁₆ inches

In 1915, the date of this drawing, Picasso turned from his cubist style and began to experiment with the possibilities of a naturalistic linear style that was to lead to his classical period. He executed portraits of many of his friends, Apollinaire, Stravinsky, Diaghilev, Max Jacob, and André Breton, this drawing being one of the earliest and most impressive of the series. The authority of his line and the careful attention to detail hark back to Ingres, revealing Picasso as a triumphant master of "traditional" draftsmanship.

Zervos, C., *Pablo Picasso.* Vol. II, Pt. 2: *Oeuvres de 1912 à 1917.* Paris, 1942, No. 922, p. 384.

47.140 The Metropolitan Museum of Art, The Elisha Whittelsey Collection, 1947.

399. Nude Woman

Pablo Picasso

Spanish, 1881–

Charcoal

Height: 19¹⁄₁₆ inches; Width: 12⁵⁄₁₆ inches

This brilliant cubist drawing, which dates from 1910, was shown in what seems to have been the first exhibition of Picasso's work in the country, held at Alfred Stieglitz' Photo-Secession Gallery in 1911. It also figured in the celebrated New York Armory Show in 1913. Alfred Barr has said of the drawing that "the effect might be compared to a geometrized anatomical chart in which transparent cross sections of the body are superimposed on the silhouette."

Zervos, C., *Pablo Picasso.* Vol. II, Pt. 1: *Oeuvres de 1906 à 1912.* Paris, 1942, No. 208, p. 103.

49.70.34 The Metropolitan Museum of Art, The Alfred Stieglitz Collection, 1949.

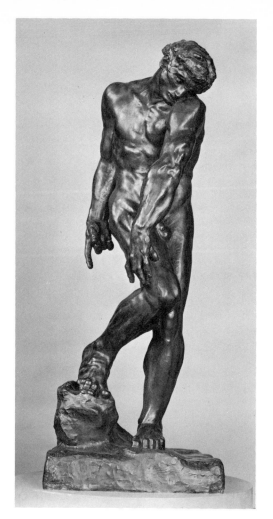

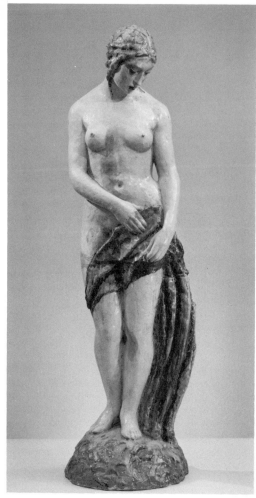

400. Adam (The Creation of Man)
Auguste Rodin
French, 1840–1917
Bronze
Height: 76¼ inches; Width: 29½ inches; Depth: 29½ inches
First modeled *ca.* 1880–1881, executed in 1910

Physical anguish, as the expression of deep and insoluble inner torment, marks this bronze as one of the sculptures associated with Rodin's Gates of Hell. With the pendant Eve, it was designed originally to flank the monumental Gates which were commissioned in August, 1880, by the French Government for the Musée des Arts Décoratifs in Paris, but still unfinished at the sculptor's death. Like Carpeaux, Rodin drew upon Michelangelo's Sistine Chapel frescoes as a direct source of inspiration, combining, in his Adam, recognizable elements of the Creation of Man and the Expulsion from Paradise as well as from the Christ of the *Pietà* in the Duomo at Florence. The original plaster model now at the Musée Rodin in Paris was exhibited in the Paris Salon of 1881. The Museum's bronze was commissioned from the sculptor in 1910.

Elsen, A., *Rodin.* New York, 1963, pp. 49–51, 218.

11.173.1 The Metropolitan Museum of Art, Gift of Thomas F. Ryan, 1911.

401. Summer (L'Été)
Aristide Maillol
French, 1861–1914
Bronze
Height: 63½ inches; Width: 28 inches; Depth: 18 inches
First modeled in 1910/1911

A generation younger than Rodin, Maillol remained totally independent of that powerful personality. Solid yet graceful, self-contained yet sensuous, Maillol's *Summer* is one of the Four Seasons, commissioned in 1910 by the Russian collector, Ivan Morosoff. The others, *Pomona, Spring,* and *Flora* are now in the Pushkin State Museum of Fine Arts in Moscow. Often it has been suggested that Greek sculpture of the early fifth century provided the model of strength, simplicity, and balance that characterizes Maillol's work. It is, however, an affinity of structure rather than surface, and Maillol's figures remain classic rather than classical.

George, W., *Aristide Maillol.* New York, and Greenwich, Conn., 1965, pp. 158–59, 221.

67.187.46 The Metropolitan Museum of Art, Bequest of Adelaide Milton de Groot, 1967.

402. Sleeping Muse
Constantin Brancusi
Rumanian, 1876–1957
Bronze
Height: 6¾ inches; Width: 9½ inches
Dated 1910

Sleeping Muse is a culmination of Brancusi's early treatment of the
bust portrait and a premonition of his later simplification of observed
reality. While still a recognizable head, it also has as valid an
existence as just a bronze oval. This effect is heightened by the closing
of the eyes, erasing the face's individuality and suggesting the
condition of sleep.

This bronze is one of four cast in 1910. Brancusi worked the surfaces
of each individually, exploring the potential of the form and subject.
Four years later he created a second version of the bronze *Sleeping
Muse,* further reducing the recognizable features and polishing it to
a reflective finish which mirrored the viewer's own features.

Geist, S., *Brancusi: A Study of the Sculpture.* New York, 1968.

49.70.225 The Metropolitan Museum of Art, The Alfred Stieglitz
Collection, 1949.

List of Lenders

Lion Demon
Ancient Near East,
Proto-Elamite, *ca.* 3000 B.C.
Magnesite or crystalline limestone
Max. height: 3⁵⁄₁₆ inches;
Max. width at elbows: 2⁷⁄₁₆ inches;
Diameter of waist: ¹⁵⁄₁₆ inch
Guennol Collection

Cup from Ur
Ancient Near East,
Sumerian, *ca.* 2500 B.C.
Hammered gold
Height: 5⅝ inches;
Diameter of rim: 3¾ inches;
Diameter base: 1⅝ inches
The University Museum, Philadelphia

Large Pottery Vase
Chinese, Prehistoric, *ca.* 2200 B.C.
Earthenware
Height: 17 inches
Mr. and Mrs. John D. Rockefeller, 3rd

Epaulette from Ziwiyeh
Ancient Near East,
Iranian, *ca.* VII century B.C.
Gold
Length: 8⅞ inches
The Pomerance Collection

Rhyton with the Figure of a Ram
Ancient Near East,
Achaemenian, *ca.* mid V century B.C.
Silver
Height: 8¼ inches
Norbert Schimmel Collection

Plate with King Hunting on Camel
Ancient Near East,
Sasanian, *ca.* V century A.D.
Silver, mercury gilding
Diameter: 7⅞ inches
Guennol Collection

Plate with a King Hunting a Lion and Boar
Ancient Near East,
Sasanian, *ca.* V-VI century A.D.
Silver, mercury gilding
Diameter: 7¾ inches; Height: 1¹¹⁄₁₆ inches
Mr. Christos G. Bastis

Drvaspa Rhyton
Ancient Near East,
Soghdian, V-VI century A.D.
Silver, repoussé and engraved, partially gilt
Height: 9⅛ inches; Width: 4½ inches;
Depth: 6⅜ inches
The Cleveland Museum of Art,
Leonard C. Hanna, Jr., Bequest

Stela
Mayan, A.D. 680
Limestone, traces of paint
Height: 8 feet;
Width: 42 inches; Depth: 2 inches
Government of Guatemala

Streams and Hills under Fresh Snow
Kao K'o-ming, active first half of XI century
Chinese, Northern Sung Dynasty
Handscroll, ink and color on silk
Length: 7 feet, 11 inches;
Height: 16⅛ inches
Signature and date corresponding to 1035
Mr. John M. Crawford, Jr.

Finches and Bamboo
Hui-tsung (Sung Dynasty emperor,
ruled 1101-1126), 1082-1135
Chinese, Northern Sung Dynasty
Cipher of the Emperor (with colophon by
Chao Meng-fu, 1254-1322,
the noted scholar, official, and artist)
Handscroll, ink and color on silk
Length: 18 inches; Width: 11 inches
Mr. John M. Crawford, Jr.

Royal Couple
Cambodian, Khmer, Bayon Style,
late XII-XIII century
Sandstone
Height of male: 54 inches:
Height of female: 55 inches
Mr. and Mrs. John D. Rockefeller, 3rd

Halberdier
Jacopo da Pontormo
Italian, 1494-1557
Oil on canvas
Height: 37¼ inches; Width: 28½ inches
Painted *ca.* 1520
Mr. Chauncey Stillman

Fisherman's Flute Heard over the Lake
Ch'iu Ying, *ca.* 1510-1551
Chinese, Ming Dynasty
Hanging scroll, ink and slight color on paper
Height: 5 feet, 2⅞ inches;
Width: 2 feet, 9⅛ inches
Signature and two seals of the artist
Mr. John M. Crawford, Jr.

Fish and Rocks
Chu Ta, *ca.* 1625-*ca.* 1700
Chinese, Ch'ing Dynasty
Hanging scroll, ink on paper
Height: 4 feet, 5 inches;
Width: 1 foot, 11⅞ inches
Signature and inscription of the artist
Mr. John M. Crawford, Jr.

The Annunciation
Luca Giordano
Italian, 1632-1705
Oil on canvas
Height: 92 inches; Width: 66¼ inches
Signed and dated (lower right):
L. Jordanus F. 1672
Mr. and Mrs. Charles B. Wrightsman

Landscape
Tai-Chi (Shih Tao) 1641-*ca.* 1717
Chinese, Ch'ing Dynasty
Album of eight leaves, ink and color on paper
Height: 6 inches; Width: 10½ inches
Inscription and seal of the artist
Mr. John M. Crawford, Jr.

Fly Whisk Handle
Tahiti, probably late XVIII century
Whale ivory, sennit cord, wood
Height: 12⁵⁄₁₆ inches
Mr. and Mrs. Raymond Wielgus

Drum (Pahu-ra)
Austral Islands, Raivavae, after 1775
Wood, sennit cord, sharkskin
Height: 54 inches
Mr. and Mrs. Raymond Wielgus

Bibliography

The bibliographical references accompanying the individual entries in this catalogue are in no way intended to be comprehensive. They are to serve only as a starting point for further research on the particular works of art cited.

For those interested in pursuing questions of a more general nature, a selected bibliography of sources providing an introduction to the study of art history and art criticism follows. This in turn is followed by a listing of Metropolitan Museum of Art Publications.

A Selected Bibliography for an Introduction to the Study of Art History and of Art Criticism

* (Denotes available in paperback.)

ART HISTORY

Ackerman, James S., and Carpenter, Rhys, *Art and Archeology*. New York, Prentice Hall, 1963.

* Gombrich, Ernest H., *The Story of Art*. New York, Phaidon Publishers, 1954.

* Hind, Arthur M., *A History of Engraving and Etching*. Boston, Houghton Mifflin, 1927.

* _____, *An Introduction to a History of Woodcut*. London, Constable and Co., Ltd., 1935.

* Holt, Elizabeth G., *A Documentary History of Art*. 3 vols. Garden City, N.Y., Anchor Books, Doubleday, 1957–1966.

Janson, H. W., *History of Art, A Survey of the Major Visual Arts from the Dawn of History to the Present Day*. New York, Harry N. Abrams, Inc., 1962.

Lee, Sherman E., *History of Far Eastern Art*. New York, Harry N. Abrams, Inc., 1964.

* Pevsner, Nikolaus, *An Outline of European Architecture*. Baltimore, Pelican Books, 1968.

* Rowland, Benjamin, *Art in East and West, An Introduction Through Comparison*. Cambridge, Mass., Harvard University Press, 1954.

Continuing series of books dealing with various periods in the history of art

Art of the World. New York, Crown Publishers, Inc.

* The Great Ages of World Architecture. New York, George Braziller.

Pevsner, Nikolaus, ed., The Pelican History of Art. Baltimore, Penguin Books.

* Piggot, Stuart, ed., The Library of Early Civilization. New York, McGraw-Hill Book Company.

* Praeger World of Art Series. New York, Frederick A. Praeger, Publishers.

* The Taste of Our Times. Geneva, Switzerland, Skira Art Paperbacks, Editions d'Art Albert Skira.

Time-Life Library of Art. New York, Time Incorporated.

ART CRITICISM

* Collingwood, Robin G., *Principles of Art*. Oxford, Clarendon Press, 1964.

* Focillon, Henri, *The Life of Forms in Art*. New York, Geo. Wittenborn, Inc., 1957.

* Friedlander, Max J., *Art and Connoisseurship*. London, B. Cassirer, 1942.

* Gombrich, Ernest H., *Art and Illusion*. New York, Pantheon Books, 1960.

* Greenberg, Clement, *Art and Culture*. Boston, Beacon Press, 1961.

* Hauser, Arnold, *The Social History of Art*. 2 vols. New York, Alfred A. Knopf, Inc., 1951.

* _____, *The Philosophy of Art History*. New York, The World Publishing Company, 1965.

* Panofsky, Erwin, *Meaning in the Visual Arts*. Garden City, N.Y., Anchor Books, 1955.

* Read, Herbert, *Art and Society*. London, Faber and Faber, 1950.

* Wöfflin, Heinrich, *The Principles of Art History*. New York, Dover Publication, Inc., 1950.

Further titles may be found in:

* Chamberlain, Mary W., *Guide to Art Reference Books*. Chicago, American Library Association, 1959.

* Lucas, E. Louise, *Art Books, A Basic Bibliography on Fine Arts*. Greenwich, Conn., New York Graphic Society Art Library, 1968.

A Selected Bibliography from The Metropolitan Museum of Art Publications

AMERICAN ART

American Paintings (The Metropolitan Museum of Art Guide to the Collections). 1962.

The American Wing (The Metropolitan Museum of Art Guide to the Collections). 1961.

Andrus, Vincent D., *Early American Silver*. 1955.

Avery, C. Louise, *American Silver of the XVII and XVIII Centures: a Study Based on the Clearwater Collection*. 1920.

Burroughs, Bryson, *Paintings of the Hudson River School* (The Bulletin of the Metropolitan Museum of Art Supplement). October, 1917.

Burroughs, Louise, *Winslow Homer*. 1939.

Cornelius, Charles O., *Furniture Masterpieces of Duncan Phyfe*. 1922.

Cowdrey, Mary Bartlett, and Williams, Hermann, *William Sidney Mount: An American Painter*. 1944.

Davidson, Marshall B., *Early American Glass*. 1940.

Downs, Joseph, *A Handbook of the Pennsylvania German Galleries in the American Wing*. 1934.

_____, *American Chippendale Furniture*. 1940.

_____, *American Pewterers and Their Marks*. 1940 (reprinted by Cracker Barrel Press, Southampton, N.Y., 1968.

_____, *The American Wing*. 1955.

Gardner, Albert T., *Yankee Stonecutters: the First American School of Sculpture, 1800–1850*. 1945.

_____, *A Concise Catalogue of the American Paintings in The Metropolitan Museum of Art*. 1957.

_____, *American Sculpture, a Catalogue of the Collection of The Metropolitan Museum of Art*. 1965.

_____, and Feld, Stuart P., *American Paintings*. Vol. I: *Painters Born by 1815*. 1965.

Halsey, R. T. H., and Cornelius, Charles O., *A Handbook of the American Wing*, 7th ed. (revised by Joseph Downs). 1942.

Kimball, Fiske, *Domestic Architecture of the American Colonies and the Early Republic*. 1922.

Levy, Florence N., *Paintings in Oil and Pastel by James A. McNeill Whistler*. 1910.

Wehle, Harry B., *American Miniatures, 1730–1850*. 1927 (reprinted by Kennedy Galleries, Inc., Da Capo Press, New York, 1970).

Exhibition Catalogues

19th Century America, Furniture and Other Decorative Arts, with an Introduction by Berry B. Tracy, and Texts by Marilynn Johnson, Marvin Schwartz, and Suzanne Boorsch. 1970.

19th Century America, Paintings and Sculpture, with an Introduction by John K. Howat and John Wilmerding, and Texts by John K. Howat, Natalie Spassky, and others. 1970.

Gardner, Albert T., *Winslow Homer: A Retrospective Exhibition.* 1959.

Smith, Hugh J., Jr., *Twentieth Century Glass, American and European.* 1950.

Sweet, Frederick A., *Sargent, Whistler, and Mary Cassatt.* 1954.

ANCIENT NEAR EASTERN ART

Crawford, V. E., Harper, P. O., Muscarella, O. W., and Bodenstein, B. E., *Ancient Near Eastern Art* (The Metropolitan Museum of Art Guide to the Collections). 1966.

Dimand, M. S., *The Second Expedition to Ctesiphon, 1931–1932* (English summary). 1933.

———— , and McAllister, H. E., *Near Eastern Jewelry.* 1944.

Hare, Susanna, and Porada, Edith, *The Great King, King of Assyria.* 1945.

ARMS AND ARMOR

Arms and Armor (The Metropolitan Museum of Art Guide to the Collections). 1962.

Bashford, Dean, *Helmets and Body Armor in Modern Warfare.* 1920.

———— , *A Crusader's Fortress in Palestine,* a report of explorations made by the Museum, 1926 (The Bulletin of the Metropolitan Museum of Art Supplement). September, 1927.

———— , *Catalogue of European Daggers Including the Ellis, de Dino, Riggs, and Reubell Collections.* 1929.

———— , *The Collection of European Court Swords and Hunting Swords of Jean Jacques Reubell.* 1929.

———— , *The Collection of European Daggers of Jean Jacques Reubell.* 1929.

Grancsay, Stephen V., *The Armor of Galiot de Genouilhac.* 1937.

———— , *Historical Arms and Armor.* 1938.

———— , *Sculpture in Arms and Armor.* 1940.

———— , *American Engraved Powder Horns,* a study based on the J. H. Grenville Gilbert Collection. 1945 (reprinted by Ray Riling Arms Book Co., Philadelphia, Pa., 1965).

———— , *Historical Armor.* 1957.

Nickel, Helmut, *Warriors and Worthies.* 1970.

CONTEMPORARY ART

The Contemporary Scene, A Symposium. Sidney Hook, James P. Warburg, Henry A. Murray, Paul J. Tillich, Hellmut Lehmann-Haupt, and Lloyd Goodrich, with Sterling A. Callisen as moderator. 1954.

Geldzahler, Henry, *American Painting in the Twentieth Century.* 1965.

Exhibition Catalogue

Geldzahler, Henry, *New York Painting and Sculpture: 1940–1970.* Published under the auspices of The Metropolitan Museum of Art by E. P. Dutton and.Co., Inc., New York, 1969.

DRAWINGS

European Drawings. Vol. I: *Italian Drawings,* a portfolio of plates. 1942.

European Drawings. Vol. II: *Flemish, Dutch, German, Spanish, French and British Drawings,* a portfolio of plates. 1943.

Bean, Jacob, *100 European Drawings in The Metropolitan Museum of Art.* 1964.

———— , and Stampfle, Felice, *Drawings from New York Collections.* Vol. I: *The Italian Renaissance.* 1965.

———— , and Stampfle, Felice, *Drawings from New York Collections.* Vol. II: *The Seventeenth Century in Italy.* 1967.

Hale, Robert B., and McKinney, Roland J., *American Water Colors, Drawings, and Prints.* 1952.

EGYPTIAN ART

Egyptian Art (The Metropolitan Museum of Art Guide to the Collections). 1962.

Davies, Norman de G., *The Tomb of Nakht at Thebes.* 1917.

———— , *The Tomb of Puyemrê at Thebes.* 2 vols. 1922 and 1923.

———— , *The Tomb of Two Sculptors at Thebes.* 1925.

———— , *Two Ramesside Tombs at Thebes.* 1927.

———— , *The Tomb of Ken-Amūn at Thebes.* 1930.

———— , *The Tomb of Nefer-Ḥotep at Thebes.* 1933.

———— , *Paintings from the Tomb of Rekh-mi-Ře at Thebes.* 1935.

———— , *The Tomb of Rekh-mi-Ře at Thebes.* 1943.

———— , *The Temple of Hibis in el Khārgeh Oasis.* Pt. III: *The Decoration.* 1953.

Fischer, Henry G., *Ancient Egyptian Representations of Turtles.* 1968.

———— , *Dendera in the Third Millenium B.C.* Published under the auspices of The Metropolitan Museum of Art by J. J. Augustin, Locust Valley, N.Y., 1968.

Hayes, William C., *Glazed Tiles from a Palace of Ramesses II at Kantīr.* 1937.

———— , *The Burial Chamber of the Treasurer Sobk-mosĕ from Er-Rizeiḳāt.* 1939.

———— , *Ostraka and Name Stones from the Tomb of Sen-mūt (No. 71) at Thebes.* 1942.

———— , *The Scepter of Egypt.* Pt. I: *From Earliest Times to the End of the Middle Kingdom.* 1955.

———— , *The Scepter of Egypt.* Pt. II: *The Hyksos Period and the New Kingdom (1675–1080 B.C.).* 1959.

Lansing, Ambrose, *Ancient Egyptian Jewelry.* 1946.

Lythgoe, Albert M., *Statues of the Goddess Sekhmet* (The Bulletin of The Metropolitan Museum of Art Supplement). October, 1919.

———— , *The Treasure of Lahun.* (The Bulletin of The Metropolitan Museum of Art Supplement). December, 1919.

———— , and Williams, Caroline R., *The Tomb of Perneb.* 1916.

Mace, Arthur C., and Winlock, Herbert E., *The Tomb of Senebtisi at Lisht.* 1916.

Phillips, Dorothy W., *Ancient Egyptian Animals.* 1942.

Scott, Nora E., *The Homelife of the Ancient Egyptians.* 1944.

———— , and Sheeler, Charles, *Egyptian Statuettes.* 1946.

———— , and Sheeler, Charles, *Egyptian Statues.* 1951.

White, Hugh G. E., *The Monasteries of the Wâd'n Natrûn.* 3 vols. 1926, 1932, and 1933.

———— , and Oliver, James H., *The Temple of Hibis in el Khārgeh Oasis.* Pt. II: *Greek Inscriptions.* 1939.

Williams, Caroline R., *The Decoration of The Tomb of Per-nēb: The Technique and The Color Conventions.* 1932.

Winlock, Herbert E., *Bas-reliefs from the Temple of Rameses I at Abydos.* 1921.

———— , *The Tomb of Queen Meryet-Amūn at Thebes.* 1932.

———— , *The Treasure of El Lāhūn.* 1934.

———— , *The Private Life of the Ancient Egyptians.* 1935.

———— , *The Temple of Ramesses I at Abydos.* 1937.

———— , *Egyptian Statues and Statuettes.* 1941.

———— , *The Temple of Hibis in el Khārgeh Oasis.* Pt. I: *The Excavations.* 1941.

———— , *The Treasure of Three Egyptian Princesses.* 1948.

———— , *Models of Daily Life in Ancient Egypt from the Tomb of Meket-rēʿat Thebes.* 1955.

EUROPEAN PAINTINGS

Allen, Josephine L., and Gardner, Elizabeth, E., *A Concise Catalogue of the European Paintings in The Metropolitan Museum of Art.* 1954.

Burroughs, Bryson, *Ceiling Panels by Pinturicchio* (The Bulletin of The Metropolitan Museum of Art Supplement). January, 1921.

Barnouw, A. J., *Dutch Paintings*. 1946.

Fansler, Roberta M., and Scherer, Margaret R., *Painting in Flanders*. 1945.

Sterling, Charles, *A Catalogue of French Paintings, XV–XVIII Centuries*. Published under the auspices of The Metropolitan Museum of Art by the Harvard University Press, Cambridge, Mass., 1955.

———, and Salinger, Margaretta, *A Catalogue of French Paintings, XIX Century*. 1966.

———, and Salinger, Margaretta, *A Catalogue of French Paintings, XIX and XX Centuries*. 1966.

Wehle, Harry B., *Fifty Drawings by Francisco Goya*. 1932.

———, *A Catalogue of Italian, Spanish, and Byzantine Paintings*. 1940.

———, and Salinger, Margaretta, *A Catalogue of Early Flemish, Dutch, and German Paintings*. 1947.

Whitehill, Virginia, *Stepping-stones in French Nineteenth-Century Painting*. 1941.

Exhibition Catalogues

The Great Age of Fresco: Giotto to Pontormo, with an Introduction by Ugo Procacci. 1968.

Rousseau, Theodore, Jr., *Cézanne: Paintings, Watercolors, and Drawings*. 1952.

———, *Dutch Painting: The Golden Age*. 1954.

———, *Gauguin: Paintings, Drawings, Prints, Sculpture*. 1959.

———, *The Splendid Century: French Art 1600–1715*. 1960.

FAR EASTERN ART

Hobby, Theodore Y., *Chinese Porcelains in the Altman Collection*. 1953.

Phillips, John G., *China-trade Porcelain*. 1956.

Priest, Alan, *Japanese Illustrated Books*. 1941.

———, *Chinese Sculpture in The Metropolitan Museum of Art*. 1944.

———, *Chinese Jewelry*. 1947.

———, *Japanese Prints from the Henry L. Phillips Collection*. 1947.

———, and Simmons, Pauline, *Chinese Textiles, An Introduction to the study of their history, sources, technique, symbolism, and use*. 1934.

Simmons, Pauline, *Patterned Silks*. 1948.

Exhibition Catalogue

Exhibition of Japanese Painting and Sculpture Sponsored by the Government of Japan. 1953.

GREEK AND ROMAN ART

Alexander, Christine, *Jewelry, the Art of the Goldsmith in Classical Times as Illustrated in the Museum Collection*. 1928.

———, *Greek Athletics*. 1933.

———, *Early Greek Art*. 1939.

———, *Roman Art*. 1939.

———, *Arrentine Relief Ware*. Corpus Vasorum Antiquorum: United States of America, fascicule 9. The Metropolitan Museum of Art fascicule 1, 1943.

———, *Greek and Etruscan Jewelry*. 1946.

von Bothmer, Dietrich, *Amazons in Greek Art*. 1957.

———, *Greek Vases from the Hearst Collection*. 1959.

———, *Ancient Art from New York Private Collections*. 1961.

———, *Attic Black-figured Amphorae*. Corpus Vasorum Antiquorum: United States of America, fascicule 12. The Metropolitan Museum of Art fascicule 3, 1963.

———, and Noble, Joseph V., *An Inquiry into the Forgery of the Etruscan Terracotta Warriors in The Metropolitan Museum of Art*. 1961.

Brown, Blanche R., *Ptolemaic Paintings and Mosaics and the Alexandrian Style*. 1957.

Cook, Brian F., *Inscribed Hadra Vases in The Metropolitan Museum of Art*. 1966.

Grinnell, Isabel H., *Greek Temples*. 1943.

Lehmann, Phyllis W., *Roman Wall Paintings from Boscoreale in The Metropolitan Museum of Art*. 1953.

McClees, Helen, with additions by Christine Alexander, *The Daily Life of the Greeks and Romans as Illustrated in the Classical Collections*. 1924.

Richter, Gisela M. A., *Greek, Etruscan, and Roman Bronzes*. 1915.

———, *The Craft of Athenian Pottery: An Investigation of the Technique of Black-figured and Red-figured Vases*. 1924.

———, *Handbook of the Etruscan Collection*. 1940.

———, *Roman Portraits*. Vols. I and II. 1941.

———, *Roman Portraits*. 1948.

———, *Attic Red-figured Kylikes*. Corpus Vasorum Antiquorum: United States of America, fascicule 11. The Metropolitan Museum of Art fascicule 2, 1953.

———, *Handbook of the Greek Collection*. 1953.

———, *Catalogue of Greek Sculptures in The Metropolitan Museum of Art*. 1954.

———, *Catalogue of Engraved Gems, Greek, Etruscan, and Roman*. 1956.

———, *Greek Painting: The Development of Pictorial Representation from Archaic to Graeco-Roman Times*. 1957.

———, *The Sculpture and Sculptors of the Greeks*. 1957.

———, *Attic Red-figured Vases: A Survey*. 1958.

———, and Hall, Lindsley F., *Red-figured Athenian Vases in the Metropolitan Museum of Art*. 2 vols., 1936.

———, and Milne, Marjorie J., *Shapes and Names of Athenian Vases*. 1935.

ISLAMIC ART

Dimand, Maurice S., *A Handbook of Mohammedan Decorative Art*. 1930.

———, *Persian Miniatures*. 1940.

———, *Islamic Pottery of the Near East*. 1941.

———, and McAllister, H. E., *Near Eastern Jewelry*. 1945.

Lukens, Marie G., *Islamic Art* (The Metropolitan Museum of Art Guide to the Collections). 1965.

Exhibition Catalogue

Islamic Carpets. The Joseph V. McMullan Collection, with an Introduction by Richard Ettinghausen, 1970.

MEDIEVAL ART

Breck, Joseph, *Catalogue of Romanesque, Gothic, and Renaissance Sculpture*. 1913.

———, *The Cloisters: A Brief Guide*. 1926.

Deuchler, Florens, ed., *The Year 1200*. Vol. II: *A Background Survey*. 1970.

Forsyth, William H., *Medieval Sculptures of the Virgin and Child*. 1939.

———, *A Brief Guide to the Medieval Collection*. 1947.

Freeman, Margaret B., *The St. Martin Embroideries*. 1968.

Porter, Arthur K., *The Crosses and Culture of Ireland*. 1931.

Randall, Richard H., Jr., *A Cloisters Bestiary*. 1960.

Rorimer, James J., *The Cloisters: the Building and the Collection of Medieval Art in Fort Tryon Park*. 1938.

———, *The Unicorn Tapestries*. 1938.

————, *Medieval Jewelry.* 1944.

————, *Medieval Tapestries.* 1947.

————, *The Hours of Jeanne d'Evreux.* 1957.

————, *The Unicorn Tapestries at The Cloisters.* 1962.

————, and Freeman, Margaret B., *The Belles Heures of Jean, Duke of Berry.* 1958.

————, and Freeman, Margaret B., *The Nine Heroes Tapestries at The Cloisters.* 1960.

Exhibition Catalogues

Gomez-Moreno, Carmen, *Medieval Art from Private Collections: A Special Exhibiton at The Cloisters.* 1968.

Hoffman, Konrad, *The Year 1200.* Vol. I: *A Centennial Exhibiton at The Metropolitan Museum of Art.* 1970.

MUSICAL INSTRUMENTS

Catalogue of the Crosby Brown Collection of Musical Instruments. Preliminary Catalogue I: *Asiatic Instruments and Some European Harpsichords.* 1901.

The Crosby Brown Collection of Musical Instruments of All Nations: Catalogue of Keyboard Instruments. 1903.

Catalogue of the Crosby Brown Collection of Musical Instruments of All Nations. Vol. I: *Europe.* 1904.

Catalogue of the Crosby Brown Collection. Vol. II: *Asia.* 1906.

Catalogue of the Crosby Brown Collection of Musical Instruments of All Nations. Vol. III: *Instruments of Savage Tribes and Semi-civilized Peoples.* Pt. I: *Africa.* Pt. II: *Oceania.* 1907.

Catalogue of the Crosby Brown Collection. Vol. IV, Pt. I: *Musicians' Portraits, Biographical Sketches.* 1904.

Catalogue of the Crosby Brown Collection of Musical Instruments of All Nations. Vol. IV, Pt. II: *Historical Groups.* 1905.

Morris, Frances, *Catalogue of The Musical Instruments of Oceania and America. Catalogue of the Crosby Brown Collection of Musical Instruments of All Nations,* n.s., Vol. II, 1914.

Winternitz, Emanuel, *Keyboard Instruments in The Metropolitan Museum of Art.* 1964.

PRIMITIVE ART

Means, Philip A., *Peruvian Textiles: Examples of the pre-Incaic Period.* 1930.

Sawyer, Alan R., *Ancient Peruvian Ceramics: The Nathan Cummings Collection.* 1964.

Exhibition Catalogues

Eighty Masterpieces from the Gold Museum, with a Preface by Luis-Angel Arango, a Foreword by Francis Henry Taylor, and a Catalogue by José Perez de Barradas. 1954.

Art of Oceania, Africa, and the Americas from The Museum of Primitive Art, with an Introduction by Robert Goldwater. 1969.

Easby, Elizabeth K., and Scott, John F., *Before Cortes: Sculpture of Middle America.* 1970.

PRINTS

Gauguin Prints, with an Introduction by Hugh Edwards. 1959.

Daniels, Margaret H., *Gardens as Illustrated in Prints.* 1941.

Ivins, William M., Jr., *Notes on Prints.* 1930 (reprinted by Da Capo Press, New York, 1969).

————, *On the Rationalization of Sight with an Examination of Three Renaissance Texts on Perspective.* 1938.

————, *The Life of Christ in Rembrandt's Etchings.* 1942.

————, *The Unseen Rembrandt.* 1942.

————, *How Prints Look.* 1943 (reprinted by Beacon Press, Boston, 1958).

Mayor, A. Hyatt, *Prints* (The Metropolitan Museum of Art Guide to the Collections). 1964.

Stokes, I. N. Phelps, *The Hawes-Stokes Collection of American Daguerreotypes by Albert Sands Southworth and Josiah Johnson Hawes: a Catalogue.* 1939.

Phillips, John G., *Early Florentine Designers and Engravers.* 1955.

WESTERN EUROPEAN ARTS

Bowlin, Angela C., and Farwell, Beatrice, *Small Sculptures in Bronze.* 1950.

Breck, Joseph, *The Collection of Sculptures by Auguste Rodin* (The Bulletin of The Metropolitan Museum of Art Supplement). May, 1912.

————, *Catalogue of Romanesque, Gothic and Renaissance Sculpture.* 1913.

————, *Italian Renaissance Sculpture.* 1941.

Clouzot, Henri, *Painted and Printed Fabrics: The History of the Manufactory at Jouy and Other Ateliers in France,* with notes on the History of Cotton Printing in England and America, by Frances Morris. 1927.

Dennis, Faith, *Renaissance Jewelry.* 1943.

————, *Three Centuries of French Domestic Silver: Its Makers and Its Marks.* 2 vols. 1960.

Hackenbrock, Yvonne, *Meissen and Other Continental Porcelain, Faience, and Enamel in the Irwin Untermyer Collection* (Vol. I of the Catalogue of the Irwin Untermyer Collection). 1956.

————, *Chelsea and Other English Porcelain, Pottery, and Enamel in the Irwin Untermyer Collection* (Vol. II of the Catalogue of the Irwin Untermyer Collection). 1957.

————, *English and Other Needlework, Tapestries, and Textiles in the Irwin Untermyer Collection* (Vol. IV of the Catalogue of the Irwin Untermyer Collection). 1960.

————, *Bronzes, Other Metalwork, and Sculpture in the Irwin Untermyer Collection* (Vol. V of the Catalogue of the Irwin Untermyer Collection). 1962.

————, *English and Other Silver in the Irwin Untermyer Collection* (Vol. VI of the Catalogue of the Irwin Untermyer Collection). 1963.

Hackenbrock, Yvonne, and Gloag, John, *English Furniture with Some Furniture of Other Countries in the Irwin Untermyer Collection* (Vol. III of the Catalogue of the Irwin Untermyer Collection). 1958.

Hunter, G. L., *Tapestries, Their Origin, History and Renaissance.* 1912.

Little, Frances, *Eighteenth-century Costume in Europe.* 1943.

McClellan, George B., *A Guide to the McClellan Collection of German and Austrian Porcelain.* 1946.

Phillips, John G., *Italian Bronze Statuettes.* 1941.

Remington, Preston, *Sculptures by Antoine Louis Barye.* 1940.

————, *A Renaissance Room from the Ducal Palace at Gubbio* (The Bulletin of The Metropolitan Museum of Art Supplement). January, 1941.

————, *English Domestic Needlework of the XVI, XVII and XVIII Centuries.* 1945.

————, *European Decorative Arts.* 1954.

Standen, Edith A., *Western European Arts* (The Metropolitan Museum of Art Guide to the Collections). 1964.

Watson, F. J. B., *The Wrightsman Collection.* Vols. I and II: *Furniture, Gilt Bronze* and *Mounted Porcelain, Carpets.* 1966.

Exhibition Catalogue

Smith, Hugh J., Jr., *Twentieth Century Glass, American and European.* 1950.